Why Is That Art?

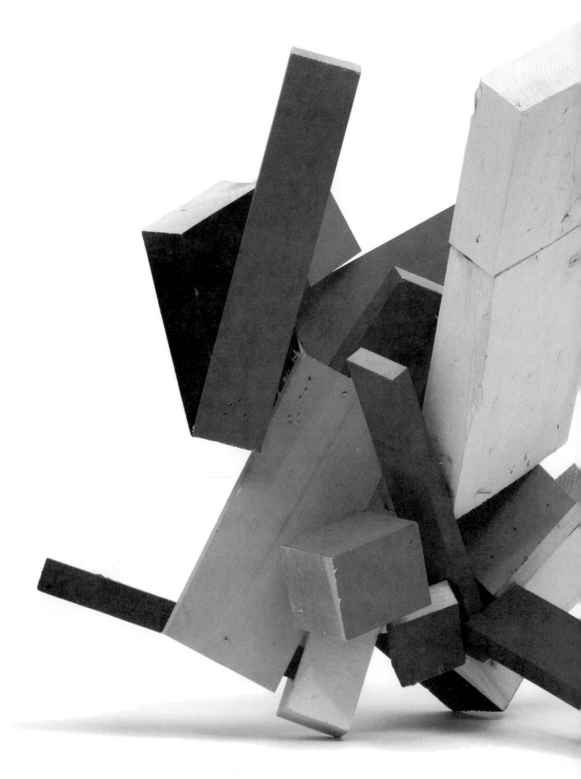

Joel Shapiro | *Study (20 elements)*, **2004.**

Why Is That Art?

AESTHETICS AND CRITICISM OF CONTEMPORARY ART

Second Edition

TERRY BARRETT

UNIVERSITY OF NORTH TEXAS

Professor Emeritus
THE OHIO STATE UNIVERSITY

New York Oxford
OXFORD UNIVERSITY PRESS

Oxford University Press, Inc., publishes works that further Oxford University's
objective of excellence in research, scholarship, and education.

Oxford New York
Auckland Cape Town Dar es Salaam Hong Kong Karachi
Kuala Lumpur Madrid Melbourne Mexico City Nairobi
New Delhi Shanghai Taipei Toronto

With offices in
Argentina Austria Brazil Chile Czech Republic France Greece
Guatemala Hungary Italy Japan Poland Portugal Singapore
South Korea Switzerland Thailand Turkey Ukraine Vietnam

For titles covered by Section 112 of the US Higher Education Opportunity
Act, please visit www.oup.com/us/he for the latest information about
pricing and alternate formats.

Published by Oxford University Press, Inc.
198 Madison Avenue, New York, New York, 10016
http://www.oup.com

Library of Congress Cataloging-in-Publication Data

Barrett, Terry, 1945–
 Why is that art? : aesthetics and criticism of contemporary art / Terry Barrett.—2nd ed.
 p. cm.
 Includes bibliographical references and index.
 ISBN 978-0-19-975880-7 (pbk.) 1. Art, Modern—Philosophy. 2. Aesthetics, Modern. I. Title. II.
Title: Aesthetics and criticism of contemporary art.
 N6350.B27 2012
 701'.17—dc23
 2011025164

Printing number: 9 8 7 6 5 4 3 2 1

Printed in the United States of America
on acid-free paper

FOR GREG, TIM, KEVIN,
PAUL, QUENTIN, AND NICK

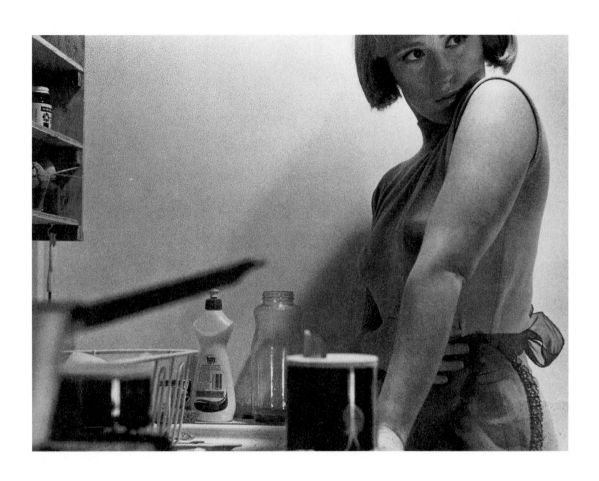

Cindy Sherman | *Untitled Film Still #3,* **1977.**

Contents

4. Formalism: Art Is Significant Form | 115

Illustrations

Preface

In this book, theory is made accessible in a way that welcomes readers into critical dialogue about art. Readers will find a wide sampling of kinds of visual artworks, including installations, abstract and representational painting, monumental sculptures, performance art, and photography. The artists, aestheticians, and critics selected for the book are international (though weighted toward Americans) and include men and women as well as persons of color.

Importantly, the book provides readers with a variety of established theories of art, clearly articulated, to account for different kinds of visual art with which readers can approach all art. The book ties theories of art to particular works of art through the writings of art critics, aestheticians, and quotations from artists whose work is presented. *Why Is That Art?* uses the traditional sets of criteria—Realism, Expressionism, and Formalism—and updates them with contemporary sources of Poststructuralism, with which one can approach any work of art.

Each aesthetic theory is explained in its context of origin, but through a twenty-first century lens. The chapters are in chronological order determined by the history of aesthetics. All theories are put to test by applying them to current art. Old theories are updated with current scholarship through quoted and paraphrased voices of aestheticians, critics, and artists. The featured theories are offered with their strengths and weaknesses: that is, what a theory accounts for best in works of art and what it cannot satisfactorily address. Each theory is applied to recent works of art. Although the tone of the book presents a positive attitude about contemporary art, aesthetics, and criticism, critical reservations about the artworks and theories are also included through the voices of objecting thinkers.

Readers are encouraged to join a fascinating discourse about contemporary art and philosophies of art. The book gives them the knowledge they need to enter critical dialogue with a newly gained sense of confidence about contemporary art and how it is judged, a variety of clearly articulated criteria, and reasoned principles with which viewers can form their own judgments. Readers should be left with new attitudes of appreciation for contemporary art, scholarship, and reasoned argumentation.

The book presents sophisticated concepts in a way that is understandable to novice readers but is sufficiently complex to hold the interest of advanced students. *Why Is*

That Art? can serve as a primary text for seminars for art students, students of modern art history, aesthetics courses, and art education. Professors of aesthetics courses and history courses can readily supplement the text with full articles, chapters, or excerpts from philosophers and historians of their choosing. The book is suitable as a supplementary text for courses in historical aesthetics, especially those that use anthologies of philosophers' writings, and courses in modern art history whose texts do not include art, art theory, and criticism of our day.

Many students, at all levels of education, have trouble understanding and appreciating contemporary works of art and the theories that support them. Many students carry misconceptions about judgments of art, too often holding the belief that judgment of art "is all subjective, anyway." *Why Is That Art?* clearly shows that statements of judgments about works of art need to be based on more than personal preference, that sound judgments need to be accompanied by defensible reasons that are implicitly or explicitly based in criteria, and that some judgments are better formulated and argued than others and are thus better.

Unlike individuals' philosophies and histories of art, *Why Is That Art?* is an explanation by the author based on eclectic sources from multiple points of view, including those of aestheticians, critics, and the artists who made the works under consideration. The reader will not receive the author's criticism or aesthetics, but the views of many different thinkers, some of whom disagree with one another. The point of the book is not to persuade readers toward the author's or any one point of view, but to encourage them to consider many criteria and to choose among them intelligently, critically examine judgments of art made by others, and make informed judgments of their own.

New to This Edition

I've updated the book throughout, and I've made numerous improvements, many of which were suggested by the students and instructors who used the first edition. Among the most notable changes:

- To help students more quickly enter the dialogue, I've included a glossary of terms as they are used in this book.
- I've significantly enhanced the treatment of postmodernism by adding strategies of art-making that postmodernists use.
- I've moved the discussion of structuralism from Chapter 5, Postmodern Pluralism, to Chapter 4, Formalism, to more explicitly acknowledge structuralism as an important force in the development of formalist theory. Poststructuralism remains in Chapter 5.
- I've reorganized Chapter 1 so that it is more consistent in format with the chapters that follow it.
- Works of the artists discussed in the book have been updated: works by Jeff Koons, Kiki Smith, Paul McCarthy, and most noticeably works by Andy Goldsworthy, to match the revised text that accompanies them.
- Of the 70 illustrations in the book, 10 of them are new to this edition, and 25 of them are in full color.

Acknowledgments

This is the third book of mine that Jan Beatty has sponsored, and each has been a pleasant experience because of her intelligence, sensitivity, and flexibility in working and negotiating with authors and publishers.

Thanks to my former dean, Karen Bell, and former chairperson, Patricia Stuhr, for the supportive research environment they provided. Thanks to Erin Preston, undergraduate research assistant, for her diligent library work, and The Ohio State University College of the Arts for financial support. Thanks to the many individuals who have helped shape this book, including students who have read sections in draft form, and Willem Elias, Michael Parsons, and Vicki Daiello. Thanks to Robert Milnes, Dean of the College of Visual Arts, University of North Texas, and to Denise Baxter, acting chair of the Department of Art Education and Art History, University of North Texas, for a pleasant place in which I now teach.

I'd also like to thank the reviewers that Oxford commissioned of the first and second editions: Julie Alderson, Humboldt State; David Apolloni, Augsburg College; Betty Ann Brown, California State University, Northridge; Chaya Chandrasekhar, Marietta College; Peter Chametzky, Southern Illinois University, Carbondale; Amy V. Grimm, Irvine Valley College; Janet Hartranft, Pennsylvania State University; Barbara Jaffee, Northern Illinois University; David Johnson, Massachusetts College of Liberal Arts; Felix Koch, Columbia University; Patrick Luber, University of North Dakota; Ben Mepham, Central Michigan University; Derek Conrad Murray, University of California, Santa Cruz; Irene Nero, Southeastern Louisiana University; Jean Robertson, Herron School of Art and Design, Indiana University—Purdue University, Indianapolis; Amir Sabzevary, Laney College; Katherine Schwartz, James Madison University; Anita Silvers, San Francisco State University; Julie Van Camp, California State University, Long Beach; Tim Van Laar, University of Illinois at Urbana-Champaign; Lita Whitesel, California State University, Sacramento; and Sarah E. Worth, Furman University. Thanks also to Oxford's production editor, David Bradley; associate editor, Lauren Mine; copy editor, Elaine Kehoe; designer, Binbin Li; proofreader, Heather Dubnick; and permissions editor, Susan Michael Barrett.

Thanks to my supportive siblings and to two excellent physicians, Doctors David Sharkis and Thomas Sweeney. Thanks most to Susan Michael Barrett, my wife, who enthusiastically read over and over again new manuscript pages as they came out of the printer and chapters that I thought were complete until she found areas that needed clarity or further explanation. She is always supportive and loving—and was especially so for challenging sections of the draft at troublesome times in the school year.

Why Is That Art?

Introduction

My nephews Nick, Quentin, Paul, Kevin, Tim, and Greg, from young ages and now, challenge me with provocative questions such as, "Is *this* art?" "Why is *that* art?" "*Who says* it's art?" I used to color and draw with them around their large kitchen table and now offer suggestions on their drawings or video animations when they ask and take them to the Museum of Contemporary Art in Chicago. They show me their latest video games, *anime*, and *manga*. Following a visit to the Museum, I recall a conversation with Tim, a grade-schooler at the time, who was persistent in his questions about examples he brought to me of what I call popular visual culture: "Is this art?" With good humor I would give him exaggeratedly firm answers, like "No—it's a comic book." He'd follow with an action figure, to ask if it was art. Eventually I tried to redirect his "Is it art?" question by telling him it really did not matter so much if it was *art*, but if it was *good*. With playful seriousness he brought more examples, and I gave more positive and negative responses about my opinions of their goodness. Eventually I changed the question to "Is it good *of its kind*?" "How does this action figure compare to your others?" "Is this comic book better than that comic book? Why do you think so?" I refrained from answering my questions and tried to facilitate him in determining his own criteria for his collection of artifacts.

This book is written in that innocent and playful spirit of questioning art, but it provides more traditional as well as contemporary answers about art and its value. It offers a variety of positive answers to common questions viewers raise about contemporary works of art and answers them from three sources: philosophers of art, art critics, and artists.

The book explains ancient and contemporary philosophies and applies each to works of art made recently. It provides you with an overview of major aesthetic theories in accessible language. It puts the theories of art into practice by applying them to many different examples of contemporary visual art. It relies on multiple voices from three sets of people: philosophers, art critics, and the artists who made the works that are discussed.

After reading the book, you should come away with new knowledge of philosophy, art criticism, and contemporary art, and be more comfortable with each. The book should allow you to join with some confidence an ongoing conversation about intriguing ideas concerning philosophy, art, and life.

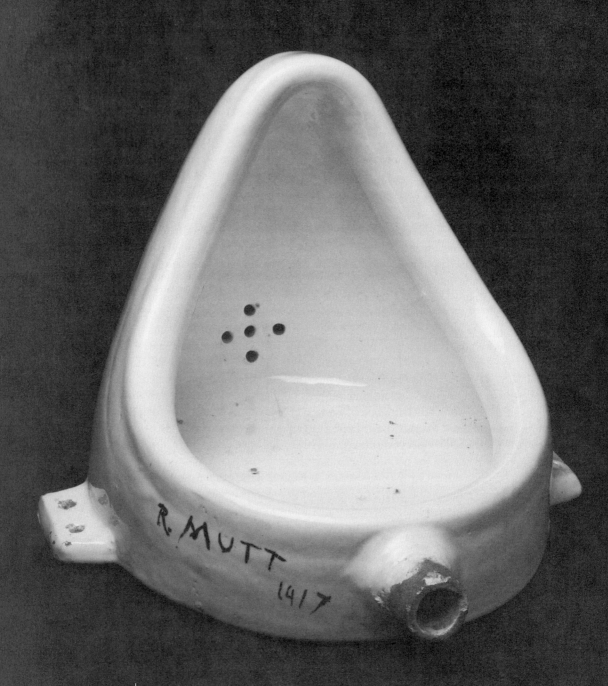

1.1 Marcel Duchamp | *Fountain* (second version), 1950.

Original version produced 1917. Ready-made glazed sanitary china with black paint, 12 inches high.
Philadelphia Museum of Art: The Louise and Walter Arensberg Collection. © 2006 Artist Rights Society (ARS), New York/ADAGP,
Paris/Succession Marcel Duchamp.

1 | Artworlds and Definitions
HOW *THAT* BECAME ART

Introduction

This chapter provides an overview of the book by addressing questions such as: What is art? How is it defined? Who decides what qualifies as art? What is art criticism? Who gets to be an art critic?[1] What is philosophy? What is aesthetics? Where will this book get me?

Art

In this book, examples of recent works of art are drawn from the major art institutions of recognized art museums, galleries, and institutions in major Western art centers such as New York City and other art centers of the world. There are many kinds of artworks that this book does not address explicitly. There is art that is shown and distributed through open-air arts and crafts street fairs and festivals, paintings made by people in watercolor societies, images made by members of photography clubs, the objects of many self-taught artists whose work is referred to as "outsider art" (outside of the mainstream), and the myriad sites providing all kinds of art on the Internet, much made specifically for it. The theories considered in this book, however, can be applied to all kinds of works of art, as well as to visual objects and images not usually referred to as "art."

Defining "art" is a major enterprise in aesthetics, historically and recently. There are two basic kinds of definitions of the term *art*, and without knowing such distinctions, we often talk past one another or become provoked, annoyed, and exasperated, ending the discussion. Two kinds of definitions are *classificatory* and *honorific*. An alternative is the *open* definition of art.

Honorific Definitions of "Art"

Usually when we say of an object, "That's a work of art," we mean that the object merits the honor of being called art. We often implicitly think of "art" as "good art" or even "great art." Such thinking is routinely reinforced by courses in art history in which all the works studied in any given course are implied to be or are explicitly stated to be

the best of their kind. The goodness of the works of art studied in art history texts and courses is rarely if ever questioned.

The history of Western philosophies of art can be seen as a series of attempts by theorists, including artists, who attempt to identify and name the honorable qualities of a good work of art. This book is structured around three examinations of major honorific definitions of art that compete with one another: Realism, Expressionism, and Formalism. A fourth theory, Poststructuralism, is more contentious than the other theories and perhaps raises more questions than it answers about what art is and what its benefits are. Poststructuralists are more likely to be satisfied with a classificatory or descriptive definition of art. Poststructuralists, for example, do not accept all "masterpieces" to be good or beneficial works of art.

Honorific definitions have some immediate consequences. For example, some Western definitions of high art that we have inherited from past centuries identify art as being valued for its own sake rather than for its functionality. As a result, as current aesthetician Stephen Davies points out, such notions bias us "against the possibility of art that is intended to be practically useful, and not to be contemplated solely for its own sake. For example, it is prejudiced against the idea that art can primarily serve domestic, religious, political, or other ritual functions, and it thereby excludes much of what might deserve the title of art,"[2] especially that of many non-Western cultures and what has traditionally and often derogatorily been referred to as "women's work."

Classificatory Definitions

A classificatory or descriptive definition of art tells us that objects x, y, and z are believed to be works of art, but that a, b, and c are not. When an object is said to be "a work of art," it does not necessarily mean that it is a good work of art, but just that it is one of the things that the community counts as art rather than some other kind of object, such as an item found in a hardware store. So, by one prominent classificatory definition, if you want to know what art is, go to art museums and look at what they display.

Questions then quickly arise as to the apparent circularity of such a definition of art as that which is in art museums: For example, "Who put *those* objects in the museum?" "*Why* are they considered good enough to be there?" "Is only art that is in a museum 'art'?" Answers come from the institutional definition of art, put forth by two contemporary aestheticians, Arthur Danto and George Dickie.

The institutional definition of art acknowledges an "artworld" and asserts that works of art are dependent on art institutions, art theory, and art history. Danto stresses the importance of historical contexts in determining works of art, and Dickie stresses functional aspects of art institutions.

According to Dickie's first institutional account in 1974, "A work of art in the classificatory sense is (1) an artifact (2) [it has] a set of the aspects of which has had conferred upon it the status of candidate for appreciation by some person or persons acting on behalf of a certain social institution (the artworld)."[3] Ten years later Dickie added clarifying requirements, summarized by Robert Stecker:

1. An artist is a person who participates with understanding in making a work of art.

2. A work of art is an artifact of a kind created to be presented to an artworld public.
3. A public is a set of persons whose members are prepared in some degree to understand an object that is presented to them.
4. The artworld is the totality of all artworld systems.
5. An artworld system is a framework for the presentation of a work of art by an artist to an artworld public.[4]

The fuller idea is that it is a system of relations rather than one authoritative agent who confers the status of "art" on an object. Many people are part of the artworld, such as artists, curators, collectors, museum directors, gallery directors, critics, historians, and others.

Danto's definition is different from Dickie's in that it is more theoretical than functional. Danto endorses this set of conditions, inferred from his writing by fellow aesthetician Noel Carroll:

X is a work of art if and only if
1. X has a subject
2. about which X projects an attitude or point of view
3. by means of rhetorical (usually metaphorical) ellipsis
4. which ellipsis requires audience participation to fill in what is missing (interpretation)
5. where both the work and the interpretation require an art-historical context.[5]

Some object that classificatory definitions do not tell us what makes a work of art good, only that it has the conferred status of "art." Aesthetician Mary Mothersill, for example, complains that the institutional definition "does not seem like a contribution to philosophy but rather a sociological echo or reflection of the market-place."[6]

Nevertheless, in practice, classificatory definitions can be useful in moving a discussion along, especially about a work of art that is under dispute. Instead of wrangling back and forth, "That's not art!" "Yes it is." "No it's not!" we can accept the authority of an artworld and let the work be called "art" and then move forward with whether it is good art, decide upon what grounds it can be considered good art, or discuss why we think someone may think it is good art.

Each of the theories and definitions of "art" have their strengths and weaknesses, and these are explicated within the forthcoming chapters of the book. The book allows you to decide which theories and ideas you find most compelling and encourages you to put them to use. As aesthetician David Fenner writes, "the fun of philosophizing about theories is in attempting to work out the bugs of whichever theory is most attractive. The key for the reader of aesthetics, then, is to either find a theory whose problems are not overwhelmingly damaging to the view or to find a theory worth saving and begin to address and answer the difficulties."[7]

Thus, all of the art examples used in this book are here by all three kinds of definitions. All of the works are honored by many critics as deserving to be called "art" according to one or more of four major (honorific) theories of art: Realism, Expressionism, Formalism, or Postmodernist theory. Each of these theories is explained

in forthcoming examples and applied to the chosen artworks. The art examples also qualify under the open definition (see the following subsection): By consensus of many artists, critics, and other scholars of art, they share family resemblances with known works of art. The examples also qualify under the descriptive definitions: For example, under Dickie's criteria, each of the artworks reproduced in the book was made by an artist intending to make art and to present it as art, and each is accepted as art by a community of artworld participants.

An immediate conclusion can be drawn about any artwork: You don't have to like it, but it would be responsible of you as a viewer to accept it as a work of art, and then to decide whether it is a good work and by what criteria. If you adhere to only an honorific notion of art, then it would be intellectually generous of you to temporarily accept it as a candidate for the honor of the term *art* until you have drawn a considered conclusion about what you think its status ought to be. To be reactionary and dismissive or unthoughtfully accepting is not to be critical in the sense that this book encourages.

The Open Definition

Most honorific definitions seek to identify essential aspects of a work of art, that is, the necessary and sufficient properties a work of art needs to be considered a (good) work of art: For example, for x to be a work of art it must be made by a human, intended to be a work of art, express something, be aesthetically well formed, and so on. However, artists sometimes intentionally defy such definitions when making art, seeking to push boundaries and resist the constraints of theoretical dogma. When art was supposed to be an aesthetically beautiful object made by an artist with the intent of making a work of art, Marcel Duchamp famously entered into a show in New York City in 1917 a used urinal placed on its back on a pedestal in the gallery space, called it *Fountain* (1.1), and signed it with the name R. Mutt. He appropriated a product and positioned it as art. This gesture changed traditional questions of visual worthiness of an art object to different questions, questions that have come to be known as (1) ontological, (2) epistemological, and (3) institutional: (1) What is art? (2) How do we know if something is art? (3) Who decides what is art? With *Fountain*, Duchamp altered the rules of the art game as it was then played, and ever after.

Aesthetician Morris Weitz, following the intellectual lead of Ludwig Wittgenstein, the influential Austrian linguistic philosopher who invented "language games," suggested in 1956[8] that we consider the term *art* to be an "open concept," one that resists definitions based on any set of necessary and sufficient conditions present or forthcoming. Weitz argues that art is a living concept that cannot and ought not be pinned down by one or a set of conditions: The best we can do is point to clear examples of objects that we consider to be works of art and look for family resemblances among other objects that are claimed to be art. Although trying to define *art* is ultimately doomed to failure, Weitz maintains that it is not a useless enterprise: By attempting to name what we honor as art we get clearer about what we value in art. Ultimately, the question is not whether it is art, but whether it is good art. Along with classificatory definitions, Weitz's notion is considered *anti-essentialist* and is opposed to definitions that seek to identify absolute essences.

Aesthetics

Aesthetics is a branch of philosophy, along with ethics, that deals with moral issues; ontology, which concerns the nature of things; epistemology, which is thought about knowledge and truth; and philosophies of particular areas of study such as science, history, and so forth.

The *Oxford Companion to Philosophy* states: "Most definitions of philosophy are fairly controversial, particularly if they aim to be at all interesting or profound. . . . The shortest definition, and it is quite a good one, is that philosophy is thinking about thinking." Philosophy is a second-order activity: thinking about thoughts about the world. Philosophy can also be defined as "rationally critical thinking" about large questions such as the nature of the world (metaphysics), justified beliefs (epistemology), and ways to live (ethics). For example, each of us has some notion of the world and our place in it: "Metaphysics replaces unargued assumptions embodied in such a conception with a rational and organized body of beliefs about the world as a whole."[9]

Philosophers generally agree that the methods of philosophy are rational inquiry, critical thinking of a more or less systematic kind, or rational argument characterized by logical thinking. Further, philosophy is usually distinguished from empirical science and religion. Questions of science are typically answered by observation and experiment; religion is dependent on faith and usually revelation, whereas questions of philosophy are not answered by means of religious revelations and explanations.

The terms *aesthetics* and *philosophy of art* and *art theory* overlap but are not synonymous. The term *aesthetics* has many different uses. This book (usually) uses *aesthetics* synonymously with "philosophy of art." *Aesthetics*, however, can also refer to one's taste in art or sensibilities regarding things artistically: "Her aesthetic is very austere." Aesthetics also can qualify an experience as an "aesthetic experience," and a value as "an aesthetic value." We also talk of a "formalist aesthetic" or a "feminist aesthetic," referring to criteria by which some judge art.

Philosophy of art includes questions and answers about the nature of art (and whether it has a nature), definitions of art and whether it can or should be defined, beauty, proper or desired responses to art or beauty, nature, relations between ethics and aesthetics, the validity or desirability of political responses to art, topics about meaning and understanding of works of art, questions of value and on what bases they are made, if judgments are subjective or objective, whether all art is good, and so forth. Answers, we shall see, vary greatly, but the questions in the hands of most artists, critics, and aestheticians are not "up for grabs." Various questions receive thoughtful competing answers from different thinkers for differing reasons, and these differences and similarities can enlighten us about art, the world, and people. Aesthetics and criticism are ongoing discussions that are open to revisions based on reasoned dialogue.

About philosophy of art, Richard Shusterman asserts, "The task of aesthetic theory, then, is not to capture the truth of our current understanding of art, but rather to reconceive art so as to enhance its role and appreciation. The ultimate goal is not knowledge but improved experience, though truth and knowledge should, of course, be indispensable to achieving this."[10]

The following chapters are written with the goal of clarifying our notions of the field of aesthetics, the various roles art plays in society, and how we might appreciate art (or negatively appraise it) through philosophical thinking about it and its effects on us and the world. This book does not intentionally or explicitly endorse any one single theory of art, and it tries to present many theories fairly and with sympathy along with criticality.

The term *art theory* today is more commonly used than "aesthetics" by the contemporary art press, artists, and in departments of art. This book attempts to bridge the "traditional aesthetics" that Anglo-American audiences often receive in aesthetics courses through the study of philosophers such as Plato, Aristotle, David Hume, Immanuel Kant, G. W. F. Hegel, John Dewey, and so forth with "art theory" that is heavily influenced by "French theory" and what is loosely called "postmodernism." Philosophy students will probably be more comfortable with the term *aesthetics* and art students with the term *art theory*.

Authors publishing in the journal *October* who have written the book *Art Since 1900* provide a succinct context for the emergence of art theory in the 1970s, for which they partly credit themselves:

> The seventies witnessed an unprecedented flourishing of journals of criticism. During this time, critical theory became a dynamic part of cultural practice: if an avant-garde existed anywhere, it might be argued, it existed there—in such publications as *Interfunktionen* in Germany, *Macula* in France, *Screen* in Britain, and *October* in the United States. More politically committed than traditional philosophy, but also more intellectually rigorous than conventional criticism, such theory was interdisciplinary in its very nature: some versions attempted to reconcile different modes of analysis (e.g., Marxism and Freudianism, or feminist inquiry and film studies), while others applied one model to a wide range of practices (e.g., the structure of language adapted to the study of art, architecture, or cinema). The master thinkers who had emerged in France in the fifties and sixties, such as the structuralist Marxist Louis Althusser, the structuralist psychoanalyst Jacques Lacan, and the poststructuralist philosophers and critics Michel Foucault, Jacques Derrida, Roland Barthes, and Jean-François Lyotard, were already influenced by modernist poets, filmmakers, writers, and artists, so that the application of such "French theory" to visual art seemed logical.[11]

Chapter 5 explores Postmodernist criticism and aesthetics (theory) and the influences and authors mentioned in the quotation.

Art Criticism

The term *art criticism* is complex. Aesthetician Morris Weitz defines criticism as "a form of studied discourse about works of art. It is a use of language designed to facilitate and enrich the understanding of art."[12] Marcia Eaton, an aesthetician, says that criticism "invites people to pay attention to special things." She adds that critics "*point* to things that can be perceived and at the same time *direct* our perception"; when criticism is good, "we go on to see for ourselves; we continue on our own."[13]

Criticism is informed discourse about art to increase understanding and appreciation of art. This definition includes criticism of all art forms, including dance, theater, music, poetry, painting, and photography. *Discourse* includes talking and writing, and many interviews of artists are quoted in forthcoming chapters. *Informed* is an important qualifier that distinguishes criticism from mere talk and uninformed opinions about art. Not all writing about art is criticism. Some art writing, for example, is journalism rather than criticism: It is news reporting on artists and artworld events.

Criticism is a means toward the end of understanding and appreciation or informed lack of appreciation. In some cases, a carefully thought-out response to an artwork may result in negative appreciation or informed dislike. More often than not, however, especially when considering the work of prominent artists, careful critical attention will result in fuller understanding and positive appreciation. Criticism very often results in what Harry Broudy, a philosopher promoting aesthetic education, calls "enlightened cherishing."[14] Broudy's "enlightened cherishing" is a compound concept that combines *thought* (through the term *enlightened*) with *feeling* (through the term *cherishing*). He reminds us that both thought and feeling are necessary components that need to be combined to achieve understanding and appreciation; criticism is not a coldly intellectual endeavor.

Interpretation and Judgment

In the language of aestheticians that philosophize about art and art criticism, and in the language of art critics, the term *criticism* usually refers to a range of activities, namely, describing, interpreting, judging, and theorizing, rather than just the act of judging. Morris Weitz, an aesthetician interested in art criticism, investigated what critics do when they criticize art. He took as his test case all the criticism ever written about Shakespeare's *Hamlet*. After reading the volumes of *Hamlet* criticism written through the ages, Weitz concluded that when critics criticize they do one or more of four things: They *describe* the work of art, they *interpret* it, they *judge* it, and they *theorize* about it. Some critics engage primarily in descriptive criticism; others describe, but primarily to further their interpretations; still others describe, interpret, judge, *and* theorize. Weitz drew several conclusions about criticism, most notably that any one of these four activities constitutes criticism and that judgment is not a necessary part of criticism.[15]

To interpret a work of art is to make sense of it. To interpret is to see something as "*representing* something, or *expressing* something, or *being about* something, or *being a response to* something, or *belonging in a certain tradition*, or *exhibiting certain formal features*, etc."[16] It is to ask and answer questions such as: What is this object or event that I see or hear or otherwise sense? What is it about? What does it represent or express? What does or did it mean to its maker? What is it a part of? Does it represent something? What are its references? What is it responding to? Why did it come to be? How was it made? Within what tradition does it belong? What ends did a given work possibly serve its maker(s) or patron(s)? What pleasures or satisfactions did it afford the person(s) responsible for it? What problems did it solve or allay? What needs did it relieve? What does it mean to me? Does it affect my life? Does it change my view of the world?[17]

To judge a work of art is to appraise how good a work it is. A complete judgment entails (1) an appraisal of value and (2) reasons for that appraisal (3) based on identified

(or implied) criteria. Both interpretation and judgment are based on accurate or inaccurate description of the work and its causal environment. Descriptions (statements of "fact"), interpretations, and judgments are interrelated and interdependent. How one values a work may well affect how one describes it. What one understands a work to be about will affect one's judgment of it: For example, I may maintain that such and such a work of art is aesthetically engaging but morally reprehensible, or that another work of art is ugly but socially beneficial. We will encounter such examples in the following chapters.

The notion that judgment alone constitutes criticism is widespread, especially in daily uses of the term. A definition in an encyclopedia of philosophy asserts, simplistically, "To criticize a work of art is to make a judgment of its overall merit or demerit and to support that judgment by references to features it possesses."[18]

Critics differ on the importance of judging art. Clement Greenberg, the foremost critic of Modern art, asserts: "the first obligation of an art critic is to deliver value judgments." He is insistent on the point: "You can't get around without value judgments. People who don't make value judgments are dullards. Having an opinion is central to being interesting—unless you're a child." Roberta Smith, a critic for the *New York Times*, says: "You have to write about what you think. Opinion is more important, or equally as important, as description." She adds, "you also define yourself as a critic in terms of what you don't like." Robert Hughes, a critic for *Time* magazine, titled one of his books *Nothing If Not Critical,* and by "critical" he means "judgmental."

James Elkins, an art historian who studies recent art and its theory, argues that if criticism is limited to description, it "dissolves into the ocean of undifferentiated nonfiction writing on culture." He also resists dogmatic judgments that merely assert. He seeks "critics who are serious about judgment, by which I mean that they offer judgments, and—this is what matters most—they then pause to assess those judgments." However, he cautions, along with art critic Rosalind Krauss, "criticism cannot become *exclusively* a forum for meditation on judgment . . . because then it would lose itself in another way—it would dissolve into aesthetics."[19]

Contrary to popular beliefs, when critics judge artworks their judgments are more often positive than negative: As art critic and poet Rene Ricard says, "Why give publicity to something you hate?"[20] Abigail Solomon-Godeau, who often writes about photography, says there are instances when it is clear that something is nonsense and should be called nonsense, but she finds it more beneficial to ask questions about meaning than about aesthetic worth. Andy Grundberg, currently a freelance critic and former photography critic for the *New York Times,* puts the point well: "Criticism's task is to make arguments, not pronouncements."[21]

This book centers on questions of value, which entail statements of judgment. However, each of the artists' works that are critically examined are *interpreted* as well as judged (positively and negatively). The judgments cited are accompanied by arguments in their support supplied by the critics.

Critics on Criticizing

Most of those who write and publish aesthetics and art history are "accredited" in the sense that most have college degrees in philosophy and art history, usually PhDs. Some authors are both critics and aestheticians, sometimes in the same piece of writing. Some

artists also write art criticism: Peter Plagens makes and exhibits art and writes for *Newsweek* and art magazines. Artists sometimes contribute directly to aesthetics, philosophy of art, or what recent artists often call "theory" by writing: For example, Donald Judd, a minimalist modern sculptor, wrote philosophical articles about art. All artists contribute to aesthetics and criticism in the basic sense that there would be much less to write about in aesthetics, and none in art criticism, if artists did not make art. New art can push aesthetics, and new ideas in aesthetics can influence artmaking. Critics respond both to new art and to new art ideas and may affect both.

Of those who are actively engaged in activities of aesthetics, criticism, and artmaking, very few can economically sustain themselves by writing about or making art. Most aestheticians, artists, and critics make a living by teaching or some other primary means of employment. The artists cited in this book are self-sustaining based on their artmaking, and so are a few of the critics, but probably none of the aestheticians are.

Art critics are more or less self-appointed. Art critics become critics by writing and publishing art criticism. Art critics come from a variety of backgrounds: Some hold degrees in art history or artmaking, some are practicing artists as well as critics, some are museum curators who write essays in museum catalogs and conduct interviews for publication in the art press. Art critics, above all, are writers whose specialty is recent art. Their credibility is built on the respect they garner from those who read them, especially their peers within the artworld. Barry Schwabsky, an art critic and poet, wrote in *The Nation* about his sense of criticism:

> [T]he critic is a self-appointed observer; all that counts is that he offers an articulate account of aesthetic experience: "painting reflected by an intelligent and sensitive mind," as one of the greatest art critics, the young Charles Baudelaire, put it in 1846. Erudition is no impediment to the critic, but imagination and gusto are more essential; an aptitude for generating ideas and interpretations is more valuable than the ability to test and verify them.[22]

"What do I do as a critic in a gallery?" Peter Schjeldahl, critic for *The New Yorker*, asks. He answers: "I learn. I walk up to, around, touch if I dare, the objects, meanwhile asking questions in my mind and casting about for answers—all until mind and senses are in some rough agreement, or until fatigue sets in."[23]

About his writing of art criticism, Dave Hickey says: "I see the object. I translate that seeing into vision. I encode that vision into language, and append whatever speculations and special pleadings I deem appropriate to the occasion." Roberta Smith says that sometimes her criticism is "just like pointing at things . . . One of the best parts of it is that occasionally, maybe more than occasionally, you get to write about things that haven't been written about yet, new paintings by new artists you know, or new work by artists who aren't known."[24]

When Schjeldahl is confronted by a work he does not like, he asks himself these questions:

> "Why would I have done that if I did it?" is one of my working questions about an artwork. (Not that I *could*. This is make-believe.) My formula of fairness to work that displeases me is to ask, "What would I like about this if I liked it?" When I cannot deem myself an intended or even a possible member of a work's audience, I ask myself what such an audience member must be like.[25]

Donald Kuspit, an aesthetician and critic, asks: Why do "we respond to this artist's image of a Madonna and child rather than that artist's image? Why do we like a certain texture and not another texture?" He goes on to say, "It's part of the critic's task, perhaps his most difficult task, to try to articulate the effects that the work of art induces in us, these very complicated subjective states."[26]

Joanna Frueh writes of the need for intuition when writing art criticism:

Art criticism, like other disciplines that privilege the intellect, is generally deprived of the spontaneous knowing of intuition—of knowledge derived from the senses, and experience as well as the mind. Nerves connect throughout the body, conduct sensations, bits of knowledge to the brain. Blood pumping to and from the heart flows everywhere inside us. Knowing is being alive, wholly, not just intellectually. It is a recognition of human being, the intelligence of the body. The intellectual may feel enslaved in matter. If only she could escape from the body. But the mind will not fly unless we embrace the body as a path to freedom.[27]

Most critics consider what they write as incomplete and somewhat tentative; that is, what they write is not the final word, especially when it is about new work. Chuck Close, one of the most famous and most admired of living artists, tells a story about John Canaday, at the time the art critic for the *New York Times*, who "hated my work. I saw him just before he died. I had never before met the man, and this small, old, old man walked up to me at an opening and said, 'Mr. Close, I just wanted to tell you that I made a terrible mistake with your work. I didn't get it, and I really missed the boat. I made a terrible mistake, and I'm sorry for what I said.' It was absolutely amazing."[28] Artist Alex Katz commented to Close: "Everyone has a right to change their minds. The artist does, and so does the critic."[29] Schjeldahl originally disapproved of Philip Guston's new figurative works; ten years later, the critic admitted in print that he now sees them as great.[30]

Thus, instead of making eternal pronouncements of truth, most critics feel they are contributing to an ongoing conversation. Their comments are not unleashed speculations; they are carefully considered points of view—but they are views open to revision.

Criticizing Criticism

In his general preface to anthologies of writings by critics, Kuspit calls them "master art critics" because they provide sophisticated treatments of complex art. He praises their independence in their points of view and their self-consciousness about their art criticism. He admires their passion, their reason, and their lack of dogmatism. "They sting us into consciousness."[31]

In her review of an Arthur Danto book, Marina Vaizey, an art critic for the *Sunday Times of London*, praises his writing for being able to make the reader "feel, see and, above all, think" and to describe "the sheer captivating sensuality of a particular work."[32] Her criteria for good criticism include literary merit, judgments made in a setting that is more than local, and insights that have a relevant vitality that goes beyond the short time span implied by publication in a periodical of current comment.

Marcia Eaton praises the literary criticism of H. C. Goddard because she finds him to be a "superb pointer" and teacher who shows us how to contemplate and scrutinize art in ways that will produce delight.[33] He does not have to distort the text in order to get us to see things hidden in it. He does not try to force his views. He expresses humility and readiness for exchange of insights. He is a good inviter.

Thus Kuspit, Vaizey, and Eaton offer criteria for good criticism: sophisticated treatment of art, critical independence, self-consciousness of the critical process, passionate reasoning, lack of dogmatism, delightful insights without distortion of the work of art, and humility. Kay Larson, a critic for *New York* magazine, adds fairness to the artist as a criterion. Mark Stevens tries to avoid "nastiness" when criticizing art and regrets the times he has been sarcastic in print. He thinks critics should be "honest in their judgment, clear in their writing, straightforward in their argument, and unpretentious in their manner." For him, good criticism is like good conversation—"direct, fresh, personal, incomplete." Jerry Saltz, an art critic for the *Village Voice*, says a critic's writing "should be about what he or she has seen; it should be in accessible, clear language and not a lot of brainy gobbledygook that no one understands. A critic should want to be understood. . . . A critic's job is simply to look and then record his or her responses as honestly and clearly as possible."[34]

Criticism and Aesthetics

Activities of art criticism and aesthetics at times overlap and distinctions between the two are loose, especially today when boundaries between disciplines are intentionally being dismantled. Critics generally write about individual works of art and issues that they raise, but their writing of criticism tends to be less broad in scope than that of aestheticians, who tend to make claims and arguments about "art" that are often meant to pertain to *all* art. When a writer attempts to build a philosophical theory of art, for example, that large project has vague boundaries. Aesthetician Robert Stecker puts it this way:

> A theory of art will typically concern itself centrally with questions of value, for example whether there is some unique value that only art works offer. In any case, it will attempt to identify the valuable properties of art that are responsible for its great importance in most, if not all, cultures. It may give attention to cognitive issues, such as what one must know to understand an artwork, and what it is for an interpretation of a work to be good, acceptable, or true. A theory of art may be interested in other sorts of responses or attitudes to artworks, such as emotional responses. It may focus on the fictionality characteristic of so many works of art, or on their formal, representational, or expressive properties. It may deal with the social, historical, institutional, or intentional characteristics of art. A theory of art will address several of these issues, display the connections among them, and sometimes, but only sometimes, attempt to formulate a definition either of art or of artistic value, or both on the basis of some of these other artistic properties.[35]

Such large projects are not usually the domain of critics writing as critics about an exhibition. A critic in the course of his or her article will certainly touch on some or many of these issues but, as a critic, will not likely try to build a theory of art.

Skepticism about Art, Aesthetics, and Criticism

Some viewers generally think that the current artworld, especially when it promotes "modern" art, is "putting them on." Morley Safer of the *60 Minutes* television news magazine reinforced their attitudes in the 1990s in a very derogatory segment about recent art and its promoters.[36] Such viewers and Mr. Safer would likely take such a view of much of the art reproduced and discussed in this book.

Some artists are skeptical about the value or need for art criticism, resenting critics who intrude in their artmaking expertise, especially when they think critics "don't get" their work. Some artists are uninterested in aesthetics, criticism, or "theory" in general—"I just want to make my art." Or, as painter Barnet Newman said, "Aesthetics is for artists what ornithology is for birds."[37]

Some theorists argue that all aesthetic values are the products of an upper social class strategy of cultural dominance. They cite sociologists who observe a correlation between elitist tastes for fine art and class membership based on economic and social status. French sociologist Pierre Bourdieu, for example, argues that "refined" taste is a mere epiphenomenon without any solid basis and states that such taste is a strategy for maintaining distinctions to separate the upper class from others.[38]

Aesthetics, Art Criticism, and Visual Culture

Visual cultural studies is an emerging field that seeks to expand scholarly consideration from "fine art" to all humanly made visual items found in daily living as well as in museums. *Fine art* is a part of the larger field of objects and images that the term *visual culture* encircles.

Richard Shusterman, a contemporary philosopher, notes, "Popular art has not been popular with aestheticians. . . . When not altogether ignored as beneath contempt, it is typically vilified as mindless, tasteless trash."[39] Nonetheless, he recommends that aestheticians not so easily dismiss the area as irrelevant, unimportant, or lacking the content to give us insight into our world: "I consistently affirm both high and low pleasures, both aesthetic and functional values. One crucial capacity of art (whether high or low) is to be appreciated in various modes and on different levels."[40]

Kevin Tavin, a scholar and advocate of including visual culture in arts education, challenges us with these questions about all visual images, not just those objects and images confined to "fine art" venues:

> What images are we currently exposed to in visual culture? What investments do we have in certain images? What are these investments? What do we learn from these images? What do the images not teach? Do these images provide or signify a certain lifestyle or feeling for us? Do these images help mobilize desire, anger, or pleasure in us? Do we believe these images embody sexist, racist, ablest, and class-specific interests? What are the historical conditions under which these images are organized and regulated? How is power displayed or connoted throughout these images?[41]

This book addresses popular visual culture through examinations of the work of artists such as Jeff Koons (Chapter 2), who both draws upon popular culture and

pushes boundaries between popular culture and fine art with objects such as monumental puppy dogs sculpted out of flowers, and the very realistic futuristic paintings by Alexis Rockman (Chapter 2), whose work would fit comfortably in both *National Geographic* magazine and *Artforum* magazine. Formalism (Chapter 4) grows out of contempt for "the shallow" in mass consumer culture. In Chapter 5, photographs by Cindy Sherman directly examine constructions of the "feminine" and "woman" based in visual culture; Lorna Simpson's work challenges racist and sexist conditions in contemporary American culture; and Paul McCarthy's installations and videos viscerally call attention to the denial of the unpleasant in Disneylike mass cultural entertainment.

The major theories of Realism and Expressionism can be applied to examinations and positive and negative evaluation of all artifacts, and criteria derived from these theories are not limited to art in museums. Realist and Expressionist criteria are called into play daily in response to movies and television programs.

Aestheticians, Artists, Critics, and Readers

This book voices concerns expressed by aestheticians, artists, and critics, in their own words and in paraphrase, with citations for further reading. It treats aestheticians, artists, and critics as important members of a community who express insights about life, art, and being human. It assumes that several points of view about a work of art are more informative than one view, even that of the artist whose work is being discussed. You can decide which view or combinations are most meaningful to you, based on the arguments you read in light of what you know and what you see in the artwork and its context.

Many aesthetics books are devoid of art examples; many art books lack theory with which to more fully understand the art; other books express only the words of the artists or omit the artists' voices altogether. This book intentionally brings philosophers, critics, and artists together to obtain different perspectives on the same work of art and issues those works raise. It allows the reader to make choices about which points of view are most helpful in deciding issues and deciphering meanings and values. New theories can be applied to old art, and old theories can be applied to new art. The book invites you into the ongoing discussion of aesthetics, past and present, but especially as it can be applied to art made within our lifetimes.

Questions for Further Reflection

Currently, what is your personal philosophy of art?

Regarding works of art in general, of what are you most certain?

Where in discussions of art and aesthetics do you feel most uncomfortable? What would you like to know that would disarm that discomfort?

Notes

1. For a fuller discussion of the large topic of art criticism, see Terry Barrett, *Criticizing Art*, 3rd ed., New York: McGraw-Hill, 2012.

2. Stephen Davies, *The Philosophy of Art*, Malden, Mass.: Blackwell, 2006, p. 202.

3. George Dickie, *Art and the Aesthetic: An Institutional Analysis*, Ithaca, NY: Cornell University Press, 1974, p. 34.

4. Dickie, in Robert Stecker, "Definition of Art," in *The Oxford Handbook of Aesthetics*, ed. Jerrold Levinson, New York: Oxford University Press, 2003, p. 147.

5. Noel Carroll, in Stecker, "Definition of Art," p. 147.

6. Mary Mothersill, "Beauty," in *A Companion to Aesthetics*, ed. David Cooper, Malden, Mass.: Blackwell, 1992, p. 50.

7. David Fenner, *Introducing Aesthetics*, Westport, Conn: Praeger, 2003, p. 46.

8. Morris Weitz, "The Role of Theory in Aesthetics," reprinted in *Aesthetics: A Reader in the Philosophy of Art*, ed. David Goldblatt and Lee Brown, Upper Saddle River, NJ: Prentice Hall, 1997, pp. 518–524.

9. Ted Honderich, ed., *The Oxford Companion to Philosophy*, New York: Oxford University Press, 1995, p. 666.

10. Richard Shusterman, *Pragmatic Aesthetics: Living Beauty, Rethinking Art*, 2nd ed., New York: Rowman & Littlefield, 2000, pp. xv-xvi.

11. Hal Foster, Rosalind Krauss, Yve-Alain Bois, and Benjamin Buchloh, *Art Since 1900*, New York: Thames and Hudson, 2004, p. 571.

12. Morris Weitz, *Hamlet and the Philosophy of Literary Criticism*, New York: Dutton, 1964, p. vii.

13. Marcia Eaton, *Basic Issues in Aesthetics*, Belmont, Calif: Wadsworth, 1998, pp. 113–120.

14. Harry Broudy, *Enlightened Cherishing*, Champaign-Urbana: University of Illinois Press, 1972.

15. Weitz, *Hamlet and the Philosophy of Literary Criticism*.

16. Paul Thom, *Making Sense: A Theory of Interpretation*, New York: Rowman & Littlefield, 2000, p. 64.

17. Terry Barrett, *Interpreting Art: Reflecting, Wondering, and Responding*, New York: McGraw-Hill, 2003, p. 201.

18. Colin Lyas, "Art Criticism," in *The Shorter Routledge Encyclopedia of Philosophy*, ed. Edward Craig, New York: Routledge, 2005, p. 69.

19. James Elkins, *What Happened to Art Criticism?* Chicago: Prickly Paradigm Press, 2003, p. 84.

20. Rene Ricard, "Not about Julian Schnabel," *Artforum*, 1981, p. 74.

21. Andy Grundberg, "Toward a Critical Pluralism," *Afterimage*, October 1988.

22. Barry Schwabsky, "Octoberfest," *The Nation*, December 26, 2005, http://www .thenation.com/doc/20051226/schwabsky, June 6, 2006.

23. Peter Schjeldahl, "Critical Reflection," *Artforum*, Summer 1994, p. 69.

24. Roberta Smith, quoted by Deborah Drier, "Critics and the Marketplace," *Art & Auction*, March 1990, p. 172.

25. Schjeldahl, "Critical Reflections," p. 64.

26. Donald Kuspit, in Terry Barrett, *Criticizing Art*, 2nd ed., New York: McGraw-Hill, 2000, p. 23.

27. Joanna Frueh, "Toward a Feminist Theory of Art Criticism," in *Feminist Art Criticism*, ed. Arlene Raven, Cassandra Langer, and Johanna Frueh, Ann Arbor: UMI Press, 1988, p. 58.

28. Chuck Close, *The Portraits Speak: Chuck Close in Conversation with 27 of His Subjects*, New York: A.R.T. Press, 1997, p. 318.

29. Ibid.

30. Peter Schjeldahl, "The Junkman's Son," *The New Yorker,* November 3, 2003, pp. 102–103.

31. Donald Kuspit, in Arlene Raven, *Crossing Over: Feminism and the Art of Social Concern,* Ann Arbor: UMI Press, 1988, p. xv.

32. Marina Vaizey, "Art Is More Than Just Art," *New York Times Book Review,* August 5, 1999, p. 9.

33. Eaton, *Basic Issues in Aesthetics,* p. 122.

34. Jerry Saltz, in *M/E/A/N/I/N/G: An Anthology of Artist's Writings, Theory, and Criticism,* ed. Susan Bee and Mira Schor, Durham, NC: Duke University Press, 2000, pp. 334–335.

35. Stecker, "Definition of Art," Levinson, pp. 136–137.

36. Michael Kimmelman, "Art View; A Few Artless Minutes on '60 Minutes,'" *New York Times,* October 17, 1993, http://query.nytimes.com/gst/fullpage.html?res=9F0CE0DA 1530F934A25753C1A965958260, June 1, 2006.

37. Artlex Art Dictionary, http://www.artlex.com/ArtLex/a/aesthetics.html, retrieved October 4, 2006.

38. Alan Goldman, "Evaluating Art," in *The Blackwell Guide to Aesthetics,* ed. Peter Kivy, Malden, Mass.: Blackwell, 2004, p. 95.

39. Shusterman, *Pragmatist Aesthetics,* p. 167.

40. Ibid., p. xii.

41. Kevin Tavin, "Wrestling with Angels," *Studies in Art Education,* Vol. 44, No. 3, Spring 2003, p. 208.

2.1 Andres Serrano | *The Morgue (Fatal Meningitis III)*, **1992.**

Cibachrome, silicone, Plexiglas, and wood frame, 60 x 49 1/2 inches. Edition 1/3, ASE-274-A-PH.
Courtesy of Paula Cooper Gallery, New York.

2 | Realism

ART IS REALISTIC, TRUTHFUL, AND BEAUTIFUL

Introduction

This chapter explores Realism and art. Realism is the oldest theory of art in Western aesthetics, dating back to the ancient Greeks, particularly Plato and Aristotle. These major questions guide the chapter: What constitutes Realism in art? What are Plato's and Aristotle's contributions to aesthetics? Are their ideas relevant to art made today?

To explore Realist theories of art, we will look at the work of three prominent contemporary artists whose work is "realistic": Jeff Koons, a sculptor and painter, makes replicas of objects and images selected from popular visual culture; Alexis Rockman paints large, realistic, and often futuristic murals that are based on scientific research; and Andres Serrano, a photographer, has made images of body fluids, bodies in morgues (2.1), members of the Ku Klux Klan, homeless persons, people having sex, and his dreams.

After a brief introduction to a general notion of Realism, we will look at the thinking of Plato, apply it to some artworks by Koons, and consider kitsch. Then we will examine Aristotle's thinking about art and apply it to artworks by Rockman. Photographs are often cited as the most realistic of representational images, and Serrano's photographs provide examples for consideration of the realism of photography, pornographic realism, censorship, and different conceptions of why we think representations are realistic.

A Brief Overview of Realism

In simple terms, a theory of Realism would have one believe that a work of visual art should look like what it is meant to show. One current definition describes Realism in art as "That quality of a depiction which allows the viewer quickly and easily to recognize what it is a picture of: that quality of a literary text which relates it closely to everyday life."[1]

Realism as a theory of art is known by different names, including Copy theory, Imitation theory, and Mimetic theory (*mimesis* in Greek), Representation theory, and Representationalism. In the late twentieth century, Realism has engendered philosophical discussion of what it means for a representation to be Realistic.

For ancient Greeks, what an artwork was meant to show was usually taken to mean something in nature, including historical human events. Western art primarily was made within a Realistic tradition from the time of the ancient Greeks until the eighteenth century, when *expression* became more important than *representation*: Expression theory is the topic of the next chapter. Along with the notion that art is and should be realistically representational and based in nature came concomitant notions that art also is and should be truthful and beautiful.

Realism as a theory of art came to us by way of Plato and Aristotle, two of the first thinkers to systematically theorize art. They did not invent Realism, however, but inherited it from their ancient Athenian culture and pondered it in talks and writings, some of which have survived today, although often in incomplete and fragmented form. Plato's and Aristotle's conception of "Realism" overlaps "Idealism": It is the real in its perfect, ideal form that is the object of beauty. Realism for the ancient Greeks is a means of visualizing perfection.

Both Plato and Aristotle accepted art as imitation, but as we shall see, they radically disagreed about the value of art because of its effect on people. Plato wanted art banished from his ideal society, whereas Aristotle valued art.

Plato

Plato (428–348 B.C.) wrote more about drama than the visual arts, but all arts, for the Greeks, are imitative of nature. Poetry and drama are imitative literarily, were often spoken, and imitated emotions and actions of gods and historical figures. Music is thought to imitate action such as patterns of resistance, development, and closure.[2] Sculptures and paintings are visually imitative: Plato's visual cultural environment in Athens included statues of gods and warriors created to look like ideal human figures, within the stylistic constraints of Greek sculpture at the time.

The Greeks did not have a term equivalent to our modern term of "art." The Greek term *techne* refers to expertise or craft, and for Plato, the paradigmatic examples of *techne* are medicine, architecture, and arithmetic; these, for Plato, are superior to artistic pursuits such as music, poetry, drama, painting, and sculpture. Note how Plato's values in his hierarchical list of *techne* parallel the status we give to careers and contributions today in our own society.

Plato's thinking about art is embedded in his larger theories of metaphysics (philosophy of ultimate reality) and epistemology (philosophy of truth and knowledge) and in his concern for specifying and promoting an ideal human society. The arts, for Plato, are clearly to be in the service of higher goods such as truth and good behavior. Plato's world is twofold: a physical world available to the senses, which are deceptive and not to be trusted, and the invisible true world available only to the intellect that is freed from illusion and emotion. The imperfect world that we see and otherwise experience is made up of particular instances that are mere imitations of ideal "Forms" in the perfect world that we cannot see.

In Plato's famous analogy, a bed is made by a carpenter who bases it on the notion of the ideal Form of a bed, which really exists somewhere but cannot be seen by humans. It would be much better to have the ideal bed, rather than the carpenter's rendition of it. More meager yet, in Plato's view, is an artist's painting of a bed, which is

an imitation of the carpenter's bed, which is an imitation of the ideal bed. Thus Plato's well-known assertion: A work of art is thrice removed from the reality it depicts, and thus neither to be trusted nor valued.

Plato's belief in an invisible but real world of an ideal bed, chair, tree, or what have you, floating above in a heaven of Forms, may seem too absurd to be taken seriously today. However, before dismissing such notions, consider how many of us do hold in our minds, if not in an actual heaven of Forms, the ideal body, car, racehorse, rose, sunset, and so forth against which we measure particular bodies, cars, and horses. We often seek the perfect, imagine the perfect, and attempt to make the perfect, and we judge things according to our mental ideals, many of which are highly influenced by prior images, today often found in mass media.

In addition to being mere and imperfect imitations that may give us untrustworthy and often false knowledge, Plato believes that artworks can and do engage us emotionally, often to the detriment of our being able to reason clearly, obtain true knowledge, and act morally. (Do these claims not sound familiar today when recalling discussions about the purported negative effects of video games, movies, and television programs?)

Some Platonic anxieties about the power of images are echoed today by the influential French social and cultural critic Jean Baudrillard. He argues that images and simulated realities are all that exist now: Television images, advertising, and fashion photography, for example, create a false sense of reality or a replacement reality that obscures what is really real. Baudrillard's term for this condition is "the simulacrum," a kind of world in which representations of things, and not the things themselves, are taken to be real.[3]

Beauty plays an important part in Plato's thinking about the arts, and he tries to find what common properties all beautiful things share, and these are embodied in the Form of Beauty. Simple things are beautiful in their unity; complex things are beautiful when they are proportionally unified. Beauty and unity, however, are not identical.

Plato proposes an educational theory to teach about beauty: The young should be taught to love beauty, first in one single beautiful human body, then be taught to recognize shared features of beautiful bodies, and ultimately to learn that the beauty of "souls" is superior to the beauty of bodies. The young should be taught physical beauty first, and then to love beautiful practices and customs, the beauty of knowledge, and ultimately to know that all beauty is embodied in the Form of Beauty.[4]

Beauty is not a value in itself, for Plato: Contemplation of beauty is in the service of the development and maintenance of good moral character. In the *Republic*, in writing about education, Plato states that the arts should be "fine and graceful"

> so that our young people will live in a healthy place and be benefited on all sides, and so that something of those fine works will strike their eyes and ears like a breeze that brings health from a good place, leading them unwittingly, from childhood on, to resemblance, friendship, and harmony with the beauty of reason.[5]

Plato is not critical of the arts because he does not like them; "on the contrary," according to aesthetician John Andrew Fischer writing today, "it is because they are so

enjoyable and alluring that they are potentially dangerous and must be subjected to critical scrutiny."[6] Plato worries about the effects of the arts, particularly their reputed psychological effects on behavior: If we enjoy the fictional imitations we experience, we may have an increased disposition to act in a similar fashion in daily living.

Plato was one of the first in the West to recognize that the arts are emotionally powerful and that politicians and educators can put the arts to good (or harmful) use.[7] Imitations are generally dangerous for Plato's ideal society because they are not necessarily based on real things, they may not communicate truth, they often appeal to emotions rather than to reason, and they may encourage us to live immorally. In Mary Mothersill's summary of Plato's position, "The only poets or playwrights allowed in the Republic are those who are careful to depict the good guys in glowing colors and the villains as despicable."[8] In short, poets and playwrights ought to be banished, but whereas banishment is probably not feasible, given the popularity of the arts, censorship of some works is feasible and advisable.

Plato's notions of art are very different from Modernist conceptions of art as an autonomous, independent, and free activity unfettered by social concerns—what is commonly known in the twentieth century as "art for the sake of art," or the theory of Formalism, the topic of Chapter 4. Moreover, Plato's notions are also opposed to Modernist ideas of the free and independently creative artist who can make art as he or she pleases: In Plato's ideal society, no art is personal to anyone, and all art belongs to the state. There are correct moral values, to which works of art are subservient, and it is not the role of the artist to invent, critique, or alter them.[9]

Aristotle

Like Plato, Aristotle was born into a culture that held Realism to be the correct theory of art. Like Plato, Aristotle accepts Realism and its requirements that truth and beauty be embodied in representational imitations of nature. Unlike Plato, however, Aristotle is friendly to the arts and thinks they are valuable. Aristotle does not accept Plato's belief in a heaven of ideal Forms. For Aristotle, reality consists of the natural world that we sense.

Although art is imitation for Aristotle, he thinks that the artist does not simply copy nature, but celebrates it by finding the universal or archetypical, representing an amalgamation of the best that nature provides. Works of art are thus better, aesthetically, than any original persons or objects on which they are based. Mimesis, for Aristotle, does not limit the artist to what actually is. As aesthetician Steven Halliwell explains, for Aristotle, "All the mimetic arts can represent anyone of three things (as well as combinations of them): actual reality, past or present: (popular) conceptions of, or beliefs about, the world: or normative ideas of what 'ought' to be the case."[10] Mimesis includes the possibility of beautifying, improving, and generalizing qualities found in nature.

Aristotle acknowledges and delights in the enjoyment that representations provide. A successful representation, for Aristotle, engages our attention and emotions almost as would the real thing. The artist offers viewers a point of view, showing something from one specific vantage point. Thus, what the artist presents is not simply the

subject matter in itself, but "a subject matter as it matters to and for an experiencing human intelligence."[11] Importantly, for Aristotle, one criterion for a successful work of art is that it presents subject matter in a way that invites the viewer to think about it because of the way the artist has presented it for perceptual experience. Viewers ought to interpret and judge the world as represented in a work of art in similar ways to how they interpret and judge the world outside of the work of art. Both the making and the apprehension of a work of art are modes of understanding.

Plato worries about the psychological effects of art, namely, that a vivid portrayal of a morally wrong action might persuade viewers to act in similarly immoral ways or that listening to melancholy music may cause us to be melancholy. Aristotle, however, disagrees and argues that such experiences are good because they offer us vicarious satisfactions of our own antisocial tendencies and make us less likely to act out what we experience in art.[12] Note how frequently you have heard similar arguments about sex and violence in the media. Some argue that seeing inappropriate sex and violence may cause us to act harmfully. Others argue that seeing sex and violence is a safe release and a socially acceptable way of negotiating urges to act in potentially harmful ways.

Stephen David Ross, a contemporary aesthetician, explains that the ancient Greeks had two senses of "beauty"—inclusive and exclusive. In their inclusive use of "beauty," the Greeks hold that almost anything worthy of admiration might be regarded as beautiful, including character traits of humans, goodness, truths, and both the natural and the divine world. In their exclusive (more limited) use of "beauty," the Greeks refer to how things appear and the joy of experiencing beautiful things, including human bodies, natural creatures, artifacts, and things. The exclusive sense includes implicit and explicit comparisons, and it is a binary concept: This is beautiful, that is not. Although these two inclusive and exclusive senses of the same term seem distinct, the Greeks did not keep them distinct.[13]

Thus, the ancient Greeks' concept of beauty is complex, and it links key concepts such as knowledge, truth, goodness, nature, and art. Such linkages influenced later European intellectual history. Greek "beauty" expresses both what is finite, perceivable in form, in the natural world, as well as what is unperceivable and infinite and beyond the physical world. Beauty links the human, natural, and divine worlds, and beauty is the good, the ethical, and the invaluable in all things, finite and infinite, measurable and immeasurable. Ross lists ten ways the Ancient Greeks understood beauty: (1) as wonderful and supreme; (2) as beyond all measures and distinctions; (3) as pertaining to all things; (4) as pertaining to the gods and to natural things as well as to humans and their works, including works of art; (5) as pertaining to finite things, shapes, colors, sounds, thoughts, customs, characters, and laws; (6) as inseparable from goodness and excellence; (7) as pertaining to visible things more than to poetry and music; (8) as order in relation to the arrangement of parts; (9) as harmony, symmetry, and proportion; and (10) as that which is pleasant to see and hear.[14]

Plato embraces both inclusive and exclusive conceptions of beauty, and especially honors a supreme sense of beauty as evidenced by his invention of a Platonic Form of Beauty. Aristotle, however, uses beauty in an exclusive sense, restricting it to attributes such as size, order, proportion, harmony, and symmetry. Aristotle also includes function and apt fulfillment of a purpose as criteria for good art. Thus, Aristotle's notion of beauty is embodied in form in two important ways: as appearance and as function.

Beauty, for Aristotle, is "always more or less," and in Ross's words, "Things are more or less beautiful as they are more or less orderly, fulfill their formal purposes more or less perfectly, give more or less pleasure in their apprehension."[15] Aristotle's ideas about beauty were very influential through the Renaissance, and they remain current today for many artists, critics, and aestheticians.

Nickolas Pappas, an aesthetician, explains that for Aristotle, beauty is a real property of beautiful things: Beauty is not merely in the mind of the beholder. To say that something is beautiful is to perceive some quality in the thing. Furthermore, each art form has a nature. If the nature of painting is mimesis, then a painting is beautiful and pleasing because of its likeness to that which it shows. The pleasure we take in viewing mimetic art is a good thing, for Aristotle.

Aristotle has a tolerantly broad conception of beauty. When teaching about biology in *Parts of Animals*, for example, he urges his students not to abhor what they might find unsightly: Living things reveal beauty because they demonstrate an organization that suits their purpose, and therefore their design is beautiful. There are many kinds of beauty because there are many kinds of things: Thus, for Aristotle, there is not one ideal (Platonic) form of beauty.

Very importantly, in Aristotle's view, to intelligently call something "beautiful," one has to know what the thing is: Beauty, for Aristotle, is based on knowledge first, then on the appearance and function of that which is said to be beautiful.[16] Aristotle links beauty to form and form to meaning. The beauty of form entails the integration of the parts of a piece. Beauty cannot be achieved with individual elements: As Aristotle wrote in *Poetics*, "a painter would never allow a figure to have a foot that was disproportionate, however beautiful it might be in itself."[17] Although proportion is an important aspect of beauty, it can only be discerned interpretively through cognitive attention to an artwork's figurative, narrative, or dramatic meaning. For example, an element that is dramatic in itself would not be successfully dramatic unless it were proportionately placed within the whole of the work, just as a beautifully rendered foot in an otherwise unsuccessful painting would not justify the painting as a good work of art. Thus, to discern form is to discern meaning and its significance to the whole. Aristotle makes the judgment of beauty dependent on an interpretation of an artwork's purpose.

Form, for Aristotle, is not an independently valuable item: It is always subservient to the larger purpose of art, and that purpose is to represent aspects of the world. Halliwell explains Aristotle's concept of form this way:

> Form consists of an organization of parts, but an organization that functions as the bearer of meaning. The form and unity of a work of art cannot be explicated, on Aristotle's model, without at least implicit reference to the world. Thus unity is not a self-contained condition, but implies a certain kind of imagined reality . . . the point remains that form and unity inside the work of art constitute a structure whose intelligibility connects it to the world outside the work . . . the form of a representational work, and the way in which it is interpreted, cannot be divorced from the kind of reality that is the subject of the work.[18]

Much later, twentieth-century aestheticians, critics, and artists known as Formalists separated form from content, making form an independently and exclusively valuable

aspect of art (see Chapter 4). Formalists consider form to be autonomous and independent of all other values. Aristotle is not a Formalist: For him, form must always be dependent on and subservient to connections the artwork makes to the world.

Kitsch

The term *kitsch* arises frequently in dialogue about the works of Jeff Koons, an artist featured in this chapter (Color Plates 1–3), and kitsch is an important concept in modern discourse about art and culture. Although the term was not introduced until around 1870 when German philosophers invented the term and defined the concept, Plato (arguably) would abhor kitsch.

Gordon Bearn, a contemporary aesthetician, provides examples of kitsch current today:

> Hummel figurines, paintings on black velvet of a tearful clown or a beatific Elvis Presley, Muzak, Eiffel tower pepper grinders, ice cubes shaped like breasts, peek-a-boo anything, paintings of mournful waifs with the outsized eyes made familiar by Margaret or Walter Keane, Walt Disney Tudoroid or Bavarioid architecture, heart-shaped grave stones, plates adorned with cute fluffy kittens; some critics provocatively include among examples of kitsch the paintings of Adolphe-William Bouguereau, Lawrence Alma-Tadema, Andrew Wyeth, Norman Rockwell, the poetry of Robinson Jeffers; some go so far as to proclaim Richard Wagner and Salvador Dali "masters" of kitsch.

Bearn identifies the philosophical problem of kitsch this way: "What does the kitschiness of kitsch consist in?"[19] Kitschiness is thought to have "trashiness," but if it does, its trashiness is not due to lack of technical competence in the production of kitsch: Note, for example, the careful skills exemplified in the kitschiest of objects made by Koons. Critics of kitsch generally agree that kitsch and art are significantly different in quality: Kitsch, in opposition to art, is argued to be nongenuine and inauthentic. Bearn thinks the concept of kitsch is important because by identifying what it is, we can come to a clearer understanding of what art is.

Bearn summarizes three historical objections to kitsch: Kitsch is said to be (1) too easy, (2) too formulaic, and (3) a lie. Kitsch is thought, by some, to be too easy in the sense of its being too easy to enjoy, or that it is merely enjoyable, and is nothing more than entertainment that appeals only to emotions. It is also called too sentimental, too cute. Herman Broch (1886–1951), a German philosopher and novelist, criticized some novels as kitsch because they depicted the world only as people wanted it to be. Broch identified two classes of kitsch: the sweet and the sour. Examples of sweet kitsch are the easy enjoyments of cute puppies, children, and lovers in moonlight. Sour kitsch is exemplified in sympathy cards, war movies, and war memorials, for example. In Bearn's summary: "Sour kitsch presents death, danger, and despair, but with the anguish removed, the pain anesthetized, the experiences become enjoyable."

Clement Greenberg, the prototypical Formalist of the twentieth century (see Chapter 4), criticized some paintings as kitsch because their effects were too formulaic, too easy to achieve. There is nothing surprising about kitsch; its familiarity contributes to the comfort of kitsch. Broch describes kitsch's use of the formulaic as a deceptive

replacement of the inaccessible, mysterious, and ideal with the mundane, accessible, and pseudo-ideal.

Philosopher Friedrich Nietzsche (1844–1900) criticized composer Richard Wagner's music as being "never true" because of its kitschy reliance on the theatricality of big, popular effects. More recently, Milan Kundera, in his novel *The Unbearable Lightness of Being*, writes forcefully about the lies of kitsch: "Kitsch is the absolute denial of shit, in both the literal and the figurative senses of the word; kitsch excludes everything from its purview which is essentially unacceptable in human existence." Kundera comes to this conclusion, in part, from a theological position. For him, "Shit is a more onerous theological problem than evil." He argues that since, in Christian anthropology, God invented man in His image, either God has intestines or man is not like Him. Kundera cites the Gnostics' solution to the "damnable dilemma" when in the second century Valentinus claimed that Jesus "ate and drank but did not defecate." Kundera continues:

> Since God gave man freedom, He is not responsible for man's crimes. The responsibility for shit, however, rests entirely with Him, the Creator of man. . . . The daily defecation session is daily proof of the unacceptability of Creation. Either/or: either shit is acceptable (in which case don't lock yourself in the bathroom!) or we are created in an unacceptable manner.
>
> It follows, then, that the aesthetic ideal of the categorical agreement with being is a world in which shit is denied and everyone acts as though it did not exist. This aesthetic ideal is called *kitsch*.[20]

In Bearn's conclusion about Kundera's and others' objections to kitsch, kitsch is harmful because by denying anything that is difficult, kitsch purveys pleasurably sanitized and deceitful representations of the world. Based on what we have of Plato's writings, it is likely that he would agree with much of the criticism leveled at kitsch, especially its appeal to emotion, general neglect of intellect, and distorted representations.

Pornography

Mimetic imagery, especially photographs, films, and video images, such as Jeff Koons's "Made in Heaven" series and Andres Serrano's "History of Sex" book and exhibition, frequently generates discussions about pornography. Although what ought to be considered "pornographic" is a hotly contested topic, generally people agree that pornography in pictures "can be described as any set of images that exist solely for the purpose of sexual arousal and features nudity and explicit sexual acts."[21] Opinions about pornography vary radically and can be broken into two opposing views. A first view upholds pornography as socially valuable because it gives visibility to varied sexualities and practices and can lead to greater understanding and tolerance of differences. Film theorist Brian McNair writes that pornography allows "the affirmation or strengthening of minority or subordinated sexual identities."[22] A second view condemns pornography as a "fundamentally amoral/immoral category of representation, deeply implicated in negative social phenomena."[23]

Some who accept pornography do so under principles of free speech and reluctantly defend images they find objectionable. Aesthetician Julie Van Camp writes, "I am 'pro-free speech,' but I would not call myself 'pro-pornography' . . . we can consistently defend free speech while finding abhorrent some of the things we defend thereby."[24]

Some classify different types of pornography, such as "soft" and "hardcore" pornography and pornography involving children. Some versions are acceptable; others, such as child pornography, are not. Film theorist Susan Hayward asserts that "pornography aimed at women, lesbians and homosexuals can serve to assert their respective sexualities as meaningful, as subjectivized not objectified . . . marginalized sexualities can also appropriate the dominant form of heterosexual pornography and adapt it to their own readings."[25] McNair adds that "in the private worlds of fantasy and sexual relationships . . . women have increasingly used pornography—subversively decoding male-oriented material on the one hand, consuming material produced by women for women on the other."[26]

Anti-pornography arguments hold the one position that all pornography is bad, but for differing reasons. One argument, associated with Catharine MacKinnon,[27] a professor of law, asserts that pornography is degrading to women and reinforces patriarchal ideology. Another argument supported by some lobbying groups and church groups agrees that all pornography is bad, but for the reason that it weakens family values and degrades marital sex.

Obscenity and Censorship

Some will and others will not find certain images to be obscene, and those who do often call for their censorship. Recall that the sheriff and police closed down Robert Mapplethorpe's exhibit "The Perfect Moment" in Cincinnati on April 7, 1989, and confiscated for evidence seven photographs that "pandered obscenity." The show was shortly thereafter reopened, with the offending photographs put back in place; during the ensuing court case the prosecution was unsuccessful in its arguments.[28]

The history of art, from ancient times to the present, as reproduced in history books and collected and displayed in world-famous museums, contains many explicitly sexual images of homosexual and heterosexual activities. Recall that ancient Greeks, for example, depicted on ceramic vessels sexual intercourse between males. These are, however, in stylized silhouettes. Picasso has many sexual drawings and etchings that are routinely displayed without public objection. They are explicit and representational but are drawn in a freely expressive way and do not utilize a high degree of mimetic Realism.

Arguments over what should and should not be shown have heated up in recent years, and such debates are often referred to as "culture wars," skirmishes waged among people with strongly held and differing ideologies about what is good and proper. Plato advocates censorship of images and other artworks for the good of his ideal community. United States Senator Jesse Helms and mayor of New York City Rudolph Giuliani also advocated censorship of the arts.

On the floor of the U.S. Senate, former Senator Helms called Andres Serrano "a jerk" for making *Piss Christ*, a photograph of a plastic crucifix floating in urine, and

proposed an amendment that would have banned the public funding and display of any art that was offensive to any group or individual. In 1999, former Mayor Giuliani threatened to withhold the city's $7.2 million annual operating budget from the Brooklyn Museum of Art, withhold a promised $20 million for building improvements, dismiss the museum board, and reclaim the city-owned building if the museum did not remove one painting by Chris Ofili from its "Sensation" exhibition that the mayor found offensive, calling it "sick stuff." A federal court blocked the mayor's threatened actions and the painting remained in the show.[29]

Stephen Dubin, an art historian, presents a provocative argument against censorship by inventing the character *Homo censorious*:[30]

- *"Homo censorious* insists on a single interpretation of a work of art," failing to realize that "the most compelling art typically generates multiple interpretations."
- *"Homo censorious* takes a few elements out of context—specific words, titles, part of a design—and treats them as if they embody the entire work of art."
- *"Homo censorious* assumes a paternalistic attitude toward the public," and *Homo censorious* "is both self-righteous and adamant about what he believes, and assumes that others are incapable of deciding for themselves what is good and bad, right and wrong." This paternalistic attitude is based on beliefs that there is a natural as well as cultural hierarchy among living things and that the male of the human species is on top, ought to exert control, because he knows best what is good for the rest. Sometimes *Homo censorious* claims to be trying to protect children but usually extends his surveillance to adults.
- *Homo censorious* "overestimates the power of exposure to different forms of cultural expression and assumes the effects to be immediate and irreversible," and believes that if you "eliminate what you perceive to be pernicious, you've performed a momentous deed."

The temporary closing of the exhibition and confiscation of Mapplethorpe's photographs from the Cincinnati Center for Contemporary Art and Mayor Giuliani's pressure to remove a painting from the Brooklyn Museum of Art raise many philosophical questions that are continually debated: What constitutes censorship? When is the choice of what to display and where a matter of selection rather than censorship? Ought there to be any censorship? These questions are not answered here, but artists and artworks will likely continue to raise them.

Photography, Reality, and Truth

Publicly displayed or available photographs of sex are much more frequent targets of social objection than are other art forms depicting similar subject matter. Had Mapplethorpe presented the same subjects as drawings, his images may well have received little if any negative publicity, and most likely not a court trial. Some who see Serrano's *Head* (2.11) may well find it more troubling than a drawing of the same act, not just because it is so Realistic in style (mimetic), but because it is a photograph. Because it is a photograph, we intuitively know or believe that what is depicted did

happen in real life, between real people, and is not merely the figment of an artist's imagination. Further, the couple in *Head* is noticeably aware of being photographed and is cooperating with the photographer, who is another real human witnessing their act very closely. The woman openly gazes at the camera, and we realize her complicity. As we look at the photograph we also realize our complicity in voyeurism.

Photographs and other lens-based images (film, video, TV) generate perplexing questions about Realistic representations. The fundamental question is this: Do photographs grant us unique and privileged access to reality that other media (writing and painting, for example) do not? Scholars debating the issue are not in agreement. Their answers to the question (Are photographs more real than other representations?) can be placed along a continuum between Essentialism and Conventionalism. Essentialists argue that photographs are unique and ought to be privileged as information; Conventionalists argue that photographs, like all other representations, are human constructs and are no "more real" than other kinds of representations. The argument is referred to as the ontological debate about photography, ontology being the philosophy of the nature of things.

Roland Barthes (1915–1980), a French philosopher interested in how photographs mean, is well aware of encoding practices conventionally embedded in photographs, such as denotations (what a photograph actually shows) and connotations (what an image implies by what it shows and how it shows it). In Barthes's example, a photographic advertisement for a bottled tomato sauce denotes (shows) whole onions and peppers and other ingredients in their natural form in order to connote (imply) freshness and wholesomeness.[31] All images, including photographs, use humanly constructed conventions to communicate, and in this sense photographs are like other representations.

However, for Barthes, photography is also "a magic, not an art" because photographs uniquely convince him that what he sees in a photograph was really there in reality. No other medium can give him such certainty. He defines a *photograph* as "that which has been."[32] Barthes is referring to what the American pragmatist philosopher C. S. Peirce (1839–1914), also interested in semiotics, calls the "indexical" quality of certain signs. That is, a photograph is a sign that is caused by what it shows, akin to a footprint in wet sand.

A photograph is indexical because of the way it comes to be. A typical photograph is the result of light bouncing off of a subject in the real world, through a lens, and captured on a light-sensitive material such as a negative or stored in pixels in a digital camera. Barthes meditates on a snapshot of his deceased mother taken of her when she was a child: The photograph gives him comforting certainty that she was there. Early proponents professing the wonders of the newly invented medium of photography also relied on the causality of photographs for their arguments. William Henry Fox Talbot (1800–1877), a British inventor of photographic processes, refers to photography as "the pencil of nature."[33] The pencil of nature is different from the pencil of the artist: The camera, in Talbot's view, allows nature directly to inscribe an image onto paper without an interfering and fallible hand of a human artist. Photographs are also proffered to be "a universal language," transcendent of cultural constraints and able to be understood unmistakably by anyone, anytime, anywhere.

In opposition to Essentialists and earlier writers on photography, recent Conventionalists, such as Joel Snyder, argue that photography is no more privileged than painting or language in getting us to the "really real." He argues that we have falsely come to believe that the camera gives us privileged access to the world because of our ignorance of the historical developments in the invention and refinement of photography. The camera was invented to match the ways of picturing developed by Renaissance artists—namely, drawing in Western, Renaissance perspective. The standards for rendering developed by Renaissance artists are invented, not natural; they are socially agreed-upon conventions for depicting the world on a two-dimensional surface. Snyder points out that cameras themselves have been made to conform to standards of Renaissance painting: Further, the round lens of the camera obscura that "naturally" creates a circular image was modified by Renaissance painters and draftsmen to a rectangular format to meet traditional expectations for paintings and drawings.[34]

Geoffrey Batchen, a current historian of photography, provides compelling examples of some invented conventional customs of early photography in his discussion of "the picturesque" in English landscape photography in the nineteenth century. While recognizing early photographers' claims that nature itself was making the images by means of cameras, Batchen reminds us of the aesthetic concerns of early practitioners with how nature was represented. By means of invented visual devices, protophotographers for many centuries were attempting not merely to reproduce reality but to visually improve it, to make it picturesque.

Batchen reminds us that Louis-Jacques-Mandé Daguerre, inventor of the daguerreotype, one of the earliest ways of fixing an image obtained through a camera device, was a professional artist. As a teenager Daguerre sketched landscapes and later worked as an assistant to an artist who made large historical paintings; he also exhibited paintings and drawings of his own.

Talbot was also well versed in the picturesque aesthetic of that time. Artists and leisurely travelers of the period walked the countryside and made drawings, and when nature itself was not sufficiently picturesque, they used machines to enhance its beauty, including an easily carried device called the *camera lucida* that was invented in 1801. It is a mirrored device that makes nature look reminiscent of painted landscapes of the time. The *camera lucida* diminishes details in favor of prominent features of a scene, tones down colors so that they look like colors in varnished paintings, bends trees so that they better compose an aesthetically pleasing view, and allows one to hold both foreground and background in focus, achieving pictorial integrity.[35]

The introduction of computer technology into photographic practices is cause for alarm to some Realists because they see it as threatening the reality base of photography, which for them is the optical and chemical relationship between the camera and what it photographs. If the photograph's reality base is compromised, Realists fear that the photograph's truth value is weakened or lost altogether. For Conventionalists, the introduction of computer technology into photography is not alarming, but merely a continuation of practices that artists and photographers have invented and used throughout history to make expressive photographs.

Adrian Piper, a philosopher and artist who uses lens-based images in her work, ruminates on the special nature of the photograph and its ability to accomplish what

other media cannot (a Realist position) while acknowledging how images are conventionally constructed:

> They have a kind of transparency that other media don't have. Although there are obviously all sorts of choices that go into what ends up in the photograph, and there are all sorts of ways in which it can be manipulated. Even given all you can do with changing the photographic image using Photoshop, I still think that there is a directness of reference to the thing that is photographed. It's less mediated by individual idiosyncratic choices about how to render—all of those things—than other media.[36]

Piper's thoughts offer a calming and balanced view of computer technology and photography: There is something special about the photograph's relation to what is photographed, even when that information is adjusted with Photoshop.

Examples of manipulations of photographs prior to digital technology are plentiful in the history of photography. Manipulations of two kinds are available: altering the subject matter before photographing it to suit the photographer's purposes and distorting photographic negatives or prints after initial exposures have been made.[37]

In sum, Conventionalists argue that photographs are human constructs rather than mechanically derived and naturally inscribed pictures of the world. The history of photography is full of photographs leaning toward either end of the Essentialist–Conventionalist continuum. NASA photographs and medical photographs, for example, are painstakingly made to be scientifically accurate, although many of them, unbeknownst to viewers, are computer enhanced. Many other photographs are overtly fictional and highly directed, such as Koons's "Made in Heaven" photographs. Regardless of these ontological arguments, however, photographs tend to be given a lot of epistemological credence by everyday viewers. Being aware of two ways of looking at photographs—as conventional images, or as indexes, and as implementations of both—can enrich the viewing experience of photographs and aid in sensible interpretations of them. One can and should ask of all images but especially photographs: What is factual and what is fictional about this image?

What Does It Mean to Say That a Work Is "Realistic"?

In ordinary talk, we would likely agree that Andres Serrano's photograph *Rene* (Color Plate 6), from "The Nomads" series, is a Realistic portrait. Commonly, we would say that *Rene* shows Rene how he really is. But *Rene* is flat, still, silent, two-dimensional, rectangular, with no lower body, from one point of view, and in colors intensified by the Cibachrome process. Rene the person, however, is not really this way: Rather, he is three-dimensional, has a full and nonrectangular body, moves, makes sounds, can be seen in the round, and so forth. Further, philosopher Nelson Goodman argues that showing anything the way it really is is an impossible task:

> "To make a faithful picture, come as close as possible to copying the object just as it is." This simple-minded injunction baffles me: for the object before me is a man,

a swarm of atoms, a complex of cells, a fiddler, a friend, a fool, and much more. If none of these constitute the object as it is, what else might? If all are ways the object is, then none is *the* way the object is. I cannot copy all these at once; and the more nearly I succeed, the less would the result be a realistic picture.[38]

Nonetheless, when a picture or representation is called "Realistic," the speaker generally does mean that the picture is Realistic because it looks like what it is a picture of. That is, in general, the more closely the representation resembles what it represents, the more Realistic it is. Sometimes it is put this way: A picture is Realistic if a typical viewer tends to be deceived by it, thinking the picture is what it is a picture of. The history of art and aesthetics includes popular stories of reportedly convincing illusions made by early Greek and Renaissance artists. According to Pliny, Apelles painted a horse so realistically that other horses neighed at it. In a competition between Parrhasius and Zeuxis, Zeuxis supposedly painted grapes so realistically that birds pecked at them. Parrhasius countered by painting a curtain that was so convincing that Zeus asked him to remove it so he could see the painting. In the Renaissance, Giorgio Vasari tells stories of Bernazzone painting strawberries that peacocks pecked at and of Giotto supposedly painting a fly on the nose of a portrait that Cimabue was working on, causing Cimabue to try to scare the fly away.[39]

These various answers to what makes a picture Realistic are based on what is known as a resemblance theory of Realism. Those believing that Realism is based on resemblance would define Realism something like this: "That quality of a depiction which allows the viewer quickly and easily to recognize what it is a picture of."[40] Realism (sometimes called Illusionism) is dependent on degrees of verisimilitude, the quality of appearing to be real. As noted earlier, however, Serrano's *Rene* does not appear to be Rene, and no one is going to be deceived into thinking *Rene* the picture is Rene the person.

Ernst Gombrich, an art historian, and Goodman account for what makes a picture Realistic by arguing that a picture is Realistic if the pictorial conventions it uses are extremely familiar to the viewer, so familiar, in fact, that they make the picture seem to be the way reality is. All Realism, in their account, is relative to culturally based pictorial systems, which allow ease of recognizing depicted things. In the West, we have inherited Renaissance inventions and conventions for picturing and seeing, notably Renaissance pictorial perspective, whereas ancient Egyptians likely thought their system of representing things from a kind of flattened bird's-eye view was very Realistic. Gombrich's and Goodman's versions are Conventionalist theories of Realistic representation relying on familiarity with a culturally conventional system of representing, rather than on resemblance.

Philosopher Dominic Lopes[41] summarizes the competing arguments about whether Realism is based on resemblance or convention in the following way. We frequently understand which object a given work visually represents without effort and without explicit instruction. When a work visually represents an object, we have a visual experience of the pictorial object as if it were of that object. However, there are many variations of ways to represent the same object within different times and cultures: for example, Serrano's photographic portrait of a face, Picasso's Cubist rendering of a face, and an Inuit carved facial mask. Therefore, we wonder *if* it is necessary for a

successful visual representation to look like what it depicts *or* if what counts as "successfully looking like" is determined by conventional codes in use in different times and different places by different cultural groups.

In his summary thoughts about Realism, Conventionalism, and resemblance, philosopher Jonathan Gilmore favors Conventionalism but also recognizes the appeal of Realistic resemblance:

> Finally, support for the resemblance view, although not an explanation of pictorial resemblance per se is found in studies such as Julian Hochberg's demonstration that a child raised to nineteen months in a picture-free environment was able, when confronted with pictures for the first time, to recognize and speak of the objects in the pictures in the same way that he recognized and spoke of the objects themselves. This kind of experiment—and those with chimpanzees, that, after being taught to communicate with objects, are able, without further training, to use pictures of the objects for the same functions—suggest that however one explains pictorial resemblance, it exists in a form that is not exclusively, although perhaps extensively, a conventional phenomenon.[42]

Conventionalist and resemblance theories of Realism can both offer insights into our understandings of, responses to, and questions about kinds of images and representations that purport to be Realistic. One or the other, Conventionalism or resemblance, offers incomplete answers to how a picture is thought to be Realistic.

Works of Art by Jeff Koons

Jeff Koons (1955–) is a contemporary rich and famous American artist who gained widespread notoriety in the artworld and among the general public in the 1980s, and his notoriety continues today. He is famous—or infamous—depending on the critic—for successfully combining art, publicity, and money. In 2007 Koons's stainless steel *Hanging Heart* (2.2) set a new record for a living artist at auction when Gagosian Gallery bought it at Sotheby's for $23.6 million dollars.

Critical Commentary on Koons's Work

Koons is known by many people for his large sculpture *Puppy*, which has been installed at various worldwide locations, including its first incarnation in front of an eighteenth-century castle in Arolsen, Germany (Color Plate 1), at Rockefeller Plaza in New York City, and near the Guggenheim Museum designed by Frank Gehry in Bilbao, Spain. Art critic Robert Rosenblum describes *Puppy* as

> a Koons extravaganza, a colossus of kitsch in the form of a puppy, almost 40–feet high, who sits in the courtyard like the most adorable of guard dogs. Made of thousands of flowering plants, from petunias and geraniums to begonias and chrysanthemums, this giant topiary toy telescopes the old and the new baroque, mixing memories of the kind of fantastic garden follies which were meant to dazzle the absolute monarchs who could afford them.[43]

2.2 Jeff Koons | *Hanging Heart*, **1994–2006.**
Stainless steel, 9 feet high. © Jeff Koons.

The artist himself says of it: "*Puppy* communicates love, warmth and happiness to everyone."[44]

In Plato's view, perhaps, Koons has made a sculpture of a dog, although not in the manner of or with materials common to ancient Greek sculptors. It is not a "copy" as a Greek marble statue of a warrior would be a "copy," partly because the texture of

Koons's flowering plants is much different than the smoothed texture of marble. Although faded to white now, Greek sculptures were once painted: Thus the color and texture of a sculpted warrior would more closely resemble the skin color and texture of an actual warrior than the colors and textures of the flowers of Koons's *Puppy* resemble the fur of an actual dog. *Puppy* is huge, and its scale is more disproportionate to a living creature than would be a Greek warrior statue. Nonetheless, *Puppy* is recognizable as a dog, and in a loose sense can count as a copy or a mimetic representation.

Clearly, *Puppy* is a creation of the artist, distancing his work from traditions of classical sculptural materials, subject matter, and form. *Puppy* draws attention and has garnered the artist fame as well as fortune. Koons has set himself apart from honored artistic conventions and does as he whimsically wishes. Plato would have the artist revere and adhere to artistic tradition.

Puppy has strong emotional appeal: It does seem to convey love, warmth, and happiness to many people, including those not ordinarily sympathetic or responsive to much of the art made today. Such emotional appeal may arouse Platonic anxiety because that appeal could well be seen as distracting from the truth of the ideal dog, and truth in general. *Puppy* may also encourage us to act frivolously, uninformed by reason. Any appeal to the development of good moral character, or civic responsibility, is not immediately apparent in contemplating Koons's work. Perhaps Plato would have *Puppy* banned from society, or at least not have allowed it to be shown in so public a space as Rockefeller Plaza in New York City.

In 1988, Koons put together a show of his works he called "Banality" and exhibited it simultaneously in New York, Chicago, and Cologne. The "Banality" works consist of greatly enlarged reproductions of small popular objects such as statues of saints, cartoon animals, Hummel figurines, busty women, naked children, and a souvenir doll of pop singer Michael Jackson. These figures are meticulously crafted in porcelain and wood, painted and sometimes gilded in gold, by artisans in Italy and Germany whom Koons supervises. One art critic described the finish of the objects as "syrupy-slick, the colors sickly bright, the modeling and the painting no better or worse than those of pop archetypes."[45]

Koons continues to make banal pieces copied from objects and artifacts in popular visual culture (2.3). Rosenblum calls the collection "a Jeff Koons Gift Shoppe."

In his inventory of immaculately wrought, gleamingly new objects, usually produced as multiples, the range of consumer temptations is vast. There are such useful items as Spalding basketballs, tea kettles, Hoover Deluxe shampoo polishers, Shelton wet/dry vacuum cleaners, aqualungs, Baccarat crystal sets and travel bars, as well as a broad spectrum of decorative accessories that can adorn nurseries, rumpus rooms, and boudoirs for every taste and budget: Venetian-glass erotica, stainless-steel trolls and flower arrangements, gilded rococo mirrors, wooden Yorkshire terriers, sculptured icons of veneration such as superstars Michael Jackson, Bob Hope and the artist himself, and for the more conventionally pious, even a polychrome porcelain St. John the Baptist worthy of a Neapolitan souvenir shop.[46]

In Plato's terms, Koons has presented some things from the real world of commerce —Spalding basketballs and Hoover vacuum cleaners—as works of art. Koons suspended

2.3 Jeff Koons | *Ushering in Banality,* **1988.**
Polychromed wood, 38 x 62 x 30 inches. © Jeff Koons.

the balls in transparent liquid held in glass cases and mounted the vacuum cleaners similarly in dry, sealed cases. These are not copies of things but actual objects one could purchase in a store; thus in a Platonic sense they are probably superior to sculptures of the objects. However, by Platonic standards, they are likely not objects worthy of contemplation that would lead viewers to "truth" and higher moral standards. Critic Eleanor Heartney interprets the suspended objects as dealing with "abstract concepts like equilibrium, perfection and modular repetition in an irreverently conceptual way."[47] *Irreverent* contemplation would not fit Plato's agenda. The other items are meticulously enlarged copies of smaller objects that themselves are copies of Michael Jackson, the comedian Bob Hope, and St. John the Baptist. Heartney refers to their "mind-boggling ugliness and deliriously vapid expressions,"[48] qualities not admired by Plato.

Koons built another exhibition of works centered on his short-lived marriage (1991–1992) to Ilona Staller, a Hungarian-born Italian media star better known as La Cicciolina, famous for her live pornographic performances, magazine photographs, and films that she produced and in which she starred. She was also a member of the Italian parliament. Staller and Koons met when he sought her permission to sculpt him and her in sexual sculptures. Koons then turned their romance and marriage into collectible

artworks under the general title of "Made in Heaven": "even the couple's most intimate indoor and outdoor sexual raptures could be translated into collectibles in both two and three dimensions, quasi-religious glimpses of an ecstatic, celestial joy."[49]

The first showing at Sonnabend gallery in New York City of the series "Made in Heaven" (2.4) consisted of realistic-looking marble busts of the couple, nine glass sculptures of the two performing sex acts, eight large silkscreen-on-canvas images made in conventional pornographic poses and settings, sculptures of brightly colored wooden flowers in a vase and as a wall-relief, sculptures of cherubs, and sculptures of cute poodles, terriers, and a cat.

Peter Schjeldahl, an art critic for *The New Yorker* magazine, refers to "Made in Heaven" as "the artist's strangest excursion." Writing nineteen years after it was first exhibited, the critic admits that he has never known what to do with the works, "other than to gawk at them in vague alarm."[50]

2.4 Jeff Koons | *Wolfman (Made in Heaven)*, **1991.**
Silkscreen on canvas, 90 x 60 inches. © Jeff Koons.

Annie Sprinkle, a former pornographer and current video artist who calls herself a "post-porn modernist," reviewed "Made in Heaven" for *Arts Magazine* and wrote this about the sexual images on canvases:

> The poses are classic porn-star poses—garters in place, hands carefully positioned so as not to hide the action, cock and cunt in full view. My professional eye notices that Ilona has no hemorrhoids, Koons's cock is relatively larger than average, and there are no condoms used in this pleasure garden. Also, having made many batches of fake cum on porn shots, I can assure you the cum here is the real thing.[51]

"Made in Heaven" might provide Plato with an interesting test case as a work of art. Many of the images in the set are very realistic, as Sprinkle attests. It would be difficult for Plato to deny the beauty of the bodies of the subjects. From them one might well learn to love a particular body, and then to generalize an ideal body aesthetic. Questionable is whether these images would ultimately lead to love of "souls" and a general love of ideal Beauty. In Plato's educational program for fostering love of Beauty, he says we ought to come to love "the Beautiful itself, absolute, pure, unmixed, not polluted by human flesh or colors or any other great nonsense of mortality."[52]

Koons has designed and supervised the painstaking making of billboard-size paintings based on magazine photographs and photographic ads in glossy magazines he collects from around the world. He calls the set of paintings "Easy Fun—Ethereal" (see *Lips*, Color Plate 3). The paintings are highly dependent on Koons's use of Photoshop technology: He meticulously cuts and layers parts of commercially produced images into a single, if disparate, image similar to a collage of pasted photographs. Three teams of three assistants, working eight-hour shifts, twenty-four hours a day for more than a month are required to produce the paintings that are exacting renditions of Koons's computer-based collages.[53] Rosenblum details the artist's working process in making this series of paintings:

> In this new role for the artist, Koons has become an impresario in charge of a high-tech production process supervised by hired experts. Colors are not mixed and altered on the artist's palette; limbs and faces are not recontoured or repositioned by the artist's brush and pencil; additional images are not inserted by hand. All of this once manual work is done on a computer screen, constantly readjusted under the artist's surveillance to create unfamiliar refinements of hue, shape, and layering. Then, in the backroom of the studio, the final, approved printout is given to a large, highly skilled staff who, with the clinical accuracy of scientific workers and with an industrial quantity of brushes, paint tubes, and color codes, replicate exactly the hues, shapes, and impersonal surfaces of the computer image through the traditional technique of oil on canvas.[54]

Jan Avgikos reviewed in *Artforum* an exhibition of five of these paintings and characterizes them this way:

> The five canvases on view here (all works 2000) unabashedly indulged in a mesmerizing, maximal onslaught of cleverly composed, superrealistic depictions of the lush life. Numerous appetites converge in glowing images of absolute perfection. Spilling from flesh to food to beach life to sunlight, amid a great deal of streaming,

splashing, and swirling, the effects of sustained visual excess are those of tour-de-force animation, full of dizzying warps and folds of deep and shallow space and speed-of-light shifts in subject matter. . . . Every image is distilled from the great renewable resource of mass visual culture.[55]

Koons has commented that painting as fine art is becoming obsolete and that he finds his most important visual stimulation in advertising.[56]

Rosenblum characterizes the "Easy Fun—Ethereal" paintings in these ways:

luxuriously synthetic fantasies of creamy textures, electronic rainbows, magical buoyancy from international anthology of glossy magazines . . . food, fun, and games (stuffed animals, water slides, Pokémon characters, sandwiches sporting happy faces made of sliced-olive eyes and mustard smiles, a Thanksgiving turkey made of ice cream) to the pleasures of grown-up lust (wafting visions of lipsticked mouths, silk-smooth legs, perfumed hair, nail-polished toes) . . . an infinity of visual seductions that might include sexy Greek models in bikinis, a cascade of orange juice, a disembodied eyelid covered with purplish-gray eyeshadow, a sharp focus photo of stalactites, a toy abacus with bead in kindergarten colors . . .[57]

Rosenblum champions Koons's work, especially in essays in exhibition catalogs of Koons's exhibitions. When given the opportunity by *Artforum* magazine to write a tribute to any recent artwork by any artist, Rosenblum chose *Christ and the Lamb* by Koons, an eighteenth-century Rococo gilded framed mirror—"flamboyant and asymmetrical, this object could make flesh crawl, should that flesh belong to an art-lover who abides by the rules of good taste." In that tribute in 1993, the critic writes: "Koons is certainly the artist who has most upset and rejuvenated my seeing and thinking in the last decade." The title of the mirror refers to a detail in the frame of Christ holding a lamb, which is hard to see because of the gilding. The reproduction of the mirror reflects one of Koons's other sculptures on a white pedestal.

Rosenblum sees Koons as delighting in the glory of ugliness and praises him for storming the artworld as "a ruffler of feathers," jangling "our preconceptions of the beautiful and the ugly, forcing us to look head-on at the weird, intricate fusion of the repellant and the enticing that marks the world of kitsch." For the critic, the artist's most startling assault on current artworld sensitivities is Koons's resurrection of Rococo-style art (2.5), especially in its "most spectacularly excessive variations" that are so at odds with the minimalist taste that is prevalent in art circles today. Rosenblum continues: "Koons's sweeping vision would cover our planet with an unsettling hybrid of history and modernity, of the unspeakably vulgar and the seductively beautiful, rattling Modernist and even Post-Modernist nerves with his delirious excesses."[58]

Many critics, however, are less generous in their assessments of Koons's works. Art historian Erika Doss includes Koons in her book *Twentieth-Century American Art*, introducing him as one that is interested in consumerism and mass taste, and notes that

critics blasted Koons's art and his self-aggrandizing PR campaigns as "cynical" and "repulsive" but museum and collectors eagerly bought his "limited edition" and very pricey products—which raised questions about the critical effectiveness and contradictory nature of appropriation art. Does the ironic appropriation of images (and styles) truly subvert the original meaning of those materials?[59]

2.5 Jeff Koons | *Michael Jackson and Bubbles*, 1988.
Porcelain, 42 x 70 x 32 inches. © Jeff Koons.

In her statement, Doss interprets Koons as attempting to critique the objects that he has appropriated, adding that he cynically questions distinctions between art and consumer goods.

Hilton Kramer is one of the critics who blasts Koons's work. He also thinks of Koons's work as cynical. Founder of the *New Criterion* journal of art criticism, Kramer called Koons's work "crap." Kramer does not fault Koons's works for being accessible, but argues that "it has no other meaning but to be accessible. . . . He's pandering to a taste that already exists, whereas great art has always created its own tastes. . . . [Koons's art] just recycles something that already exists." Kramer thinks that Koons is a master of publicity but is fraudulent as an artist because his art is based on a calculated analysis of what will be purchased by the artworld. In Kramer's view, Koons is a cynical manipulator of the art public because his art "does not derive from a serious view of life or the world, which the greatest art does." Kramer's criteria for good art include "a very highly developed view of human experience. It does really tell us something about life." Kramer understands Koons's subject to be "shallow" and thus "failed art" that is "hollow." In the critic's view, Koons's work only advances our knowledge of Koons's career.[60]

Edward-Lucie Smith, an art critic and historian, accepts Koons's work as "neither neutral nor ironic, but celebratory." Smith argues that "if there is a status quo Koons aims to subvert, it is that of the supposed avant-garde, and in particular its confidence in its own sophistication." Smith, writing in 1995, understands "Made in Heaven" to be an intentional challenge to "the politically correct segment of the feminist movement which denounces all forms of pornography."[61]

Robert Hughes, an art critic for *Time* magazine, in his book *The Shock of the New*, gives one dismissive rhetorical question to Koons's work. He asks: "Why should anyone care about the porcelain inanities of a Jeff Koons, let alone suppose that they posed 'issues' that should be responded to?"[62]

Peter Schjeldahl, referring to Koons's large paintings (see Color Plate 3), also finds too little to think about when viewing the works:

> Many of the works are big paintings in a collagelike mode, combining fragments of photographic imagery clipped from magazines or staged by the artist. Reminiscences of original, superior artists—Rauschenberg and Rosenquist, as well as Warhol—do Koons no favors. Made largely by assistants, the pictures are painstakingly crafted and impressive in technique. But these are secondary virtues. Painting is a medium of concerted imagination, symbolizing consciousness. It's not a flat dump for miscellaneous ideas.[63]

In a similarly dismissive tone, Ann Landi, writing in *ARTnews* about Koons's "Easy Fun" series of paintings and sculptures shown in 2004, advises:

> it seems best not to puzzle too hard about their meaning . . . unlike the works of the senior statesman of the Pop movement, Koons's are empty of any satiric thrust. These seem to be the childish fantasies of an aging superstar from the 1980s, and if he doesn't want to grow up, maybe the best response is that of the peanut gallery: giggles and squeals of delight.[64]

Thus, although Rosenblum praises Koons for provoking us to think, Kramer, Hughes, Schjeldahl, and Landi assert that there is nothing in Koons's work to think about, implying their acceptance of Platonic criteria that works of art should further human thinking toward ideals and moral behavior.

It is more likely than not, were Plato to appraise the art of Jeff Koons, that he would likely have it banished from his ideal society. Although Koons's work is generally very realistic—the display of actual objects, casts of actual objects, photographs of himself and his wife, and paintings carefully derived from photographic magazine ads—Koons's choices of subjects would probably be appalling to Plato. Note some of the titles of Koons's series in comparison to the lofty ideals of truth and beauty that Plato upholds for art in society: "Easy Fun," "Luxury and Degradation," and "Banality." It is not the "ideal" of Plato that Koons's work celebrates but the "banal" of contemporary society. That many of Koons's works have enormous popular appeal, as well as commercial success in the artworld, would raise further concerns for Plato because their very appeal will distract viewers from deeper levels of thinking and higher standards for morality.

Koons's Thoughts about His Own Work

Koons openly acknowledges his desire for commercial success. He was a highly successful commodities trader on Wall Street, and his monetary gains allowed him to invest in the making of his own art. He promoted himself and his art in full-page ads in art magazines such as *Artforum* and *Art in America*, marketing himself in ways similar to executives in Hollywood and on Madison Avenue: "I want to be as big an art star as possible. I like the idea of my work selling for a lot of money."[65] He compares himself to the Beatles: "I've made what the Beatles would have made if they had made sculpture. Nobody ever said that the Beatles' music was not on a high level, but it appealed to a mass audience. That's what I want to do."[66]

In response to accusations of cynicism leveled at his work by its critics, Koons adamantly denies any intentional irony in his work, and wishes that it be taken straightforwardly as celebrations of what it depicts. He thinks that *Puppy*, for instance, "is about love" because for him it is a "totally generous piece; it doesn't segregate."[67] He believes that artists can create icons that can "reflect the needs of the people, not only in our time, but that they're chameleon enough to reflect the needs of the people in the future, whatever their needs may be."[68]

Koons contrasts the liberatory images and sculptures in his "Made in Heaven" series to Masaccio's *Expulsion from the Garden of Eden*, an early Renaissance painting in the Brancacci Chapel in Florence, a painting Koons sees as paradigmatic of suffering and guilt about sex. Koons refutes notions that his works are pornographic: "Pornography is alienation. My work has absolutely no vocabulary in alienation. It's about using sexuality as a tool to communicate."[69] Koons intends for "Made in Heaven" to relieve people of guilt and shame. He intends his works to be uplifting.[70]

Paintings by Alexis Rockman

Alexis Rockman, whether or not he is aware of it, seems to be working within an Aristotelian aesthetic philosophy, although he is a young contemporary American artist. Rockman is a Realist painter of nature, as it is, as it was, and as it might be in the future: Recall that Aristotle's notion of mimesis includes all three. Rockman's mother, a scientist, took him as a young child to Peru, where she was conducting archaeological research on the Incas. She also worked at the Museum of Natural History in New York City with Margaret Mead. Rockman thought that he too would be a scientist but developed an interest in painting nature—"I've always been interested in the history of the representation of nature."[71] He now paints very large, mimetic depictions of different aspects of the natural world.

Although Rockman is familiar with Realist landscape painters in art history, he cites other sources of inspiration for his work, such as Charles Knight, a paleontological illustrator, and Sid Meade, who designed the futuristic movie *Blade Runner*. Rockman reads science, although he has not formally studied it. He does not read science fiction.

Critical Commentary on Rockman's Paintings

The Brooklyn Museum of Art commissioned Rockman to paint a large mural. He completed *Manifest Destiny* (Color Plate 4 and 2.6, 2.8) during 2003–2004. It is an eight-foot high and twenty-four-foot wide panoramic landscape of downtown Brooklyn, New York, as seen from Manhattan after three millennia of global warming have submerged it in water. In the catalog published to accompany the painting, Maurice Berger describes *Manifest Destiny* this way:

> The scene is empty of human beings. The local flora and fauna that have survived are joined by migrant life from the tropics and new, bioengineered species. Mangrove trees, algae, and vines grow on decaying structures. Harbor seals, lampreys, carp, jellyfish, sunfish, and lionfish swim in a murky East River. A lone cockroach strolls around a barrel, one of the few objects that remain above water. Cormorants, egrets, gulls, and pelicans swoop and fly overhead. The mural's ominous tone is accentuated by the presence of outside diagrammatic images of deadly viruses and bacteria—HIV, West Nile, and SARS—that float across its surface.[72]

2.6 Alexis Rockman | *Manifest Destiny* (detail, middle), **2003–2004.**

Oil and acrylic on four wood panels, 8 x 24 feet. Courtesy Leo Koenig Inc.
© 2006 Alexis Rockman/Artist Rights Society (ARS), New York.

Berger informs us that in preparation for painting the mural, Rockman consulted ecologists, paleontologists, biologists, and archaeologists so that he could make an accurate rendering of an imagined future. Diane Lewis, an architect, created computer models of the structures and terrain of Brooklyn as she imagined them three thousand years from now. She informed her work with contemporary street plans of the area, geographic and social history, and demographic and geological information (2.7). Her illustrations are exhibited with the mural.

In a catalog essay for a 2010 exhibition, Rockman's friend Thomas Lovejoy, the scientist who first used the term *biological diversity*, says that Rockman's "vision is based

2.7 Don Foley | *Bedrock Elevation*, 2003.
Computer-generated image, size variable. Illustration by Don Foley.

2.8 Alexis Rockman | *Manifest Destiny* (detail), **2003–2004.**
Oil and acrylic on four wood panels, 8 x 24 feet. Courtesy Leo Koenig Inc.
© 2006 Alexis Rockman/Artist Rights Society (ARS), New York.

on a real understanding of what's going on. It's a surrealism that is seriously anchored in reality."[73]

Anna Hammond, writing a review in *Art in America* of a 2001 Rockman exhibition, seems to use Aristotelian criteria when she examines his work, implicitly praising the artist for his knowledge of his subject, which he is able to put into painterly form:

Alexis Rockman knows his subject matter: he knows the difference between a bug and an insect, the details of their carapaces and whether they are extinct or not. He collaborates regularly with geologists, paleontologists, entomologists and tropical disease specialists, and he has worked on various projects, from a program for the Discovery Channel to an illustrated column for *Natural History Magazine* to a book project exploring the photographic archives of the Bronx Zoo and the American Museum of Natural History. Rockman is an obsessive explorer, and his omnivorous approach to acquiring, digesting and regurgitating his field data has resulted in the six new large-scale paintings shown in this exhibition. . . . Rockman's work has always addressed a natural world gone awry, a place where illness and mutation thrive, and where the natural is anything but utopian. Deadly parasites and enormous, terrifying plants and animals are the denizens of this terrain, all of them either eating or being eaten.[74]

That Rockman knows his subject is a good thing for both Aristotle and Hammond, the contemporary critic. Rockman knows the nature of things, the knowing of which is very important to Aristotle's epistemology. Rockman closely observes nature and then represents it accurately. Through his art, he adds to our knowledge of the world, while also providing us with the pleasure of mimetic representation.

In a review of a very large mural called *Evolution* that Rockman made in 1992, Jerry Saltz in *Art in America*[75] also seems to employ Aristotelian criteria, but by that criteria, the critic ultimately finds Rockman's painting lacking. Saltz describes the subject matter and structure of the mural this way:

> *Evolution* unfolds in a loose back-and-forth narrative from beautifully painted frogs and salamanders to Boschian malformations and bizarre, horror-show monstrosities. The fetid volcanic air is filled with unnamable species of eccentric birds, while beneath the waterline, which demarcates the bottom quarter of the painting, menacing creatures glide past skeletal remains. Here, a giant sea tortoise lunges at flying fish, there, a four-eyed snake-fish-insect gnaws on the entrails of a cooperative squirrel-duck-antelope mutant.

Saltz acknowledges that as interesting as the subject matter is, "it's the verisimilitude of rendering that rivets you—and can also wear you down." Thus, Saltz seems ambivalent about mimesis. He echoes Aristotle's notion of taking pleasure in mimetic verisimilitude, but then seems to tire quickly of it. Based on this snippet, we do not know if he tires of all mimetic art, or just Rockman's.

Saltz also seems to require a knowledge base for the making of mimetic art, like Aristotle, but seems to distrust or dismiss Rockman's knowledge base by referring to the painting as "quasi-scientific." *If* the painting is less than scientifically accurate, Aristotle, too, would likely lessen the painting's value as true knowledge. Thus, a critical question remains to be answered about *Evolution* if we are applying Aristotelian criteria to it: Does *Evolution* offer scientifically accurate knowledge?

More importantly, however, Saltz asserts that Rockman's scientific knowledge "can get in the way of the art." This is a reversal of Aristotelian principles. It seems for Saltz that the artfulness of a painting is paramount and its subject is secondary. Aristotle, however, holds the reverse: It is the subject of a work that is paramount, and its artfulness is secondary to its subject. For Aristotle, art is first for the sake of knowledge of the world.

Saltz uses another Aristotelian criterion—that of proper proportion—in judging *Evolution*: "Every glistening dewdrop, every ant is painted in such dazzling detail that it threatens to undermine the impressive underlying structure of the work. . . . Rockman has become so adept at depicting a profusion of parts that the painting as a whole can't quite come together." *If* Saltz's objection is justifiably applicable, Aristotle's principle of proportion would not allow for a dazzling detail to undermine the unifying narrative and formal structure of the work.

David Rimanelli, reviewing Rockman's paintings in *Artforum*,[76] is in general agreement with Saltz, and also employs Aristotelian criteria. Rimanelli, too, takes pleasure in Rockman's mimetic skills—"Rockman has tapped into a rich vein of psychotronic cinematic pleasure"—but he finds the painting to be "a bore." Rimanelli

asserts, "Rockman's sensibility is that of an adolescent boy; hence the penchant for horror, sci-fi, gross-out." (Note that Rimanelli's remark that Rockman has the sensibility of a boy is what is known as an *ad hominem* error in logic: That is, it is a statement directed at the person rather than at the subject of the discussion, the painting. It might also be a remark that would be hard to defend given that Rockman has taught at Columbia and Harvard universities.) Rimanelli ties Rockman's paintings to popular culture, a culture that the critic demeans as appealing to a "14-year-old mentality."

Ultimately Rimanelli concludes: "a fine painting alone just isn't enough to guarantee quality and interest . . . we can say 'So what?' to technical proficiency divorced from intellectual aspiration."[77] Rimanelli's criterion is in agreement with Aristotle's: That is, technical proficiency is insufficient to make a work a good work of art. However, we do not know if Aristotle would accept Rimanelli's application of the criterion to Rockman's work; Aristotle might see Rockman's work as technically proficient *and* substantive in content.

Rockman's Thoughts about His Own Work

Rockman describes his general purpose in making art. "My artworks are information-rich depictions of how our culture perceives and interacts with plants and animals, and the role culture plays in influencing the direction of natural history."[78]

Rockman wrote the following statement about *The Farm* (Color Plate 5), a large painting (nine feet tall) that he made in 2000:

> *The Farm* contextualizes the biotech industry's explosive advances in genetic engineering within the history of agriculture, breeding, and artificial selection in general. The image, a wide-angle view of a cultivated soybean field, is constructed to be read from left to right. The image begins with the ancestral versions of internationally familiar animals, the cow, pig, and chicken, and moves across to an informed speculation about how they might look in the future. Also included are geometrically transformed vegetables and familiar images relating to the history of genetics. In *The Farm* I am interested in how the present and the future look of things are influenced by a broad range of pressures—human consumption, aesthetics, domestication, and medical applications among them. The flora and fauna of the farm are easily recognizable; they are, at the same time, in danger of losing their ancestral identities.[79]

In an interview with Sara Rosenbaum about *The Farm*, Rockman says that to make the painting, he had to work with a molecular biologist at the Museum of Natural History: "I felt I had a lot to learn before I even started it in terms of the history of genetics and artificial selection." He related the following about the organizational structure and form of the painting:

> The way I constructed it is that, as in a lot of Western culture, we read things from left to right. And the way I tried to organize the structure, and then also break it, is that on the left side of the image are the ancestral species of the chicken, the pig, the cow, and the mouse, if you look carefully at the bottom. And if you go across

to the right, you see contemporary versions of the pig, cow, chicken, and mouse. And as you go further to the right, you start to see permutations of what things might look like in the future, based on artificial selection—without losing the identity of the so-called "cowness" or "pigness," so that they still have some resemblance to the ancestral species that they're coming from. And, obviously, the dog is a very clear example of human intervention—breeding them. I felt it was a real challenge to balance the familiar with the unfamiliar, and have it not just be a freak show and completely alienating. Because part of my interest is in negotiating cultural ambivalence. That's what this painting's really about—and how nervous and confused we are about what's happening in the biotech industry and the rest of the planet, and what that means in terms of our own identity.[80]

Accurate mimeticism, even depictions of nature that he imagines in the future, is crucial to Rockman. When asked if the details in his paintings are biologically correct, Rockman replied: "Oh, yes. That's the plan. They must have credibility. I mean, that's the thing that sets the table in my mind. Absolutely; they're correct as far as I know. I looked into the origin of chickens and jungle fowl in Southeast Asia and thought, 'That looks like the one.'"[81]

Rockman intends his work to be a kind of "populist politics." He says, "I want my work to be as clear to a kid in Iowa as to an artworld insider. I try to make lucid images that speak to viewers in the same ways as sci-fi movies, documentaries, or television nature shows."[82]

Photographs by Andres Serrano

The theory of Realism raises questions for contemporary aestheticians about the nature of Realism itself: What do we mean when we call a work of art Realistic? Photographs and other camera-based images are commonly accepted as the most Realistic of the arts. We will explore contemporary issues regarding Realism and representation using photographs made by Andres Serrano (2.9) as examples to illuminate issues.

Serrano (1950–) was born in New York City, attended art school for two years in Brooklyn, and considers himself self-taught in photography. Serrano is a Catholic of mixed racial descent; his father is Honduran and his mother is Haitian, and he draws upon religion and race for inspiration for his work. He has exhibited widely since the late 1980s in the United States and abroad. He came to popular attention in the late 1980s because of well-publicized and dramatic diatribes against him (and Robert Mapplethorpe) by Senator Jesse Helms, who was vehement in his opposition to the National Endowment for the Arts (NEA) funding projects such as some of Serrano's that, at that time, utilized "taboo" bodily fluids and religious icons.

Since the NEA controversy, Serrano has produced such series as "The Klan," hooded portraits of members of the Ku Klux Klan; "Nomads," portraits of ethnic homeless people in New York City; "The Morgue," close-ups of dead bodies; "A History of Sex," with explicitly heterosexual and homosexual images; "The Interpretation of Dreams," titled after Freud's writing, showing images based on imagined scenarios; and an exhibition entitled "Shit."

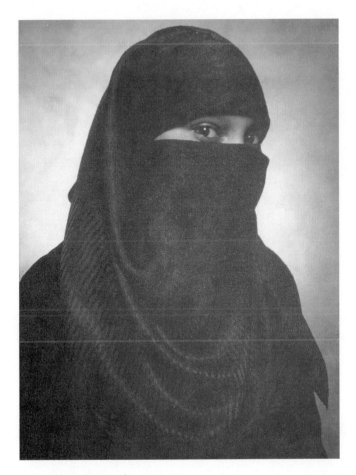

2.9 Andres Serrano | *America (Aya Basemath, Convert to Islam)*, **2002.**
Cibachrome, silicone, Plexiglas, and wood frame, 60 x 49 1/2 inches, Edition 1/3, ASE-394-A-PH.
Courtesy of Paula Cooper Gallery, New York.

Critical Commentary on Serrano's Photographs

Marcia Tucker, a museum director who exhibited a variety of Serrano's works in a show at the New Museum of Contemporary Art in New York City, says: "Andres has been innovative because his art opens up into so many issues, of popular culture and taste, of the intersection of belief and disenfranchisement, and about the spiritual and physical body. He puts together things that people have strong reactions to."[83]

Serrano says that his inspiration for "The Klan" (2.10) came from wondering what it would be like to make portraits of masked people. He called people he knew in Atlanta and eventually reached James Venable, a retired imperial wizard, who sat for him in full costume. Serrano then reached other members who posed for him, such as the Klanswoman (2.10).

To make "Nomads" (Color Plate 6) Serrano and an assistant went out late at night into the Lower East Side of Manhattan and offered homeless people ten dollars each to

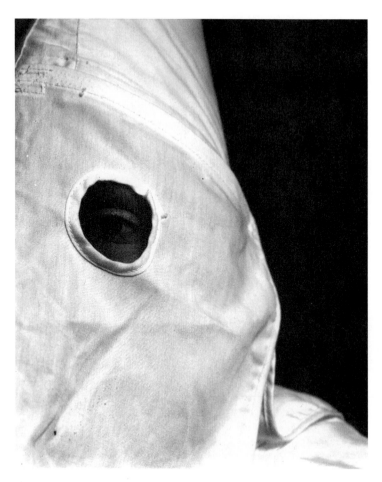

2.10 Andres Serrano | *Klanswoman (Grand Klaliff II), (The Klan)*, **1990.**
Cibachrome, silicone, Plexiglas, and wood frame, 60 x 49 1/2 inches, Edition 1/10, ASE-99-B-PH.
Courtesy of Paula Cooper Gallery, New York.

pose for him. He brought them to a makeshift studio that he had set up in a subway, lit them in a flattering manner, photographed them, and made massive, wall-sized prints. Serrano feels that although he has never been homeless, he has been "on the outside—part of that marginal element,"[84] having himself been a drug addict and alienated from mainstream society for a number of years.

Critic Wendy Steiner likens Serrano's photographic treatment of the people in "The Nomads" to glossy magazine fashion plates:

> In these photographs the physical reality of homeless people—their neglected bodies, their hunger, their displacement—is hidden behind a surface of costume. . . . The strain of seeing the homeless as fashion plates undermines the formal perfection of these images, producing irresolvable tension between moral and aesthetic response.[85]

Robert Hobbs also recognizes tensions between glamour and reality and concludes, "Rather than settling these contradictions, Serrano's photographs suspend them, leaving viewers with the dilemma of being either prospective consumers or, possibly, serious advocates of social change."[86]

Peter Schjeldahl acknowledges the tension between morals and beauty in Serrano's works, but faults the photographs in "The Morgue" (2.1) for trivializing death by making aesthetically pleasing images of it:

> Serrano's relentless aestheticizing defuses the psychic mechanism of identification (*that could be me or that could be my loved one*), which can make pictures of the dead particularly unbearable. . . . In Serrano's work, both fantasy and reality fall away, leaving only the aesthetic . . . in this light, Serrano's show is not about death at all. It is only about art—art with an attitude.[87]

Hobbs, however, argues that Schjeldahl's critique does not recognize "that beauty is an essential component of Serrano's art, which heightens its tension by seducing viewers with the radiance of subjects traditionally considered objectionable."[88]

Serrano began making a series of dead people in 1992 and called it "The Morgue." He made these pictures "to find some humanity and love." He thinks that the photographs confront "fear and dread" about death, noting that the Victorians photographed the dead and "didn't see anything scary about death."[89] Art writer Celia McGee thinks all of Serrano's photographs "show his desire to penetrate all that is human, whatever the form."[90]

Hobbs, in a catalog essay for the exhibition "Andres Serrano: Works 1983–1993," finds "The Morgue" photographs "extremely beautiful images of horrific situations involving murder, accidental mortality, and death by suicide."[91] In a different catalog essay for "The Morgue," Daniel Arasse offers further thoughts on Serrano's provocations about death:

> If there is provocation on the part of Serrano, it is that he demands us to look, eye to eye, at what we have a growing tendency today to dismiss, not to want to know, not to envisage. In this mediatic and glamorous culture, you don't die anymore; the more images of the body overwhelm us with their models of immutable youth and sumptuous and asepticized beauty—and meanwhile, the inventor of American utopia, Disneyland, big Walt, is waiting, cryogenized, for this return to life. In this series, Serrano has chosen to envisage death and to give a face back to dead people. Photographic art puts in front of our eyes, close-up, the various aspects of the dead nobody, in its physical flesh, right there.

Arasse also cites the Christian tradition of meditating on death, *Memento mori*. If we are willing to look meditatively at these works, "one doesn't exactly come out of it the same as when one entered. One learns; one is educated; one prepares for it."[92]

Serrano made photographs for "A History of Sex" (2.11) in Rome and Amsterdam between 1995 and 1996. According to the editors of Taschen publication's *Art at the*

2.11 Andres Serrano | *A History of Sex (Head)*, 1996.
Cibachrome, silicone, Plexiglas, and wood frame, Edition 1/3, ASE-317-A-PH.
Courtesy of Paula Cooper Gallery, New York.

Millennium, Serrano explores "human sexuality in the most various and socially taboo forms":

> These works are much more prosaic in their subjects and in their pictorial language, which is close to the glassy aesthetic of the media. Serrano is never judgmental in his endeavor to find the "normal in the strange", and he plays with popular ideas of beauty and morality, but also with the voyeuristic curiosity of the viewers.[93]

The Erotic Museum in Los Angeles first brought Serrano's "A History of Sex" to the West Coast. The mission of the museum is "to educate the public about human

sexuality by creating entertaining exhibitions regarding the broad range of mankind's erotic endeavors through the ages." To help fulfill its mission, the museum presented Serrano's photographs to explore "the diversity of lifestyles and sexual practices of human beings":

> The works are portraits, with an emphasis on individual character. Many of the titles bear the names of those who posed for the photographs, and in most works the subject or subjects look directly at the camera. This matter-of-fact stance of the subjects may seem in marked contrast to their actions. Perhaps this is because most sexual lives are conducted privately or perhaps because the issue of how sexual imagery and practice should be dealt with publicly is controversial and politicized.[94]

Marvin Heiferman, an art writer and curator, reviewed "A History of Sex" in *Artforum* magazine when it appeared at Paula Cooper Gallery in New York City in 1997. He was not impressed. Although he admired the works for their aesthetic effect—"stunning, thanks to the scale and content of the work"—he objected to the show on epistemological grounds. He did not learn anything from it:

> What's to be learned about the rush, spirituality, or history of sex from jewel-toned pictures that bounce between off-color sentimentality and Teutonic perfection? Do the references they call to mind—figure studies, genre scenes, ethnographic nudes, bodybuilding pictures, pinups, nudist photography, and pornography—make this work more complicated? Stronger? Harder? Deeper?

Heiferman's answer is "No" to his last four questions. He then offers criteria for successful sexual images, and his criteria are also epistemologically based, bearing on acquisition of personally relevant knowledge:

> In life, the most powerful, complex, and challenging depictions of sexual explicitness don't loom over us, but speak more usefully, intimately, and convincingly of our pleasures, desires, and worst fears, of our love-hate relationships with our bodies, and to the boundaries we draw between private and public.[95]

Note that both Arasse and Heiferman employ Aristotelian criteria that art ought to inform us as well as please us: In meditating on "The Morgue," Arasse learns and therefore judges the work to be good; in seeing "The History of Sex," Heiferman does not learn anything that he did not already know and therefore judges the work to be lacking.

Serrano's photograph *The Other Christ* (Color Plate 7), which depicts a black Jesus with a white Mary, is from the artist's series he calls "The Interpretation of Dreams." *The Other Christ* is a continuation of a theme of Serrano's, identified by McGee as anti-authoritarian, especially regarding the authority of the Roman Catholic Church. Serrano says the church's policies are "at least indifferent to human need, and at worse malicious and intolerant."[96] About Serrano's church-related pictures, critic Eleanor Heartney states, "While embracing Catholicism's lush visual tradition and its almost hallucinatory imagery, Serrano is troubled by the social and political inequities embedded in the policies of the contemporary church."[97]

In 2008, the Yvon Lambert gallery was pleased to announce an exhibition of new work by Serrano, an exhibition titled "Shit" that featured large-scale photographs of excrement. The gallery explained:

> In this new series he continues his investigation of bodily functions through brightly colored photographs of excrement produced by a motley of animals. The photographs are formally constructed and demonstrate Serrano's considerable technical skill while analyzing subject matter that might make some viewers squeamish. The artist treats the feces to his familiar bright psychedelic backgrounds and titles that demonstrate his keen sense of humor. The photographs are simultaneously repellent and fascinating, allowing the viewer to inspect the manure without the deterrent of odor or other sensual aggravation.[98]

The exhibition featured sixty-six photographs, some eight feet high, of the artist's excrement (*Self-Portrait Shit*), that of his girlfriend, his dog, and other animals, such as a rabbit, jaguar, chicken, and a bull, some with punning titles such as *Bull Shit*, *Holy Shit*, *Deep Shit*, and some with historical references such as *Hieronymus Bosch Shit*.

Critic Jerry Saltz, writing in *New York Magazine*, called the photographs "slick and snazzy" with a "momentary effect thanks to their scale and rich color." The critic refers to the artist as "a button-pusher with a talent for lurid or sensational subjects." Saltz asserts "Serrano wants to shock and please at the same time, a bad combination that makes the pictures simultaneously ingratiating and desperate." Saltz says he doesn't find fault with the subject matter but writes that the artist "has done nothing with it. Every image is the same, a close-up against a colorful background."[99]

Art critic and philosopher Donald Kuspit wrote a lengthy scholarly essay about shit, rubbish, and avant-garde art, "The Triumph of Shit," in which he refers to Serrano as an avant-garde hack who "has become an unreflective asshole" and his "art has been dumbed down . . . to mindless shit, that most leveling and un-ideal of all substances." Regarding viewers of the exhibition, "Everyone knows that show business is unadulterated narcissism, and with that emotionally regressive, not to say a sign of arrested development—artistic as well as personal development, and of course of the society that produces it."[100]

Serrano's Thoughts about His Own Work

Serrano is well aware of the controversies over some of his photographs, and he says: "You can't have the sacred without the profane." He believes that "in a free society ideas, even difficult ones, are not dangerous. The only danger lies in repressing them."[101] For him, "What is wrong is to make something that isn't beautiful."[102]

He comments on the diversity of his subject matter:

> I'm driven to make unusual portraits. For example, with "The Klan," I thought, "How do you make a portrait of someone who is hiding behind a mask?" I decided to make this series because I myself am not white. If I were white, perhaps it wouldn't have been interesting for me and there would have been no point in

doing it. When I did "The Church" in Spain, France, and Italy, I tried to photograph the Cardinal of Paris. . . . The point is that I like to do the things I'm not supposed to do. For me, the question should not be, "Why 'The Morgue'" or "Why 'Shit,'" but rather, "Why Not?"[103]

About his experience of photographing "The Klan," Serrano says the Klansmen "are a lot less menacing to me now. I know who they are";[104] "They were quite nice to me, yet they represent this organization dedicated to hatred of people not like themselves";[105] "I discovered that they are very poor, at the bottom of the barrel. Even the scapegoats need scapegoats."[106]

Regarding his series "America" (2.9), he explained that he

started working on "America" a couple of weeks after September 11th. I spent three years making the 116 portraits. I did "America" for myself—it was my personal response to America being attacked by people who have no idea what America is. "America" was my way of documenting who we are. I felt that I had enlisted in the war effort, and this was my contribution. I remember speaking with an Austrian a few days after September 11th and she pointed to my armband of stars and stripes and asked me, "Why the armband?" I thought to myself, "If I have to explain it to you, I can't, so I won't."[107]

Regarding "Shit," Serrano says:

I once said I would never work with feces, and in addition to making work to challenge myself I also make work that will challenge and confront my audience. If it's not interesting for me, how can it possibly be interesting for others? Most of my work is portraiture—portraits of Klansmen, portraits of the homeless, portraits of the dead, portraits of plants (cycads)—so it made sense for me to photograph excrement as formal portraiture as well.[108]

He went on to say:

The project is also just as much about language and the use of the word "shit" in the parlance of our times—the cultural references and innuendos that exist in that word. Many of the works' titles go beyond the descriptive and the literal—they are symbolic as well. *Bull Shit* is both literal and metaphorical, as are *Freudian Shit* (feces from a therapist), *Holy Shit* (feces from a priest), and *Self-Portrait*. . . . I think I have a good sense of humor, and I can laugh at myself. I purposely gave my critics plenty of ammunition to hurl back at me with titles like *Dumb Shit, Stupid Shit, Evil Shit* (all 2007) and *Bad Shit*. You have to be one step ahead of your audience as well as your critics.[109]

Regarding the claims that he is a sensationalist, Serrano says, "One of the most stupid criticisms I've seen of my work recently is that I'm doing it for the attention. Does that mean I should make work that gets overlooked and ignored?"[110]

Conclusion

When viewing works of art that are made to be and taken to be Realistic, we tend to look *through* them, as if the pictures were *transparent*.[111] This is especially true of photographs: When showing a photograph of a daughter to a friend, for example, we are likely to say, "This is Tess," rather than saying, "This is a snapshot of Tess taken by her aunt." If we were to show a painted portrait of Tess, however, we might be more likely to say something like, "This is a painting of Tess painted by an artist on the street during our trip to Vienna."

With all pictorial representations that we take to be Realistic, we tend to focus on the subject and simplistically consider it to be "the way it is," even though it is a representation made by a person by means of a certain technology in a certain medium, using certain stylistic constraints. Realist theories of art direct our attention back to how the picture was made and how and why we take it to be "real."

Aesthetic Realism usually carries with it ontological and epistemological assumptions about the world and knowledge, namely, that there is *a* way the world really is, and to get to it and show it, we must mirror it as accurately as possible. Plato and Aristotle remind us that of any work of art, we can and should ask if it is "true." Plato's answer is "No," and Aristotle's is "It can be." Asking questions about whether representations are true and if they offer knowledge is a way of experiencing them that offers considerable advantages over mistakenly taking them to be the way things are. Within Realism, artworks take on cognitive as well as aesthetic importance.

Realism and Artists

Artists, especially those working in modes other than the Realistic, are burdened with popular expectations that they be able to draw "realistically," by which people mean with verisimilitude. The credibility of artists, in the minds of many, is dependent on skills of mimeticism. Thus, mimeticism becomes a criterion for the artworks of all artists, whether or not that art is about Realistic representation.

Conversely, artists who work today within Realism as a philosophy and within Realistic stylistic guidelines are sometimes held suspect by contemporary critics and curators who think of Realism as an outmoded and exhausted theory. Recall that Rockman's representational art, for example, does not fare well in the critical eyes of Saltz and Rimanelli writing in "high art" magazines. While artists who excel in mimetic representation may please the populace, they may displease critics.

Realism and Artworks

Whereas Expressionism, as we shall see, emphasizes the contribution of the artist's personal, psychological investment and disclosure in a work of art, Realism directs one's attention to the subject matter of the artwork: the majestic mountain, the beautiful body, the heroic personage, the holy saint, the mighty king, the homeless person. In Realism, expression becomes secondary to what is represented. Realism tends to encourage viewers to look at Realistic representations as transparent windows on

the world, uninflected by personal and cultural human intervention. Thus Rockman, for example, does not draw attention to the surface of his paintings by using thick, textured brushstrokes as does Vincent van Gogh, for example, an Expressionist who does draw attention to the emotional quality of his expression as well as to his subject matter.

Realistic representations can be understood mistakenly to be the way the world is, rather than understood more accurately as an artist's and a society's chosen means of seeing and portraying what is seen. Aristotle understood this when he stressed that any representation is from an artist's point of view: This can be taken as both a caution to the artwork's epistemological value and also a reminder to appreciate what an artist uniquely contributes to experience and knowledge.

Realism and Audiences

Like Aristotle, most people take pleasure when experiencing mimetic art: They delight in seeing Realistic representations in two- and three-dimensional forms. They often experience a sense of amazement that anything could be rendered so realistically in media such as marble or paint. They are often taken with the obviously recognized skill of the artist who is able to make convincing representations. They tend to judge an artwork by the skill of mimeticism required to make it.

Photographs, to those who do not seriously make them, seem easy to make because of the mechanical aid of cameras available to the photographer. Thus appreciation for good photographs is often missing because of many people's lack of knowledge of the particular skills excellent photography requires. Thus, mimetic Realism itself is not sufficient for appreciation.

Although Aristotle took pleasure in Realistic representations and found the pleasure to be good, he employed other criteria when judging art, most especially its contribution to true knowledge. Many viewers neglect such a requirement in their appraisals of art that pleases them because of its verisimilitude to what is represented. Plato particularly worried that the pleasure of Realistic art would lead viewers astray and in pursuit of falsehoods and, worse, immoral behaviors. Amazement of or comfort with the familiarity of Realistic photographs and other lens-based media often overrides justifiable concerns about the truth of what one may see in a photograph, in film, or on television.

Most people admire Realism, especially those untrained in art. Such audiences, however, present considerable challenges for art educators. When those who admire Realistic art are entrenched in their expectations that all art should be Realistic, they cannot appreciate the many other types of art available to them. If one's taste for and appreciation of art is limited to Realistic works, one's options for pleasure and meaning in art are severely reduced.

Questions for Further Reflection

Are Platonic and Aristotelian conceptions about the arts relevant today? If not, why not? If so, which, how, and why?

Do you think Plato and Aristotle would differ on their judgments of Koons's work? If not, why not? If so, how and why?

Can the thinking of Plato and Aristotle be applied to works of nonrepresentational, non-mimetic works of art? How or why not?

What do you imagine Plato and Aristotle might think about "reality TV"?

Plato advocates censorship of the arts. What counts as censorship? Is censorship ever justified? If not, why not? If so, when, why, by whom, and from whom?

In your personal philosophy, is "obscene art" a contradiction of terms? Why or why not?

Are vivid sexual images more obscene than vivid images of violence, poverty, displays of extreme wealth, or sickness?

Should it matter to artists working within Realist traditions whether Realism is natural or conventional? Why or why not?

Notes

1. Crispin Sartwell, "Realism," in *A Companion to Aesthetics*, ed. David Cooper, Malden, Mass.: Blackwell, 1992, p. 354.

2. Richard Eldridge, *An Introduction to the Philosophy of Art*, New York: Cambridge University Press, 2003, p. 29.

3. Andy Grundberg, "A Medium No More (Or Less): Photography and the Transformation of Contemporary Art," in Sylvia Wolf, *Visions from America: Photographs from the Whitney Museum of American Art, 1940–2001*, New York: Prestel, 2002, pp. 42–43.

4. George Dickey, *Introduction to Aesthetics*, New York: Oxford University Press, 1997, pp. 6–8.

5. Christopher Janaway, "Plato," in *The Routledge Companion to Aesthetics*, ed. Berys Gaut and Dominic McIver Lopes, New York: Routledge, 2001, p. 3.

6. John Andrew Fisher, *Reflecting on Art*, Mountain View, Calif.: Mayfield, 1993, p. 196.

7. Mary Mothersill, "Beauty," in *A Companion to Aesthetics*, p. 48.

8. Mary Mothersill, "David Hume: 'Of the Standard of Taste,'" *Encyclopedia of Aesthetics*, New York: Oxford University Press, 1998, p. 432.

9. Christopher Janaway, "Plato," *Encyclopedia of Aesthetics*, New York: Oxford University Press, 1998, p. 520.

10. Stephen Halliwell, "Aristotle," *A Companion to Aesthetics*, p. 11.

11. Eldridge, *An Introduction to the Philosophy of Art*, p. 27.

12. Mothersill, "Beauty," p. 48.

13. Stephen David Ross, "Beauty," *Encyclopedia of Aesthetics*, pp. 237–238.

14. Ibid., pp. 238–239.

15. Ibid., p. 239.

16. Nickolas Pappas, "Beauty: Classical Concepts," *Encyclopedia of Aesthetics*, p. 247.

17. Aristotle, in Stephen Halliwell, "Aristotle on Form and Unity," *Encyclopedia of Aesthetics*, p. 103.

18. Ibid., p. 102.

19. Gordon Bearn, "Kitsch," *Encyclopedia of Aesthetics*, p. 66.

20. Milan Kundera, *The Unbearable Lightness of Being* (1984), tr. Michael Henry Heim, New York: Perennial Classics, 1999, pp. 246–248.

21. Susan Hayward, *Cinema Studies: The Key Concepts*, London, England: Routledge, 2000, p. 266.

22. McNair, in Hayward, ibid.

23. Ibid.

24. Julie Van Camp, personal correspondence, 2006. See also Julie Van Camp, "Freedom of Expression at the National Endowment for the Arts: An Opportunity for Interdisciplinary Education," *Journal of Aesthetic Education*, Vol. 30, Fall 1996, pp. 43–65.

25. Hayward, ibid.

26. Ibid.

27. Catharine MacKinnon, *Women's Lives, Men's Laws*, Cambridge, Mass.: Harvard University Press, 2005.

28. For a fuller discussion of controversies over Mapplethorpe's images, see Chapter 6 in Terry Barrett, *Criticizing Photographs: An Introduction to Understanding Images*, 5th ed., New York: McGraw-Hill, 2012.

29. For a fuller discussion of the controversy surrounding "Sensation," see Chapter 3 in Terry Barrett, *Interpreting Art: Reflecting, Wondering, and Responding*, New York: McGraw Hill, 2003.

30. Steven Dubin, "How *Sensation* Became a Scandal," *Art in America*, January 2000, pp. 53–55.

31. Roland Barthes, "Rhetoric of the Image" (1964), in *Image-Music-Text*, ed. Roland Barthes, New York: Hill & Wang, 1971, pp. 32–51.

32. Roland Barthes, *Camera Lucida: Reflections on Photography*, New York: Hill & Wang, 1981, p. 63.

33. William Henry Fox Talbot, *The Pencil of Nature*, London: Longman, Brown, Green, & Longmans, 1844.

34. Joel Snyder, "Picturing Vision," in *The Language of Pictures*, ed. W. J. T. Mitchell, Chicago: University of Chicago Press, 1980.

35. Geoffrey Batchen, *Burning with Desire: The Conception of Photography*, Cambridge, Mass.: MIT Press, 1997, p. 56.

36. Diana Stroll, "Interview with Adrian Piper," *Afterimage*, No. 166, Spring 2002, p. 46.

37. Barrett, *Criticizing Photographs*, pp. 167–173.

38. Nelson Goodman, *Languages of Art*, Indianapolis: Hackett, 1976, pp. 6–7.

39. Gabriela Sakamoto, "Resemblance," *Encyclopedia of Aesthetics*, p. 143.

40. Sartwell, "Realism," p. 354.

41. Lopes, as summarized in Eldridge, *An Introduction to the Philosophy of Art*, p. 31.

42. Jonathan Gilmore, "Pictorial Realism," *Encyclopedia of Aesthetics*, p. 110.

43. Robert Rosenblum, "Notes on Jeff Koons," in Jeff Koons, *The Jeff Koons Handbook*, New York: Rizzoli, 1992, p. 21.

44. Koons, *The Jeff Koons Handbook*, p. 144.

45. David Littlejohn, "Who Is Jeff Koons and Why Are People Saying Such Terrible Things about Him?," *ARTnews*, April 1993, p. 91.

46. Rosenblum, "Notes on Jeff Koons," p. 13.

47. Eleanor Heartney, "Jeff Koons at Sonnabend," *Art in America*, May 2004, p. 155.

48. Ibid., p. 15.

49. Ibid., p. 13.

50. Peter Schjeldahl, "A Jeff Koons Retrospective," *The New Yorker*, June 9, 2008, retrieved August 1, 2010, http://www.newyorker.com/arts/critics/artworld/2008/06/09/080609craw_artworld_schjeldahl?currentPage=1

51. Annie Sprinkle, "Hard-Core Heaven," *Arts Magazine*, March 1992, p. 46.

52. Plato, *Symposium*, quoted in Eldridge, *An Introduction to the Philosophy of Art*, p. 47.

53. Scott Rothkopf, "Screen Test: Jeff Koons's *Olive Oyl*," *Artforum*, October 2004, pp. 169–172.

54. Robert Rosenblum, "Dream Machine," in Jeff Koons, *Easy Fun—Ethereal*, Berlin: Deutsche Guggenheim, 2000, p. 52.

55. Jan Avgikos, "Jeff Koons, Sonnabend Gallery," *Artforum*, February 2003, p. 137.

56. Thomas Kellein, in Jeff Koons, *Jeff Koons: Pictures 1980–2002*, New York: D.A.P., 2003, p. 85.

57. Rosenblum, "Notes on Jeff Koons," pp. 46–49.

58. Robert Rosenblum, "Jeff Koons, *Christ and the Lamb*," *Artforum*, September 1993, p. 149.

59. Erika Doss, *Twentieth-Century American Art*, New York: Oxford University Press, 2002, p. 213.

60. Interview with Hilton Kramer, http://www.pbs.org/wnet/egg/flash/2011/2011.swf, March 16, 2005.

61. Edward-Lucie Smith, *Artoday*, London: Phaidon, 1996, p. 310.

62. Robert Hughes, *The Shock of the New*, New York: Alfred A. Knopf, 1996, p. 412.

63. Schjeldahl, "A Jeff Koons Retrospective."

64. Ann Landi, "Jeff Koons, Sonnabend," *ARTnews*, February 2004, p. 110.

65. Koons, quoted in Doss, *Twentieth-Century American Art*.

66. Koons, *Handbook*, p. 114.

67. Barbaralee Diamonstein, *Inside the Art World*, New York: Rizzoli, 1994, p. 131.

68. Ibid., p. 132.

69. Koons, *Handbook*, p. 36.

70. Kellein, in Koons, *Jeff Koons*, p. 59.

71. http://www.viewingspace.com/.../gc_w02_rockman.htm.

72. Maurice Berger, "Last Exit to Brooklyn," in Alexis Rockman, *Manifest Destiny*, New York: Brooklyn Museum, 2004, p. 6.

73. Cathleen McGuigan, "Painter Alexis Rockman Pictures Tomorrow," *Smithsonian*, December 2010, Smithsonian.com, retrieved November 22, 2010, from http://www.smithsonianmag.com/arts-culture/Painter-Alexis-Rockman-Pictures-Tomorrow.html

74. Anna Hammond, "Alexis Rockman at Gorney Bravin + Lee," *Art in America*, April 2001, p. 134.

75. Jerry Saltz, "Alexis Rockman at Sperone Westwater," *Art in America*, 1992, p. 113.

76. David Rimanelli, "Alexis Rockman, Jay Gorney Modern Art," *Artforum*, December 1993, p. 81.

77. Ibid.

78. http://www.viewingspace.com/.../gc_w02_rockman.htm.

79. Ibid.

80. Ibid.

81. Ibid.

82. Rockman, quoted in Berger, "Last Exit to Brooklyn," p. 9.

83. Celia McGee, "A Personal Vision of the Sacred and Profane," *New York Times*, Sunday, January 22, 1995, p. H35.

84. Ibid.

85. Wendy Steiner, "Introduction: Below Skin Deep," in *Andres Serrano: Works 1983–1993*, p. 14.

86. Serrano, quoted in Robert Hobbs, "Andres Serrano: The Body Politic," in *Andres Serrano: Works 1983–1993*, Philadelphia: University of Pennsylvania, 1994, p. 36.

87. Peter Schjeldahl, in Hobbs, ibid., p. 17.

88. Hobbs, "Andres Serrano," p. 21.

89. Ibid.

90. Ibid.

91. Ibid., p. 41.

92. Daniel Arasse, "Les Transis," in Andres Serrano, *The Morgue*, Paris: Galerie Yvon Lambert, 1992.

93. *Art at the Millennium*, London: Taschen, 1999, p. 458.

94. http://upcoming.org/event/14201/, April 2, 2005.

95. Marvin Heiferman, "Andres Serrano—Paula Cooper Gallery, Chelsea, England," *Artforum*, Summer 1997, http://www.findarticles.com, April 2, 2005.

96. Ibid.

97. Eleanor Heartney, "Looking for America," in Andres Serrano, *America and Other Work*, London: Taschen, 2004, n.p.

98. Yvon Lambert, "Paris: Andres Serrano—Shit, September 2008–16 October 2009," retrieved September 18, 2010, from http://www.re-title.com/exhibitions/archive_YVONLAMBERTPARIS3166.asp.

99. Jerry Saltz, "Looking Out for No. 2," *New York Magazine*, September 21, 2008, retrieved July 22, 2010, from http://www.artnet.com/magazineus/features/saltz/saltz9-29-08.asp.

100. Donald Kuspit, "The Triumph of Shit," *Artnet Magazine*, retrieved July 22, 2010, from http://www.artnet.com/magazineus/features/kuspit/kuspit9-11-08.asp.

101. Serra Kessler, "Andres Serrano Interview in Whitehall," July 29, 2001, http://sarahkessler.wordpress.com/2008/12/28/andres-serrano-interview-in-whitewall/

102. Hobbs, p. 21.

103. Kessler, ibid.

104. Charles Hagen, "Andre Serrano, After the Storm," *ARTnews*, September 1991, p. 62.

105. McGee, "A Personal Vision."

106. Hobbs, "Andres Serrano," p. 39.

107. Kessler, Ibid.

108. Ibid.

109. Ibid.

110. Ibid.

111. Kendall Walton, "Transparent Pictures: On the Nature of Photographic Realism," *Critical Inquiry*, Vol. 11, December 1984.

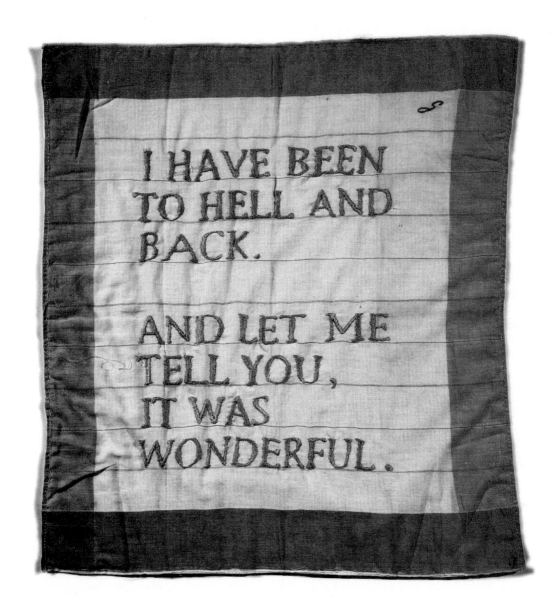

3.1 Louise Bourgeois | *Untitled (I Have Been to Hell and Back)*, **1996.**
Embroidered handkerchief, 19 1/2 x 18 inches. Collection Jerry Gorovov, New York.
Photo: Christopher Burke. VAGA.

3 Expressionism and Cognitivism

ART SHOWS FEELINGS, COMMUNICATES THOUGHTS, AND PROVIDES KNOWLEDGE

Introduction

Expressionism is an eminent, popular, and appealing theory of art. Succinctly, Expressionists assert that "artists are people inspired by emotional experiences, who use their skill with words, paint, music, marble, movement and so on to embody their emotions in a work of art, with a view to stimulating the same emotion in an audience."[1] The Romantic poet William Wordsworth in 1800 characterized art as "the spontaneous overflow of powerful feeling."[2] Expressionism is a theory of art that is held by many artists, as well as aestheticians and critics, and it is popular among those in the general public who are able to accept abstract and nonobjective works of art—that is, those who are not limited to Realism in their appreciation of art.

Cognitivism is a more recent twentieth-century development in art theory that is closely related to but distinct from Expressionism. Cognitivism asserts that art provides knowledge of the world in unique and powerful ways and that such knowledge would be lost to us if it were presented in forms other than artistic forms. Art is a special way of knowing the world. One of its ways of knowing is through emotions. However, as viewers we also commonly "celebrate some works for their profundity, their insights into the human condition, for how they make us see the world anew; we criticize other works for their shallowness and their escapist pandering to people's illusions."[3]

Expressionism in art is generally thought of as having begun in the middle of the nineteenth century and is often associated with Modern art. Many artists are considered Expressionists, perhaps most famously Vincent van Gogh (1853–1890) in Holland, German Expressionists around the time of World War II such as Franz Marc (1880–1916) and Ernst Kirchner (1880–1938), and later Jackson Pollock (1912–1956), who is the most famous of the Abstract Expressionists of the New York School. Artists continue to work within Expressionism today. Two deceased and one living Expressionist artist are the focus of this chapter: Joan Mitchell, an abstract painter; Louise Bourgeois (3.1), best known for her sculpture; and Kiki Smith, a sculptor and printmaker.

Expressionism in aesthetics (also referred to as Expressivism and Emotivism) emerged during the 1800s and is most famously associated with philosophers Leo

Tolstoy and Benedetto Croce. Sigmund Freud's introduction of psychoanalytic theory is very influential in Expressivist theory and has gained renewed import through recent psychoanalytic work. Expressionism took a more cognitive turn[4] in the twentieth century with the writings of R. G. Collingwood, Suzanne Langer, John Dewey, Nelson Goodman, and Arthur Danto.

This chapter proceeds with examinations of the similarities and differences of Expressionism and Cognitivism by its major philosophical proponents—Leo Tolstoy, Benedetto Croce, R. G. Collingwood, Suzanne Langer, John Dewey, Nelson Goodman, and Arthur Danto. It also introduces psychoanalytic theory in the writings of Freud. The chapter then views Expressionist and Cognitivist theories through critics writing about Mitchell, Bourgeois, and Smith.

Expressionism and Cognitivism

Expressionism offers appealing answers to questions about the nature of art, why we make art, and why we enjoy looking at it. A painted portrait, for example, may be expressive of love or hate, more particular feelings, and new feelings perhaps not expressed in ways other than the artist's. Artists sometimes begin with unarticulated feelings and struggle to clarify and reveal them in paint on canvas or with pixels in a computer animation. "It is not only sensations, feelings, moods and emotions that may be expressed, but also attitudes, evaluations, atmospheric qualities, expectations, disappointment, frustration, relief, tensings and relaxings."[5] Artists need not show only brief bursts of feeling, but large worldviews or sustained experiences of inner life. Felt experience is essential to the Expressionist artist, and the subject of Expressionist art is the human subject. Recently, Expressionism is linked with cognitive theories of art: that is, the belief that works of art add to knowledge (as well as express feelings) in unique and valuable ways.

Expressionist theory appeals to common sense. It draws upon experiences of artists who have strong feelings and different ways of looking at the world who attempt to express them by means of their chosen medium, whether in poetry, film, or paint. The theory makes sense to audience members because it often resonates with their individual responses to works: People see a work and are moved by it (or not). If viewers are not moved by a work, they often use this lack of personal identification as the basis for negatively judging the work by saying, for example, "It doesn't do much for me."

Contemporary philosopher Berys Gault is an articulate advocate of the value of a Cognitivist view of art, or what he calls "aesthetic cognitivism." Aesthetic Cognitivism is the conjunction of two claims: (1) art can nontrivially teach us, and (2) the capacity of art to teach is part of its aesthetic value. He does not argue that the only value of art is cognitive, but that it is one among many values. Also, he believes there are a variety of types of knowledge that art can impart to its viewers, including propositional knowledge, know-how or skills, knowledge of what it is like to experience something, conceptual knowledge, and knowledge of values. Gault reminds us that we commonly use cognitive criteria in judging art: "we celebrate some works for their profundity, their insights into the human condition, for how they make us see the world anew; we criticize other works for their shallowness and their escapist pandering to people's illusions."[6]

Philosopher Cynthia Freeland articulates Cognitivist views of art this way:

(1) Artworks stimulate cognitive activity that may teach us about the world. . . .
(2) The cognitive activity they stimulate is part and parcel of their functioning as artworks. (3) As a result of this stimulation, we learn from artworks: we acquire fresh knowledge, our beliefs are refined, and our understanding is deepened. (4) What we learn in this manner constitutes one of the main reasons we enjoy and value artworks in the first place.[7]

When writing about Cognitivism in art, philosopher Eileen John calls to our attention that "Many works of art, in order to be appreciated and enjoyed as art, call out for understanding, as opposed to sheer awe or delight. This understanding often requires cognitively lively or demanding activity, as we try out ideas, feelings and attitudes important to understanding the work."[8] Freeland and John agree that an artwork's content requires complex acts of artistic interpretation. John asserts that public discourse, along with individual response, should be part and parcel of the cognitive functioning of art.[9]

Expressionist and Cognitivist Theories of Art

There are many versions of Expressionism, and theorists continue to evolve their theories and critique others' theories. During the nineteenth century the Imitation theory of art (Chapter 2) began to be challenged as the dominant view of art. Expression theory grows out of eighteenth- and nineteenth-century Romanticism, which resists the Industrial Revolution and what was considered Immanuel Kant's "overly rationalist" theory of knowledge. Kant (1724–1804) asserts two worlds: the empirical world of nature that we can know through science and an invisible world of things-in-themselves that lie behind the visible world and are undistorted by the limitations of the human mind—akin to Plato's Forms (Chapter 2). Kant is discussed further in Chapter 4.

Romanticism stresses strong emotion—trepidation, awe, and horror as sublime aesthetic experiences—individual imagination with a concomitant freedom from classical notions of art, and overturning the aristocracy as influenced by the French Revolution (1789–1799). The label of "Romantics" refers to many artists (J. M. W. Turner and John Constable), poets (William Blake, Lord Byron, Samuel Taylor Coleridge, Percy Shelley, William Wordsworth, and John Keats), and musicians (Wolfgang Amadeus Mozart, Joseph Haydn, and Ludwig van Beethoven), as well as philosophical and social thinkers (Jean-Jacques Rousseau) who emphasize imagination, feeling, and intuition. Some scholars understand Romanticism to be continuous into the present, some see it as the beginning of modernity, some see it as resistance to the rationalism of the Enlightenment, and others date it as the direct aftermath of the French Revolution.

Philosophers of Romanticism such as Johan Fichte (1762–1814), Friedrich Schelling (1775–1854), Arthur Schopenhauer (1788–1860), and Friedrich Nietzsche (1844–1900) reacted against what they saw as a general overdependence on empirical (Realist) philosophy, science, and rationality, especially as proposed by Kant. As Dickie writes, these philosophers attempted "to reach behind the sensuous screen of ordinary knowledge to something thought to be vital and important." Philosophical

Romanticism generated a new respect for the artist and artistic creation. Romantic philosophers conceived of the artist as one who could attain knowledge inaccessible to science. Artists could access emotion, and emotion provides a superior kind of knowledge. Art came to be understood as the expressions of the emotions of artists in form.[10]

Leo Tolstoy

Early versions of Expressionism are concerned with two terms: the artist and the artwork. Leo Tolstoy (1828–1910), the Russian writer best known for his novels *War and Peace* and *Anna Karenina*, also wrote *What Is Art* in 1897. He importantly brings a third term to the theory, the viewer: "Art is a human activity consisting in this, that one man consciously, by means of certain external signs, hands on to others feelings he has lived though, and that other people are infected by these feelings and also experience them."[11] In contemporary aesthetician Marcia Eaton's view, Tolstoy's is the very strong version of Expressionism: "According to Tolstoy, an angry or sad author, when successful, actually makes the reader angry or sad."[12] Tolstoy's requirement that a work of art actually transmit feeling to a viewer is too strong and too simplistic for other Expressionists.

For Tolstoy, the expression of emotion in a work of art is not sufficient to make the work good: The mere production of pleasure is not a good reason to make art; expression has to be clear and sincere, and, very importantly, it should express the religious and moral attitudes of the day. Tolstoy does not put credence in art as a means of furthering rational thought; rather, in Eaton's words, for Tolstoy the purpose of art "is not to make us smarter, but more humane."[13] By transmitting feelings through works of successfully made art, artists cause viewers to become more aware of and sensitive to the feelings and needs of others. In Eaton's view, Tolstoy argued that art is important because it enables people to communicate emotionally with one another, and the consequence of this is that these people are so bonded together that they come to treat one another better—with more kindness or respect, for instance. Thus Tolstoy substituted "a moral theory for an aesthetic one."[14] His theory can be characterized as "consequential" or "instrumental" based on art's "extrinsic" rather than "intrinsic values": That is, an artwork, for him and other "instrumentalists," is valued according to what it contributes to causes outside of itself.

Benedetto Croce

Croce (1886–1952), an Italian aesthetician, art critic, cultural historian, and anti-fascist, helped establish liberal institutions in Italy after World War II. He wrote *The Aesthetic as the Science of Expression and of Linguistics in General* in 1902, and the influential essay "What Is Art?,"[15] likely in reference to and to distinguish his views on art as different from Tolstoy's book of the same title. He also published criticism on the works of Dante, Johann Wolfgang von Goethe, and William Shakespeare.

Croce's view, generally, is that art is an activity of intuitive expression by which the artist provides a particular form for experience. Artists are particularly adept at putting inchoate stimuli and experiences into articulated form in media. We all put stimuli into some form to make sense of them, so art is common to all and is not a rarified activity by or for the elite.

Recent philosopher Colin Lyas articulates corollaries that follow from the idea that art is the activity of intuitive expression by which we all give form (expression) to life's stimuli. (1) Each work of art is a unique expression, and to experience it properly, we need to grasp its uniqueness. (2) Making art (an artistic expression) is morally innocent; deciding to show that expression becomes a moral matter. (3) There are no general rules for making works of art. (4) The beauty of art is not the beauty of nature: Art is essentially human creative expression. Natural beauty is not artistic beauty. (5) Art is dependent on expression, not its physicality: Attending to an artwork's physicality without its expression is insufficient. (6) Art is an organic unity of idea and form. (7) To judge a work of art one ought to see it through the view of its maker.[16]

R. G. Collingwood

Collingwood (1889–1943) is a British historian, philosopher of history, and aesthetician with what recent philosopher Gordon Graham calls a sophisticated version of Expressionism, crediting Collingwood's *Principles of Art*,[17] written in 1938, "as one of the major works of aesthetics in the twentieth century."[18] Collingwood agrees with Croce that art is mental: The finished work of art must be re-created in the mind of its viewer for it to function as a work of art. For Collingwood, the work exists (comes to life and has meaning, becomes art) in the imagination of the viewer. Collingwood agrees that art expresses emotion, but it is emotion processed by the artist by means of the artist's imagination. The artist expresses what he or she feels, but such expression is not mere transcription of raw emotion: The artist must transform his or her raw, inchoate feelings into communicative expressions. Through the process of making art and putting their feelings into physical form, artists come to better know themselves.

The viewer, in turn, collaborates with the artist in imaginatively reconstructing the artist's emotive and imaginative expression. Thus, art is collaboration between artist and viewer. The viewer is not a passive receptor of the artist's emotion, but an active participant in creation: Croce writes, "art is not contemplation, it is action"; the role of the viewer is "not a merely receptive one, but collaborative."[19] By mentally working with the expression of the art, viewers come to better know their own interior lives.

Collingwood objects to scrutinizing the artist's history and psychology to find the meaning of the work. Collingwood writes:

> The artist's business is to express emotions; and the only emotions he can express are those which he feels, namely his own. . . . If he attaches any importance to the judgment of his audience, it can only be because he thinks that the emotions he has tried to express are . . . shared by his audience. . . . In other words he undertakes his artistic labor not as a personal effort on his own private behalf, but as a public labor on behalf of the community to which he belongs.[20]

Graham offers this articulation of Collingwood's theory:

> in sharp contrast to other versions of expressivism, imagination plays a central role in Collingwood's aesthetic. In fact, art proper as he describes it has two equally crucial elements, expression and imagination. A work of art expresses

emotion, certainly, but its creation and appreciation are both acts of imagination, and the work itself can exist only in the imagination. In line with Croce's distinction between art and "physical fact," Collingwood holds that works of art must be recreated in the minds of their audience. Just as it is by imaginative construction that the artist transforms inchoate emotion into an articulate expression, so only by imaginative reconstruction can the audience apprehend it. The process of artistic creation is thus not a matter of making external what already exists internally. It is instead a process of imaginative discovery and, since the psychic disturbance is the artist's, a process of self-discovery. Herein, in fact, lies its peculiar value: self-knowledge.[21]

Graham concludes that Collingwood's views assert that art does more than express emotion; it transforms emotion into knowledge of self for the artist, and for the viewer who can imaginatively know emotion when it is clarified in works of art. Thus art provides valuable knowledge. Collingwood's is a Cognitivist theory.

Suzanne Langer

In response to the problem of explaining how an artwork might express, Suzanne Langer (1895–1985) importantly posits how it is by the ideas that an artwork might express: It is by means of ideas of feelings that are in the work.[22] Aesthetician Thomas Alexander explains Langer's philosophical project as one of offsetting the Positivist (Realist) tendency to dismiss emotive expression as meaningless.[23] Art, for Langer, gives us an alternative form of meaning. Langer argues that artworks are somewhat like language: The visual artist uses elements other than words that are less specific and freer than words constrained by definitions, and we see the artist's use of the elements —sounds, marks, gestures—and understand them directly and immediately. The artist, by the use of symbolism, has the capacity to think about things without implying the existence of those objects. Whereas philosophy and science use discursive language (proceeding to a conclusion with reason rather than intuition) and propositional language (logically expressed statements), art uses nondiscursive language, that is, symbolism that cannot be directly or easily translated into literal, logical statements. Works of art, however, are ways to organize our world meaningfully, liberating rationality from finite and practical concerns, through metaphoric thinking. For Langer, science and art are the two major modes of making meaning; science attends to practical concerns and art to visionary concerns. Langer's theory, however, (problematically) assumes a universal audience that has no need of learning the elements of art and how artists variously use them and different audiences read them.

John Dewey

In a summary and commentary on the general philosophy and aesthetic philosophy of the American pragmatic philosopher John Dewey (1859–1952), Alexander credits Dewey's treatment of art as "one of the most powerful, original and challenging theories in the literature."[24] Alexander brings together thoughts from Dewey's books

Experience and Nature (1925) and *Art as Experience* (1934) to explain Dewey's philosophy of art, which is central to Dewey's general philosophy.

Dewey's general philosophy and aesthetic philosophy hinge on his concept of "experience." Experience is a learning experience whereby an individual acts and responds to his or her environment in a continuous and developing pattern. The individual as part of a community uses symbols, expression, and communication to direct experience toward intrinsically fulfilling ends that give human existence value and meaning. In Alexander's summation, experience, for Dewey, "signifies the shared social activity of symbolically mediated behavior which seeks to discover the possibilities of our objective situations in the natural world for meaningful, intelligent and fulfilling ends. And the skill at doing this Dewey calls *art*."[25]

Dewey, in opposition to the views of his contemporary Formalist aesthetician Clive Bell (see the next chapter), insists that art and its experience derives from daily experience of human living and is not an isolated, pure, or mystified phenomenon, as Bell has it. Dewey holds an "instrumentalist" view of art, that is, that art is not intrinsically valuable but valuable as a means to something else. For Dewey, the arts can serve as a model to show people how to fulfill their desire to live a lively and complex life full of meaning and value. We make our world meaningful by "doing and undoing," anticipating, acting, responding on the basis of past experience and predictable consequences, constructing interpretations of objects and events. The enemies of such ("aesthetic") experience are mindless, repetitive, or chaotically random responses to experiences.

Like Collingwood, Dewey believes that expression results from an ongoing relationship between the viewer and the artwork. Like Collingwood, Dewey, too, believes that a drawing, for example, is more than ink on paper: The work is the result of the interaction of the viewer and the object, the meaningful integration of the object and the viewer's life. Also like Collingwood, Dewey believes that the artist does not merely transcribe emotions or pour them out, but rather, the artist forms emotions and thoughts while struggling to embody them in physical form.

According to Dewey, the artist's expression ought to be shaped by the artist's desire to communicate to another, whether or not the work will be shown to others. While making art, the artist is in dialogue with himself or herself. The viewer, in turn, to know and appreciate what the artist has rendered, ought to attempt to reconstruct the artist's decisions. When the artwork is interpreted it becomes part of a dynamic dialogue within the human community. There is no one single "real" work of art, nor should there be a haphazard variety of interpretations, but many thoughtful and divergent interpretations of the work within a community.[26]

Nelson Goodman

Nelson Goodman's (1906–1998) contributions to aesthetics in *Languages of Art* (1968)[27] and *Ways of Worldmaking* (1978)[28] reinforce the cognitive nature of art. Emotions function cognitively. Feelings that a work evokes are sources of understanding the world. Emotional sensitivity to subtle and significant features of artworks grants us access to similar subtle and significant features of the world. Expression, however, is not restricted to feelings: The arts enhance understanding. For Goodman, aesthetics is

a branch of epistemology. Thus, the most beneficial approaches to works of art are toward understanding them, rather than appreciating them, having aesthetic experiences of them, or attending only to their beauty.

Understanding a work of art is a matter of interpreting it correctly, by seeing how and what it symbolizes and how and to what effect its meanings interact with other versions and visions of the world. There may be many competing correct interpretations of any work of art, especially since works of art are rich and complex symbols. Judgments of works are also sources of understanding: Different assessments of a work draw us to different aspects of the work that we might not otherwise notice.

For Goodman, works of art belong to symbol systems, and each of the arts uses different systems. Visual artworks, such as those by Louise Bourgeois, Joan Mitchell, and Kiki Smith that we will examine soon, make references to the world by means of denotation and exemplification. Bourgeois's spiders (3.7) *denote* insects while they *exemplify* many things: perhaps maternal protectiveness, possessiveness, and danger. Any one symbol can make many references simultaneously. Mitchell's highly abstract landscapes (3.2, 3.3) do not denote hills and trees, but they exemplify aspects of her memories and feelings about hills and trees. Artworks are "replete" (plentifully abundant): Everything counts toward meaningful expression in a work of art— the paper that Smith uses, its wrinkles, the thickness of each line of ink at every point. Smith's *In a Field* (3.13) may simultaneously "denote" (a naked female and a wolf), "exemplify" (desire and fear), "express" (interdependence of humans and nature), and "refer" or "allude" to (*Little Red Riding Hood*, myths, and lives of the saints).

Metaphor figures predominantly in Goodman's account of art; recall that each of the three artists is credited by different critics for making metaphors of their experiences. Expression is a form of metaphorical exemplification: That is, artworks show us something *as something*. As Goodman writes about picturing a man, "the object before me is a man, a swarm of atoms, a complex of cells, a fiddler, a friend, a fool, and much more."[29] Because the artist cannot show all the ways a man is, the artist shows the man as something. Such showing-as-representations are "apt, effective, illuminating, subtle, intriguing, to the extent that the artist or writer grasps fresh and significant relationships and devises means for making them manifest."[30]

Arthur Danto

Danto (1924–) is both a philosopher and a regularly publishing art critic who concentrates on new art and the challenges it raises for both aesthetics and criticism. He especially pays attention to Modernist art of the twentieth century that largely challenges older definitions of art, seeking the essence of art. He attributes the "end of art" to Pop artist Andy Warhol's *Brillo Box* made in 1964. *Brillo Box* is an artwork that looks very much like an unopened case of Brillo boxes, such as one would find in a grocery store. In Danto's view, Warhol posed a crucial philosophical question concerning the differences among objects that look alike, one an artwork and the other an ordinary item. The difference is not perceptual; it is conceptual and based on something outside of the object itself. The work of art is theory dependent. It depends on

its place within art history and an evolving artworld. What transforms ordinary objects or real things into works of art is an interpretation added to the object. Artworks, unlike real things, have "aboutness." Art is theory dependent. Artworks are dependent on interpretation.

By "end of art" Danto means the end of Modernist avant-garde art that is made with a philosophical knowledge of its place in history. He typifies the historical progression of Modernism as one of "erasures." In the twentieth century, "art did not have to be beautiful; it need make no effort to furnish the eye with an array of sensations equivalent to what the real world would furnish it with; need not have a pictorial subject; need not deploy its forms in pictorial space; need not be the magical product of the artist's touch."[31]

Danto's proclamation of the end of art does not mean that art will or has ceased, but that Modernism has come to its own fulfillment, opening the way to Postmodern Pluralism (the subject of Chapter 5). Danto understands "the end of art" as liberation: "Once art had ended, you could be an abstractionist, a realist, an allegorist, a metaphysical painter, a surrealist, a landscapist, or a painter of still lifes and nudes. You could be a decorative artist, a literary artist, an anecdotalist, a religious painter, a pornographer. Everything was permitted since nothing was historically mandated."[32]

Philosopher Robert Stecker asserts that Danto's most important work in the philosophy of art is his book *The Transfiguration of the Commonplace*, published in 1981, in which Danto elaborates on the considerations stated here. Stecker thinks it was left to commentators to fashion an explicitly stated definition of art based on Danto's writings, the best of which, and one endorsed by Danto, is provided by Noel Carroll:

> X is a work of art if and only if *(a)* X has a subject *(b)* about which X projects an attitude or point of view *(c)* by means of rhetorical (usually metaphorical) ellipsis *(d)*, which ellipsis requires audience participation to fill in what is missing (interpretation) *(e)*, where both the work and the interpretation require an art-historical context.[33]

In Stecker's view, it is the last condition (e) that sets Danto's definition apart, which requires that an artwork and its proper interpretation be in historical relation to other works of art.

Metaphor

Metaphor is important to all art, according to many aestheticians; it figures prominently in Expressionist theories (for example, especially in the thinking of Croce, Langer, Goodman, and Danto) and Postmodernist (Chapter 5) theories and less prominently in Realism and Formalist theories. A current aesthetician, Mark Johnson, articulates traditional Western (Realist) beliefs about meaning, language, and metaphor. In this view, metaphors are not important and lack any claim to truth or knowledge.

The Western tradition is both objectivist and literalist in character. It is made up of related views about the nature of the world, how the mind works, and how language can be about the world. The core set of defining beliefs includes the following:

The world consists of mind-independent objects that have properties and stand in various determinate relationships.

Meaning is an abstract relation between symbolic representations (either words or mental representations) and objective reality.

Meaning is sentential; that is, it consists of propositions that are capable of being true or false.

Meaning is fundamentally literal. By definition, literal concepts are those that directly represent, or map, the objects, properties, and relations that make up our world.

A metaphor, therefore, is a derivative, cognitively dispensable phenomenon, since its meaning should be reducible to a set of literal propositions.[34]

Contrarily, in Postmodernist beliefs, for a strikingly contrasting example, metaphors are highly respected, so much so that many Postmodernists claim that *all* language and other sign systems are metaphoric, that we know and explain our experiences of the world only through metaphors. Such views about language and "the real" will be discussed thoroughly in Chapter 5. Metaphors are also very important to Expressionist theorists and artists, as the following pages will show.

Psychoanalytic Theory

Psychoanalytic theory is itself a vast domain of knowledge. It could merit a chapter of its own. It cuts across or through other theories of art. Psychoanalytic critics would not limit themselves to "Expressionist" art and might have much to say about the "Realism" of Andres Serrano, for example. Nevertheless, psychoanalytic theory is introduced in this chapter with Expressionism and Cognitivism because psychoanalytic theories generally assert that artists express what is buried within their subconscious mind and that works of art provide us with knowledge of artists as making-subjects and of viewers as viewing-subjects. Sigmund Freud is profiled here because he is especially relevant to critical commentary of the artists discussed in the chapter. Louise Bourgeois, for example, refers often to Freudian theory to explain her artmaking impulses.

Sigmund Freud (1856–1939), the Austrian medical doctor who invented psychoanalysis, "his talking cure," as one of his patients described it, defined psychoanalysis in 1922 as consisting of three aspects: (1) a discipline focusing on the unconscious, (2) a therapeutic method for treating nervous disorders, and (3) research on many aspects of culture, including art history, literature, and philosophy. His intellectual legacy in Modernist humanities is immense, and many of his ideas fund current thinking in Poststructuralism and Postmodernism.[35]

Freud proposed that all is not as it seems and that people can be seen as "texts." The "unconscious" and "repression" are two interrelated terms that work dynamically as the basis of Freud's psychoanalytic theory. The repressed is part of the unconscious. Repression occurs when an instinct from the unconscious arises but is deemed by the

conscious to be dangerous, threatening, destabilizing, or socially taboo. The unconscious is the nonconscious part of the mind that affects conscious thought and actions but is not directly open to interpretation—thus the need for analysis.

Freud describes the speaking human subject as one that is divided between the unconscious (the id) and a site of conflict and negotiation (the ego) that mediates between the id and the site of one's rational thought and conscience (the superego). The ego distorts or disguises unconscious desires.

In analysis, the patient tells life stories and dreams, and the analyst looks for what is troubling in the telling: Distortions caused by unconscious desires and repression manifest in what Freud calls "striking omissions, disturbing repetitions, palpable contradictions, signs of things the communication of which was never intended."[36] The subject's life history is a text full of "suppressed and abnegated material" open to interpretation. The subject's conscious sense of itself (the ego) is presumed by the subject to be self-evident and unified but is actually a fiction masking a self divided between desires and repressions.

Marxist Aesthetics

Marxism might be considered part of Expressionist theory because it, like psychoanalytic theory, holds that artists and artworks express what is invisible or below the surface, sometimes unbeknownst to the artist, other times consciously. The ideas on art put forth by Karl Marx are introduced here; more recent versions of Marxist theory are explored in Chapter 5.

Karl Marx (1818–1883), a German philosopher, has a conceptual affinity with Freud in that both see realities beneath the surface of what appears to be "the real." Freud looks beneath the personal (and cultural), and Marx examines what is beneath the social (and personal). Marxist theory, or Marxism, a critique of industrial capitalism in both its physical and cultural manifestations, is based on the work of Marx and his compatriot Friedrich Engels (1820–1895). Marx and Engels wrote *The Communist Manifesto* in 1848 and collaborated on three volumes of *Das Kapital*, the first of which was published in 1867.

Marx knew Hegel's philosophy well and adapted it. Both Hegel and Marx assert that history progresses: Hegel's history is driven by a spiritual force of ideas and values; Marx's history is driven by material causes such as the need for and lack of food and shelter and class struggle over who owns and controls the production of goods. Hegel's theory of change was dialectical ("spiritualism"): thesis, antithesis, and synthesis. Marx's theory of historical change was dialectal materialism, which emphasized class struggle because of the actions of individuals and materials rather than divine intervention or other extra-human force. Dialectical synthesis will manifest itself in a classless, just society.

Art historian Jae Emerling summarizes two important aspects of Marxist theory:

> We can conceive of Marxist theory in at least two ways. First, Marxist theory is a revolutionary critique of capitalist society. Marx was personally concerned with the need for social change in light of what he saw as the injustice and oppression caused by nineteenth-century industrial capitalism and the economic relations it

engendered. His analyses of how industrial capitalism operated and how it caused oppression were directed at changing this system and thereby ending the human suffering that it produced. Second, and more important for our purposes, Marxist theory is a way to analyze not only economic relations (the base in Marx's terms), but also those values and viewpoints created by industrial capitalism that impact ostensibly nonpolitical endeavors such as religion, literature, and other cultural products (the superstructure). Marxist theory underscores the ideological nature of all human enterprises.[37]

Marxist theory applies to cultural production in that all forms of production, material and cultural, are determined by a society's economic means of producing goods and services. Thus, artworks are not independent and autonomous but are highly influenced, some say determined, by the society in which they are produced. Social constructions and relations also influence the ways artworks are studied. Art and its study are not disembodied or disinterested, as Kant would have it; as Marx has it, the production and apprehension of art are socially dynamic and relevant.

People in capitalist societies are alienated in many ways. People in different social classes are separated. Upper-class capitalists own the production systems in which lower-class workers labor to make goods from which the owner profits and from which the worker is alienated. Workers sell or rent themselves to owners and are alienated from being human because they are commodities.

Marx attributes transformative powers to art. Art can merely be a symptom of society, mirroring it, but works of art can also reveal how we view the world and aid us in changing it by producing an awareness of others in the larger social sphere, thus reducing individual alienation. When calling for a materialistic art history, Marx insists that we seriously consider the role of social and historical context in how we interpret works of art.[38]

Joan Mitchell, Painter

Joan Mitchell (1916–1992) is one of a very limited number of women artists to achieve critical success in the male-dominated art scene in the United States in the 1950s when she began exhibiting. She accepted the challenges of competing in the New York School of Abstract Expressionism, which was also driven by men. Chronologically, she worked after Jackson Pollock, and thus was referred to as a "second-generation" Abstract Expressionist. "Second-generation" sounds less than laudatory today, but it was more of a neutral and descriptive term at the time. Most recently her import grows through posthumous retrospective exhibitions at major institutions. Once known as "an artist's artist," that is, one appreciated mostly by other artists, her work is currently gaining increased notoriety in the wider community of arts-interested people.

To focus your reading about the individual artists and critical responses to their artworks in the following pages, consider the following questions: Does the artist believe she is expressing something, and if so, what? What does the critic believe the artist is expressing? Is there a match between artist and critic? If not, what are the discrepancies? When you look at the reproductions, what do you think the work is expressing? Why are words an inadequate substitute for the works of art? Are your

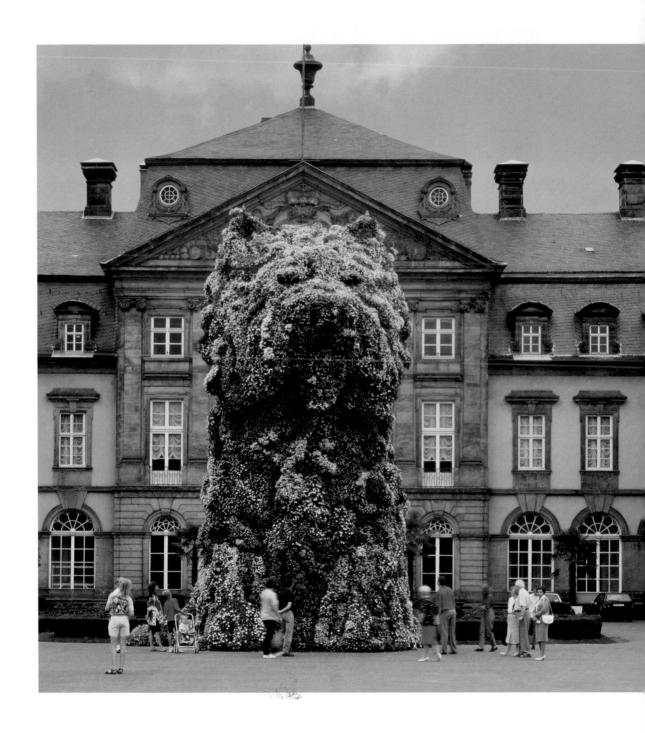

1. Jeff Koons │ *Puppy,* **1992.**
Stainless steel, soil, geotextile fabic, internal irrigation system, and live flowering plants, 486 × 486 × 256 inches.
© Jeff Koons. Arolsen, Germany.

2. Jeff Koons | *Couple (Dots) Landscape*, **2009.**
Oil on canvas, 108 × 148-1/8 inches. © Jeff Koons.

3. Jeff Koons | *Lips*, **2000.**
Oil on canvas, 120 × 168 inches. © Jeff Koons.

4. Alexis Rockman │ *Manifest Destiny*, **2003–2004.**

Oil and acrylic on four wood panels, 8 × 24 feet. Courtesy Leo Koenig Inc.

© 2006 Alexis Rockman/Artists Rights Society (ARS), New York.

5. Alexis Rockman │ *The Farm*, **2000.**

Oil and acrylic on wood panel, 96 × 120 inches. (Courtesy of JGS, Inc.) Courtesy Leo Koenig Inc.

© 2006 Alexis Rockman/Artists Rights Society (ARS), New York.

6. Andres Serrano │ *Nomads (Rene),* **1990.**
Cibachrome, silicone, Plexiglas, and wood frame, 60 × 49 1/2 inches, Edition 1/4, ASE-120-A-PH.
Courtesy of Paula Cooper Gallery, New York.

7. Andres Serrano | *The Interpretation of Dreams (The Other Christ)*, **2001.**
Cibachrome, silicone, Plexiglas, and wood frame, 24 × 20 inches, ASE-352-C-PH.
Courtesy of Paula Cooper Gallery, New York.

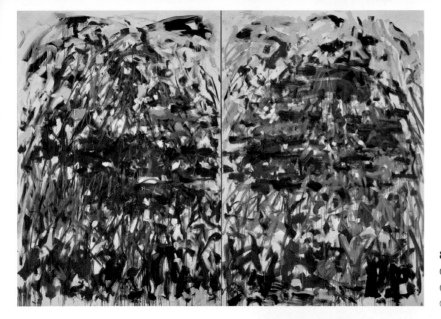

8. Joan Mitchell │ *Rivière*, **1990.**
Oil on canvas, 110 1/4 × 157 1/2 inches
(diptych). The Joan Mitchell Foundation.
© The Estate of Joan Mitchell.

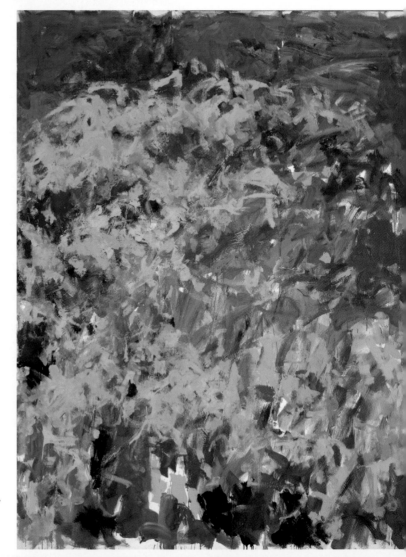

9. Joan Mitchell │ *La Grand Vallée O*, **1983.**
Oil on canvas, 102 × 78 3/4 inches. Private collection.
Courtesy Edward Tyler Nahem Fine Art, New York.
© The Estate of Joan Mitchell.

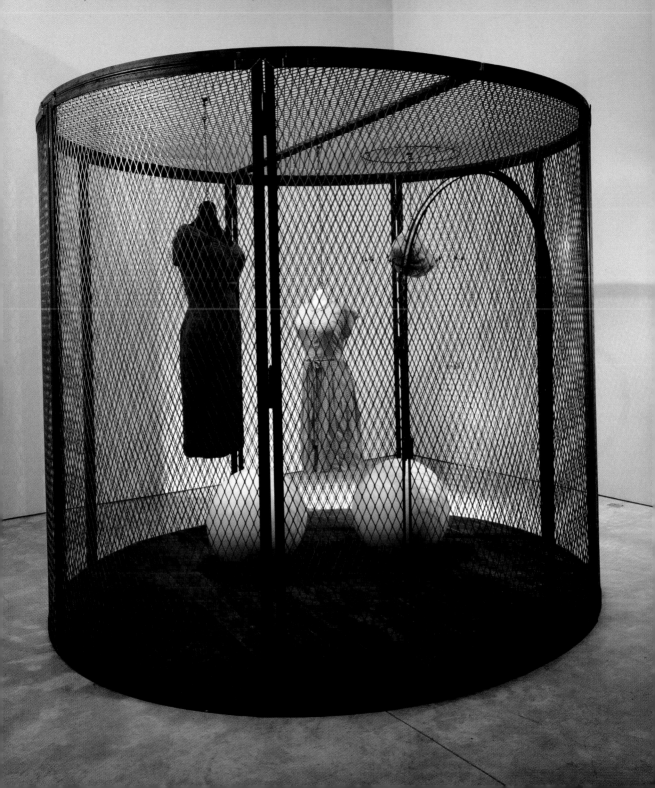

10. Louise Bourgeois | *Cell XXV (The View of the World of the Jealous Wife)*, 2001.
Steel, wood, marble, glass, and fabric, 100 × 120 × 120 inches.
Courtesy Cheim & Read, New York. Photo: Christopher Burke. VAGA.

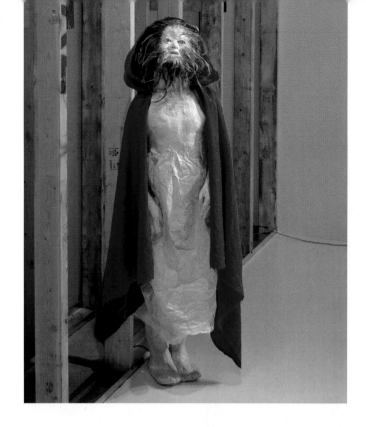

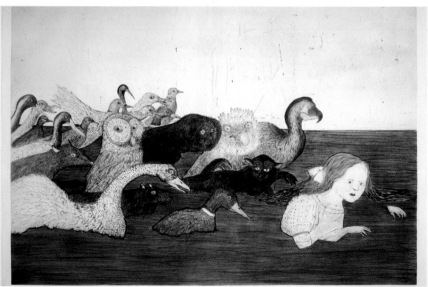

11. Kiki Smith | *Daughter,* **1999.**

Nepal paper, bubble wrap, methyl cellulose, and hair, 48 × 15 × 10 inches. Photo by Ellen Page Wilson, courtesy PaceWildenstein, New York. © Kiki Smith, courtesy PaceWildenstein, New York.

12. Kiki Smith | *Pool of Tears 2,* **2000.**

One color intaglio with hand-applied watercolor, 51 × 74 3/4 inches, paper. © Kiki Smith, courtesy PaceWildenstein, New York.

13. Kiki Smith │ *Singer* (detail), **2008.**

Cast aluminum, 65 × 27 × 24 inches. © Kiki Smith. Courtesy the artist and The Pace Gallery.

Photo by Volker Dohne/Courtesy of The Pace Gallery.

14. Agnes Martin │ *Untitled*, **1995.**

Watercolor wash and pencil on transparentized wove paper, 11 × 11 inches. Photograph by: Kerry Ryan McFate, courtesy

PaceWildenstein, New York. © 2006 Agnes Martin/Artist Rights Society (ARS), New York.

15. Agnes Martin ⎪ *The Peach*, **1964.**

Oil and graphite on canvas, 72 x 74 inches. Dia Art Foundation; promised gift of Louise and Leonard Riggio.
Photo Credit: Bill Jacobson. © 2006 Agnes Martin/Artist Rights Society (ARS), New York.

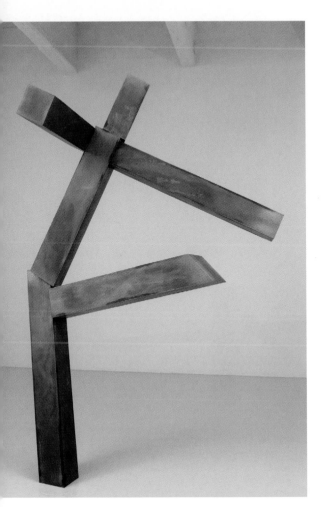

16. Joel Shapiro | *Untitled,* **2005.**

Bronze, 107 × 72 × 44 inches. Photograph by: Ellen Labenski, courtesy PaceWildenstein, New York.

17. Joel Shapiro | *Study (20 elements),* **2004.**

Wood and casein, 16 1/2 × 14 3/4 × 15 inches. Photograph by: Kerry Ryan McFate, courtesy PaceWildenstein, New York.

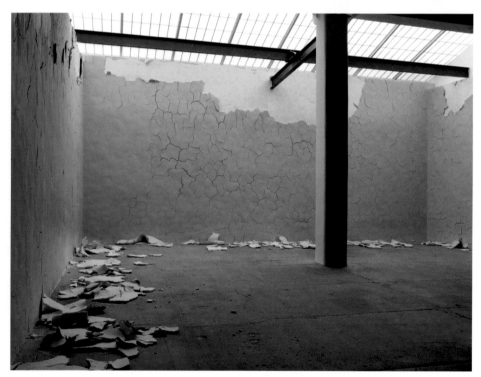

18. Andy Goldsworthy │ *Elm Leaves/Laid on a Wet Rock/Behind a Small Waterfall* (right panel inscribed with text), **2007.**

2 C-prints, each 16 × 16 inches. © Andy Goldsworthy. Courtesy Galerie Lelong, New York.

19. Andy Goldsworthy │ *White Walls*, **Pictured: Day 3, 2007.**

1,964 linear feet, one inch thick (dimensions variable), installation at Galerie Lelong, New York City.

© Andy Goldsworthy. Courtesy Galerie Lelong, New York.

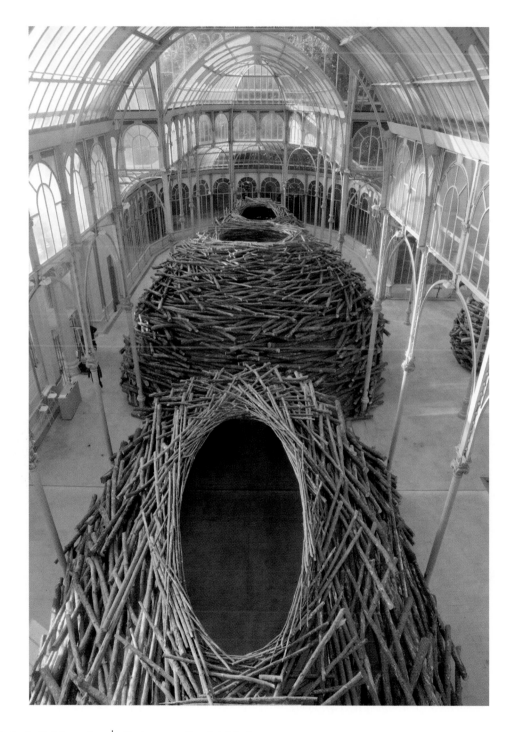

20. Andy Goldsworthy │ *En las entrañas del árbol*, **October 2, 2007–January 21, 2008.**

Palacio de Cristal, Parque del Retiro, Madrid, Spain. Organized by the Museo Nacional Centro de Arte Reina Sofia.

Photo: Raúl Lorenzo. © Andy Goldsworthy. Courtesy Galerie Lelong, New York.

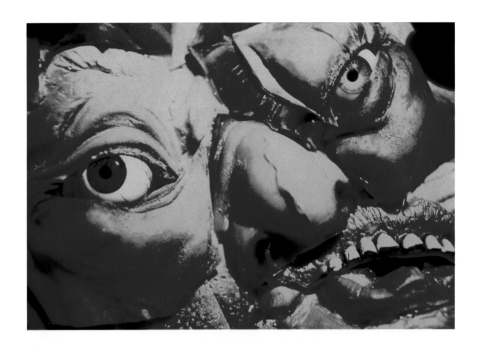

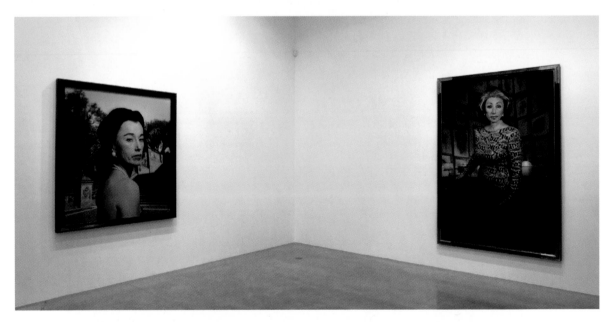

21. Cindy Sherman | *Untitled (#31 4F),* **1994.**
Photograph. Courtesy of the artist and Metro Pictures.

22. Cindy Sherman | *Untitled (Installation View),* **2008.**
Metro Pictures, New York City.

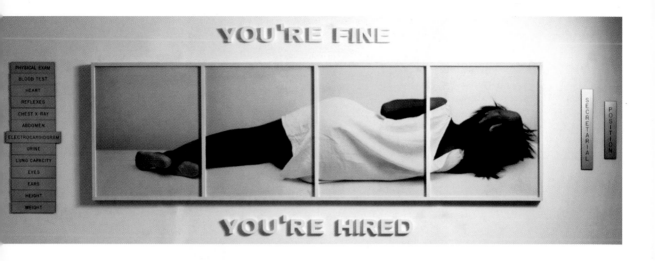

23. Lorna Simpson │ *You're Fine*, **1988.**
Four Polaroid prints, fifteen engraved plastic plaques, ceramic letters, 40 × 103 inches.
Courtesy of the artist and Sean Kelly Gallery, New York. Used with permission. 2006.

24. Lorna Simpson │ *Corridor*, **2003.**
Double projection video installation, color HD video transferred to DVD, duration of single cycle 13:49, sound.
Courtesy of the artist and Sean Kelly Gallery, New York. Used with permission. 2006.

25. Paul McCarthy │ *Pinocchio Pipenose Householddilemma*, **1994.**
Performance, video, installation, and photographs. Private Collection. Courtesy the artist, Hauser & Wirth Zürich London.

26. Paul McCarthy │ *Pig Island*, **2003–2010.**
Mixed media, 11 × 10 × 6 meters. Installation view, Palazzo Citterio, Milan, 2010. Exhibition produced by Fondazione Nicola Trussardi.
Photo by: Roberto Marossi. Courtesy the artist, Fondazione Nicola Trussardi, Hauser & Wirth. Courtesy the artist, the Fondazione
Nicola Trussardi.

conclusions consistent with the declarations of the artists and the critics about what the artists are expressing? Is there a mismatch between the thoughts of the artist, the critic, and you? If so, what are the discrepancies? What have you newly noticed about the art-works because of the words of the artists, critics, and aestheticians? Can you identify various philosophical positions about art and expression and cognition in the words of the artists and critics?

Critical Commentary on Mitchell's Paintings

In 1957, Irving Sandler, a well-known art writer, profiled Mitchell in *ARTnews* maga-zine. The article served as an honorary introduction to the artworld of what he thought to be a promising young artist. Sandler focuses his article on Mitchell's making of the painting *George Went Swimming at Barnes Hole, but It Got Too Cold* (3.2).

Mitchell attributes the painting to her memory of a summer day at the beach with her dog, George. During an interview with Sandler that occurred when she was mak-ing the painting, she tells him she carries her landscapes around with her, and Sandler relates her comment to one of Baudelaire's: "A man who looks out of an open window

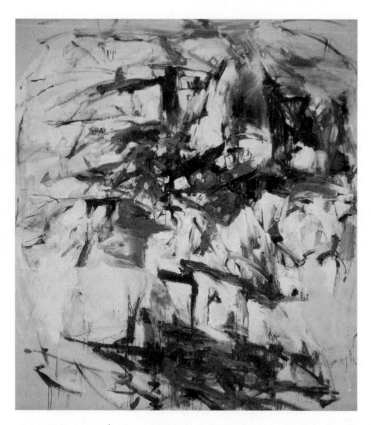

3.2 Joan Mitchell | *George Went Swimming at Barnes Hole, but It Got Too Cold,* 1957.
Oil on canvas, 85 1/4 x 78 1/4 inches. Albright-Knox Art Gallery, Buffalo, New York;
Gift of Seymour H. Knox, Jr. © The Estate of Joan Mitchell.

never sees as much as a man who looks out of a closed one." Mitchell's work is abstract and nonobjective, but it refers to a beach and a dog and her memory of and feelings for them. The emotions she expresses in paintings have real-world references, ones about which she feels strongly. According to Sandler, Mitchell attempts to "recreate both the recalled landscape and the frame of mind she was in originally . . . her bridge, lake, or beach must transcend the finite (what can be seen) and partake in some of the Infinite, expressing its paradoxes and ambiguity." Mitchell says, "The painting has to work, but it also has to say something more than that the painting works."[39]

Sandler provides a description of the artist's process and its effects:

> *George Went Swimming at Barnes Hole* began as a lambent yellow painting, but during the second all-night session, the work changed. The lustrous yellows turned to opaque whites, and the feeling became bleak; therefore, "*but It Got Too Cold.*" The artist did not carry her buoyancy any further; the beach was transposed from summer to fall. It seemed as if the hurricane that struck East Hampton in the autumn of 1954 invaded the picture. Since her early childhood, lake storms have been a frightening symbol both of devastation and attraction, and the sense of tempestuous waters appears frequently in her work. . . . The contrast of the happy heat of the multi-colored central image, the shimmering water and the sun-streaked atmosphere with the fearful suggestion of the impending hurricane creates a remarkably subtle tension.[40]

Mitchell tells Sandler that the expression of her remembered joy takes precedence over her painting process; she tries to forget herself while she is working. She says, "The moment that I am self-conscious, I cease painting."

Mitchell usually painted on a very large canvas cloth that she tacked to a wall, a canvas that was not stretched taut over a wooden support. When the painting was finished, she then mounted it onto wooden stretcher bars. Because she worked large, she needed a studio spacious enough that she could back away from her painting and see it from a distance. She sometimes began with a very simple charcoal sketch of the structure of the image—perhaps a horizontal line—and then worked rapidly on the canvas with oil paints from tubes. She used a variety of brush sizes, house-painters' and artists', and sometimes her fingers and rags. She often made her strokes with a fully stretched arm. She kept large amounts of ready-to-use pigments available to her in tin cans and on palettes. She allowed *George* to sit a day and resumed the next evening, working through the night, painting more slowly, pausing often to study the painting: "I paint from a distance. I decide what I am going to do from a distance. The freedom in my work is quite controlled. I don't close my eyes and hope for the best." She normally added paint, and rarely scraped any away. If she was dissatisfied with a painting, she destroyed it rather than rework it. Sandler says that "above all, she must like her pictures," and Mitchell stressed, "I am not a member of the make-it-ugly school."[41]

Sandler's introduction of Mitchell and her work was written in 1957, when the artist was forty-one; Richard Kalina, a painter and a critic, included a biographical sketch of the artist and her work in *Art in America* upon the occasion of a major retrospective of Mitchell's work at the Whitney Museum of American Art in New York City in 2002, ten years after her death:

Mitchell, who died of lung cancer in 1992 at the age of 66, was a central and lively figure in the art world. There has been much made of her difficult personality: her anger, alcoholism, sharp tongue and general orneriness . . . she was rich and well connected. . . . Mitchell grew up in comfortable circumstances, honed her competitive instincts in sports, winning junior championships in tennis and figure skating, and lived in a home where people on the order of Thornton Wilder (who read poems to her and her sister), Dylan Thomas, and T. S. Eliot came to visit. . . . Although as an adult she lived modestly, having money meant avoiding certain time and energy-draining compromises. . . . Mitchell never had to work at a job, could travel when she wished, was able to live in France and still keep a place in New York, could afford good quality art supplies and did not have to be financially dependent on a man. . . . That she was one of the few who was able to keep gestural Abstract Expressionism vital through the early '90s, deepening and expanding it, is a testament both to her ability as an artist and to the ongoing challenges offered by that particular approach to painting.[42]

The Whitney Museum mounted two major retrospectives of Mitchell's paintings, the first in 1974 and the latter in 2002. Curator Marcia Tucker in the 1974 exhibition catalog offered this summary comment about the paintings: "What is expressed by her work—which is private, vulnerable, full of the energy of madness and genius, elegance and unparalleled physical intensity—are those primal forces found in the natural world which provide us with the metaphors for our own existence."[43]

Jane Livingston curated the 2002 show and wrote a comprehensive essay on Mitchell's life, career in painting, and a developmental account of the stylistic changes in her work from beginning to end. Livingston's biography of Mitchell is more thorough and with more anecdotes than Kalina's: The two accounts are mutually reinforcing and in agreement. Earlier, Livingston had worked with the artist when she organized and installed a group show in which she included Mitchell's work, and writes, "frankly, she frightened me":

Joan herself made a series of indelible impressions during her week in Washington—on me, on my staff, on the museum trustees and collectors who entertained her, and on the members of her entourage. That occasion provided an extraordinarily rich crop of gossipy encounters, outright insults, and clever comebacks that would become oft-repeated art world anecdotes. Some of them haunt me to this day. Mitchell was incorrigibly outspoken, unpredictable in her responses to virtually everyone and everything she saw on museum walls or in private collections, and truly unstoppable in her behavior.[44]

Livingston also provides considerable information about Mitchell's associations with artists, friends, lovers, and even Mitchell's psychiatrist.

Livingston offers many detailed analyses of different paintings by Mitchell:

From now on, each large painting would be composed with the utmost sense of either windowlike space—i.e., a scene experienced as if glimpsed in a more distant planet, a vast, enveloping, highly evolved "landscape space." And, always, clearly marked signs oriented the pictorial field from top to bottom and side to side.

Within these invented, highly disciplined spatial structures, Mitchell allowed color to become the main subject of many of her paintings, using chromatic juxtapositions in ways new not only to her but also to painting itself.[45]

There seems to be a marked contrast between the biographical information that Livingston provides and the critical commentary that she offers about the paintings: Livingston provides no connection between the sets of information. The biographical data, some of it gossipy, are about Mitchell the moody and volatile Expressionist; the critical analysis is about Mitchell the Formalist. That is, Livingston, throughout her essay, generally ignores emotions in her analysis of the painter's work and instead attends to Mitchell's stylistic changes throughout her career, as in the previously quoted passage.

In contrast, in the same catalog, Linda Nochlin, a well-known historian and early feminist writer (for example, "Why Have There Been No Great Women Artists?"[46]), includes biographical anecdotes but uses them directly to address emotional expression in Mitchell's paintings. Nochlin writes:

> For Mitchell, rage, or anger, was singular, consuming. When I was with her, I could often feel rage, scarcely contained, bubbling beneath the surface of her tensely controlled behavior. Sometimes it would burst forth, finding as its object a young curator, an old friend. It was icy, cutting, and left scars. Once, when I was staying the night at her house in the country, she had an acrimonious fight with a former painter. It was terrifying; I have never seen or heard a man and a woman so angry at each other, and it went on and on, mounting in its passion, with physical violence always lurking in the background, though it never actually came to blows.[47]

Nochlin adds, "Yet it would seem to me that rage, and its artistic corollary, the rage to paint, are both central to the project of Joan Mitchell."

Nochlin chooses to write about a series of lithographs of Mitchell's to try to demonstrate that Mitchell creates meaning and emotional intensity in how she structures her pictures "by a whole series of oppositions: dense versus transparent strokes; gridded structure versus more chaotic, ad hoc construction; weight on the bottom of the canvas versus weight at the top; light versus dark; choppy versus continuous brush strokes; harmonious and clashing juxtapositions of hue—all are potent signs of meaning and feeling."[48] Thus in her critical reflections of the artist's works, Nochlin attempts to bring together biography, emotion, and form.

In the 2002 Whitney catalog, Yvette Lee, a curator at the Whitney, wrote an essay about a monumental suite of twenty-one paintings that Mitchell painted between autumn 1983 and autumn 1984—the "La Grand Vallée" paintings. Lee sees "La Grand Vallée" as an intentionally unified group of images related in spirit, palette, and stylistic traits and the best integrated body of work in the artist's career.

The curator thinks of the twenty-one works as "an idyllic vision of the joy and innocence of youth, suggesting childhood's fleeting intimations of eternal paradise."[49] Mitchell's inspiration for the paintings came from a story told to her by her good friend Gisèle Barreau, a musician and composer. When she was eight years old, Gisèle found a beautiful hidden valley eight miles from her home in Brittany, France. The

place was known only to local residents, and her grandmother told her where to find it. Gisèle told Mitchell of the valley and her childhood experiences of it. Mitchell painted the valley from mental images given to her by her friend: "In 1984, when I painted the Grande Vallée series, I was completely taken by the visual image. I never saw this place called the Grande Vallée, but I could imagine it." Lee interprets the series as representing "complete freedom from facades and boundaries" and as a series in harmony with nature, which Mitchell may have seen as "a refuge from mortality."[50]

Lee offers the following descriptive interpretation of the first of the "Grand Vallée" paintings (Color Plate 9):

> A number of the Grande Vallée canvases appear to represent vast fields of flowers painted on a tipped vertical plane with little illusion of three-dimensional space. Particularly in this cycle of paintings, Mitchell almost completely abandoned the figure-ground relationship, filling the entire surface of the picture with short, lambent brush strokes, which in *La Grande Vallée 0* produce the effect of luminous yellow, orange, and pink petals that flutter and sway in the cool summer breeze. The sun drenches the wild field in a bleaching light, shifting the green grass to an almost teal hue. Despite scattered patches of black, Mitchell's lyrical blue imbues the painting with a radiating luminosity, serving to harmonize this euphoric picture.[51]

Lee makes it clear that Mitchell did not paint likenesses of landscapes, nor did she attempt to represent nature; rather, she strove to put into paint the emotion that a landscape inspired. Lee quotes the philosopher Yves Michaud, who noted that for Mitchell, "The landscape is nothing more than a meditation on evoked feeling, a metaphor of existential experience. This is complex, for here enter notions of nature, colors, and visual mass, not to mention the tone of days, the suggestion of death, the emotional domain of the painter. For Joan Mitchell, places are more than places: they are filled with people, beings, memories of them."[52]

Mitchell's Thoughts about Her Own Work

Mitchell offered connections between her art and her life. She was very aware of her precedents in the history of art, both historical and immediate. As a young artist she was thrilled to seek out and meet her immediate and famous predecessors. When she returned to New York after an early stay in France, Mitchell sought to meet artists of the stature of Willem de Kooning, Yves Kline, and Philip Guston. She became part of the legendary New York artists' group that hung out at the Cedar Street Tavern in Greenwich Village and was one of the very few women invited to be a member of the Artists' Club, with an annual membership fee, she recalls, of $35. The club held group discussions every Wednesday evening.[53] Mitchell, however, was not overly taken by opinions of others and held to her own beliefs. She recalled "everybody . . . when you were going 'modern,' looked to Picasso. I mean everybody. But I avoided that like the plague. I loved Picasso, but it just wasn't for me."

In 1964, about a group of paintings she made between 1960 and 1962, Mitchell asserted: "These are very violent and angry paintings" (3.4); she claimed she was "trying to get out of a violent phase and into something else." The "something else" was a

series of somber paintings made in 1964. About these, Nochlin writes: "In their thick, clotted paint application and somber pigmentation they constitute a break from the intensely colored, energetic, allover style of her earlier production. They also seem to mark an end to the self-styled 'violent' phase of Mitchell's work and a transition to a different sort of expressive abstraction."[54]

Mitchell did not want to be thought of as a "woman painter." Elaine de Kooning tells a story from 1971 that Nochlin repeats: "I was talking to Joan Mitchell at a party ten years ago when a man came up to us and said, 'What do you women artists think . . .' Joan grabbed my arm and said, 'Elaine, let's get the hell out of here.'" Nochlin writes that if Mitchell "did not want to be categorized as a woman painter, it was because she wanted to be a real painter. And, at that time, a real abstract painter was someone with balls and guts."[55]

Color is very important to Mitchell, and she associated her choices of color with her lived experiences (Color Plate 8):

> The permanence of certain colors: blue, yellow, orange, goes back to my childhood: I lived in Chicago and for me blue is the lake. Yellow comes from here [Vetheuil, France]; I used very little yellow in New York and Paris. It is rapeseed, sunflowers . . . one sees a lot of yellow in the country. Purple, too . . . it is abundant in the morning; the morning, especially very early, is violet . . . when I go out in the morning, it is violet. . . . At dawn and at dusk, depending on the atmosphere, there is a superb blue horizon . . . lasting for a minute or two.

She painted at night but would not rely on artificial light:

> I often paint during the night but I have nothing to do with night. I like the light. I prefer the daylight. I also work in the afternoon, I check what I have done the night before. Certain colors change enormously with electric light. Blue is one of them. Yellow is another. They all change, but some really change. I do a bit of guessing. The next day, I walk up to the studio at noon and I am excited but also afraid: is it what I thought it was in terms of color? A painting which works in electric light does not necessarily work in daylight. I love daylight.[56]

Her use of color was firmly based in compositional relationships. "What excites me when I'm painting is what one color does to another and what they do to each other in terms of space and interaction."[57]

Mitchell rarely allowed anyone to watch her work. The limit of the largeness of her canvases was determined by her ability to have them in her studio and to maneuver them by herself. She needed space to study her work from a distance. She criticized one-size brush paintings for their lack of variation. She often began painting in the afternoon, then resumed after dinner and worked through until dawn, with "intellectual and physical energy [that] are overwhelming," listening to Mozart, Stravinsky, Bach, opera, or jazz while she was painting: "Music, poems, landscape and dogs make me want to paint. . . . And painting is what allows me to survive."[58]

Although she called herself a landscape painter, she did not paint directly from nature. As early as 1957 she wrote, "I would rather leave Nature to itself. It is quite

beautiful enough as it is. I do not want to improve it. . . . I could certainly never mirror it. I would like more to paint what it leaves me with."[59]

Yvette Lee suggests that Mitchell's fear of death was a major reason for her to make art, and quotes the artist accordingly:

> I am afraid of death. Abandonment is death also. I mean: somebody leaves and other people also leave. I never say good-bye to people. Somebody comes for dinner and then leaves. I am very nervous. Because the leaving is the worst part. Often in my mind, they have already left before they have come. . . . I think any involvement of any kind is to forget not being alive. . . . Painting is one of those things. . . . Painting is the opposite of death, it permits one to survive, it also permits one to live. . . . I am certainly not aware of myself. Painting is a way of forgetting oneself.

Lee comments, "As strongly as Mitchell felt the presence of death, this very awareness seems to have compelled her to create paintings that express her engagement with life."[60]

Mitchell and Expressionism

Based on what she has said, on her work, and on how her work has generally been accepted in artworld discourse, Mitchell would seem content to have her paintings placed within an Expressionist theory of art. She did not want to improve or mirror nature, but rather to paint her emotional experiences and memories of it (3.3). She did not view her paintings to be about themselves, nor even about her own life, but about metaphors for our own existence. She did not mind that viewers interpreted her paintings differently than she did: "Other people don't have to see what I do in my work."[61]

The value of making art, for Mitchell, was that it kept her alive. Indeed, during 1992, when she was diagnosed with advanced lung cancer, she flew from Paris to New York to see a Matisse exhibition at the Modern and also to finish a series of prints she was doing for Tyler Graphics. She then returned to France, where she died in a hospital, with visitors at her bedside who daily brought her wine. One could surmise that she hoped that viewers, when seeing her work, would somehow be moved to stay alive themselves.

Many commentators on her paintings reveal aspects of Mitchell's life, particularly her "anger" and penchant for being socially unpleasant. That Mitchell was or may have been socially difficult hangs as gossip, disconnected from meaning in her paintings, unless one is to infer that she was generally emotionally wrought in ways that influenced her artmaking. Livingston notes that what the artist may have felt and what the artist actually painted may be very different: Although Mitchell talked of her upheaval, discomfort, and anger in her life at the time she painted *Grandes Carrières* (3.4), Livingston characterizes the painting as an "opulent, irresistibly delicious canvas."[62]

Of the commentators cited in this chapter, Nochlin seems best able to connect Mitchell's emotions to her paintings. Nochlin raises philosophical questions about how the aesthetic theory of Expressionism is to work: "What do we mean when we say that violence, rage, or anger—indeed, any human emotion—are inscribed in a work of art?

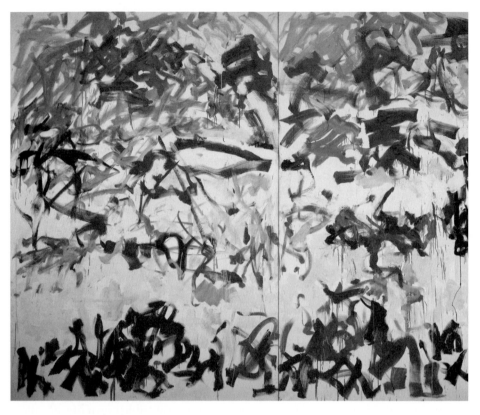

3.3 Joan Mitchell | *River,* **1989.**
Oil on canvas, 110 1/4 x 157 1/2 inches (diptych). The Joan Mitchell Foundation. © The Estate of Joan Mitchell.

How do such emotions get into the work? How are they to be interpreted?"[63] Nochlin's best (but incomplete) answer is that Mitchell turned her rage about life into a positive rage to paint.

Most commentators accept the Expressivist grounds on which Mitchell's work seems to rest. Most, however, also bring Formalist criteria to bear on their judgments of her painting: As Nochlin comments, "Without Mitchell's unerring sense of formal rectitude, however, without her daring and her discipline as a maker of marks and images, her work would be without interest."[64] Livingston generally avoids Expressivist analyses of Mitchell's paintings and instead concentrates almost exclusively on the formal properties of the paintings, for example, Mitchell's use of color, line, structure, and tensions between making paintings that were composed "allover" (as in Pollock's drip paintings) or more like a "figure-ground" relationship (as in de Kooning's paintings).

Regarding her audience, Mitchell wanted to be taken seriously as a painter (and not as a "woman painter"). She had standards for her work, however vague they may sound: She said she liked *George* but that it lacks "accuracy in intensity."[65] She destroyed works with which she was dissatisfied and left us with those which she thought successful.

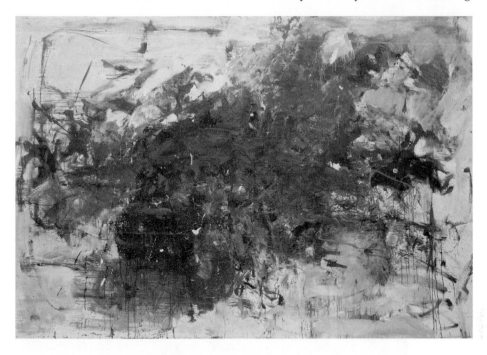

3.4 Joan Mitchell | *Grandes Carrières*, **1961–1962.**
Oil on canvas, 78 3/4 × 118 1/2 inches. The Museum of Modern Art, New York. Gift of the Estate of Joan Mitchell.
© The Estate of Joan Mitchell.

Louise Bourgeois, Sculptor

Louise Bourgeois (1911–2010; 3.5) is a greatly admired artist who enjoyed a long career, worked in many media, and made small and intimate works and large sculptures for museum exhibitions and for permanent public display. She derived her work from personal experience, often referring to her childhood and to her troublesome relationship with her father. Because her work is autobiographically based, critical commentary frequently is biographically based, and because of the psychological nature of her expressions in form, her work is also subject to psychoanalytic critical explorations. She often described her work as autobiographical and revealed aspects of her life, especially her childhood and adolescence, in interviews and essays. Her work is a major contribution to feminism, which is explored in Chapter 5.

Critical Commentary on Bourgeois's Sculptures

Bourgeois was born in Paris in 1911. Her parents ran a workshop restoring historical tapestries, and she learned to repair missing or damaged fragments. Often it was the lower portions of the tapestries that were worn away, so Bourgeois became adept at rendering feet; she also was skilled at sewing fig leaves onto genitalia of mythical figures who cavorted in classical scenes so that these tapestries would be more acceptable to collectors in the United States.

3.5 Robert Mapplethorpe | *Louise Bourgeois,* 1982.
Photograph. © The Robert Mapplethorpe Foundation. Courtesy Art + Commerce.

Most significant and troublesome to Bourgeois was her father's affair of ten years with her live-in tutor, Sadie, of which both she and her mother were painfully aware: "It was a family situation that I could not stand."[66] Robert Storr, a curator and long-time friend and biographer of the artist, writes this about her father:

[He], in addition to his constant flirtations with the women around him and the risqué jokes he told in front of his children to their intense embarrassment, also invited his English lover, Sadie, into the house as the children's tutor. Forced to ignore his obvious infidelity, obliged to be courteous to the intruder who was its cause, and called upon to play go-between for her mother who had acquiesced in the arrangement in order to keep her wandering husband from wandering off, Louise effectively lived a lie. . . . The legend of The Mistress, the emotional rival whom Louise hated, and of The Father, who was charming, unfaithful and casually cruel but whom she loved, is based upon this simple triangle, and the constellation of betrayals and falsehoods its maintenance required.[67]

When referring to a sculptural installation Bourgeois explicitly made about her father, *The Destruction of the Father* (3.6), the artist provided this interpretive narrative of the piece: "The children grabbed him [the father] and put him on the table. And he became the food. They took him apart, dismembered him. Ate him up. And so he was liquidated . . . the same way he liquidated his children. The sculpture represents both a table and a bed."[68]

Bourgeois interrupted her secondary studies to attend to her mother, who was stricken with complications from influenza and eventually died in 1932 while under her daughter's care. Thus, according to Storr, in addition to being an unwilling companion and confidante to her father when he frequented nightclubs after Sadie was finally removed from the scene, Bourgeois, the teenager, was also nurse to her mother. Years later, Bourgeois commented, "When you're sick, people don't like you; you're not

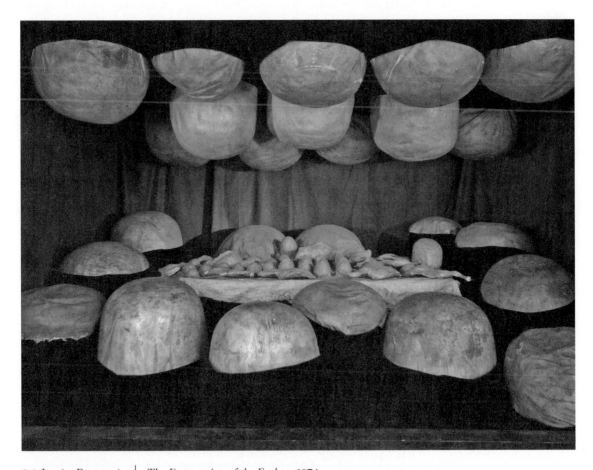

3.6 Louise Bourgeois | *The Destruction of the Father,* **1974.**
Latex, plaster, wood, fabric and red light, 93 5/8 x 142 5/8 x 97 7/8"; 237.8 x 362.2 x 248.6 cm.
Courtesy Cheim & Read and Hauser & Wirth.
Photo: Rafael Lobato/VAGA, NYC.

desirable. My mother was ill and used to cough up blood; I helped her to hide her illness from my father."[69] Storr comments,

> The excruciating inability to cope that Bourgeois felt when she herself eventually became a mother, and the crippling depressions that were triggered by her sense of inadequacy, are inextricably bound up in her sense of not measuring up to her own mother's stoic sovereignty, her guilt over having failed to prevent her from slipping away, and her anger at having been given a responsibility she could not shoulder.[70]

Bourgeois earned a degree in math from the Sorbonne, and at the age of twenty-four she began studying in art schools and left them in favor of working in the studios of Cubist painters Fernand Léger and André Lhote. Bourgeois married art historian Robert Goldwater and the couple moved to New York in 1938, where she continued to live and work. They adopted Michel in 1940 and birthed Jean-Louis that same year. Goldwater died in 1973.

Early on Bourgeois pursued painting and engraving, but she soon turned her mathematical knowledge toward sculpture and eventually mastered many sculpting techniques, including carving, modeling, assembling, and casting. Many of her pieces are life-size and larger. She uses a variety of materials, including wood, latex rubber, marble, and bronze, and incorporates found objects into her sculptures and installations. She is recognized as one of the great independent artists of the twentieth century, "a tremendously and hugely influential artist," who directly linked twenty-first-century art to Cubism, Symbolism, Surrealism, Abstract Expressionism, and all that followed."[71]

In 1966 art critic Lucy Lippard included Bourgeois's work in a show titled "Eccentric Abstraction," and this exposure brought the artist a larger audience. At about this time Bourgeois became involved with the feminist movement. In the 1980s she began carving marble. Her reputation was firmly established with the 1982 retrospective of her work at The Museum of Modern Art in New York City. She was seventy-one at the time, but her career was just beginning.

Female and male sex organs are recurring subject matter for Bourgeois. *La Fillette* (Little Girl), 1968, when hung by a wire "seems an object of hate, a castrated piece of meat." When she carries that sculpted penis in Robert Mapplethorpe's portrait of her (3.5), it seems "an object of love, a baby held by its mother." Hal Foster and his coauthors offer further psychoanalytic interpretation of *La Fillette* and her other works, which they generally interpret and refer to as "patricidal aggression":

> According to Freud, women might associate penis and baby in order to compensate the lack of the first with the gain of the second. But this "little girl" is no mere fetish or penis-substitute; she is a personage in her own right. In this way *La Fillette* is a bold gesture . . . a feminist appropriation of the symbolic phallus.[72]

In the mid- to late 1980s, through most of the 1990s, and into the first decade of 2000, Bourgeois devoted her artistic attention to "Cells" (3.8, Color Plate 10), a series of sculptural installations of metal cubes with transparent and opaque walls into which

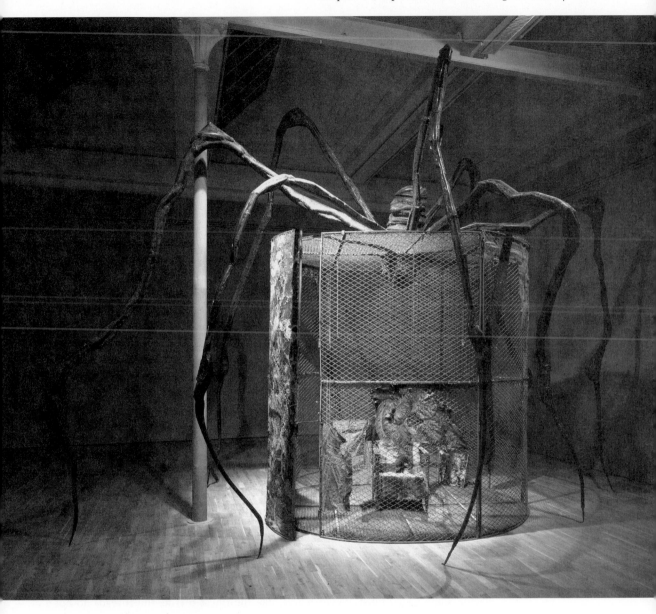

3.7 Louise Bourgeois | *Spider,* **1997.**
Steel, tapestry, wood, glass, fabric, rubber, silver, gold, and bone, 175 x 262 x 204 inches.
Collection of the artist. Photo: Attilio Maranzano. VAGA.

viewers could see but not enter (3.8). In 2003, when the artist was ninety-one, Storr referred to "Cells" as "the most complex development of Bourgeois's late work—and its crowning achievement to date."[73]

Storr offers this summarizing praise for the work of Bourgeois, paying tribute to her ability to weave her emotionally fraught life into "a piece," ultimately unified in

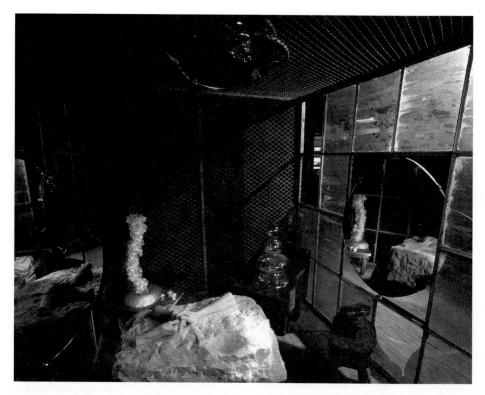

3.8 Louise Bourgeois | *Cell (You Better Grow Up),* **1993.**
Steel, glass, marble, ceramic and wood, 83 x 82 x 83 1/2 inches. The Rachofsky Collection.
Photo: Peter Bellamy. VAGA.

all of its diversity of materials in forms that are coherent in themselves and within a
life's work:

> In sum, the weave of her work—mimicking the flux of her mind and her emo-
> tions—holds seemingly incommensurable realities together like the elaborate
> designs of the Baroque tapestries she grew up refurbishing. At any moment the
> overall coherence of her art and the fabric of her explanations for how one thing
> is intrinsically connected to another may seem to be skewed by some unforeseen
> factor, some added twist. Nevertheless, like the finest textile, the threads do not
> pull apart, but rather absorb this added test of their strength. . . . The extraordi-
> nary nature of Bourgeois' work resides not only in the multiple and interchange-
> able ways of viewing the enigmas and contradictions of existence that it affords us,
> but in the fact that it, almost miraculously, is ultimately all of a piece.[74]

Allan Schwartzman offers these summary rhetorical questions in praise of
Bourgeois's work after his editors at the *New York Times* (an unspecified "number of
years ago") decided not to give him approval to write an article on her because they
were not sure of her importance. Their response stupefied the critic because he could
think of few artists more important than Bourgeois: "Not only is Bourgeois one of the

defining artists of our time, she is one of the great artists of the twentieth century." He considered her at the beginning of the twenty-first century to be at the height of her powers and reflects on why any curator or critic would doubt her contributions:

> What, I wonder, do those who refuse to acknowledge her importance reject or fail to see? Do the conceptually oriented resist her exquisite craft? Or are the traditionalists confounded by her fluidity of materials, her ability to allow the carved and the found, the sewn and the manufactured to cohabit? Does the trouble lie with the content of Bourgeois' art? Is it the work's psychological insight that worries them? Do they find off-putting the emotional exposure at the core of her work? Or is it the presence of her rage and how effectively she has honed it that scares them off? Perhaps it is the poetry with which all this anger has been visualized that confuses them.

In response to his rhetorical questions, Schwartzman personally finds it "comforting that such an intensity of emotion can be articulated so exquisitely."[75]

Schwartzman praises Bourgeois's work for its contribution to the expansion of the ideational content of art in the twentieth and twenty-first centuries, claiming that Bourgeois's investigation of herself in the 1940s and her frank examination of female sexuality begun in the 1960s "occupies a pivotal role in the development of modern art." This praise is twofold: first for her originality and second for her contribution to knowledge through art and within the artworld. The critic credits the artist with shifting from art that is simply about art itself (form only) to art that has content beyond itself—a shift that the critic sees as "the shift from Modernism to Postmodernism."[76] Postmodernism is explored in Chapter 5 of this book.

Schwartzman cites Bourgeois's contribution to feminist art and its role in transforming the male-dominated Modernist canon. Feminist artists, and Bourgeois prominently among them, brought to recent art history "autobiography, the small-scale, soft materials, narrative, ambiguity, otherness—so much that has become essential to the fabric of art today." He acknowledges that Bourgeois and her investigation of the self, which dates back to the 1940s, and her frank examination of female sexuality "occupy a pivotal role in the development of modern art."[77]

Furthermore, and perhaps most importantly for Schwartzman, Bourgeois's work "makes a shift in focus from form to content (the examination of the place and identity of the individual). This shift—from an art that is simply about art to an art concentrating on something beyond this." He credits Bourgeois "for taking art out of the frame and placing the self front and center, for making the exploration of issues of identity the purpose of art."[78]

Eleanor Heartney, an art critic writing in *Art in America*,[79] is less enthusiastic than Storr and Schwartzman are about at least one of Bourgeois's works in her "Cell" series (Color Plate 10). Heartney describes two cells, *Red Room (Child)* and *Red Room (Parents)*, from 1994, one dedicated to parents (likely Bourgeois's) and the other to a child (likely Bourgeois). To see the parents' room visitors pass through a narrow curving passageway to come upon an open interior. The child's room includes a similar curved pathway, but access to the room is denied; viewers can peer at the room through a window.

Heartney identifies "voyeurism" as the work's theme, with two violations of privacy: "the first by the artist child who secretly crept into the parents' private bedroom, the other by the viewer who followed the child, first into the parents' room and then into the hidden chamber of the artist child's memories." The memories were dark and the rooms were "suffused with red, carrying connotations of blood, sin, wanton sexuality and violence." Heartney sees the rooms as promising "a thrill of transgression" and "hinting at a narrative" of Bourgeois's "trauma-filled, sexually bewildering childhood." The critic identifies the many symbolic objects that fill the rooms, such as a large bed with red pillows and coverlet in the parents' room with an oval mirror at its foot. She interprets these elements to signify "revelation and concealment" and to reinforce the theme of voyeurism. The child's room is more crowded: "shelves and pedestals containing red wax hands, spools of red and blue thread, red candles, gloves, kerosene lamps, red coiled glass sculptures, as well as two closed briefcases." The critic interprets these as referring to "flesh, the creative process, light and life."

Ultimately, Heartney finds the piece less than successful because the narrative only teases us with the "possibility of joining the artist in her psychic return to childhood." The sculpture's "ultimate signification remains obscure . . . locked in the artist's mind." Heartney is particularly frustrated by the work because it aroused her attention with its hints of autobiographical revelations and implied promises of entering a rich psychic life.

Bourgeois's Thoughts about Her Own Work

Bourgeois considered herself an Expressionist artist. In 1988 in an interview with philosopher and critic Donald Kuspit, she passionately iterated that art is a privilege, a unique favor given to the artist, a gift of access to the unconscious, and also an ability to sublimate through art the painful aspects of what one finds there:

Art is a privilege, a blessing, a relief. Privilege means that you are a favorite, that what you do is not completely to your credit, not completely due to you, but is a favor conferred upon you. Privilege entitles you when you deserve nothing. Privilege is something you have and others don't. Art was a privilege given to me, and I had to pursue it, even more than the privilege of having children.[80]

She drew upon her knowledge of psychoanalysis and said:

The privilege was the access to the unconscious. It is a fantastic privilege to have access to the unconscious. I had to be worthy of this privilege, and to exercise it. It was a privilege also to be able to sublimate. A lot of people cannot sublimate. They have no access to their unconscious. There is something very special in being able to sublimate your unconscious, and something very painful in the access to it. But there is no escape from it, and no escape from access once it is given to you, once you are favored with it, whether you want it or not. . . . To escape you have to have a place to go. You have to have the courage to face risk. You have to have independence. All these things are gifts. They are blessings. . . . Sublimation is a gift . . . The life of the artist is basically a denial of sex.[81]

When Bourgeois accessed her subconscious she discovered content that she had to express in form, but she also had to invent new ways to express it, since Modern art offered no fixed artistic solutions. What one expresses, according to Bourgeois, is oneself:

> What modern art means is that you have to keep finding new ways to express yourself, to express the problems, that there are no settled ways, no fixed approach. . . . It is about the hurt of not being able to express yourself properly, to express your intimate relations, your unconscious, to trust the world enough to express yourself directly in it. It is about trying to be sane in this situation, of being tentatively and temporarily sane by expressing yourself. . . . Some questions are too painful to answer. Some questions we are unwilling to ask. And some are impossible to answer.[82]

Bourgeois provided an example of her intense self-reflection: "Why my mother died and abandoned me would be clear if the question was perhaps a different one. If the question was replaced by why do I suffer so much from this loss, why am I so affected by this disappearance."[83]

Bourgeois developed as an artist during the height of Surrealism; was for a period of time associated with Andre Breton, known as the father of Surrealism; and is sometimes associated with Surrealism. She insists that she is not and was not a Surrealist. Storr asserts that there is a fundamental difference between Bourgeois's and the Surrealists' approaches to art: "Bourgeois had no use for the Surrealist cultivation of the dream as a means of access to the subconscious. In her sometimes clairvoyant, sometimes panicky wakefulness Bourgeois had direct access to the deepest levels of her well-stocked and often feverishly fertile imagination."[84] Her feminism also was resistant to Surrealists' sensibilities about women. As Storr states, "After all, the only real role for a woman within their movement was that of a muse to be worshipped either as a Sphinx, a seer, a seductress or an enchanted wild-child. Never was there a question of a woman being the creative or intellectual equal of men."[85] Nonetheless, despite Bourgeois's likely objection, Storr sees it as "undeniable fact" that aspects of the Surrealists' aesthetic rubbed off on Bourgeois, even though she rebelled against them.

Bourgeois declared that she was a feminist. Her feminism is historically early and seemed rooted in everyday experiences as a woman with men, rather than with feminist theories that would later emerge in the feminist movement. She said, "My feminism expresses itself in an intense interest in what women do." She related personal anecdotes about herself as a woman artist in the artworld as the wife of a prominent art historian:

> Because of the profession and personality of my husband, I lived among these people. It was interesting. And because I was French and kind of discreet, they tolerated me—with my accent I was a little strange, I was not competition—and I was cute, I guess. They took me seriously, on a certain level, but they refused to help me professionally. The trustees of the Museum of Modern Art were not interested in a young woman coming from Paris. They were not flattered by her attention.

They were not interested in her three children. I was definitely not socially needed then. They wanted male artists, and they wanted male artists who did not say that they were married. They wanted male artists who would come alone and be their charming guests. . . . It was a court. And the artist buffoons came to the court to entertain, to charm.[86]

When interviewing the artist, Paulo Herkenhoff said:

I can tell you the six key events in Louise's early life: the first is the introduction of Sadie, the children's governess, into the family and Sadie's ten-year relationship with Louise's father while living in the house. The second is the death of her mother in 1932. The third, her marriage to Robert Goldwater in 1938; the fourth, their moving to New York. And then there was the adoption of Michel in 1940 followed by the birth of Jean-Louis that same year.[87]

Bourgeois responded: "Yes; that is why I came to the United States. My father had love . . . all the time. It was a family situation that I could not stand. I come from a dysfunctional family." The subject turned to jealousy, "painful" jealousy and how Bourgeois comes to terms with jealousy, fear, and other threatening emotions, and defeats them: "You convert the menace, the fear, the anxiety, through the redemptive force of art. What is the color of fear? What is its heat? What is its value?" She said, "I carry my psychoanalysis within the work. Every day I work out all that bothers me. All my complaints." She asserted, "The only remedy against disorder is work. Work puts an order in disorder and control over chaos. I do, I undo, I redo. I am what I am doing. Art exhausts me."[88]

Bourgeois talked with some specificity about *Janus Fleuri*, from 1969 (3.9), and she also related anecdotes about the well-known photograph of her that Robert Mapplethorpe made (3.5). She believed that when she talked about her works, she made them dry and lifeless. When talking about *Janus Fleuri*, the artist admitted that in a sense she was talking around it—talking "shop talk," as she said—rather than revealing much of her intended meaning for the piece. The piece is made of bronze, but was first in the form of plaster. In relating this technical information, she admitted to distracting the viewer from thinking about meanings and the piece. "If I am asked what I want to express, then this makes more sense. At that point there is a mystery we can at least talk about, since for a lifetime I have wanted to say the same thing." She did not, however, reveal its mystery, but provided many hints for her intentions for its interpretation, and ultimately she admitted that it was, "perhaps," a self-portrait:

Janus Fleuri has the permanence of bronze, although it was conceived in plaster. It hangs. It is simple in outline but elusive and ambivalent in its references. Hanging from a single point at eye level it can both swing and turn, but slowly, because its centre of gravity is low. It is symmetrical, like the human body, and it has the scale of those various parts of the body to which it may, perhaps, refer: a double facial mask, two breasts, two knees. Its hung position indicates passivity, but its low slung mass expresses resistance and duration. It is perhaps a self-portrait—one of many.[89]

3.9 Louise Bourgeois | *Janus Fleuri,* **1968.**
Bronze and gold patina, 10 1/8 x 12 1/2 x 8 3/8 inches.
Photo: Christopher Burke. VAGA.

Upon the occasion in 1982 that she was to be photographed by Robert Mapplethorpe (3.5), she thought of how she could put the photographer at ease. So, in her wit, especially in light of the fact that Mapplethorpe was infamous for his homosexual imagery, Bourgeois brought the prop of *La Fillette,* one of many sculptures of penises that she made in the late 1960s. In her recollections about the studio visit, the artist reveals insights into her sculpture and her attitudes toward men: "You have to feed them, tell them they are great, you literally have to take care of them." In referring to her holding of her penis sculpture for her portrait session with Mapplethorpe, she says, "You see the triple image of the man you have to take care of, of the child you have to take care of, and of the photographer you have to take care of."[90]

Bourgeois and Expressionism

Bourgeois worked during and through the apex of Modernist theory when many of her artistic and scholarly peers claimed that above all else, art was about other art. Bourgeois, however, declared: "Art is not about art. Art is about life, and this sums it up."[91]

Bourgeois presented herself as an Expressionist or, more accurately, used Expressionist language when talking about her work. She iterated strongly and clearly that she believed "art was a privilege given to me . . . the privilege was the access to the unconscious." As an artist, she believed she had special access to life: "Privilege is something you have and others don't . . . a lot of people have no access to their unconscious."[92] In a thought reminiscent of Collingwood's ideas about Expressionism, she said that such access, however, does not automatically allow the artist to translate her emotional knowledge into works of art: She must fashion what she knows or feels into visible form. "You convert the menace, the fear, the anxiety, through the redemptive force of art."[93]

Bourgeois's life's work also seems to fit comfortably into an Expressionist theory of art: It seems based on her deeply felt life experiences, which she is able to form into visual works of art that communicate emotionally to viewers. Schwartzman writes that it is "comforting that such an intensity of emotion can be articulated so exquisitely."[94] Schwartzman's brief comment implies three criteria: (1) an intensity of emotion (2) articulated (3) exquisitely.

Kiki Smith, Printmaker and Sculptor

Kiki Smith (1954–) became known as an artist in the 1980s primarily because of her sculptures, and she is still probably best known as a sculptor, although she has become equally fluent in printmaking and now considers printmaking an equally vital part of her work. As a sculptor she explores a range of materials, including clay, bronze, glass, plaster, and shaped paper. As a printmaker, Smith made her first screen print in 1980, has investigated traditional forms of printmaking such as etching and lithography, and has also innovatively explored nontraditional processes such as photocopies, rubber stamping, transfer tattoos, and printing on fabric and on large hand-made papers not usually used in printmaking. Making prints and sculptures has been a parallel exploration, sometimes moving thematically in different directions and sometimes coalescing.

Smith is the daughter of the well-known minimalist sculptor Tony Smith. She is largely self-taught as an artist but fondly recalls the importance of growing up and with her sisters participating in her father's artistic processes. She was born in Germany, grew up in New Jersey, and moved to New York City when she was twenty-one, where she has lived since.[95]

Critical Commentary on Smith's Work

During her early years as an artist in the late 1970s, Smith worked outside of the commercial gallery system with a cooperative artists' group that explored social issues in representational work, in inexpensive alternative spaces for showing art. They sold inexpensive multiple works of art and artist-made accessories. They made art that centered on community concerns and used representational styles that were more aesthetically accessible to a wider audience of viewers than was abstract minimalism, the reigning style of the time. Some of Smith's social concerns include her "awe at the vastness of the human population, her passionate belief in women's rights, and her concern over child abuse."[96]

In her earliest exhibitions, Smith's work addressed the human body, inside and out. She sculpted a series of paper sculptures that examined the body's skin in the late 1980s, and in the early 1990s she made life-size sculptures that depicted anonymous women in confrontational poses. She then turned her attention to nature: birds, animals, and the cosmos. In the late 1990s into the 2000s she has told stories about women based on religious figures and fairy tales, which she freely intermixes (3.10).

According to Wendy Weitman, curator of prints and illustrated books at the Museum of Modern Art, while working with "our primary means of experiencing the world"—the body—"Smith sought to unravel its functions, marvel at its mysteries,

3.10 Kiki Smith | *Trinity/Heaven and Earth,* **2000.**
Etching, 58 x 44 inches. Edition of twenty-nine. © Kiki Smith. Courtesy Pace/Prints, New York.

and acknowledge its place within the wider environment. Her depictions of our vital biological parts are shockingly honest, nonhierarchical, nearly clinical."[97] Smith focused on "the abject"—internal organs such as the pancreas and gall bladder; investigated skin as a boundary; and made full-scale figurative sculptures. She also made pieces about bodily fluids, saying, "You see how much of your life surrounds those liquids. Semen and saliva are social and political, and also extremely personal. Diarrhea is one of the largest killers of children."[98] In Weitman's view, Smith's use of the abject,

frail, fragmented body inside and out is her way of "learning about it, gaining control over it, and showcasing its importance."[99] Weitman credits Smith for making "a break from the long history of male artists' exploitation of women's bodies as tools of erotic aesthetic!"[100]

Following her intense concentration on the body, Smith turned to nature, making art about birds, for example, that alluded to the fragility of the natural environment and people's relation to it. She explored insects, and moths became sexual metaphors in her work, which she uses to reference female sexual anatomy and to symbolize fragility and metamorphosis.

Smith also attends to the influence of the heavens on humans, using the moon and constellations as important motifs. While a guest artist at Columbia University, she collaborated with a university astronomer, and they photographed the moon with Columbia's telescope on a night in January 1997. Later she and another faculty colleague, who had a specialized panoramic camera, went to Coney Island and photographed ocean waves. Smith combined the images of the moon and the waves to make *Tidal*, an artist's book with thirteen panels, accordion folded (3.11). Each of the thirteen pages, corresponding with thirteen full moons in a year, holds a photogravure of a full moon. Beneath the moons she attached a long sheet of paper with a continuous image of rolling ocean waves. *Tidal* plays with the dichotomy of the seeming stillness of the moon and the motion of the waves and refers to the opposing forces of the moon and the sea. According to Weitman, "The evocation of the monthly pull of the moon on the ocean's tides also suggests a woman's bodily cycle, highlighting Smith's theme of the interdependence between people and nature."[101]

More recently, Smith has been making narrative art about women through archetypal figures in religion and fairytales. Two major exhibitions and books of the same titles, *Telling Tales*[102] and *Books, Prints & Things*,[103] highlight this work. *Telling Tales* was first a one-person exhibition by Smith of three related multimedia environments: Little Red Riding Hood, Eve, and The Puppet. The published book is small and easily held in the hand, with the look and feel of a children's book. The exhibition consisted of flat work and some sculpture. It was large and was displayed in 2001 in midtown

3.11 Kiki Smith | *Tidal*, 1998.

Photogravure, photolithography, and silkscreen, 10 1/4 x 9 11/16 inches, image. Edition of thirty-nine.
© Kiki Smith. Courtesy Pace/Prints, New York.

Manhattan at the International Center of Photography in New York City. *Books, Prints & Things* was first a large exhibition at the Museum of Modern Art in New York City in the winter of 2003–2004. The museum owns fifty of Smith's print projects, books, and multiple-editioned sculptures. *Books, Prints & Things* was a comprehensive mid-career survey of Smith's work as a printmaker.

Both of the books, *Telling Tales* and *Books, Prints & Things*, were written as catalogs of the exhibitions, with essays written by scholars. Because the publications are catalogs of the exhibitions with commissioned essays, the authors and their essays can be presumed to have the approval of the living artist about whose work they were employed to write. Thus they are sources of interpretive information likely sanctioned by the artist.

Helaine Posner, an essayist in *Telling Tales*, writes an overview of the thematic content of Smith's narrative work:

> Since she began making art in the early 1980s, Kiki Smith has also been telling stories. The overall tale Smith has told takes the form of her own creation myth, an engagement and reshaping of the religious, literary, and art-historical narratives that have defined the way we understand our origins and being, with the body as her focus. Although her primary reference has been the Christian creation story, she has also borrowed freely from diverse cultural traditions to express her personal vision. In Smith's creation tale, humanity begins in an abject state: Adam and Eve have fallen from grace. Once expelled the Garden, they witness disease, death, and loss. The inevitable physical and psychological disintegration that follows is made manifest by Smith as isolated, fragmented, and damaged bodies or bodily parts. As her work has progressed, she has understood her mission to be nothing less than the healing of our fractured selves, and she has sought this renewal through remarkable depictions of such key Christian icons as the Virgin Mary and Mary Magdalene. Smith's goal in reinterpreting these tales is to restore humanity to a state of grace, envisioned as an ideal realm in which human beings, the animal world, and the landscape exist in harmony.[104]

Note Posner's use of "abject" in this statement in describing Smith's presentation of early humankind. It is akin to Julia Kristeva's usage of "the abject" as horrific.

Posner explains that Smith's journey culminates in a return to the Garden of Eden, the natural and miraculous setting of biblical stories, myths, and fairy tales. Posner thinks that Smith shows us her poetic visions through the eyes of a child. Symbols are rampant in Smith's stories: Eve and the serpent, fairy tale characters of Little Red Riding Hood and the wolf, and Sleeping Beauty, for example. These gardens of innocence are each disturbed by the heroine's curiosity and submission to temptations. In each story, according to Posner, "the heroine seeks more, and goes through a critical rite of passage or initiation to attain the experience and knowledge necessary for individual growth. The ensuing loss of innocence is often fraught with risks, represented in these tales as encounters with witches or with cunning or dangerous beasts." Posner sees Smith's underlying theme as fear engendered by quests of exploration and the painful vulnerability of childhood.[105]

Wendy Weitman also discusses Smith's uses and conflations of female biblical, mythological, and fairy tale figures when she examines Smith's sculpture *Eve* (3.12):

> In traditional interpretations, Eve, and by extension, all women, are considered weak, easily tempted and seduced, and the cause of pain, distress, and death due to Original Sin. Smith does not absolve Eve of blame but, like many contemporary feminists, sees her role as far more interesting and complex. By eating the apple at the snake's urging, Eve becomes the activator, the person who sets things in motion. After the Fall, we may be deprived of the eternal joy and serenity of the Garden, but we gain the very qualities that make us human. By committing the first act of transgression and partaking of the apple, Eve acquires knowledge of good and evil; in losing her innocence she has become capable of both moral judgment and spiritual growth. According to Smith, Eve marks the beginning of "ego consciousness" or the emergence of a more mature and integrated sense of self. She has become, in essence, an adult.[106]

According to Weitman, in Smith's art, Sleeping Beauty and Snow White both inhabit the gardens of innocence with Eve, and Sleeping Beauty and Snow White share the consequences of eating forbidden fruits.

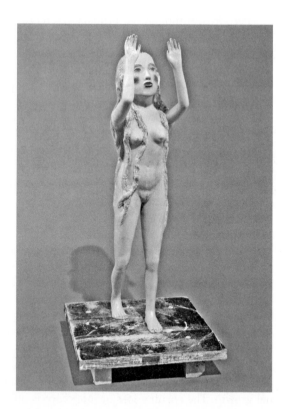

3.12 Kiki Smith | *Eve*, 2001.

Manzini (resin and marble dust) and graphite, 20 3/8 x 5 x 6 3/4 inches. Edition of three + two Aps.
Photo by: Gordon R. Christmas, courtesy PaceWildenstein, New York. © Kiki Smith. Courtesy PaceWildenstein, New York.

In her use of fairy tales, Smith has given most attention to Little Red Riding Hood. In her commentary on Little Red Riding Hood, Posner accepts Bruno Bettelheim's interpretation of the fairy tale in his book *The Uses of Enchantment: The Meaning and Importance of Fairy Tales*[107] as a parable that warns children to be dutiful and attentive and not to succumb to temptations. The story also addresses the transition to adolescence and its accompanying perils, especially the girl's fear of her own budding sexuality, symbolized by her red cape, which suggests her confused sexual feelings tinged with violence that she is too young to comprehend. After Red Riding Hood returns home safely, having survived her ordeal, she is thankful for her miraculous rebirth, her newly acquired wisdom, and her ability to better meet the challenges of life.[108]

Smith depicts Little Red Riding Hood and the wolf in many different ways, situations, and media. Some of her visualizations of the characters are traditional and innocent, and others are startling derivations from the original story. *Daughter*, for example, is a paper and cloth sculpture in which Smith depicts Red Riding Hood (Color Plate 11) as a young girl wearing the traditional red cape, but with the hair of a wolf on her face and head. Posner suggests that Smith shows that "the innocence of Red Riding Hood and the viciousness of the world are not as antithetical as we assumed. The artist shows us that even the gentlest creatures may possess a darker side and may quite suddenly manifest the aggressive, animalistic tendencies represented by the wolf."[109] Posner says that Smith imagined a scenario in which Little Red Riding Hood and the wolf, both outsiders, marry and give birth to *Daughter*: "Their improbable offspring becomes the embodiment of male, female, and animal characteristics, the unique progeny of disparate beings."[110]

Posner supports her interpretations with other pieces Smith has made. The artist depicts the wolf in bronze, life-sized, and realistic detail, as a noble creature of nature, and not as the anthropomorphized villainous creature of the fairy tale. In a series of paintings on a fifty-foot piece of glass, Smith depicted the wolf and Red Riding Hood as companions. About this representation, Posner says, "Smith envisions this energetic pair as colleagues in an effort to protect their fragile domain, whether it be understood to be the enchanted garden, or in contemporary terms, our fragile environment."[111]

Wendy Weitman's reading of Smith's treatment of Little Red Riding Hood is in alignment with Posner's. Weitman interprets Smith's pervading theme as

> the poignant vulnerability of childhood: as she reworks and reinvents the stories she accentuates the tension between childhood innocence and sexual awakening, between youth and budding maturity. In many images her interest in nature leads her toward dynamic moments between the girls and their animal protagonists.[112]

Weitman acknowledges Smith's use of feminist readings of the Red Riding Hood fairy tale as a story of male domination and female submissiveness and rape: "Smith plays on all of these allusions as she shifts and reorients her narratives of a young girl's journey."[113]

Weitman updates Posner's reading of Smith's Red Riding Hood by introducing more recent and more blatant sexual connotations in etchings of women and animals, specifically one of Red Riding Hood and the wolf (3.13):

> Smith removes any narrative context by placing the figures in the center of a blank background, leaving the viewer to fill in the gaps. The works seem to be images of violence, but their titles—*Rapture, In a Field*—belie any sense of attack and suggest sexual interpretations and a sense of the woman's complicity. The contrasts and ambivalences underlying Smith's complex works based on fairy tales blend a remarkable sense of wonder and innocence with a telling knowledge, as if childhood were being not witnessed but remembered and seen through the prism of experience.[114]

Smith has made many other images about girls, their animal protagonists, and her concerns for the natural environment. For example, Smith made *Pool of Tears 2* (Color Plate 12) based on Lewis Carroll's description of Alice in Wonderland swimming in a pool of her own tears, and he surrounds Alice with animals and birds who have fallen into the pool. By print standards, the image is huge, over six and a half feet wide. The print's size and Smith's use of scale are vital aspects of its expression: The print engulfs the viewer, the animals dwarf Alice and may be chasing her, she looks frightened, the water appears gray and cold, and the sky is cloudy. Weitman tells us that Smith has

3.13 Kiki Smith | *In a Field,* **2002.**

Soft and hardground etching with aquatint, 24 3/4 x 33 inches. Edition of thirteen. © Kiki Smith.
Courtesy Pace/Prints, New York.

frequently used tears in her works since 1990. Weitman says that in the print, Smith is expressing her concern for the damage that people have inflicted on the environment and the animal world; she quotes the artist: "If it's the humans who are at fault, it's the animals who start falling by the wayside because of the human situation."[115]

Weitman offers high summary praise for Smith's work: "No artist, male or female, has ever treated the female form with such honesty or vulnerability."[116] The curator goes on to explain with an air of praise the feminine contexts of Smith's work:

> From her early growing up as, in her phrase, a "girl-child" to her later years of maneuvering through the professional art world as a female artist, Smith has strongly identified with her gender. While rarely presenting any polemical agenda, much of her work revolves around feminine forms and contents and could only have been made by a woman. Smith attempts to express universal concerns from a female perspective. In the course of this career-long endeavor she has turned to a large cast of characters from the domains of literature, myth, history, and religion, ranging from Egyptian goddesses and classical Greek nymphs through biblical figures to the heroines of fairy tales. Smith does not just co-opt these personas to convey her own meanings, she reinterprets their stories and reputations from a female point of view.[117]

Weitman concludes: "Kiki Smith is among the most significant American artists of her generation."[118]

Weitman's criteria for her positive judgments of Smith's work in these statements are based in Expressionist theory, especially the cognitive aspects of Expressionism. In the curator's view, Smith's art has contributed uniquely new ways to view women and offers new interpretations to familiar accounts of women throughout the ages. Weitman also credits Smith with knowing when to move on from the body as exclusive subject to other realms: "As increasing numbers of artists in the 1990s began addressing themes of the body, Smith moved on to concerns outside it, turning her attention to images from nature—birds, animals, and the cosmos. Her renderings of birds allude to subjects ranging from the fragility of the environment to the realm of the Holy Spirit."[119]

Art writer Mara Witzling also offers high praise, based on cognitive grounds, for Smith's depictions of women's bodies: "Because of her emphasis on the permeable human body, Smith's work is at the forefront of late-twentieth-century discourse concerning the body in its cultural context, and the revision of an art historical tradition that has positioned women as the object of a dominating gaze." She goes on to write,

> Smith's images defy and transgress the Renaissance ideal of the active, heroic, virile male body, and the contained, passively pleasing female body, in their stress on pain, impermanence, and permeability. Rather than hiding or tidying that which is not pretty, in piece after piece Smith emphasizes the tangibility of the open, protruding, extended, secreting body and the matter that is secreted from its orifices. Smith believes that our bodies are "basically stolen from us, and [her art is] about trying to reclaim one's own turf, or one's own vehicle of being here to own it and use it to look at how we are here."[120]

Commentators also praise Smith on grounds of originality, as well as expressiveness. Weitman praises the way Smith's work on paper has expanded the scope of printmaking: "From editioned giveaways to unique screen prints to collaged assemblages of lithographs, Kiki Smith has expanded the scope of printed art."[121] Smith has done this by being "innovative, indeed utterly unconventional," in the medium of printmaking. Weitman's praise of Smith's innovativeness is closely linked with Smith's combination of medium and meaning: "Printed art forms and their inherent characteristics, including transference, repetition, and public accessibility, resonate conceptually with themes important to Smith."[122] Glenn Lowry, director of the Museum of Modern Art, also praises Smith's originality: "Kiki Smith has emerged as one of the most innovative and distinctive voices in American art of the last twenty years."[123]

In a review of Smith's exhibition, "Sojourn," at the Brooklyn Museum of Art, Karen Rosenberg, critic for the *New York Times*, asserts that Smith's work is "powerfully visceral." However, she cautions that viewers unfamiliar with Smith's earlier art about the body and its fluids "might think that she is merely a maker of pretty, shiny objects." In "Sojourn," Rosenberg thinks Smith sugarcoats death with craft (Color Plate 13): "papier-mâché, antique glass, gold and silver leaf and glitter everywhere."[124] Rosenberg offers us a reservation about judging all of an artist's work by considering only some of it.

Smith's Thoughts about Her Own Work

Smith acknowledges her Catholic upbringing as an influence on her concerns with the body as a theme for her artmaking:

> Catholicism has these ideas of the host, of eating the body, drinking the body, ingesting a soul or spirit; and then of the reliquary, like a chop shop of bodies. Catholicism is always involved in physical manifestations of spiritual conditions, always taking inanimate objects and attributing meaning to them. In that way it's compatible with art.[125]

Smith forcefully states, "To me the most essential thing is your spiritual life."[126] When she worked with the body as subject, in the words of Weitman, Smith "sought to unravel its functions, marvel at its mysteries, and acknowledge its place within the wider environment."[127] Her mentors include Louise Bourgeois.

When Smith turned to the animal kingdom for subject matter, she began making bird sculptures in 1992. She had always been fascinated by birds and once had over thirty of them in her bedroom. She sometimes uses birds to represent the Holy Spirit and generally uses them in her work as expressions of souls: "I dream about birds. . . . A few years ago I started to notice all these images from around the world of bird-humans—how birds become stand-ins for souls, that our identity is deeply, sometimes tragically connected with the natural world."[128]

Smith views herself as a populist artist, and she wants her art to be accessible to the many rather than the few. She says that her art is influenced by Peter Schumann's Bread and Puppet Theater, whose work she saw when she was a young girl. Bread and

3.14 Kiki Smith │ *Free Fall,* **1994.**

Photogravure, etching, and sanding on handmade Japanese paper, folded and mounted into cardboard folder, 1 x 9 1/8 x 5 3/4 inches, closed; 33 x 41 1/4 inches, open (print) edition of forty with five APs and two PP. Photo by: Sarah Harper, courtesy PaceWildenstein, New York. © Kiki Smith, courtesy PaceWildenstein, New York.

Puppet Theater is a socially motivated theatric group that has performed in the streets since the 1960s and 1970s. The group often performs with puppets larger than life with very expressionistic forms and faces. Smith often refers to the influence of Bread and Puppet Theater, especially "its collaborative methods, social messages, and crude large-edition woodcuts—and as a teenager she collected its prints and books."[129] Smith says, "The group of artists that I come out of are populist artists . . . it seemed important to make things accessible and to demystify." Her choice of printmaking (3.14) as one of her media is based partly in the historical uses of the print that were common and everyday and a means to disseminate information to people in an affordable way: "I like the fact that people are empowered through printmaking."[130]

Smith and Cognitivism

Commentaries on Smith include little if any biographical information, whereas the work of the other two Expressionists examined in the chapter, Mitchell and Bourgeois, almost invariably include biographical information. Perhaps this is so because Smith's

works do not directly refer to her specific personal history, although they certainly pertain to her life as a woman. Her works are more about women than about an incident in Smith's life as a child (as for Louise Bourgeois) or her emotional experiences in front of a landscape (as for Joan Mitchell). Thus Smith's work lends itself more aptly to Cognitivism than to Expressionism.

Although her work arouses emotions in viewers, it also expands their knowledge by giving them new and unique ways to look at the body, at women, and at the animal world. She makes new connections among disparate traditional representations of women, cross-referencing the religious Madonna with women in secular mythology and women and girls in fairy tales. Smith makes these connections with sincerity and not with cynicism or skepticism. She expresses an interest in expanding viewers' notions of women, bodies, life and their participation in it, and their relationship to the natural environment.

As an Expressionist, Smith is very concerned with her audience, and she wants her work to be accessible to a range of people. This is one reason she makes prints—they are multiples, unlike paintings, for example, which are one of a kind. The economic implications are that more people can afford to have a Smith multiple than if she only made unique objects.

Concomitantly, because of what she calls her "populist" beliefs, Smith makes representational images rather than abstract work: bodies and their parts, stars and the moon, saints, mythological and fairy tale women, animals. She says, "If you make things, especially bodies or faces, [viewers] don't have to know anything special about them. Everybody has equal experience with them, very different, but equal experience." She does not want her work to be overly referential to other art because then, to fully appreciate her work, viewers would need historical knowledge of art. She says her art "just comes out of life, my life."[131]

Smith's Expressionist concerns for her audience also influence her choices of subject matter: For example, she does not make a specific, identifiable person, as in a portrait. Rather, she makes images that are more general to allow more viewers to identify with the subjects she depicts. Regarding her depictions of bodies and faces, she says, "I thought if you made it specific, people could say, 'Oh, that's happening to that particular person, but it couldn't happen to me.' I wanted the work to be more general as a whole so that you could see that you could possibly be in that situation."[132]

The Problem of Artistic Intent

Perhaps more than other theoretical dispositions toward works of art, Expressionism invites thoughts about artistic intent: If we want to know what a Smith sculpture is about, why not simply ask her what she meant to show, reveal, or disclose? If we want to know what *Eve* is supposed to express, to communicate, or to make us feel, why not ask Smith what she had in mind when she made her sculpture of Eve? Questions about what role, if any, an artist's intent ought to play when interpreting meanings or judging merits of works of art arise with all works and within all theories of art.

Questions about the intent of the artist seem particularly to come into play, however, when dealing with Expressionist works. If one wants to know what an artwork expresses, or is meant to express, at first thought it seems sensible simply to ask the artist what he or she had in mind in making the work. Indeed, many of the critical commentaries on the works in this chapter are dependent, in part, on what the artists have told the critics. Biographical and anecdotal information about the artists is more complete in this chapter than it is for others in the book.

One can appeal to artistic intent as an interpretive strategy—as a means of making sense of the work—and as a strategy for judging the work's success, or both. Artists, for example, often think their art means what they meant it to mean; and they also judge the work successful if they accomplished what they intended to accomplish in making it.

Some theoreticians—E. D. Hirsch, for example—do hold that the ultimate arbiter of what a work means is what its maker meant it to mean.[133] Some critics—Roger Kimball, for example—argue that an artist's intent in making a work ought to severely constrain interpretations of that work.[134] This book honors the thoughts of the artists whose work is included by quoting them on their own views of their art and its meaning to them.

There are, however, problems with depending too heavily on the artist's intent in both interpreting and judging a work of art. Two aestheticians, Monroe Beardsley and William Wimsatt, famously referred to a reliance on artistic intent to interpret a work of art "the intentionalist fallacy."[135] Wimsatt and Beardsley identified problems of intent in a 1946 article about the interpretation of poems. The fallacy of the intentional fallacy is one of irrelevance: The work and the maker of the work are two separate entities; it is the job of the critic to make sense of the work itself, and investigations of the life and psychology and intentions of the maker are digressions. Further, meanings of words are public, not private; thus a poem is accessible to those who read the language in which the poem is written, and therefore appeals to the author's internal meanings are unnecessary and distracting from the poem itself.[136]

The concern with intentionality in criticism arose as an objection to too many critics writing biographical and psychological studies of poets, rather than directly attending to the poem themselves. "New Critics" in literature argued for distinctions between writing criticism and writing psychological biographies. For example, T. S. Eliot, a poet and literary critic, wrote in 1919, "honest criticism . . . is directed not upon the poet but upon the poetry."[137] Anti-intentionalist stances migrated to art criticism (and eventually to Formalist art theory, the topic of the following chapter).

Knowledge of artists and their expressed intents, when available, can be enlightening sources of contextual information. Although relying on the artist's intent to interpret what a work means seems appealing, there are sensible objections to an overreliance on intent for interpretation and judgment:

1. Artists are not always available or willing to comment on their works: Some artists are anonymous and deceased; some artists resist putting their works into words.

2. Artists may not always be aware of what they intend to express during and after making the work.
3. Artworks may mean more, less, or differently than their artists meant them to mean.
4. A reliance on intent for interpretation (or judgment) renders the viewer passive and dependent on the artist's views.
5. Too much attention to what artists say they intend may lead us to see what might not actually be in the work.[138]

When using intent to judge the merits of a work, more difficulties arise:

1. Because an artist fulfills his or her intent in making a work of art does not necessarily mean that the work should be judged a good work.
2. Artists may supersede their intents in making a work.
3. The intent itself may be judged to be trivial, although met by the artist.
4. Artists often start out intending to make one work but end up making a quite different work from the one they intended.

Viewers also bring their own intents to works of art, looking for ideas that they want to see. This can be a beneficial way of viewing art, to inspire oneself to look at many kinds of art for the ideas or inspirations one wishes to derive from art. However, Umberto Eco, for one, cautions against viewers who try to beat a work into a shape that suits the viewer's own purpose. Eco argues that artworks set limits on how they can be interpreted, and he asserts that artworks have rights. The limits and rights are determined by the work's "internal textual coherence," as well as knowledge of a work's historical and cultural influences.[139]

Limitations of Expressionism and Cognitivism

Among the limitations of Expressionist theory are the philosophical difficulties of clearly making sense of what it means to say that a work of art expresses. Marcia Eaton, for example, identifies six different philosophical explanations of the claim that "x expresses y" and finds problems with each of the explanations, especially when any one of the versions is applied to all works of art.[140] Her dissatisfactions with the simplest version—"x expresses y if and only if the artist was or felt y when producing x"—are many, one of which is that artists do not necessarily feel sad when painting a sad painting. Conversely, recall that Livingston noted that Mitchell made paintings of the Grand Vallée while the artist was feeling anguished over her life situation, yet her paintings of the Grand Vallée would be interpreted by many as gloriously joyful. If Mitchell felt sad when she made *La Grand Vallée O*, she did not seem to express her sadness in the painting. An artist does not have to actually feel an emotion to paint that emotion, and what an artist may be feeling when making a work might not be the same feeling being expressed in the work.

Among doubts about Expressivist theory, Gordon Graham raises these two. First, "Many celebrated artists have expressly denied that emotion lay at the heart of their

endeavors." Second, if for an Expressionist arousing emotion in an audience is of great value, should highly successful horror films be counted as great works of art, better than Shakespearean tragedy, for example?[141]

Problems of expressing ideas, and not just emotions, also arise in Expressionist theory. How, what kind, and with what specificity can a work of art express an idea or communicate knowledge? What kind of ideas can artworks express? How are they communicated to viewers?

Strengths of Expressionism and Cognitivism

Expressionism and its cognitive variations have much to offer us. It attempts to accomplish many things. It provides art with a central place in Western culture, especially in the nineteenth century, when science and technology had enhanced status. Expressionism theory asserts that art is beneficial for people. It places the artist in a socially important position. It relates art to the daily lives of people, through emotion, which is both important and understandable to everyone. Expressionism also accounts for the emotional quality of art and how it moves people. Whereas Imitation theory (Chapter 2) can account for some art, it does not adequately account for nonrepresentational art.

When Expressionist theory includes cognitive as well as emotional aspects of art, it becomes a very powerful theory that can account for many works of art, different kinds of art, and designed objects and performative events made outside of the Western tradition. Given tenets of Expressionist theory, we can and should ask of any artifact, Coke ad or Cubist portrait, native ritual dance or music video: What does this express? What view of the world does it show me? What does it awaken in me? What knowledge does it provide? What are its social consequences?

Conclusion

Expressionism, Cognitivism, and Artists

In Eaton's words, in the view of Expressionists, "artists are special on two counts: (a) they have strong feelings that they want to communicate, and (b) they are able to embody their feelings in publicly communicable ways. There is a rare combination in them of sensitive personality and technical skill."[142]

Whereas Realism privileges external reality, Expressionism and Cognitivism place the artist at the center of the world, positioning artists as unique among sentient beings and as special purveyors of knowledge not readily available to other inquirers. Thus these theories tend to inflate the importance of the individual rather than the communal, reinforce suspect notions of individual artistic genius, and overlook contributions of past and contemporaneous cultural influences on artmaking.

Expressionism also feeds notions of the artist as strange, outside the realm of social expectations, isolated in the attic of individual creativity, driven, and sometimes out of control. Almost implicit in the commentary on the work of Mitchell is an acceptance of her suggested dependence on alcohol and reported socially inappropriate behavior.

In the extreme, in popular conceptions, van Gogh is heralded for being the creative and tormented genius who was so troubled by his interiority so as to slice off his ear. Salvador Dali's eccentricities and bizarre manners are made to be positive spectacles of expression in media representations of the artist. Jackson Pollock is celebrated for drunkenly urinating in the fireplace of Peggy Guggenheim. Expressionist romantic mythology tends to applaud artists who live excessively and eccentrically, even when they are driven to suicide. Such behaviors are romanticized to be creative outpourings of uninhibitedly and uncontrollably sensitive creators.

Criteria for artists derived from Expressionist theory might include these sample iterations:

> Artists ought to feel deeply concerning what they make works about.
> Artists ought to be sincere in their artmaking.
> Artists should make work that communicates to viewers.

Additional criteria for artists derived from Cognitivist theory might include these sample iterations:

> Artists ought to respect their views of the world and present them in media.
> Artists ought to trust their insight and intuitions and base their work on them.

Expressionism, Cognitivism, and Artworks

Expressionism and Cognitivism hold artworks to be uniquely valuable: They open experiences to us we would otherwise miss; they present ways of knowing the world to which other means of knowing do not have access. Artworks are more than mere providers of aesthetic pleasure; they can change us and can increase our sensitivities to the feelings of others and feelings of our own. Artworks, when viewed Expressionistically, can unite individuals to others, can make differences of belief more understandable than strange, and can perhaps help us to be more willing to look at differences sympathetically rather than attempting to extinguish them as threatening.

Criteria for artworks derived from Expressionist and Cognitivist theories might include these sample iterations:

> Works of art should vividly communicate thoughts and feelings.
> Works of art should be sincere expressions of feelings and insights.
> Works of art ought to enliven the thoughts and emotions of their viewers.

Expressionism, Cognitivism, and Audiences

Expressionism and Cognitivism require that viewers be active while engaging with works of art. They cannot merely sit back and be bathed in aesthetic delight in the presence of a work of art. Artworks demand the audience's interpretive engagement. Viewers are inquiring partners of artists in creative and expressive activities. Without

responsive viewers, paint on a canvas, however wonderfully put there by whatever brilliant artist, is mere pigment on cloth.

Criteria for audiences derived from Expressionist and Cognitivist theories might include these sample iterations:

Viewers of a work of art should approach it sincerely and expect enlightenment in experiencing the work.

Viewers of art should make sincere efforts toward understanding what is expressed in a work of art.

Viewers of an artwork should consider ways to change their lives as a result of experiencing the work.

Questions for Further Reflection

When, if ever, is knowledge of an artist's intent in making a work of art valuable and relevant to interpreting or judging that work?

When, if ever, is biographical information of a psychological nature relevant when interpreting and judging a work of art?

What does it mean to say that x expresses y?

Is a "sentimental" work of art a good work of Expressivist art?

Can knowledge derived from works of art be trusted?

What is the relevance of Expressionist or Cognitivist aesthetics to a working artist?

What is the relevance of Expressionist or Cognitivist artworks to an aesthetician?

How might John Dewey and R. G. Collingwood (or any of the other philosophers in the chapter) interpret and judge the work of Louise Bourgeois, Kiki Smith, or Joan Mitchell?

Notes

1. Gordon Graham, "Expressivism: Croce and Collingwood," in *The Routledge Companion to Aesthetics*, ed. Berys Gault and Dominic McIver Lopes, New York: Routledge, 2001, p. 119.

2. In Marcia Eaton, *Basic Issues in Aesthetics*, Belmont, Calif.: Wadsworth, 1988, p. 23.

3. Berys Gault, "Art and Cognition," in *Contemporary Debates in Aesthetics and the Philosophy of Art*, ed. Matthew Kieran, Malden, Mass.: Blackwell, 2006, p. 116.

4. Berys Gault's list of supporters of aesthetic Cognitivism in recent years include himself, Dorothy Walsh, R. W. Beardsmore, Nelson Goodman, David Novitz, Martha Nussbaum, and Peter Kivy (1997); his list of anti-cognitivists include Jerome Stolnitz, T. J. Diffey, Peter Lamarque, and S. Olsen.

5. Ronald Hepburn, "Theories of Art," in *A Companion to Aesthetics*, ed. David Cooper, Malden, Mass.: Blackwell, 1995, p. 422.

6. Gault,"Art and Cognition," p. 116.

7. Cynthia Freeland, in Eileen John, "Art and Knowledge," in *The Routledge Companion to Aesthetics*, 2nd ed., New York: Routledge, 2001, p. 419.

8. John, "Art and Knowledge," p. 420.

9. Ibid., p. 426.

10. George Dickie, *Introduction to Aesthetics*, New York: Oxford, 1997, pp. 48–49.

11. Ibid., p. 50.

12. Eaton, *Basic Issues in Aesthetics*, p. 24.

13. Ibid., 22.

14. Ibid., pp. 68–69.

15. Benedetto Croce, "What Is Art?" in *Guide to Aesthetics*, New York: Bobbs-Merrill, 1965.

16. Colin Lyas, "Benedetto Croce," *Encyclopedia of Aesthetics*, New York: Oxford, 1998, pp. 474–476.

17. R. G. Collingwood, *Principles of Art*, Oxford, England: Clarendon Press, 1938.

18. Graham, "Expressivism," p. 124.

19. Ibid., p. 125.

20. Ibid.

21. Ibid.

22. Suzanne Langer, *Feeling and Form*, New York: Scribner's, 1953; *Problems of Art*, New York: Scribner's, 1957; *Mind: An Essay on Human Feeling*, 3 vols., Baltimore, Md.: Johns Hopkins University Press, 1967, 1972, 1982.

23. Thomas Alexander, "Suzanne Langer," in *A Companion to Aesthetics*, ed. David Cooper, Malden, Mass.: Blackwell, 1992, pp. 259–261.

24. Thomas Alexander, "John Dewey," in *A Companion to Aesthetics*, p. 121.

25. Ibid., p. 119.

26. Ibid., pp. 120–121.

27. Nelson Goodman, *Languages of Art*, Indianapolis: Hackett, 1968.

28. Nelson Goodman, *Ways of Worldmaking*, Indianapolis: Hackett, 1978.

29. Goodman, *Languages*, p. 6.

30. Ibid., p. 32.

31. Arthur Danto, *Beyond the Brillo Box: The Visual Arts in Post-Historical Perspective*, New York: Farrar, Straus, and Giroux, 1992, p. 9.

32. Ibid., p. 9.

33. Robert Stecker, "Definition of Art," in *The Oxford Handbook of Aesthetics*, ed. Jerrold Levinson, New York: Oxford University Press, 2003, p. 146.

34. Mark Johnson, "Metaphor: An Overview," *Encyclopedia of Aesthetics*, New York: Oxford, 1998, p. 209.

35. Jae Emerling, *Theory for Art History*, New York: Routledge, 2005, pp. 3–4.

36. Ibid., p. 5.

37. Ibid., p. 17.

38. Ibid., pp. 20–22.

39. Irving Sandler, "Mitchell Paints a Picture," *ARTnews*, October 1957, p. 45.

40. Ibid., p. 67.

41. Ibid., p. 69.

42. Richard Kalina, "Expressing the Abstract," *Art in America*, December 2002, pp. 91–92.

43. Marsha Tucker, *Joan Mitchell* (exhibition catalog), New York: Whitney Museum of American Art, 1974, p. 16.

44. Jane Livingston, *The Paintings of Joan Mitchell*, New York: Whitney Museum of American Art, 2002, p. 10.

45. Ibid., p. 31.

46. Linda Nochlin, "Why Have There Been No Great Women Artists?," first published in *ARTnews*, Vol. 69, No. 9, January 1971. Reprinted in Linda Nochlin, *Women, Art and Power and Other Essays*, New York: Harper & Row, 1988.

47. Linda Nochlin, "Joan Mitchell, a Rage to Paint," in Livingston, *The Paintings of Joan Mitchell*, p. 53.

48. Ibid., p. 57.

49. Yvette Y. Lee, "'Beyond Life and Death': Joan Mitchell's Grande Vallé Suite," in Livingston, *The Paintings of Joan Mitchell*, p. 62.

50. Ibid.

51. Ibid., p. 64.

52. Ibid., p. 63.

53. Livingston, *The Paintings of Joan Mitchell*, p. 20.

54. Nochlin, "Joan Mitchell," p. 49.

55. Ibid., pp. 50–51.

56. Livingston, *The Paintings of Joan Mitchell*, p. 33.

57. Lee, "'Beyond Life and Death,'" p. 68.

58. Tucker, *Joan Mitchell*, p. 7.

59. Ibid., p. 8.

60. Ibid., p. 63

61. Sandler, "Mitchell Paints a Picture," p. 70.

62. Livingston, *The Paintings of Joan Mitchell*, p. 25.

63. Nochlin, "Joan Mitchell," p. 49.

64. Ibid., p. 53.

65. Sandler, "Mitchell Paints a Picture," p. 70.

66. Paulo Herkenhoff, "In Conversation with Louise Bourgeois," in *Louise Bourgeois*, ed. Robert Storr and Paulo Herkenhoff, London: Phaidon Press, 2003, p. 9.

67. Robert Storr, "A Sketch for a Portrait: Louise Bourgeois," in *Louise Bourgeois*, ibid., p. 39.

68. Sasha Bergstrom-Katz, "In Focus: The Destruction of the Father 1974," *Artslant*, retrieved August 27, 2010, from http://www.artslant.com/la/articles/show/2711.

69. Bourgeois, *Louise Bourgeois*, p. 137.

70. Ibid., p. 42.

71. Adrian Searle, "Louise Bourgeois Dies in New York, Aged 98," Guardian.co.uk, retrieved August 27, 2010, from http://www.guardian.co.uk/artanddesign/2010/jun/01/louise-bourgeois-dies-new-york-98.

72. Hal Foster, Rosalind Krauss, Yve-Alain Bois, and Benjamin Buchloh, *Art Since 1900*, New York: Thames and Hudson, 2004, p. 501.

73. Storr, in *Louise Bourgeois*, p. 85.

74. Ibid., p. 93.

75. Allan Schwartzman, "Untitled," in *Louise Bourgeois*, p. 96.

76. Ibid., p. 96.

77. Ibid.

78. Ibid., p. 101.

79. Eleanor Heartney, "Louise Bourgeois at Peter Blum," *Art in America*, January 1995, p. 105.

80. Bourgeois, in Donald Kuspit, "From an Interview with Donald Kuspit," *Louise Bourgeois*, p. 123.

81. Ibid.

82. Ibid., p. 125.

83. Ibid., p. 132.

84. Storr, in Bourgeois, *Louise Bourgeois*, p. 42.

85. Ibid., pp. 41–42.

86. Bourgeois, *Louise Bourgeois*, p. 125.

87. Paulo Herkenhoff, "In Conversation with Louise Bourgeois," in *Louise Bourgeois,* p. 9.

88. Ibid., p. 9.

89. Bourgeois, *Louise Bourgeois,* p. 188, first published in *Art Now,* Vol. 1, No. 1, September 1969.

90. Ibid., p. 130, from a speech of the artist's on August 19, 1990, at the MacDowell Colony in Peterborough, New Hampshire.

91. Bourgeois, *Louise Bourgeois,* p. 125.

92. Kuspit, "From an Interview with Donald Kuspit," p. 123.

93. Ibid.

94. Schwartzman, "Untitled," p. 96.

95. Mara Witzling, "Kiki Smith," in *Contemporary Women Artists,* ed. Laurie Hillstrom and Kevin Hillstrom, Detroit: St. James Press, 1999, p. 626.

96. Ibid., p. 15.

97. Wendy Weitman, "Experiences with Printmaking: Kiki Smith Expands the Tradition," in Kiki Smith, *Books, Prints & Things,* New York: Museum of Modern Art, 2003, p. 16.

98. Smith, quoted in ibid., p. 18.

99. Weitman, "Experiences with Printmaking," p. 11.

100. Ibid.

101. Ibid., p. 34.

102. Helaine Posner, "Once Upon a Time . . .," in Kiki Smith, *Telling Tales,* New York: International Center of Photography, 2001, p. 5.

103. Smith, *Books, Prints & Things.*

104. Posner, "Once upon a Time . . .," p. 5.

105. Ibid., pp. 5–6.

106. Weitman, "Experiences with Printmaking," p. 15.

107. Bruno Bettelheim, *The Uses of Enchantment: The Meaning and Importance of Fairy Tales,* New York: Vintage Books, 1989, p. 35.

108. Posner, "Once upon a Time . . .," pp. 8–9.

109. Ibid., p. 9.

110. Ibid., p. 10.

111. Ibid., p. 12.

112. Weitman, "Experiences with Printmaking," p. 36.

113. Ibid., p. 36.

114. Ibid., p. 39.

115. Ibid., p. 36.

116. Ibid., p. 11.

117. Ibid., p. 34.

118. Ibid., p. 11.

119. Wendy Weitman, "Kiki Smith, Prints, Books & Things" (exhibition brochure), The Museum of Modern Art, December 5, 2003–March 8, 2004, n.p.

120. Mara Witzling, "Kiki Smith," in *Contemporary Women Artists,* pp. 626–627.

121. Weitman, "Experiences with Printmaking," p. 39.

122. Ibid., p. 12.

123. Glenn Lowry, in Smith, *Books, Prints & Things,* p. 7.

124. Karen Rosenberg, "On Being a Woman, From Cradle to Grave," *New York Times,* February 13, 2010, retrieved September 1, 2010, from http://www.nytimes.com/2010/02/13/arts/design/13sojourn.html.

125. Ibid., p. 16.

126. Posner, "Once upon a Time . . .," p. 5.

127. Weitman, "Experiences with Printmaking," p. 16.

128. Ibid., p 29.

129. Ibid., p. 16.

130. Ibid., p. 12.

131. Chuck Close, *The Portraits Speak: Chuck Close in Conversation with 27 of His Subjects*, New York: Art Press, 1997, p. 592.

132. Ibid., p. 595.

133. E. D. Hirsch, *The Validity of Interpretation*, New Haven, Conn.: Yale University Press, 1967.

134. Roger Kimball, *The Rape of the Masters*, San Francisco: Encounters, 2004.

135. Monroe Beardsley and William Wimsatt, "The Intentionalist Fallacy," in *On Literary Intention*, ed. Newton de Molina, Edinburgh: Edinburgh University Press, 1967.

136. Colin Lyas, "Intentional Fallacy," in *A Companion to Aesthetics*, pp. 230–231.

137. In Colin Lyas, "Intention," in *A Companion to Aesthetics*, p. 227.

138. Ibid.

139. Umberto Eco, ed., *Interpretation and Overinterpretation*, New York: Cambridge University Press, 1992, p. 95.

140. Eaton, *Basic Issues in Aesthetics*, pp. 24–29.

141. Graham, "Expressivism," pp. 122, 124.

142. Eaton, *Basic Issues in Aesthetics*, p. 21.

4.1 Joel Shapiro | *Untitled,* **2004.**

Wood, wire, and casein, 34 1/4 x 13 x 15 inches. Photograph by: Kerry Ryan McFate, courtesy PaceWildenstein, New York. © 2006 Joel Shapiro/Artists Rights Society (ARS), New York.

4 | Formalism

ART IS SIGNIFICANT FORM

Introduction

Anyone involved in the arts is interested in the form of a work, whether the thing being examined or made is a poem, a dance, or a painting. The term *form*, in art talk, refers to the perceptual elements of an artwork and how they are in relation to one another. Formalism, however, is a theory of art. Formalism is the belief that aesthetic values can stand alone and that judgments of art can be detached from other considerations, such as ethical or social ones. Formalists give sole importance to the purely compositional or abstract qualities of the work, paying exclusive attention to arrangements of visual elements such as line, shape, color, and so forth, regardless of their expressive content. Formalism is frequently identified with the slogan "Art for the sake of art."

Richard Anderson, a scholar of comparative aesthetics across time and cultures, points out the radical difference between Formalism and all other theories of art:

> Of all Western aesthetic theories, formalism is the most exceptional. Its assertion that art exists solely for aesthetic satisfaction and its claim that any social, cultural, or even representational message is a distraction from art's higher purpose, is, so far as I know, unprecedented in comparative aesthetics. The art-for-art's-sake premise of formalism stands in marked contrast to the various art-for-life's-sake themes found in other aesthetic traditions.[1]

Formalism has a long history of development and emerged as the dominant aesthetic ideology in the late nineteenth and early twentieth centuries during the advent of Modern art. "Modernism" and "Formalism" are sometimes used synonymously, and the two concepts overlap considerably.

Realists, Expressionists, and, as we shall see in the next chapter, Instrumentalists are all very concerned with the form of their artworks. Realists want the use of form to be subservient to, and not distracting from, what a work of art truthfully shows about the world. Expressionists want the form of a work of art to embody the emotion articulated and communicated in a medium. Formalists, however, want the form and *the form alone* to be attended to by the maker and the perceiver: Nothing else matters,

such as expression of emotion, narratives contained within works, functions of what a work is designed to perform, or references to the world a work may depict.

Thus, a Formalist artist would not have made any of the works we have viewed so far. Works by Jeff Koons, Alexis Rockman, Andres Serrano, Louise Bourgeois, and Kiki Smith are so dependent on subject matter (puppies, dinosaurs, homeless persons, spiders, and fairy tale characters) that they distract from the form of the works. Paintings by Joan Mitchell and sculptures by Louise Bourgeois are so laden with the artists' personal psychologies that the artists' anxieties and joys distract from the form of their works. The themes relied upon by Koons, Rockman, Serrano, Mitchell, Bourgeois, and Smith, such as taste, environmental degradation, social issues, personal traumas, and women's issues, are all irrelevant to the true purpose of art, which is to present significant form.

A viewer looking at art from a Formalist perspective would consciously ignore everything about the works we have seen so far, except their uses of form: A Formalist, if he or she would pay attention to *Manifest Destiny*, would likely just as soon look at Rockman's mural upside down and backward so as not to be distracted by all the representational matter in it. It is also likely that a Formalist would wish that *Manifest Destiny* be printed in an issue of *National Geographic* magazine rather than installed in the Brooklyn Museum of Art, believing that it does not deserve the status of an art museum because of its dependence on subject matter and its moralizing purpose.

This chapter examines the theory of Formalism, variations within the theory, its history, and its key philosophical contributors, such as Immanuel Kant, G. W. F. Hegel, Clive Bell, and Clement Greenberg. The chapter exemplifies Formalism in visual art by examining sculptures by Joel Shapiro (4.1), paintings and drawings by Agnes Martin, and environmental works by Andy Goldsworthy. The chapter concludes with considerations of strengths and weaknesses of Formalist theory.

Precursors to Formalism

Some theorists of art turned their attentions away from representation and expression to experiences of aesthetic qualities, and certain philosophical questions emerged: How is a thing aesthetically pleasing? What qualities are needed for something to be beautiful? Is beauty in the mind of the beholder or in the thing beholden? Is there a special faculty of the mind that allows for aesthetic pleasure? Philosophers' answers to these questions tend to concentrate (1) on identifying distinct features of things that make them "beautiful" and (2) on our manner of attending to things so that we see them as "beautiful" or aesthetically pleasing.

Is Beauty Objective or Subjective?

St. Thomas Aquinas

Plato and those following him were concerned with beauty as a central aspect of art. For many centuries after Plato, beauty was considered an objective quality of art: That is, beauty is in the object. During the Middle Ages, however, Aquinas (1225–1274) introduced subjectivity to considerations of beauty. His ideas of beauty are objective in the sense that he identifies properties of beautiful objects: perfection, harmony, and clarity. In line with Aristotelian thought, however, Aquinas stresses the experience of

beauty, and such an experience is a property of an individual subject. He also stresses cognitive aspects of seeing and enjoying beauty. The role of the subject experiencing beauty gained new attention.[2]

David Hume

Hume (1711–1776), a Scottish philosopher, historian, and diplomat, wrote an important essay on art called "Of the Standard of Taste," published in 1757, which influenced aesthetics after it, including Formalism. Hume was most interested in philosophy and history, disliked music, and had little knowledge of visual art;[3] thus his knowledge of and writing about the arts is based on drama and poetry, and he generalizes from these art forms to all of art. Hume holds that some "judgments of taste" about some works of art are foolish and unable to be defended; thus he sets out to establish how criticism can be empirical, factually based, and rational, like other respectable discourses.

Hume's descriptions of and recommendations for experiencing and judging works of art continue to be relevant today. By Hume's account, we occasionally see or otherwise experience an art object and take pleasure in it and then look longer at it, or otherwise experience it more closely, and think about it so that we may continue to enjoy it. By experiencing the object further, we enhance our first positive impressions of it. Then we try to find and identify those pleasurable properties of the object that please us so that we can share them with someone else.

Importantly, we cannot comprehend an art object merely by being in its presence and sensing it. To merely see, feel, hear, smell, or touch it is not enough: We must mentally engage with the object, trying to identify its meaning and establish its value. That is, an artwork calls for interpretation and judgment. For Hume, to make a proper judgment of an artwork, we must avoid superficial first impressions ("prejudices"), consider all relevant aspects of a work, compare it to other works, and consider its similarities and differences as a means of verifying our judgment.

Hume is well aware, however, that people's judgments often differ about the same work of art, and thus he seeks to identify "standards of taste," or a rational means to resolve disputes over different judgments. He does not believe that beauty is a perceptible property either in the art object or in the critic's mind. Aesthetician Mary Mothersill uses this analogy to explain Hume's idea: Beauty is not like a magnet that inevitably attracts the mind of the viewer, nor does the viewer have a magnet that attracts itself to beauty.[4] Rather, we *decide* that something is beautiful, upon repeated considerations, and we suppose that others will also find it beautiful.

Hume provides an open-ended list of qualities of beautiful things, such as uniformity, variety, clarity of expression, mimetic exactness, brilliance of color, and so forth. His theory of taste argues that some people have more acute and discriminating taste than others do. He also accounts for acceptable differences in taste that are due to age and temperament: For example, the young will choose some things as beautiful, while older viewers will choose something else, but both groups are able to make defensible discriminations.

British philosophers' attempts to identify beauty during the eighteenth century resulted in a list of different qualities. William Shaftesbury (1671–1713) stressed Plato's conception of the Form of Beauty. Francis Hutcheson (1694–1746) identified the

primary property of beauty to be uniformity in variety, an idea that eventually became a Formalist principle of design. Edmund Burke (1728–1797) identified qualities of beauty as smallness, smoothness, polished finishes, lines that deviate from hard angles, and so forth. These philosophers did not reach consensus regarding whether beauty lies in the object, the subject, or the interaction between the two.

Hume on Art Criticism

Because judgments of beauty are decisions made by people, Hume's theory of beauty is commonly positioned with subjective theories. Nevertheless, Hume offers sound advice for good criticism that deserves scrutiny and admiration for its clarity and directedness. Mothersill summarizes Hume's thoughts on good criticism: A critic must have the ability to make fine discriminations. A good critic can explain why a work of art (typically a poem, for Hume) is excellent and can show how the individual parts contribute to its overall effect. A good critic is also able to find aspects of a work that are inconspicuous to others and make them evident. Good criticism requires competence, and competence comes from practice. Practice consists of making comparisons among works. For comparisons to be illuminating, the critic must not be prejudiced ("I must . . . in general, forget, if possible, my individual being and my peculiar circumstances"). A good critic must also be sensitive to the maker's intentions and what it took to achieve them. Finally, a good critic must have developed the capacity to feel the logical and dramatic coherence of a work.

Early Formalism
Aesthetic Attitude and Aesthetic Experience

In Germany, Alexander Baumgarten first used the term *aesthetics* in 1750 to identify a "science of sensory cognition."[5] Baumgarten posited that merely by the arrangement of their parts, things please the mind when they are apprehended, regardless of other concerns such as their accuracy or truth. With this initial idea, theories of aesthetic attitude were developed in Britain in the eighteenth century and in Germany in the late eighteenth and early nineteenth centuries.

Having an "aesthetic attitude" is necessary for experiencing art through a Formalist lens. The purpose of assuming an aesthetic attitude is so that one may have an "aesthetic experience." An aesthetic experience is generally thought of as a unique and heightened kind of human experience whereby one delights in something for its own sensual sake, and not for any other reason such as its utilitarian, moral, or economic value. The concept of "aesthetic experience" is applicable beyond Formalist theory: John Dewey, the influential American pragmatist philosopher, was not a Formalist but did promote notions of the goodness of aesthetic experience.

An aesthetic attitude is a voluntary, human manner of perceiving things, and the attitude can be turned on and off; that is, it is not automatically triggered by something in the world. To perceive something aesthetically is to perceive it with concern only for its aesthetic features, that is, aspects of sensory beauty. One can perceive *anything* aesthetically, if one chooses to, including rotting, stinking trash as well as paintings of majestic landscapes. One can also choose *not* to view something aesthetically, even if it

was designed to be experienced that way: A beautiful grove of trees may be viewed as a tiresome source of leaves to rake, and a beautiful painting of that grove may be seen as a way to cover an unsightly stain on a wall.

An aesthetic experience is generally considered to be less voluntary than assuming an aesthetic attitude. Aesthetic experience is more likely to occur when one has an aesthetic attitude, but the attitude does not guarantee the experience. It happens or doesn't, independent of one's willfulness, somewhat like a sexual orgasm, perhaps.

Current aesthetician Jerrold Levinson lists the features that have been developed over many years to distinguish aesthetic from other states of mind:

> disinterestedness, or detachment from desires, needs and practical concerns; non-instrumentality, or being undertaken or sustained for their own sake; contemplative or absorbed character, with consequent effacement of the subject; focus on an object's form; focus on the relation between an object's form and its content or character; focus on the aesthetic features of an object; and figuring centrally in the appreciation of works of art.[6]

Disinterestedness

The concept of "disinterestedness" is a key component of the aesthetic attitude, and it is also a necessary condition for having an aesthetic experience. "Disinterested" does not mean "uninterested": On the contrary, it is a special kind of heightened interest. Dickie credits William Shaftsbury (1671–1713), an English philosopher, for introducing the concept of "disinterestedness" as a condition for viewing art aesthetically. Shaftsbury contrasts enjoying beautiful things (disinterestedly) with a desire to possess them (interestedly) and offers examples of the distinction, such as contemplating a grove of trees without desiring to eat their fruit and contemplating human beauty without the desire for sexual possession.

A beautiful sunset serves as a commonly used and clear example of something aesthetically pleasing, and something that may yield an aesthetic experience, if we enjoy it "for its own sake," or disinterestedly, appreciating it for its beauty rather than for some other utilitarian use, such as information it may provide about forecasting the weather. In recent views of aesthetics and nature, aestheticians are increasingly aware of ethical complications of responding to a "beautiful" sunset while overlooking the industrial pollution that may enhance it.[7] Many theorists and viewers of art consider the potentiality of art providing an aesthetic experience to be a (or *the*) primary purpose of works of art. Artists commonly revise the form of their works, by adjusting colors, rearranging shapes, altering scale, increasing visual texture, and so forth, to make the experience of their works aesthetically engaging. Some artists, namely, Formalists, make works of art *solely* for their aesthetic apprehension, rather than to increase knowledge, to express feeling, to motivate moral behavior, or for any other purpose.

Decontextualization

One unintended consequence of aesthetic attitude theories is that they tend to encourage the perception of art apart from its origins and purposes, that is, to see it only as form, rather than as having specific and special meaning for its makers and its original

users. Religious objects from different times and places, for example, have been torn from their original contexts and decontextualized on walls in museums of art or natural history. In 1984 art critic Thomas McEvilley raised a critical brouhaha over a "blockbuster" exhibition mounted by the prestigious Museum of Modern Art in New York City. The exhibition was called "'Primitivism' in Twentieth-Century Art: Affinity of the Tribal and the Modern," and it displayed tribal works from around the world along with modern art influenced by the "primitive" made by Picasso and others to demonstrate affinity between the modern and the "primitive." McEvilley raises questions about the intent and execution of the show, among them this concern:

> The museum's decision to give us virtually no information about the tribal objects on display, to wrench them out of context, calling them to heel in the defense of formalist modernism, reflects the exclusion of the anthropological point of view. Unfortunately, art historians and anthropologists have not often worked well together; MoMA handles this problem by simply neglecting the anthropological side of things. No attempt is made to recover an emic, or inside, sense of what primitive aesthetics really were or are. The problem of the difference between the emic viewpoint—that of the tribal participant—and the etic one—that of the outside observer—is never really faced by these art historians, engrossed as they seem to be in the exercise of their particular expertise, the tracings of stylistic relationships and chronologies.[8]

Aestheticization

Another unintended effect of aesthetic attitude theories, identified in the late twentieth century, is that they promote the aesthetic viewing of *anything*, and some find such beautifying of the ugly socially problematic: lush and dramatic classical paintings of rape scenes, glorious representations of the torture of Jesus and martyrs, and beautiful photographs of starving children, for example. Susan Sontag, an essayist, novelist, and social critic, argued strongly against such uses of photography in her book *On Photography* published in 1973: Photography "has the peculiar capacity to turn all its subjects into works of art."[9]

Dickie (1997) offers a succinct and dismissively sarcastic summary of the concept of "aesthetic experience":

> The traditional picture of the aesthetic experience of a work of art goes like this: the work and the person or subject who is experiencing it are surrounded by an impenetrable, psychological wall "secreted" by the subject that experientially nullifies all relations that the work has to things outside the experience. Aspects of works of art may, and frequently do, refer, but a "proper" subject of aesthetic experience cannot take account of such references.[10]

The Sublime

"Beauty" is an ancient concept that receives continuing attention throughout the history of aesthetic theory, but the concept of "the sublime" became topical in aesthetic discourse during the eighteenth century. It is an ancient concept, dating back to the

early Greeks and Longinus, who considered it as a part of the study of rhetoric. Longinus typified the sublime as the vast and indefinite, the unpredictable and terrible.[11] In the eighteenth century, scholars brought the sublime into the realm of aesthetic experience of nature and of art. Edmund Burke related beauty to companionability, familiarity, and comprehensibility and related the sublime to confrontation, the surprising, the unfamiliar, and experiences that extended beyond an individual's reach.[12] Dickey attributes Shaftsbury's conception of the sublime to Shaftsbury's "conception of the world as a creation of God; the vastness and incomprehensibility of that creation could only be described as sublime."[13]

In general, the beautiful is characterized by harmony, companionability, comprehensibility, and the way it absorbs and calms the viewer. The sublime is thought of as terrifying, awe-inspiring, unruly, invigorating, surprising, and unfamiliar. A flowering meadow might be beautiful, but the Alps are sublime. Burke and others applied both the beautiful and the sublime to nature and to works of art, but Kant limited the sublime to nature only. By limiting the sublime to nature, Kant shows that aesthetic experiences can be had with events that are not intentionally made by artists to be meaningful: The sublime provides examples of "purposiveness without purpose," an important feature of Kant's notion of beauty.[14]

Immanuel Kant

The German philosopher Immanuel Kant (1724–1804) is a very important contributor to the history of philosophy in general, and to aesthetics in particular. In one of his major works, *Critique of Judgment*, written late in his career, in 1790, Kant attempts to answer the question: "What is required in order to call an object beautiful?" Kant's analysis of beauty is considered by philosophers "one of the most carefully and well executed examinations of the question"[15] in the history of aesthetics, but also as having "many obscurities and confusions,"[16] with aspects of it "profound, provocative, and problematic"[17] in its "sheer complexity,"[18] and "difficult, technical, and best adapted to a strictly philosophical setting."[19]

In general, Kant decided that correct aesthetic judgments were possible and required two things: (1) that people have the same faculties for understanding the world and (2) that if the individual viewer appreciates an object with no regard for its actual existence, the viewer would judge it just as other similarly disposed people would judge it.[20]

Kant's aesthetics are very important to discourse that has followed it, particularly these four key concepts: (1) that the aesthetic sphere is autonomous, (2) that what makes an experience aesthetic are its formal properties, (3) that the aesthetic experience is distinct, and (4) that the aesthetic is bound up with expression and ideas.[21]

Kant's systematic and complex aesthetic analyses are meant to apply both to nature and to art, although he applied most of his discussion to nature. According to Kant, the goal of art is beauty. Ultimately, form is all that is required for something to be judged beautiful. Dickie summarizes Kant's aesthetic theory in this one sentence: "A judgment of beauty is a disinterested, universal, and necessary judgment concerning the pleasure that everyone ought to derive from the experience of a form of purpose."[22] Thus, four major concepts are entailed: (1) disinterestedness, (2) universality, (3) necessity, and (4) the form of purpose.

Kant's concept of disinterestedness shares prior positions articulated by Shaftsbury and Burke. Kant, however, takes the idea further by asserting that to be disinterested is to not care if the object of appreciation even exists.

The universality condition is Kant's attempt to answer the question of whether a judgment of beauty is merely subjective, that is, in the eye of the beholder, or objective, that is, an actual property of that which is being judged. He inherited the problem particularly from Hume, who argues that taste is subjective. Kant disagrees with Hume and offers this argument. Because judgments of beauty are disinterested, they do not derive from personal and idiosyncratic conditions, and thus are common to all humanity.

Kant believes that judgments of beauty are objective. That is, when we judge something to be beautiful, we make an implicit demand that everyone agree with us, but this is rarely the case. There should be agreement, according to Kant, because we all share the same mental faculties, and what is found to be beautiful by one ought to be shared by all. Kant does not, however, provide general rules of beauty, and he does not tell us how we can achieve agreement over differing judgments of beauty.

In *Critique of Judgment*, Kant uses this variety of terms when considering the fourth condition, form of purpose: "purposiveness without purpose," "formal purposiveness," "the mere form of purposiveness," "formal subjective purposiveness," and "purposive form."[23] It is a difficult concept to pin down. He locates purposiveness in the rational order of a thing that he derives from his metaphysical beliefs, which include God's purposive system of nature, God's "unfathomably great art."[24]

G. W. F. Hegel

Georg Wilhelm Friedrich Hegel (1770–1831), the German Idealist philosopher, is the last philosopher to build a great metaphysical scheme and to formulate a grand systematic theory of art. His views have influenced the major philosophical positions developed since. Aesthetics is central to Hegel's general philosophical system.

Stephen Houlgate, a current philosopher, provides an overview of Hegelian aesthetics. Hegel does not see the primary value of art to be providing pleasure, but instead to add to our understandings of the world and ourselves in it. Like Aristotle, Hegel locates the value of art in its ability to disclose truth. Skill of representation and beauty of form are important to Hegel, but not sufficient for genuine art. Genuine art must exhibit a profound respect for human freedom based in the divine. The divine includes ancient Greek and Christian manifestations, but Hegel also embraces secular works of art. Genuine art celebrates human freedom in its diversity and provides an inner feeling of freedom, well-being, and delight, even in the face of hardship. Art is a mode of understanding the human, and like understanding in philosophy and religion, art develops and progresses in time. Beauty is the harmonious joining of the subject of freedom in sensuous materials with appropriate formal expression. Hegel's belief in harmonious beauty is at odds with later twentieth-century thinkers who want to free art from the constraints of traditional beauty.[25]

Houlgate summarizes five of Hegel's contributions to aesthetics that remain significant today.

1. Hegel shows that art provides a distinctive form of aesthetic freedom and experience that is not simply subservient to the pursuit of political and social goals. . . .

2. Hegel explores the expressive possibilities of different arts and forces us to consider whether particular arts may not be better suited to the expression of certain kinds of subject matter than others.

3. Hegel emphasizes the importance of a historical approach to art and is one of the first aesthetic theorists to take a serious interest in non-Western art.

4. Unlike Kant (and some noted twentieth-century aesthetic theorists), Hegel always tries to breathe life into his ideas about art and beauty by showing how they are exemplified in individual artworks with which he is familiar (works by artists as varied as Sophocles, Aristophanes, Raphael, Michelangelo, John Milton, Rembrandt van Rijn . . .). Hegel thus demonstrates that it is possible —indeed, essential—to integrate one's concrete experience of actual works of art into any systematic aesthetics.

5. Not only is Hegel eclectic, but his theory of art offers, together with important philosophical insights, interpretations of individual artworks and artistic styles. . . .[26]

According to Lucian Krukowski, a current aesthetician, many summary accounts of Formalism stress the significance of Kant's aesthetics but overlook the contributions of Hegel. Krukowski's overview of Formalism, which he understands as many variations rather than as a monolithic doctrine, posits two differing emphases of Formalist theory, one that he attributes to Kant and the other to Hegel. The first is that all artworks are to be judged solely on the basis of their formal properties; the second is that the best works of art are those whose emphasis is on their formal properties. Krukowski credits the first emphasis to Kant, namely, that all works of art should be judged primarily on their formal properties, regardless of their other content. To Hegel he attributes the second emphasis, namely, that works of art should be built exclusively upon Formalist principles.[27]

Kant's emphasis on Formalist criteria to judge all art may lead to the extreme position of ignoring content other than aesthetic when viewing and judging a work of art, a strict Formalist position taken up in the twentieth century by Clement Greenberg. Subject matter is irrelevant and even distracting to a good work of art. Hegel's emphasis that the best works of art are those that emphasize form leads to nonobjective abstraction in the twentieth century, also promulgated by Greenberg.

Twentieth-Century Formalism

In the twentieth century, Formalist theorists centered on particular art forms, most especially painting and, to a lesser extent, sculpture. Early Modernist artists—such as Wassily Kandinsky, Piet Mondrian, and Kazimir Malevich—who developed abstract forms of art are main contributors to later Formalism. Two major contributors to twentieth-century aesthetics are Clive Bell and Clement Greenberg. Bell, an English art critic, is much influenced by Kant and by "aesthetic responses" to works of art. Bell is most famous for identifying in successful works of art a quality he called "significant

form." Bell applies his theory to all works of art through history. Clement Greenberg is the American critic often credited with moving the center of the artworld from Paris to New York City by employing Formalism in explaining and defending the greatness of the work of Jackson Pollock and other modern American artists, especially painters working between 1945 and 1960. Greenberg was interested in explaining and promoting what he called the "new American painting." The contributions to Formalism made by Bell and Greenberg are considered later in this chapter.

Early Modern Abstractionists Kandinsky, Mondrian, and Malevich

Different artists writing and painting in different places in the early twentieth century contributed to the development of Modernist ideas about art that contributed significantly to Formalism. They contributed ideas about both the form of work and its social significance, which they took to be "spiritual" in different but overlapping senses. The three artists discussed here have in common optimistic ideals about the ability of art to improve humankind, a vividly felt need especially after the devastation in Europe during World War I.

Wassily Kandinsky (1866–1944), a Russian-born French painter, art theorist, and author in 1914 of *Concerning the Spiritual in Art*,[28] is often considered the first abstractionist, introducing the term "non-objective painting" and adding *purely* to the term *abstract*. He is the most famous of early abstractionists. Influenced by Friedrich Nietzsche's philosophy, Kandinsky visualized his theory of art with a large triangle similar to a pyramid, with art at its apex. The triangle is spiritual, and it is the artist's mission to raise others to the top through the exercise of their talent. Souls fall from the top to the bottom when people search for external success and ignore purely spiritual forces: Art could awaken the capacity to experience the spiritual in material and in abstract phenomena, such as art. For Kandinsky, formal qualities of light, color, and shapes were more important in a painting than the subject matter they may represent.

Piet Mondrian (1872–1944) was a Dutch painter best known for his nonrepresentational paintings consisting of rectangular forms of red, yellow, blue, or black, separated by black rectilinear lines. He and Kandinsky, each in their own ways, in their thinking and artmaking, furthered what seemed to them the historical inevitability of art progressing to abstraction. Both saw art as a means of confronting a higher reality. Art historian Kermit Champa credits the two artists, neither of whom was formally educated in philosophy, together and separately, with producing "the nearest thing to tightly argued philosophical analyses for the enabling conditions of modernist pictorial practice." Mondrian conceived of an artwork as a unique space in which a viewer could contemplate a universal and nonsubjective (Platonic) reality in an intense way. Mondrian wrote three important essays for *De Stijl* magazine that contributed significantly to Formalist theory. The essays are "evangelical in tone" and simultaneously address modern aesthetics and ethics by use of binary distinctions, such as "objective," which is modern, reasonable, and free, and "subjective," which is outdated and too personal.[29]

Kazimir Malevich (1878–1935), a painter and art theoretician, pioneered geometric abstraction and was an important member of the Russian avant-garde and an art movement he coined as "Suprematism." Malevich advocated the "supremacy of

forms," forms conceived in and of themselves and unrelated to anything except geometric shapes and colors. The purpose of such abstract artworks is to reveal reality and to transform viewers. The supreme reality is pure feeling. According to Malevich: "under Suprematism I understand the supremacy of pure feeling in creative art. To the Suprematist, the visual phenomena of the objective world are, in themselves, meaningless; the significant thing is feeling, as such quite apart from the environment in which it is called forth."[30] In the words of art historian Myroslava Mudrak, "Suprematism, as implied by its name, was to be a new and prophetic kind of painting, representing a world to be, rather than one that is."[31] The avant-garde and Suprematism were squashed by the Stalinist communist regime and replaced with Socialist Realism in 1932.

Clive Bell

Clive Bell (1881–1964), an English art critic, and his associate Roger Fry (1866–1934), an English painter and critic, were important contributors to twentieth-century Formalism. Bell claimed that representation and emotion in themselves do not contribute to aesthetically experiencing a work of art. Instead, it is the "significant form" within the work that determines its artistic content and value. In *Art*,[32] written in 1914, he argues that what makes an object art is its possession of "significant form," that is, a composite of line, mass, proportion, chiaroscuro, and color. When these elements are arranged successfully, they result in a viewer having an "aesthetic emotion." He defines significant form for painting as relations and combinations of lines and colors and considers significant form to be common to all works of visual art, asserting it as the definition of art. His theory relies on treating "aesthetic experience" as an emotion distinct from other emotions, and one that is triggered by significant form, the common quality of any work of art.

Under the rubric of significant form, Bell includes many paintings and also the Hagia Sophia in Istanbul, the stained glass windows in Chartres cathedral, and Persian carpets. With his criterion of significant form, Bell denies the status of art to many paintings of his time, such as Victorian paintings with sentimental scenes meant to evoke moral, historical, psychological, and patriotic values. In the Formalist spirit, French painter Maurice Denis in 1890 proclaimed, "a picture, before it is a warhorse, a naked woman, or some anecdote, is essentially a flat surface covered by colors assembled in a certain order."[33]

Theorists of early modern art, such as Bell and Fry, believe that there is a causal link between a viewer having an aesthetic response and the form of a work of art. Bell relegates mimetic Realism and narratives in a work of art to a place of secondary importance. What makes a work a good work is its "significant form" or lack thereof. However, his means of identifying such an elusive quality as significant form is circular: If one has an aesthetic response to a work, it is because it has significant form, and if a work has significant form it will be evidenced in a viewer's aesthetic response.

The criterion of having significant form applies to all works, present and future. The quality of significant form is universal, applying to all works from all times and cultures—all periods of art history, "primitive" art, classical art, and non-Western as well as modern art. There are artworks that do not have significant form, and there

are viewers who do not recognize significant form when they see it: This is because of different levels of discriminating aesthetic capabilities of artists or viewers.[34] The importance of "significant form" for Bell is that through its recognition "we become aware of its essential reality, of the God in everything."[35]

Clement Greenberg

In 1949, *Life* magazine presented Jackson Pollock to the American public with the subtitle, a quote from Greenberg, that Pollock is "the greatest living painter in the United States." *Time* magazine had already attacked Greenberg for his exaltation of Pollock's paintings and for his seemingly outrageous claim that David Smith was the only major American sculptor. As Danto points out, Greenberg's early recognitions of the achievements of artists would eventually become universally acknowledged. Greenberg explained and defended what he called "American style painting" at a time when Paris held sway as the center of Modernism with its introduction of Impressionism, Cubism, and Fauvism; at a time when Picasso dominated; and when contemporaries of Pollock such as Marc Chagall and Amadeo Modigliani were celebrated.

In a brief posthumous article about Greenberg (1909–1994), philosopher and art critic Arthur Danto pays tribute to the influential critic. As Danto explains, by the 1960s, Greenbergian aesthetics dominated and largely determined curatorial, journalistic, and academic attitudes: "Greenbergian formalism had become the enemy to be defeated." Danto concludes: "Ornery, sarcastic, dogmatic, and outrageous as he seems to have enjoyed being, his writing and example remain as important as the art he helped the world to understand and accept."[36]

Greenberg's Formalism is distinguished by the following features. As it is for Bell, the primary value of a work of art is its form, but rather than *looking through* a work's pictorial illusions, its subject matter, or its narrative, if it has one, to find its formal structure, Greenberg advocates that we *ignore everything but* the work's form. Greenberg advocates for art that rejects subject matter, pictorial illusions of three-dimensional space on a two-dimensional surface, atmospheric light, and any other devices artists might use in creating a picture of something. Ultimately, "flatness" and "frontality" became the distinguishing features of good painting for Greenberg. Flatness, however, is more than a stylistic choice, it is a theoretical point: Flatness means that a painting should have no illusions and external references but attain the autonomy of self-reference, such as Jackson Pollock's canvases.

Greenberg's Formalism was in large part a discovery and exploration of the materiality of art: the flat surface of a painting, its shape, the structural support of the canvas, the pigment, and so forth. In Greenberg's view, the Old Masters treated these as negative factors to be disguised, hidden, or disregarded. Greenberg saw them as positive factors that ought to be acknowledged openly in artworks. In Danto's summary of Greenberg's position, "Modernism, so understood, is the progressive unconcealing of the material truth of paintings as physical objects. . . . Modernist art in general, was about its material conditions, while the mere physical objects that the works outwardly resembled were not about anything at all. Modern art was ultimately about itself; the subject of art was art."[37]

Danto considers the coming of age of Formalism as a series of "erasures." Since 1900, the history of Formalist Modernism is:

> a history of the dismantling of a concept of art which had been evolving for over half a millennium. Art did not have to be beautiful; it need make no effort to furnish the eye with an array of sensations equivalent to what the real world would furnish it with; need not have a pictorial subject; need not display its forms in pictorial space; need not be the magical product of the artist's touch.[38]

Currently Michael Fried and Rosalind Krauss are two prominent critics who emerged in the 1960s and who embrace their own variations of Formalism. Krauss is particularly interested in the contributions of Structuralism to Formalism.

Structuralism

Structuralism is an influential movement that conceives of all cultural phenomena, including artworks, as sign systems that operate on the basis of a deep and hidden structure. It is mistaken to think of Structuralism as one doctrine or that there is a homogenous set of thinkers called Structuralists. Structuralism evolved from early work of Ferdinand de Saussure, a Swiss linguist, and was largely adopted by European and particularly French scholars of many disciplines. There are parallels between what is known as Structuralism in Europe, Formalism in Russia, and Formalism in the United States. Nelson Goodman, among other American philosophers, may be considered a Structuralist, although he would probably not have referred to himself as one. Art critic Dave Hickey, writing today, says he employs Structuralist art criticism.[39] Structuralism remains influential worldwide in many areas of study, especially literary studies and criticism, aesthetics and criticism, anthropology, and psychoanalytic theory. Structuralists work in an array of subject areas and cross-disciplinarily but do not adhere to a single set of procedures.

Ferdinand de Saussure

Saussure (1857–1913) was able to explain languages both as they exist in a historical time and as they change over time. His theory addressed all languages as well as specific utterances in any language. He saw all human languages as a self-contained system of signs with its own rules and regulations for use. He divided language into two main parts: *langue* (the system of language) and *parole* (a person's individual use of a language) and was most interested in discovering the governing rules of *langue*. Saussure's analogy of language to chess is helpful: Language is like a game of chess. It is self-contained, self-regulating, and governed by rules. The rules (or grammar or *langue*) of chess allow pawns to make some moves but not others, knights to make other moves, and so on. The pieces were defined by how they functioned, just as a word functions in a certain way in a language. Individual chess pieces (and words) are known by their difference: A pawn does not function like a knight, and a verb does not function like a noun. Further, the differences were discovered to be often binary:

black/white, man/woman, nature/culture. The concept of "difference" became essential to theory.

Saussure explained language as a system of "signs" composed of a "signifier" (word) and a "signified" (mental concept): The word *cat* and a mental idea of a cat conjoined in the mind as an act of understanding. Importantly, there is no natural relationship between the word *cat* and what it signified. Any term works—*cat* (English), *neko* (Japanese), *maanjar* (Marathi)—as long as the language community agrees upon how to use the term and to what it refers. The connections are arbitrary but agreed upon by communal consensus. The concept of the "arbitrariness of signs" became essential to the theory that followed.

Another key concept is that no single term or thing makes sense except in relation to another term or thing: The term *pawn* does not mean anything without a concept of chess, and any word does not give off a meaning apart from the sentence in which it occurs. Saussure predicted a future "science of signs" or "semiology," which is now generally known as "semiotics." Semiotics and Structuralism are approaches that comfortably coexist.

A basic construct about language runs through Structuralism, Poststructuralism, and Postmodernism. That is, we cannot separate "reality" from the way we represent it in language or the narratives we construct about it. Language can never be an "innocent" or "transparent" reflection of reality.

Awareness of the limitations of language is not the sole domain of Structuralist thinkers. Ludwig Wittgenstein (1889–1951) made clear that his thought was restricted by the limits of whatever the language in which he attempted to express them was. Martin Heidegger (1889–1976), in the phenomenological tradition of philosophy, famously declared, "language speaks us." In 1975, Fredric Jameson, the American Marxist theorist, published *The Prison-House of Language* on the peculiar nature of language. In writing about seeing and representing, American philosopher Nelson Goodman (1906–1998) in *Languages of Art*, published in 1976, argued along with art historian Ernst Gombrich, "there is no innocent eye . . . not only how but what it sees is regulated by need and prejudice . . . nothing is seen nakedly or naked."[40]

Structuralism was most popular in the 1950s and 1960s, especially in France. In 1967 *La Quinzaine Littéraire* published a cartoon depicting Claude Levi-Strauss, Jacques Lacan, Roland Barthes, and Michel Foucault as Structuralists by a shared costume, but it is not obvious what the four share, and it is arguable that Foucault was a Structuralist and Lacan became a Poststructuralist.[41] *Art Since 1900* refers to Lacan as a Structuralist and Foucault as a Poststructuralist.[42] At the time, Levi-Strauss and Barthes were particularly influential: Both considered cultural phenomena as narratives, and they argue that all narratives share common features, or codes, and a common structure.

Claude Levi-Strauss (1908–2005), a Belgian-French social anthropologist, applied Saussure's language theories to study cultures as systems of communication analogous to the workings of language. He sought to identify universal structures of the mind in myths, cultural symbols, and social organizations. For example, cultural myths are variations based on themes: If an explanatory myth required divine intervention, that function of the myth is in all cultural myths but in different forms such as a human

god, an animal god, or a god of wrathful nature taking the form of destructive storms. The different narratives share a similar deep structure that needs to be uncovered through structuralist analysis.

Russian linguist Roman Jakobson (1896–1982) extended Saussure's model to the study of language, poetry, art, film, and eventually to the whole of communication sciences. Jakobson collaborated with Levi-Strauss and completed his career at Harvard University, bringing Structuralist influences to the United States.

Roland Barthes

Barthes (1915–1980), a French literary and cultural theorist, was one of the first to apply Saussure's structural model of language to literature and to all kinds of cultural phenomena, including fashion, advertising, wrestling, zoos, music, films, photographs, and paintings. In his studies of cultural phenomena he sought to expose the ideologies behind popular cultural myths. He also wrote books on love: Love and death delimit states of human existence and change discourse. In 1968 he announced the "death of the author,"[43] by which he meant to destabilize the sole authority of the author as the meaning-maker for a passive reader and to encourage the reader to be an active maker of meaning. Barthes conjoined the death of the author with the "birth of the reader."

Modernists talk of "works," including poems, novels, and paintings, while Postmodernists talk of works as "texts." A work is attributed to an author with authority. A text, however, is a play of one text among many texts. Texts can only be understood in relation to other texts. The reader is no longer passive but active in reading and making meanings. There is *pleasure*—*jouissance*—a type of aesthetic experience, in such readings. By the 1970s Barthes was one of France's most internationally known critics. He pioneered social and cultural criticism of photographs, which he considered the predominant media of mass culture.

In *Camera Lucida*, the last book written before his death, Barthes contemplated what he considered the unique medium of photography, based more on chemistry than on art, and declared photography to be "a magic not an art." Because of photography's chemical means of producing analogues of reality, a photograph is "an image without a code," photography is "magic" rather than "art," and photographs require more sophisticated interpretation than other media do.[44]

Charles Sanders Peirce (1839–1914), an American pragmatist philosopher, independently of Saussure, elaborated a system of signs, distinguishing "icon" from "index" from "symbol." An icon of a cat resembles (a realistic drawing of a cat); an index of a cat refers (a cat's paw prints in the mud); and a symbol of a cat stands in for, arbitrarily, upon consensus (the word *cat*). Later, some photography theorists ("Realists") picked up on the notion that photographs were both iconic and indexical: Photographs look like what they picture, and they are also caused by what they picture.

Others ("Conventionalists") favor a theory of photography that thinks of photographs as based on coded conventions that we mistakenly take as "real": They argue that we are so familiar with the conventions of photography that photographs seem natural rather than constructed.[45] Barthes mixes both Conventionalist and Realist orientations in his analyses of photographs. Goodman argues that we replace "iconic"

notions of art, that art communicates by resembling what it shows, in favor of under-standing art as an arbitrary symbol system; that is, pictures don't resemble what they picture so much as they signify through a languagelike system. Goodman understands science, philosophy, and art to be languages, that is, systems of rules to manipulate symbols in order to construct new ways of conceiving of the world.

Structuralism became influential in Marxist thought in the 1950s to the 1970s through the work of Louis Althusser (1918–1990), the leading intellectual of the French Communist Party. Althusser saw repressive structures within institutions that function to control thought and behavior of individuals. The state controls the media, education, and the legal system, and it can call upon police and armies to repress dissent. These entities attempt to prevent the questioning of dominant ideology and the exposing of hidden contradictions encoded within an ideology. Althusser and his followers read cultural texts "against the grain" to reveal the ways in which repressive structures control societal thought. If one critically interrogates texts, one can identify the secrets of the dominant ideology and resist it.[46]

Although Structuralists uphold the arbitrariness of language and sign systems, they do not hold that we can read any sign in any way we please. Interpretations are constrained by rules and conventions. As Umberto Eco, an Italian semiotician and novelist, asserts, "texts have rights."[47] Nor can one just make up a sign out of nothing and expect it to signify: Signs are relational to other signifying practices and mean through difference from related signs shared by a language or sign community.

The promise of Structuralism, in all its manifestations, is that it will make visible the unobservable deep structures that lie beneath and determine the visible world. Structuralists have confidence in being able to identify deep but formerly hidden stability, order, and objectivity. In these beliefs it is similar to Modernist beliefs, and some scholars see it as the final stage of Modernism.[48] Modernist humanists object that Structuralist understandings minimize individual freedom by attributing cause to deep structures: Humanists place the subject at the center of meaning as authors of texts, and Structuralists decenter the author in favor of a view that places authors within a pre-existing structure of language. Authors are not as original as we think; they rearrange elements in an already existing system, recombining what is already written. Poststructuralists continue to look for structures and agree that structures are made up of binaries, but they add the important idea that those binaries are not equal, that one is always privileged over the other.

While acknowledging limitations of Structuralism, Stuart Sim, a British scholar of Structuralism, summarizes its contributions:

> Structuralism has made enormous contributions to twentieth-century thought. It remains a superb basis for comparative analysis (between cultures or literary genres, for example), and it has had many notable successes in this regard, with the work of Barthes in particular still finding an audience and informing current critical practice and debate. Few methods of cultural or aesthetic inquiry have not adopted something from structuralism, and many of its techniques have now become absorbed to the point where they are simply taken for granted by critics and teachers alike.[49]

In his later writings Barthes embraced aspects of the thinking of Nietzsche, Lacan, Derrida, and other Poststructuralist influences (to be discussed in the following chapter), and he and others distanced themselves from what they took to be the rigidity of Structuralist methodology and its insistence on the linguistic model to give order to all cultural phenomena. In 1974 Barthes published *S/Z*,[50] a book in which he proposes that all texts be seen as a "galaxy of signifiers" with inexhaustible sources of meaning that are open to multiple interpretations.

Structuralism and Formalism

Hal Foster, Rosalind Krauss, Yve-Alain Bois, and Benjamin Buchloh, coauthors of *Art Since 1900*, however, account for Formalism through Structuralism, crediting especially Roland Barthes and Ferdinand de Saussure and minimizing Clive Bell, "whose concern was merely good design." The authors deem it essential to retrieve "formalism (as structuralism) from the wastebasket of discarded ideas." Their account of Structuralist formalism is that

> signs are organized into sets of oppositions that shape their signification, independently of what the signs in question refer to; every human activity partakes of at least one system of signs (generally several at once), whose rules can be tracked down; and, as a producer of signs, man is forever condemned to signification, unable to flee the "prison-house of language," to use Fredric Jameson's formulation. Nothing that man utters is insignificant—even saying "nothing" carries a meaning (or rather multiple meanings, changing according to the context, which is itself structured).[51]

Barthes was influenced by Marxist German playwright Bertolt Brecht (1898–1956) and his articulation that language was not a neutral, transparent vehicle that conveyed ideas directly from person to person. For Brecht, form and content are inseparable. Thus, the authors of *Art Since 1900* recognize two kinds of Formalism: Formalism that sees form as "structural" and that is still useful today and Clive Bell's Formalism, which is too restricted to aesthetic appearance.[52]

Agnes Martin: Paintings and Drawings

The paintings and drawings of Agnes Martin (4.2, Color Plates 14 and 15) exemplify many tenets of the theory of Formalism, especially a primary concern for form, radical abstraction, a belief in artistic progress, an intent to provide aesthetic experience, a striving for the sublime, an acceptance of the autonomy of art, and belief in artistic originality.

Agnes Martin (1912–2004) was born in Maklin, Saskatchewan, and died in Taos, New Mexico, where she and Georgia O'Keeffe are legends. Age did not hamper Martin's steadiness of production: In the year of her death she had two critically acclaimed shows in New York City of her signature and uniquely spare grid paintings and drawings (Color Plates 14, 15), which she arrived at in the early 1960s.

4.2 Agnes Martin | *Untitled,* **1995.**
Watercolor wash and pencil on transparentized wove paper, 11 x 11 inches. Photograph by: Kerry Ryan McFate. Courtesy PaceWildenstein, New York. © 2006 Agnes Martin/Artist Rights Society (ARS), New York.

Prior to the grids, Martin made traditional still lifes and portraits, and then painted landscapes in her version of Abstract Expressionism.[53] Throughout the 1950s, Martin struggled to make paintings to reveal her inner mind, what art writer Kristine Bell calls "a metaphysical place where she felt the beauty and perfection of the external world resided as absolute ideas . . . a space where the fleeting presence of perfection and beauty of the natural world was eternal."[54] She embraced aspects of Zen and Buddhist belief and was especially influenced by two Taoists, Lao Tse and Chuang Tzu, who encouraged her to look within and be guided by her own mind and soul.[55]

Critical Commentary on Martin's Work

Inspired by these beliefs, Martin sought to make visual the immaterial world of her mind, continually experimenting with formal ideas, seeking beauty and perfection that transcended the natural world.[56] Curator and critic Lynn Cooke writes that Martin's "art is a means of transformation by which she seeks perfection,"[57] and Kristine Bell asserts that Martin's work of over fifty years represents "the pursuit of perfection, happiness, and beauty."[58] Critic Michael Govan attributes to Martin's work "a pure, abstract, egoless, untroubled state of mind."[59]

Bell identifies Martin's work with pursuit of the sublime:

> Her painting acted as a vehicle to recapture the experience of the sublime. . . .
> Martin continued to experiment with formal ideas that would bring her closer to
> the ultimate goal of finding an abstract format that allowed the mind to empty itself
> of the ego and other distractions. It would be through pure abstraction, that Martin
> felt would allow the viewer to experience the sublime. . . . The grid served as a
> perfect geometric solution for an all-over pattern that would lead the mind away
> from the material world towards a purer experience of the sublime. The decentral-
> ized composition reflects the infinite space of the mind. For Martin, it was through
> uniform spacing and compositional equilibrium that transcendental reality could be
> attained . . . making the attainment of the sublime her central theme.[60]

The sublime to which Kristine Bell appeals is not the terrifying sublime of nature, but
the awesome sublime of the beautiful.

Martin's means of providing experience of the sublime, implied by Bell in the pre-
vious quote, were prolonged experimentation with form that eventually lead her to
pure abstraction that utilizes a decentralized allover pattern, ordered spacing that uni-
fied her compositions, and a concern with transcendental reality rather than repre-
sentation of earthly matter.

The authors of *Art Since 1900* provide a Structuralist analysis of Martin's work.
In their understanding, the strength of Martin's paintings is that they play with dif-
ference between the spiritual and the material, the material grid and its spiritual dis-
appearance in the paintings' luminosity: "In other words, the canvases become 'lumi-
nous atmosphere' only in relation to—that is, by differing from—the other
experiences of the works as material objects, and vice versa."[61]

Lynne Cooke admires "the surprisingly diverse formal repertoire" Martin pro-
duced within her intentionally limited choice of syntax:

> patterns composed of reticulated linear marks, skeins woven from repeated dashes
> and dots, razor-sharp incisions subdividing a matte plane, warm grounds contrast-
> ing with cool grids or the converse, and febrile graphite webs that pinion washy
> overlays so that they never quite become atmospheric. Minute fluctuations and
> irregularities in the thickness or density of the penciled and painted lines and in
> the steadiness of her hand further animate these works.[62]

Govan writes that Martin's abstractions combine ideal geometry and the lightest
touch of the artist's hand "to achieve a pitch of emotion and feeling." He points out,
however, that the grid that underlies her paintings is "never mechanical and never
rigid."[63] He implies that she has achieved such pitch of emotion through a resolution
of unity (ideal geometry) and variety (her grids are never mechanical).

Richard Tuttle, an artist and close friend to Martin, explains his sense of her grids,
reinforcing some of the ideas expressed by Bell and Govan earlier:

> In essence, Martin employs the grid at the same time that she attempts to over-
> come it. Her unique way of integrating drawing and painting results in a compo-
> sition that is geometrically stable on the one hand, yet visually deceptive on the

other. Although Martin uses a ruler to apply the delicate lines of graphite on her lightly gessoed canvases, the resulting image slips away from the hard-edge clarity of many geometric paintings. Graphite gently dragged across the woven terrain of the canvas creates a subtle but sensuous irregularity in the line. Invariably these lines, although ostensibly straight and regular, take on a life of their own, establishing a rhythmic buzz or tremolo across the surface of the picture. The sense of order and geometry that was apparent initially becomes mutable and illusive.[64]

Nancy Spector, curator for the Guggenheim Museum, further articulates Martin's use of the grid in her analysis of a single painting, *White Flower*:

Unlike the more rigidly formulaic art of much Minimalist work, there is nothing systematic about Martin's use of the grid; the arrangement of coordinates shifts in scale and rhythm from work to work. The grid in *White Flower*—composed of intersecting white lines that form individual rectangles punctuated by symmetrical white dashes—resembles woven fabric. Consistent throughout Martin's mature oeuvre is an absolute equivalence of form. The compositions are emphatically non-hierarchical; no one component is privileged over another. The delicacy of Martin's style—promoted by the artist's frequent use of light graphite lines and cool tones such as pink and pale gray—masks her impulse toward stringent formal equality. Her paintings must be read as unitary entities, not as assemblies of single elements. This does not mitigate the complexity of their construction, however. The freely drawn grids, fragile, almost dissolving lines, and hushed tones of the paintings require quiet contemplation in order for the subtleties of their individual compositions to be revealed.[65]

Reviewing one of the last of Martin's exhibitions, Ken Johnson, an art critic for the *New York Times*, writes that Martin's paintings "do not invite you to look through them to another world, but to gaze at them in the here and now, as ends in themselves." He continues, "Her drawings may engender associations with landscape, light and atmosphere or with notions of wholeness and harmony, but they do not explicate anything beyond themselves. By virtue of their exquisitely subtle formal and sensual qualities, they hold our attention in the immediate present."[66]

That is, consistent with Formalist principles, the critic argues that Martin's paintings and drawings are to be experienced aesthetically in the present, and ought not be seen as explications of anything beyond their edges. They are to be enjoyed and valued because of their exquisite formal qualities and the pleasurable experience those qualities elicit. Johnson's reflections on Martin's works are reminiscent of Kant's concept of "purposiveness without purpose." Kant applied the concept especially to nature— God's unfathomably great art—and Martin was inspired by nature, although she did not want to replicate it.

Martin's Thoughts about Her Own Work

Martin herself sounded very much like a Formalist when she spoke about her approach to making art. Although Martin maintained that she was inspired by woods, plains, deserts, vast skies, and weather, she denied using such imagery or making any direct

references to landscapes in her art, even though the titles Martin gave to her paintings would seem to indicate otherwise: *Wheat, Earth, The Spring, Rain, Leaf, Dark River, Milk River, Lemon Tree,* and *White Flower,* for example. She claimed, "Anything can be painted without representation."[67]

She said that her uniquely spare grids of variously spaced graphite lines grew out of her pressing need to express what she called "the most simple, powerful things."[68] She recalled her first use of the grid: "When I first made a grid I happened to be thinking of the innocence of trees and then a grid came into my mind and I thought it represented innocence, and I still do, and so I painted it and then I was satisfied. I thought, this is my vision." Martin expounded: "My formats are square, but the grids never are absolutely square; they are rectangles, a little bit off the square, making a sort of contradiction, a dissonance, though I didn't set out to do it that way. When I cover the square surface with rectangles, it lightens the weight of the square, destroys its power."[69]

In the late 1960s and early 1970s, Martin wrote about her reflections on art and life, the themes of which she identified as beauty, joy, innocence, truth, solitude, and the inward eye.[70] She wrote this poem in 1973:[71]

> I can see humility
> Delicate and white
> It is satisfying
> Just by itself . . .
> And Trust
> absolute trust
> a gift
> a precious gift
> I would rather think of humility than
> anything else.
> Humility, the beautiful daughter
> She cannot do either right or wrong
> She does not do anything
> All of her ways are empty
> Infinitely light and delicate
> She treads an even path.
> Sweet, smiling, uninterrupted, free.

Martin wrote about fellow artist Lenore Tawney's textiles: "it can be said that trembling and sensitive images are as though brought before our eyes even as we look at them; and also that deep, and sometimes dark and unrealized feelings are stirred in us." Martin concluded, "There is an urgency that sweeps us up, an originality and success that holds us in wonder."[72] Cooke observes that these same words apply to Martin's works.

Martin associated her art with that of Mark Rothko, Ad Reinhardt, and Barnett Newman, artists of her time, each of whom in their own ways sought transcendental and revelatory experiences through art, intimating the existence of higher realities. Martin believed that Rothko's and Newman's Abstract Expressionist works were founded in joy, and she admired Jackson Pollock's painting for its "complete freedom and acceptance."[73]

About beauty, Martin commented, "Beauty is the mystery of life. It is not in the eye, it is in the mind."[74] She bluntly asserted that her subject "is not politics . . . but the immaterial, immaterial perfection."[75] Although she was actively working during the feminist movement, she has avoided any overtly political topics in her art and writing. She once said, "It is not the role of the artist to worry about life—to feel responsible for creating a better world."[76] That is, in alignment with Formalism, Martin asserts that art is an autonomous realm, apart from other concerns, and sufficient unto itself.

Martin disavows influence and embraces the possibility of originality in art: "I don't believe in influence, myself," she stated in 1989, "I don't believe that anybody is influenced by anybody at any time. I think that we all live by inspiration, whether we pay attention to it or not."[77] "I suggest to artists," she wrote, "that you take every opportunity of being alone."[78]

Martin can be understood as embracing Plato's idealism (though not his presumption that art visually mimics reality), as well as that of Hegel: "When I think of art I think of beauty. Beauty is the mystery of life. It is not in the eye, it is in the mind. In our minds there is awareness of perfection." She also can be seen to embrace Dewey's experiential emphasis of aesthetic experience, with her many utterances similar to this: "Happiness is being on the beam with life—to feel the pull of life."[79]

When art writer Richard Polsky visited Agnes Martin at her residence in Taos in 1994, he expected to find the major artist living in splendor:

> Instead, I found her to be living what appeared to be a marginal lifestyle. She lived in an ordinary one-bedroom apartment in a humble retirement village. As my eyes scanned her walls, I figured that I might, at least, see one of her wonderful paintings, but the only picture she had hanging was a Georgia O'Keeffe. Upon closer inspection it turned out to be a Georgia O'Keeffe *poster*. The irony was that Martin was wealthy enough to afford a whole roomful of O'Keeffe *paintings*.

He asked her what she spent her money on, and she replied that she had one luxury, a new white BMW. However, she also revealed that she had set up an anonymous fund to purchase works by Abstract Expressionist artists to donate to museums. It was her way of being supportive of the art she admired.[80]

Another writer visited the artist in 2003 and observed that Martin's studio was a three-hundred-year-old adobe cottage with white walls, a skylight, and a window. "Inside it was arranged simply: a work table with paintbrushes and three rulers; a couple of chairs. Hanging on the wall was a painting in progress—a five-by-five-foot white canvas with one blue stripe on the top." At the age of ninety-one, she painted three and a half hours a day, saying, "Painting is hard work. It's very hard to paint straight. You paint vertically, but the paintings hang horizontally—there are no drips that way." The happiest part of making paintings for Martin was "when they go out the door into the world."[81]

She lived simply and routinely: "I never watch television. I have no television, I have no radio. For news, I read the headlines on the local papers. I listen to music. On CDs. Beethoven's Ninth. Beethoven is really *about* something. I go to bed at 7 P.M. I go to sleep when it gets dark, get up when it's light. Like a chicken."[82]

Joel Shapiro: Sculptures

Joel Shapiro (1941–) is an acknowledged Modernist sculptor of significance. He was born in New York City and continues to work there. He attended college intending to become a physician, but after graduating, he spent two years in the Peace Corps in India, and his interests changed from medicine to art. He completed graduate work in art at New York University. Early in his career, he won critical acclaim for small-scale sculptures of subject matter that implied human presence, such as houses and chairs. In the 1970s he turned to treelike forms, and in the 1980s to the human figure, making life-size minimalist abstractions of the body devoid of individual identity, sexual specificity, narrative, and social context—"stumbling, dancing, and falling into the viewer's space as real presences."[83]

Shapiro completed a commission for a sculptural project for the United States Holocaust Memorial Museum in Washington, DC. After the attack on the World Trade Center in New York City in 2001, he began making work that abandoned the figure and embraced chaos. Shapiro has actively exhibited and been frequently reviewed in the art press throughout his career and has been especially active since 2000 (4.3). The following analyses are of works of his made between 2000 and 2005.

4.3 Joel Shapiro | *Untitled*, **2004.**

Wood and casein, 17 x 17 x 19 inches. Photograph by: Kerry Ryan McFate. Courtesy PaceWildenstein, New York.
© 2006 Joel Shapiro/Artist Rights Society (ARS), New York.

Critical Commentary on Shapiro's Work

Steven Nash, director of the Nasher Sculpture Center, identifies Shapiro's signature elements that he uses in his figurative work (4.4) as these: "Blocky shapes formed in wood and often cast in bronze are joined in upright, dynamic compositions evocative of fragmented bodies caught in strenuous actions such as running, stretching, dancing, or lifting." He adds: "Sometimes the segments multiply in gymnastic combinations, and other times morph into suggestions of trees and branches." Nash makes the crucial observation that when Shapiro increases emphasis on a sculpture's figural presence, he "creates a back-and-forth flicker between anatomical recognition and pure abstraction that animates and complicates the viewer's experience."[84]

Michael Amy, a critic writing in *Art in America*, also emphasizes Shapiro's treatment of the figure and its references to the body:

> Shapiro has spent many years examining the severely geometricized three-dimensional human body in a state of imbalance. He showed us how the poses and gestures of anonymous stick figures could convey a gamut of emotional states, ranging from an explosive *joie de vivre* to utter despair. The reason we could project so

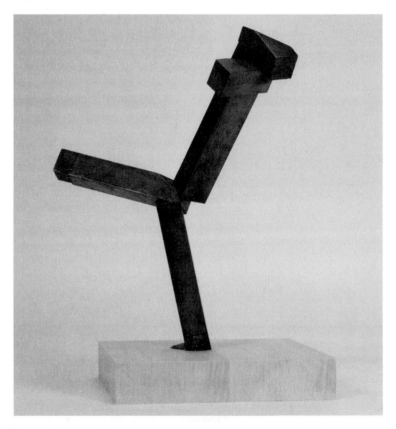

4.4 Joel Shapiro | *Untitled*, **2001–2004.**

White bronze, 16 1/4 x 12 1/2 x 11 inches. Photograph by: Kerry Ryan McFate. Courtesy PaceWildenstein, New York. © 2006 Joel Shapiro/Artist Rights Society (ARS), New York.

much meaning onto their awkward forms is that whatever the scale, they referenced our own bodies, and, like us, they inhabited and even seemed to move through actual space.[85]

These two statements by Nash and Amy emphasize Expressionist aspects of qualities of Shapiro's work—running, stretching, dancing, lifting, anatomical recognition, and emotional states ranging from joy to despair—while also referring to his use of abstraction—blocky shapes, dynamic compositions, geometricized bodies, imbalance, and scale.

If Shapiro's work is to be considered Formalist, it is not in the strict Greenbergian sense of referring only to itself or abandoning subject matter or denying references to the real world. The work, however, is highly self-conscious of the purity of its materials, embraces abstraction, and relies on its form for success (Color Plate 16).

Donald Kuspit, a philosopher and art critic, refers to Shapiro's body-based sculptures as "ambiguously figural and purely geometric" and identifies balance as the key formal principle of Shapiro's work. Kuspit notes that Shapiro's latest nonfigurative work relies on successful lack of balance:

> These constructivist balancing acts indeed convey a lack of balance—and the precariousness of all balance. In a number of works, rectangular fragments of varying lengths, densities, and textures shoot off in all directions, dispersing randomly in space with the thrust of Futurist vectors. Each piece seems like an intricate engineering feat, at once free-spirited and carefully planned. One might even say that these works are about decentering. . . . There is an air of great at-oddsness about these sculptures, a sense that they're about to tear themselves apart or collapse into chaos—that they're about "de-constructing" as well as constructing, taking apart as much as putting together.[86]

Critics writing about Shapiro's work pay much attention to his use of materials, a Formalist concern and emphasis, and its effect on meaning. Nancy Princenthal in *Art in America* comments on the artist's use of wood in his treelike constructions:

> each trunk and limb is stained a different color, and their joints are treated with the precision and care of fine cabinetry, though Shapiro likes to confound expectations with fractionally missed alignments. Equally close calculations of measurement and surface texture are reflected in similar bronze sculptures cast from wood. In these works, Shapiro finds a figure of inspired simplicity to evoke the opposing experiences of mass and buoyancy, of rootedness and dynamic growth, even of animation and its illusionary sculptural double.[87]

Barbara MacAdam in *ARTnews* also writes that Shapiro's sculptures "draw attention to the nature of their materials. The bronzes are often painted a close-to-bronze color, both confusing and reminding the viewer of the artifice of the object and reinforcing a critical distance."[88]

When Amy refers to Shapiro's new nonfigurative work, the critic is fascinated "because they evoke natural forces in almost completely abstract terms, and are thus geared not toward us, but toward nature itself. In these sculptures everything seems to be in a state of flux. When walking around the works, we see radically different

configurations, for they come alive before a mobile viewer." He attributes the success of the pieces to the artist's formal means: "their scale, organization of elements, urgency of implied movement, material, and color."[89]

In a 2005 show of his work at PaceWildenstein in New York City, Shapiro introduced "new and more daring" work that eliminates figurative references. Nash writes of "compositions that traffic solely in confident manipulations of volume, space, weight, mass, and connective tensions, works which feel liberated and satisfyingly self-sufficient . . . the language is strictly nonobjective." Although nonobjective, "this dialogue in geometry has a palpable drama and somber mood, new to a sculptor whose expression has always been more formally than emotionally oriented."[90]

Nash is most intrigued with Shapiro's new hanging constructions made of wire and wood (4.1): "These works hang in space with collapsed clusters of fragile, vulnerable forms linked by twisting wires, overwhelmed by gravity, defying verticality and geometries of construction." He refers to them as "Shapiro's exploration of disoriented collapse" that communicate "disturbing disunities" and are "suggestive of architectural disintegration, with chunks of debris held in suspension by twisted rebar and strewn utility lines."[91] Nash interprets the changes to "Formal evolution" but also to our shattered cultural topography since the collapse of the World Trade Center towers and other international disasters.

Nash concludes that Shapiro is successfully pushing boundaries of Formalism into areas it has avoided: "In a formal language that would not generally be considered conducive to social commentary or observation, Shapiro has put his finger on a pulse generated by vital human concerns. These new works address the history of sculpture but respond even more intensely to contemporary life."[92]

Shapiro's Thoughts about His Own Work

I wanted to create a sculpture that would be sympathetic to the architecture and the site. I wanted the sculpture to be large but not overwhelming, enduring but not leaden, open and expansive but not monumental, complicated but easy to read. You can see the sculpture as a joining of individual parts into a coherent and unexpected whole. I wanted it to be animate and human—about growth and conjunction. I wanted the work to use common language that all could understand. I wanted it to be accessible and moving: about the future, understood from common pasts. I wanted to make a sculpture that would represent the close historical ties and relationship between our two nations.

As this quotation indicates, Shapiro is eager to distance his work from Formalism of the type that isolates art from life. To the question posed to him, "Is it fair to say that the works are neither purely abstract, nor representational, and that they merged the influences of minimalism with human concerns?" he responded, "Yes."[93]

In referring to his figurative work (4.4), he said in 1994 that "I want the work to be animate; I want the form to be animate. Not a surrogate for a human being or for a figure, but invested with humanity and meaning." He added, "I reacted strongly to the proclamations the minimalists made, that they wanted their work to be nonreferential: that couldn't have interested me less. What I was interested in was work that was

entirely referential, so it had its own life, that referred to life rather than to some very refined, elitist experience."[94]

While he works to invest his sculptures with "humanity and meaning," he does so with an intentionally limited Formalist vocabulary. He is intrigued and motivated by "the reduced vocabulary of minimalism," although not by its ideology of aloofness from life and referentiality.[95]

He says that it is "form that engages me," and form, when successful, "is a manifestation of my own thought and feeling at the time . . . form can communicate that thought and feeling. That's what I would expect the perceiver to see." It is through his use of form that his meaning becomes manifest: "I think that if you put two forms together it's meaningful, it signifies something. It's willful, it's intentional, it's creative."[96]

Shapiro judges his work by a Formalist criterion, namely, "the standard of invention and contribution to a vocabulary."[97] He also adheres to Formalist tendencies to think of form as universally communicative: "My sense is that all artists in their syntheses—their internalization of the external—reach common psychic states that get manifest as form. To some extent it cuts through culture."[98]

Shapiro is influenced by Formalists' concern for purity of media. He recalled early work in his career: "I began to cast work in iron, I chose iron because it is fundamental. Also, it was elemental. It was a single element. I chose iron, not steel, because steel was an amalgam of metals and therefore impure. I had this notion of purity. Iron was fundamental, and you could not reduce it beyond its elemental state."[99]

The materiality of form is extremely important to Shapiro. As fellow artist Chuck Close said to him, "You were working out a lot of concerns with materiality." Shapiro agreed, adding, "I'm always interested in the process being revealed."[100] Unlike some artists who are protectively secretive about their processes and techniques of making works, Shapiro is very forthcoming about his process. Concerning his process, he says: "Meaning is elusive and making is pretty straight: push stuff around until it configures. Acceptance has to do with meeting internalized standards or their transgression. I try to push form and find meaning. It is hard to talk about meaning which is so intrinsic to the process or for that matter to the declaration of being an artist."[101]

Concerning his actual fabricating techniques (4.1, 4.3), Shapiro says:

The smaller pieces are cast directly from wood, which I put together with hot glue and pins. Sometimes I use scrap; other times I cut the wood to a certain size but inevitably it gets altered. I tend to use soft wood for speed of assembly. The means are simple and fast: band saw, hand saw, chisel, and hot glue and a pin gun—a tool that uses compressed air to shoot very thin pins into wood. It does not split the wood and allows for very fast joining so the development of form is congruent with the speed of thought.[102]

Shapiro likes to work quickly, and without too much technical fastidiousness. When he works with wood, he often works on a small scale, and he does not measure or use technically complicated joining methods for his many angular constructions. He relies on Ichiro Kato, an excellent woodworker, to scale his pieces up and measure everything exactly and join them precisely with the skills of a master carpenter. Shapiro does not

have the patience for this kind of finished redoing of work with which he is already satisfied.[103]

Many of Shapiro's sculptures that he first makes in wood are finally cast in bronze as permanent sculptures (4.4, Color Plate 16). He reflects on the materiality of the wood cast into bronze: "I want the surface to refer to the wood, how it was cut, glued, separated and flipped over. Since there is minimal patina, you see raw bronze." He also carefully faces decisions about painting some of his wooden sculptures (Color Plate 17), and whether and how to paint his bronze pieces, saying, "color and texture can unify the form or break the form."[104]

Shapiro would agree with Nelson Goodman's concept of "repleteness" as a symptom of the aesthetic; that is, in a work of art, everything counts toward meaning. In referring to one of his sculptures, Shapiro noted, "If you were looking at the joint on that little piece, the way I chose to do that is significant, and it has a psychological dimension to it."[105]

Andy Goldsworthy: Environmental Sculptures

Andy Goldsworthy (1956–) was born in England and now lives in a small rural village in Scotland: "It is cold and rains a lot up there, but he doesn't mind, spending his days pottering about the countryside searching for leaves, stones, twigs, petals and even icicles, which he fashions into lovely, evanescent sculptures that he likes to refer to as earth works." Some of his creations are permanent, and many are ephemeral, enduring in photographs that he exhibits and publishes in books. Most of these works are known only though reproduction (Color Plate 18).[106]

Goldsworthy is a popular artist among those who follow contemporary art. He usually works directly in nature with only materials gathered in nature, and his works last as long as nature allows. *Midsummer Snowballs* is a four-screen video projection of thirteen one-ton snowballs melting in different locations in London during the summertime; *Torn Stones* is a video installation showing rocks actually melting into puddles in a kiln. Other of his ephemeral pieces include "pools dyed blood red with pigment rubbed from on-site iron-oxide rocks; translucent arches of ice destined to self-destruct in the winter sun; rocks smeared with peat to coal black; thrown clouds of sand or snow, photographed at the sprayed arc of their ascent; coronas of bracken stalks fastened with thorns and hung from trees; delicate strings of pale-green rush threaded about a mossy trunk."[107]

Other of his works are likely to last for a very long time, such as his stone wall (4.5), *Storm King Wall* (alternately called *Wall That Went for a Walk*), that winds between trees at Storm King Sculpture Center in New York, which he built over a two-year period, 1997–1998, with the aid of wall-building craftsmen whom he brought from England for the project. The wall is 5 feet wide by 2278 feet long and is made of stones that Goldsworthy gathered from the Center property. The work is part of a renowned permanent outdoor collection of Modernist sculpture.

Goldsworthy's works are both his sculptures and the photographs he makes of them (Color Plates 18, 19). He has produced many gorgeous photographic books of his art works, finished and in process, including *A Collaboration with Nature* (1990), *Stone* (1994), *Wood* (1996), *Arch* (1999), *Time* (2000), *Wall* (2000), and *Hand to Earth*

4.5 Andy Goldsworthy | *Storm King Wall*, **1997–1998.**

Fieldstone, 5 x 2,278 feet. Storm King Art Center, Mountainville, New York.
© Andy Goldsworthy. Courtesy Galerie Lelong, New York.

(2004). Goldsworthy and his art are the subjects of a feature-length commercially distributed documentary film that he narrated while working in nature, revealing his inner thoughts as he works silently and alone: *Rivers and Tides: Working with Time*.[108]

Critical Commentary on Goldsworthy's Work

Goldsworthy's first one-person exhibition in the United States in 1993 at the Galerie Lelong in New York City was greeted with critical acclaim in *Art in America* magazine by David Bourdon:

> One of the sprightliest, most engaging artists to emerge from Great Britain in the last decade is Andy Goldsworthy, whose extraordinary handwork with natural materials has been featured in numerous museum exhibitions from Edinburgh to Tokyo, and who is only now getting around to having his first solo show in New York. The English-born, Scottish-based sculptor is an itinerant conjuror of Mother Nature's staples—including leaves, twigs, bark, rocks and icicles—which he assembles into abstract and sometimes startlingly elaborate configurations. The pieces are site-specific and ephemeral, most of them surviving just long enough for him to document in color photographs.[109]

The critic concludes his review with praise of Goldsworthy's sculpture, photographs, and books: "Goldsworthy's ingeniously crafted work is immensely appealing to viewers because it reawakens a childlike joy in the unexpected metamorphoses of commonplace materials. He reminds us that the first art materials available to humankind were those of the earth. His exhibition coincided with the publication of *Hand to Earth*, an enlightening and laudable book."[110]

Ken Johnson, an art critic for the *New York Times*, wrote about *Storm King Wall*, the work referred to earlier: "The wall runs straight down a hill into a pond, re-emerges on the other side and ascends into the woods. There it snakes back and forth between tall trees that grow in a straight line. It is delightful how this solid, inanimate structure seems to have an errantly playful mind of its own and fits the landscape like a glove." Johnson concludes with this highly complimentary sentence: "Few artists working today have a better sense than Mr. Goldsworthy of how to do outdoor sculpture."[111]

Commenting about Goldsworthy's corpus of work, Johnson writes: "Mr. Goldsworthy likes to use natural resources to create outdoor works of sensuously rich concreteness." The critic continues by saying, "Mr. Goldsworthy's is a paradoxical enterprise. He is almost puritanical in his insistence on using materials like sticks, stones, leaves or water found on site to create often ephemeral works that minimally affect the environment," yet Goldsworthy is "far from a pious environmental absolutist." Johnson attributes to Goldsworthy's work "magical artificiality in which there is almost always a play of opposites: between the natural and the unnatural, inside and outside, order and disorder, reality and illusion." He judges the artist's photographs "beautiful," one of which has "an extraordinary painterly intensity, yet it was made entirely of sumac leaves."

> Scottish stones
> collected from Glenluce Bay
> a shallow depression carved into the top of each stone
> into which the next stone was placed
> to make two tapered columns
> the top four or five small stones
> fixed to prevent them from being blown off by the wind
> enclosed in white cedar split rails
> the top few again fixed against the wind

In 2004, Goldsworthy completed a commission for a temporary installation on the roof garden of the Metropolitan Museum of Art in New York City. The text, in poetic form, that Goldsworthy includes with reproductions of *Stone Houses* explains and implies. The artist selected stones from his homeland, Scotland, in sizes from relatively large to small, hollowed away spaces on the top of each, and placed stones atop stones to build two tapered columns. He then obtained North American white cedar split rails from New England and built domes, eighteen feet high, over the stone columns. Anne Strauss, a curator at the Metropolitan who oversaw the project, interprets and positively judges the implications of the facts of the work:

> The sculpture, of seemingly effortless simplicity and elemental beauty, power, and mystery, is firmly rooted in the setting, with stone that has journeyed from Scotland

now sheltered by American wood. The stone columns appear fluid and ripe with energy as they rise skyward in an organic chain toward the domes' oculi, perhaps emblematic of life, each stone spawning a smaller one. The work includes a number of predominant themes that weave through Goldsworthy's oeuvre: the cross-cultural connection with his home in Scotland; the emphasis on stone as a living material, as seeds that nurture growth; the importance of the tradition of farming, evoked by the fencing rails; and the unpredictabilities, uncertainties, and unknowns of nature. Counterbalances resonate within the sculpture: a monumental, precisely constructed shelter, geometric in shape on the one hand, with delicate and balanced forms suggestive of the precariousness and vulnerability of nature on the other.[112]

Goldsworthy is Scottish. The Metropolitan, probably the most prestigious of American museums, commissioned Goldsworthy's work, but the Tate in London, the temple of Modernism in Great Britain, has yet to purchase one of his works. The implication is that the Tate does not value Goldsworthy's work as much as does the Metropolitan.

Roberta Smith, a prominent art critic who writes for the *New York Times*, is not enthusiastic about Goldsworthy's work. She reviewed *Stone Houses* at the Metropolitan and found it "a strange beast: a tentative step forward for the museum and a definite step backward for the artist." She thinks the work is "only vaguely site specific (wood plus stone equals Central Park)" and departs from his delicate ephemeral pieces in outdoor settings with their "irresistible if cheesy magic." She considers the artist

a maverick and an outsider, widely admired by the public but only gingerly embraced by the art world; a popularizer and domesticator of radical artistic ideas, not an innovator. His work blends and refines aspects of earth art, performance art, process art and set-up photography, rendering them more accessible with doses of bravura skill and finish that radical art tends to shun.

A typical Goldsworthy—which might attract conservationists, ikebana zealots and devotees of Martha Stewart alike—occurs in the wild, in a field, among trees or by a stream. Inextricable from its site, it represents a moment of ingenious, sometimes labor-intensive improvisation that transforms humble, readily available materials—leaves, twigs, stones, even snow or ice—into momentary feats of illusion.[113]

Smith seems ambivalent about Goldsworthy's ephemeral works in nature, but damns the work with her praise. She writes of the work in terms of "the exquisiteness of jewelry," says it is "implicitly pictorial, with a trompe l'oeil, even slick beauty that responds well to the [camera] lens," exhibits a "dazzling display of eccentric craft" with "mystical razzle-dazzle." She calls Goldsworthy "the Fabergé egg man of site-specific art, a magician of the earth, trees and stones whose efforts are poised between the commercial and the pure."[114]

Goldsworthy completed *Garden of Stones* (4.6), another permanent installation in New York City in 2003, for the Museum of Jewish Heritage as a memorial to the Holocaust. *Garden of Stones* is a sculptural installation consisting of granite boulders that have been hollowed out and planted with small saplings only six inches tall in

4.6 Andy Goldsworthy | *Garden of Stones*, 2003.
Dwarf oak saplings, boulders, permanent installation at the Museum of Jewish Heritage, Battery Park Plaza,
New York. A project of the Public Art Fund and the Museum of Jewish Heritage.
© Andy Goldsworthy. Courtesy of Galerie Lelong, New York.

2003 that will grow into trees if they are strong enough to endure the conditions.
Should the trees die, Goldsworthy wants them to remain in the boulders, metaphorically adding to the meanings of the work in relation to the Holocaust.

Simon Schama, a noted cultural historian, wrote an article with accompanying photographs by Richard Avedon about *Garden of Stones* for *The New Yorker*.[115] In it he

provides useful historical information concerning Goldsworthy's fit in contemporary sculpture, particularly a body of huge environmental pieces known as "earthworks." Schama's consideration of *Garden of Stones* brings out many critical concerns, both positive and negative, surrounding Goldsworthy's work. His thoughts on the history of earthworks may also put Smith's critical skepticism about the worth of Goldsworthy's work into context.

Schama explains that sculptors began making earthworks in the United States in the 1960s, the most famous of which is Robert Smithson's *Spiral Jetty*, tons of rocks he had placed with heavy machinery in Great Salt Lake, Utah, to form a spiral 1500 feet long and 15 feet wide. Artists making earthworks saw themselves as breaking out of the confines of museums and rejecting the pastoral lyricism of former landscape painters by working directly with the earth. As Schama understands them, sculptors of earthworks "aimed for an engagement with the outdoors that would break from the confinement of the rectangular frame; from freestanding sculpture that used a park or a landscape as an ornamental setting; and, above all, from the decorum of the gallery or the apartment wall."[116] American artists of earthworks would show unaesthetic documentary evidence of their works, often in the form of written documentation and photographs that were intentionally produced without aesthetic gloss. "Galleries dutifully filled up with lists, journal pages, rambling manifestos on entropy, and studiously amateurish photographs. The unreproducibility of the original epiphany was precisely the point."[117]

North America has vast spaces of wilderness; Great Britain does not. British artists working with the land "had to be respectful of ancient rights of way, reverently self-effacing." In 1967, Richard Long, for example, made *A Line Made by Walking*, a photograph of a dark line of grass made by his trampling on it. The bruising of the grass was temporary and naturally reparable. *A Line Made by Walking* became a canonical work hung on a museum wall as an aesthetic object.

Schama summarizes his sense of critical praise given to Goldsworthy's work: "its moral intensity; its Ruskinian devotion to work and craft; its scientific curiosity; its intelligent engagement with the long history of land use; its keen instinct for the baroque hyperbole of the natural world (all those mottlings and juttings and peelings and stainings)." He adds, though, that these very attributes of his work are "least likely to recommend it to the contemporary canon."[118] A writer in the popular press in London expresses the discrepancy this way: "Goldsworthy is often compared with epic natural artists like Robert Smithson (of *Spiral Jetty* fame). . . . This is rather like comparing a Great American Novel with a Scottish ballad. He is a rooted and local figure, determinedly following a road less traveled."[119]

Critics express different opinions about Goldsworthy's inside works (Color Plate 20) and outside works. Critic Benjamin Genocchio favors Goldsworthy's work that remains outside, and finds it less successful when Goldsworthy makes art to be displayed inside of art gallery walls. Genocchio refers to Goldsworthy's gallery works such as a fragile mesh of screen that Goldsworthy made from cattail stalks attached with thorns and to a drawing made of leaves that are pinned to the wall with thorns: "Each has a skilled performance in frugality, but they are all too quickly forgettable." Yet the critic admires the artists' "woolly romanticism" and his "sensitivity and gentleness."[120]

Ken Johnson is very complimentary of Goldsworthy's gallery installations: "Of all those who have made the great outdoors their studios . . . none have cultivated

nature so sensitively and photogenically as the British artist Andy Goldsworthy." Johnson admits that "indoors, one misses his magical play with found situations, materials and color," but the critic admires the two installations in Galerie Lelong in 2000, one of which is "a long, meandering line made of thin rush reeds. Attached to the wall end-to-end by thorns, the reeds create a line that wanders happily across ceilings and walls, around corners and back and forth through doorways." The other is "one entire squarish wall covered inches thick in mud. Smooth and unblemished at first, the mud has progressively dried, producing an all-over craquelure. It has a powerful Minimalist impact on its own."[121]

Goldsworthy's Thoughts about His Own Work

Goldsworthy provides detailed thoughts about his ephemeral works in nature in the movie that he narrates, *Rivers and Tides*. You see the artist as he succeeds and fails to build fragile sculptures of ice and other earthy materials on site. You also hear his thoughts on his process in a voiceover narrative that he has written and speaks.

Goldsworthy is also very forthcoming in interviews, and he frequently publishes excerpts from his diaries in his photographic books of both his ephemeral and temporary works. *Stone* (1994), *Wood* (1996), *Arch* (1999), and his other books contain a lot of commentary by the artist, as well as critical essays by commentators.

Thought about materials is essential to all of Goldsworthy's work. He selects materials very carefully and becomes familiar with what they can and cannot do through trial and error (Color Plates 18 and 19). To find the right stones for *Garden of Stones*, he searched forests and quarries in the northeastern United States, eventually finding the ones he wanted in Barre, Vermont. The smallest is three tons, and the largest is more than thirteen tons. He chose stones that would go together: "There is energy in a group of stones of various sizes. It becomes a family." The stones had been removed from farmlands hundreds of years ago by farmers, and this pleased Goldsworthy because he wanted to include "the continuation of the journey these stones have made. They have a history of movement, struggle, and change" that he related to the plight of the Jews of the Holocaust.[122]

Goldsworthy's selection of stones involves ethical as well as aesthetic concerns. It was important to him to take stones that had already been moved from their original geological site by farmers making room to grow crops.

> I prefer to take them from places like this rather than from where they have become rooted in woods. These glacial boulders have had a long and, at times, violent past—both natural and manmade. Granite originated in fire at the earth's core and rose to the surface, where it has been split, carried and worn down by glaciers. Farmers pulled out whatever they could to make fields, blasting those that they couldn't remove. When bulldozers arrived, the big stones were pushed to the edges of the fields intact, and this is the kind of boulder that I am lifting. Without machines these stones would not be there. Underlying the pastoral calm and beauty of a field is the destructive or creative violence (depending upon how you look at it) of stones and trees being ripped out to make farmland.[123]

When hauling stone for a different sculpture in another field, Goldsworthy worried: "The field is very soft, and the tractor carrying stone dug in badly. I loathe doing this to a field."[124] Later in the process of building this sculpture, he waited until the ground was frozen so as not to further damage the grass on which the sculpture set.

Once he had selected the stones, he had to discover how best to hollow them out so that he could plants trees in them. He researched different methods to hollow the stone, including water jet cutting, coring, and burning with a flame torch: "I rarely repeat a work twice, so each work is a step into the unknown." He settled on melting the stones with a flame torch: It was an efficient means, he appreciated that granite is a fire-formed stone, and he saw symbolic relations to the memorial.[125]

The selection of which tree to use was also a matter of research and thought-about scale in relationship to meaning: The saplings of the dwarf oak start out as small plants and will mature at about twelve feet: "Amidst the mass of stone the trees will appear as fragile, vulnerable flickers of life—an expression of hope for the future. The stones are not mere containers. The partnership between tree and stone will be stronger for having grown from the stone."[126]

In a summative comment on *Garden of Stones*, Goldsworthy remarked: "An artist makes things that become a focus for feelings and emotions—some personal, some public, some intended and some not. At best a work of art releases unpredictable energy that is a shock to both artist and viewer—I do not mean shock in conventional sense but an emotional tremor that articulates a feeling which has been in search of form."[127] In this quotation, he sounds very much like an Expressionist rather than a Formalist.

Goldsworthy works like a Formalist, especially in his concern for purity of materials and with what each material can do while maintaining its integrity as a material (Color Plates 18 and 19). "When I make a work, I often take it to the very edge of its collapse. And that's a very beautiful balance."[128] In one of his ephemeral pieces made in Canada, for example, he gathered tundra icicles, nibbled ends of them with his mouth, and then fused them together onto a rocky crag to form a swirl that glistened in the sun while it melted: Referring to the heat of his mouth and that of the sun, he said, "The very thing that brings the work to life is the thing that will cause its death."[129] Goldsworthy's thoughts of taking his work to the very edge of its collapse and his talk of its death are reminiscent of concepts of "the sublime."

Balance is a major principle by which Goldsworthy forms many of his pieces, and some are completely dependent on balance, such as *Stone House* on the roof of the Met, and especially a series of stone cairns he has constructed, both ephemerally and permanently, such as one he completed in his home town in Scotland, *Penpont Cairn*. Balance as a principle of art regulates how an artist works with the actual weight of materials: a measure of the heaviness or mass of an object, affected by gravitational force. Balance is equilibrium of weight and force. Andy Goldsworthy's *Penpont Cairn* depends on balance, or equilibrium of weight and force, to stand; were it not balanced, the cairn (a mound of stones made as a memorial) would topple to the ground in a heap. Goldsworthy selected stones from a quarry. The base stone for the cairn weighs six tons and was brought up the hill by machine. After the stones were delivered to the site, he cleaved each block along its grain into slices, which he further broke up into more manageable pieces.

He carefully shaped and then balanced each piece on pieces beneath it and across from it, as he raised the narrow oval from the ground, to its swelled middle, to its closed top. Goldsworthy learned to build stable structures by trial and error; many failed: "The problem is that every stone has to be well supported or it will break, and it is not possible to use many very thin stones for leveling lest they crumble under the weight of the stone above. . . . I live, work, sleep and breathe this piece at the moment. Stones laid in the day are turned over in my mind in the evening."[130]

Some of his cairns are intentionally temporary, built on the seashore while the tide was out and destroyed by the surf when the tide came in. He wants this one to last: "I have been very anxious about this sculpture and have given enormous thought to its making. I feel self-conscious about working so prominently in my home place. I will see the resulting sculpture whenever I leave and return to the village. My children will grow up with it."[131]

When he talks about his concern for the success of *Penpont Cairn*, many of his concerns are Formalist in nature. The following words are from a journal Goldsworthy kept while building the sculpture, from December 23, 1999, to January 28, 2000:

I decided to embed the [foundational] stone half in and half out of the ground.

This will raise the cairn about a foot, so that when viewed from the road, the bottom will appear to be setting directly on the hilltop—a joining of two rounded forms.

I have never made a cairn in such a critical location. The base will be so exposed against the sky when seen from the road as you walk up the hill towards it.

The dialogue between the rounded belly of the cone and the rounded hill is very strong. The cairn is beginning to have a presence. . . . I will discover whether the scale is right for the place.

There are irregularities within the shape that I find disturbing. . . . I always attempt to make the perfect cone but fail.

I feel a welling up of excitement at how good the form is.

To see the cairn against the sky as dawn breaks is so beautiful as it changes from a dark, mysterious, silhouette to a brilliantly illuminated three-dimensional object when the sun rises.

I set myself an almost impossible task: to make the perfect form by eye and hand. This is probably the best-shaped cairn I have made, but it still falls well short of perfection. . . . I know from past experience that the same irregularities that I so dislike now will become the qualities I most enjoy later.

I am delighted that [the finished cairn] should have a strong presence. Standing on the brow of the hill, it appears almost to float. Even I wondered momentarily what is holding it up!

[I am] unable to explain fully what the sculpture is about.[132]

Along with some of his critics, Goldsworthy, too, worries about if and how his work should be placed in gallery settings. He referred to a gallery at the Hotel Scribe in Paris, a space with shiny, black walls and a glossy, gray marble floor: "I never envisioned my work being placed next to gilded angels with lights. It has all been a bit tense, and I feel somewhat sickened by the prospect of having my work here."[133]

Martin, Shapiro, Goldsworthy, and Formalism

Of the three artists profiled here, the work of Agnes Martin, in her thoughts and in those of critics, fits most comfortably within contemporary conventional notions of Formalist theory. She consciously avoids politics in her art. She thinks of art as a realm unto itself apart from other realms of experience. Her mature work is completely devoid of subject matter and of narrative content. Its references are nature, but not specific places, as are Joan Mitchell's abstract Expressionist landscapes, for example; rather, they are more like Platonic Forms of ideal nature. Most critics discuss her works as Minimalist and Formalist works in a Greenbergian sense. However, there is an accepted air of vague and underdefined "spirituality" surrounding her work and her words about it that harkens back to early Modernists such as Paul Klee and, later, to the work of Mark Rothko. An apt and expected response to a successful Martin work is an aesthetic experience of it—at least one critic calls her work "sublime" in a use resonant with Shaftsbury's conception of the vastness and incomprehensibility of creation.

The work of Joel Shapiro and Andy Goldsworthy looks like it is Formalist art, but both artists distance themselves, in their talk and writing, from strict and narrow interpretations of Formalism. Shapiro wants and expects his work to refer to life outside of his artworks themselves: He has made figurative work and employs subject matters of trees, human figures, and houses; his wood and wire constructions following 9/11 are taken as referring to that catastrophe. He wants his work to have an effect on viewers. He believes he can use common and universal formal language that all can understand despite differing social contexts. As evidenced by his Holocaust memorial in Washington, DC, he does not avoid politics in his art, as do many Formalists. Critics of his work, however, tend to discuss his work primarily in Formalist terms, most notably its balance and its directional force.

Goldsworthy's art looks like an innovative incarnation of Formalist, Minimalist work with nature, and it is criticized within that framework. It has no subject matter. It is absolutely abstract and nonobjective. Although his visual sensibility looks cutting-edge, his sense of beauty seems to predate Minimalism and Greenbergian Formalism. He does not uphold separate domains of art that are apart from ethics, as do many Formalists. Some of his works are clearly Expressionist in intent, while Formalist in design and use of materials. His Expressionist leanings are most clearly evidenced in *Garden of Stones* (4.6), the Holocaust memorial for the Museum of Jewish Heritage.

It seems that critical disagreement arises because of differences between what might be called Goldsworthy's Modernism and Greenbergian Formalism. Goldsworthy clearly embraces Modernist notions of beauty that are less austere than Formalist Minimalism. Roberta Smith may well be negatively judging his work within the austere tradition of Minimalism, and within strict Formalist criteria. Similarly, the Tate's refusal to purchase a Goldsworthy work may be taken as an implied objection to his sense of beauty that is more elaborate than Minimalism. Schama, however, is generous in his application of Modernist notions of Goldsworthy's sense of aesthetically pleasing art. Goldsworthy's work, like Martin's, also has an aura of "the spiritual" about it, however undefined that spirituality is. Neither artist limits her or his work to a Minimalist's materiality.

Strengths and Weaknesses of Formalism

The major strength of Formalist theories of art is that they bring acute discriminatory attention to the ways artists of various times and places attend to different ways of shaping thoughts and feelings in physical media. Formalism is also liberatory for artists, freeing them from constraints of classical expectations of what an artwork should look like and how it should function. It frees artists from having to tell stories in visual media, from pictorial representations of reality, and from including subject matter. An artwork *need not* refer to the world beyond itself.

Formalist theories attempt to liberate humankind from crass commercial obsessions and from "bad taste" as found in kitsch and to raise consciousness to a higher level than daily concern with material existence. In the process, however, Formalist art often manages to alienate many people from new art, leaving them feeling ignorant and incapable of understanding it or, worse, feeling "put on" or taken advantage of by the artworld.

Late Formalist claims that art is a realm unto itself, and especially apart from ethics, is a powerful force in granting artists freedom of expression. The culmination of such aesthetic independence from moral concerns, perhaps, is the court case over the 1990 exhibition of Robert Mapplethorpe's photographs, *The Perfect Moment*, which contested seven sadomasochistic portraits seized by the sheriff from the Cincinnati Contemporary Art Center and the resulting unsuccessful prosecution of the Center and its director on charges of "pandering obscenity." Although the photographs in question are highly realistic images of a bullwhip inserted into the artist's rectum, a fist and forearm inserted into a rectum, a penis penetrated by a finger, and other explicitly sexual imagery, the case was successfully defended by artworld experts on the formal merits of the photographs. The jurors were sufficiently persuaded by the experts' Formalist arguments of Mapplethorpe's use of light and shadow, lushness of tone, fine print quality, and so forth, to look beyond the photographs' subject matter and to declare it "art" rather than "obscenity."

A major disadvantage of Greenbergian Formalism as made widely popular in the mid- to late twentieth century is its mandate that we ignore all that is not form in any work of art, including subject matter, narrative content, political leanings, religious bases, cultural uses, and intentions. Formalism in this very limited sense is an extremely narrow philosophy of art that cannot adequately account for all the powerful aspects of art that are not limited to its form. Narrow Formalism discourages artists from pursuing social issues and encourages them to adhere to the aesthetics of form itself. Artworld institutions generally ignored artworks that did not follow the rigors of late Formalist doctrine.

Richard Shusterman, a proponent of the value of aesthetic experience, summarizes the "continental critique" of aesthetic experience, including those by critical theorists, deconstructionists, and genealogical analysts who challenge the "immediacy" and the "radical differentiation" of the concept. Appreciation that is immediate is likely devoid of understanding that comes with interpretive efforts. Immediacy of experience robs art of cumulative meaning occurring with multiple interpretations over time: "Immediate reactions are often poor and mistaken, so interpretation is generally needed to enhance our experience." Aesthetic appreciation ignores "art's relation to the

world and its claims to truth." Shusterman also reminds us that insistence on interpretation is crucial to the philosophies of Nelson Goodman and Arthur Danto, as well as to the hermeneutic philosophy of Hans Gadamer.[134]

In reviewing a millennium exhibition of Modernist art held in Berlin, art critic Jill Lloyd notes that Greenbergian Formalism turns art into "a self-referential, aesthetic affair, cut off and removed from the turbulent history of its age,"[135] which included World War I, World War II, the Holocaust, and America's involvement in Vietnam. Contemporary Formalist artists Joel Shapiro and Andy Goldsworthy have both completed commissions in memory of the Holocaust, signaling that many current artists have distanced their work from art that is totally isolated from social concerns.

Many instructors in schools in the late twentieth century, and some currently, favor formal criteria above others. However, the strong social motivations of feminists, multiculturalists, pacifists in times of war, gay activists, and other socially engaged artists want to explore the social significance of art. "Political art" is a contradictory notion for many Formalist instructors. Debates among faculty of beginning, "foundational" courses often center around issues of teaching emphases of Formalist Modernism or Postmodernism (Chapter 5).

Calling oneself a "Formalist" artist or critic has generally fallen out of favor. Indeed, some nonobjective painters actively resist the term "Formalism," especially a Greenbergian view of Formalism. Contemporary painter Sean Scully, for example, limits his paintings to colors, stripes, and rectangles: They look very much like Formalist paintings. Scully, however, is careful to explain that his paintings are much more than formal explorations, and he expresses a strong desire "to make more than mere art." For him, his making of paintings is a moral activity and an ethical stance: Confrontations with "good and evil" are deeply imbedded in his work.[136] Art critic Armin Zweite recognizes Scully's "wish to liberate abstract painting from the ghetto of noncommittalism and hermetic isolation, and to incorporate in his pictures a reaction, albeit of a highly indirect kind, to the realities of the city, of nature, of the individual and society."[137]

Conclusion

Formalism and Artists

Formalist theory directs artists to attend to the compositional aspects of their artworks, sometimes to the exclusion of any other concerns. Formalism allows and encourages artists to explore, experiment, eliminate subject matter, and delight in abstraction and sensuousness of artistic materials and how they can be handled. Artists influenced by Formalism are especially aware of materials: Those who advocate Formalism explore the purity of a medium and what can best be done with it without making it appear to be some material that it is not. Those artists resisting Formalist concerns may intentionally produce "bad" works of art and ignore purity of media, turning to faux uses of materials and other uses considered by Formalists to be in bad taste. Artists trained narrowly in Formalism theory may be unwilling or unable to articulate concerns beyond formal concerns, no matter the art in question.

Formalism and Artworks

Formalism reminds us that it is crucial to be aware that form affects all artworks. Form is a given in any work of art; Formalism, however, is a theory of art. Strictly Formalist artworks are concerned only with form. Strict Formalists believe that art should only be judged by the merits of its form—all else is aesthetically irrelevant. All artworks are abstract to greater and lesser extents. Purely Formalist artworks, however, are usually nonobjective: Agnes Martin's best known paintings discussed in this chapter provide clear examples of nonobjective Formalist and Minimalist abstraction. Jackson Pollock's drip paintings are clear examples of exuberant Formalist action paintings. Martin's work may seem "cool" and Pollock's "hot," but both represent heights of Formalist art.

Formalism and Audiences

To those viewers unfamiliar with recent art history and art theory, Formalist art is a challenge. Much art through time and across cultures provides even uninitiated viewers with aspects to appreciate, whether that is narrative content, skill of representation, preciousness of materials, or insight into a time and place. Sparse grids of pencil lines on large canvases, such as those made by Agnes Martin, however, provide little enjoyment to those unaware of what to look at and why. More difficult yet are white on white canvases; variations of those, such as white paint on the back of stretched canvases, as made by Robert Ryman; and, earlier than these, very large canvases painted black by Ad Reinhardt. Such work generates cynicism about art and an artworld that perpetrates such seemingly nonsensical, unskilled, and visually unattractive "paintings." Formalist art requires of the viewer knowledge of art history, art theory, and notions of artistic "progress."

Questions for Further Reflection

Which of the artists and aestheticians in the chapter would match up best? Why?

What are the social advantages and disadvantages of isolating aesthetic value from other kinds of values?

Are there benefits and limitations of the concept of "disinterestedness" as a way to view a work of art?

Is "aesthetic experience" sufficiently different from other modes of experience to warrant its claims?

What are the advantages and disadvantages of viewing the world aesthetically?

What might "progress" in art mean?

Notes

1. Richard Anderson, *Calliope's Sisters: A Comparative Study of Philosophies of Art,* 2nd ed., Upper Saddle River, NJ: Pearson Prentice Hall, 2004, p. 324.

2. George Dickie, *Introduction to Aesthetics: An Analytic Approach*, New York: Oxford University Press, 1997, pp. 8–9.

3. Mary Mothersill, "David Hume: 'Of the Standard of Taste,'" *Encyclopedia of Aesthetics*, New York: Oxford University Press, 1998, p. 431.

4. Ibid.

5. Alexander Baumgarten, *Aesthetica* (1750), in Richard Eldridge, *An Introduction to the Philosophy of Art*, Cambridge, England: Cambridge University Press, 2003, p. 47.

6. Jerrold Levinson, "Philosophical Aesthetics: An Overview," in *The Oxford Handbook of Aesthetics*, ed. Jerrold Levinson, New York: Oxford University Press, 2003, pp. 6–7.

7. See, for example, John Andrew Fisher, "Environmental Aesthetics," in *The Oxford Handbook of Aesthetics*, pp. 667–678.

8. Thomas McEvilley, "Doctor Lawyer Indian Chief: 'Primitivism' in Twentieth-Century Art at the Museum of Modern Art in 1984," *Artforum*, November 1984, reprinted in *Uncontrollable Beauty: Toward a New Aesthetic*, ed. Bill Beckley, New York: Allworth Press, 1998, p. 157.

9. Susan Sontag, *On Photography*, New York: Farrar, Straus and Giroux, 1973, p. 149.

10. Dickie, *Introduction to Aesthetics*, p. 156.

11. Baldine Saint Girons, "The Sublime from Longinus to Montesquieu," *Encyclopedia of Aesthetics*, p. 323.

12. Frances Ferguson, "The Sublime from Burke to the Present," *Encyclopedia of Aesthetics*, p. 327.

13. Dickie, *Introduction to Aesthetics*, p. 12.

14. Ferguson, "The Sublime," 327.

15. Donald Crawford, "Kant," *The Routledge Companion to Aesthetics*, New York: Routledge, 2001, p. 52.

16. Paul Guyer, "Immanuel Kant: Survey of Thought," *Encyclopedia of Aesthetics*, p. 29.

17. Kenneth Westphall, "Kant on the Sublime," *Encyclopedia of Aesthetics*, p. 37.

18. Günter Zöller, "Immanuel Kant: History of Kantian Aesthetics," *Encyclopedia of Aesthetics*, 1998), p. 45.

19. Rudolf Makkreel, "Immanuel Kant: Kant and Art History," *Encyclopedia of Aesthetics*, p. 47.

20. David Fenner, "Attitude: Aesthetic Attitude," *Encyclopedia of Aesthetics*, p. 151.

21. Zöller, "Immanuel Kant," p. 44.

22. Dickie, *Introduction to Aesthetics*, p. 22.

23. Crawford, "Kant," p. 56.

24. Kant, in Dickie, *Introduction to Aesthetics*, p. 21.

25. Stephen Houlgate, "Hegel, Survey of Thought," *Encyclopedia of Aesthetics*, pp. 361–364.

26. Ibid., p. 364.

27. Lucian Krukowski, "Formalism: Conceptual and Historical Overview," *Encyclopedia of Aesthetics*, p. 364.

28. Wassily Kandinsky, *Concerning the Spiritual in Art*, New York: George Wittenborn, Inc., 1947.

29. Kermit Champa, "Piet Mondrian," *Encyclopedia of Aesthetics*, pp. 266–272.

30. Malevich, in Fred Kleiner and Christin Mamiya, *Gardner's Art Through the Ages*, 12th ed., Belmont, Calif., 2005, p. 1004.

31. Myroslava Mudrak, "Suprematism," *Encyclopedia of Aesthetics*, p. 336.

32. Clive Bell, *Art*, London: Chatto and Windus, 1914; reprint, New York: G. P. Putnam's Sons, 1958.

33. Christopher Reed, "Bloomsbury Group," *Encyclopedia of Aesthetics*, p. 287.

34. Lucian Krukowski, "Formalism: Conceptual and Historical Overview," *Encyclopedia of Aesthetics*, p. 216.

35. Clive Bell in N. Wolterstorff, "Art and the Aesthetic: The Religious Dimension," *The Blackwell Guide to Aesthetics*, ed. Peter Kivy, Malden, Mass.: Blackwell, p. 327.

36. Arthur Danto, "Clement Greenberg," May 30, 1994, in Arthur Danto, *The Madonna of the Future*, New York: Farrar, Straus and Giroux, 2000, pp. 66–67.

37. Arthur Danto, "Abstraction," in *The Madonna of the Future*, p. 195.

38. Arthur Danto, *Beyond the Brillo Box: The Visual Arts in Post-Historical Perspective*, New York: Farrar, Strauss, and Giroux, 1992, p. 9.

39. Dave Hickey, remarks at "States of Art Criticism: A Symposium," The School of the Art Institute of Chicago, October 11, 2005.

40. Nelson Goodman, *Languages of Art*, Indianapolis, Hackett, 1968.

41. James Marshall, ed. *Poststructuralism, Philosophy, Pedagogy*, Dordrecht, The Netherlands: Kluwer, 2004, p. xv.

42. Hal Foster, Rosalind Krauss, Yve-Alain Bois, and Benjamin Buchloh, *Art Since 1900*, New York: Thames and Hudson, 2004, p. 571.

43. Mark Olssen, "The School as the Microscope of Conduction: Doing Foucauldian Research in Education, in *Poststructuralism, Philosophy, Pedagogy*, p. 58.

44. Roland Barthes, *Camera Lucida: Reflections on Photography*, New York: Hill & Wang, 1981.

45. Joel Snyder, "Picturing Vision," in *The Language of Pictures*, ed. W. J. T. Mitchell, Chicago: University of Chicago Press, 1980.

46. Stuart Sim, "Structuralism," *Encyclopedia of Aesthetics*, p. 316.

47. Umberto Eco, ed., *Interpretation and Overinterpretation*, New York: Cambridge University Press, 1992, p. 105.

48. Sim, "Structuralism," p. 316.

49. Ibid., 316.

50. Roland Barthes, *S/Z*, New York: Hill & Wang, 1974.

51. Foster et al., *Art Since 1900*, p. 33.

52. Ibid., p. 33.

53. Michael Auping, "On Relationships," in *Agnes Martin/Richard Tuttle*, Fort Worth, TX: Modern Art Museum of Forth Worth, 1998, p. 106.

54. Kristine Bell, "Agnes Martin: Five Decades, February 20–April 26, 2003," Zwirner & Wirth, http://www.zwirnerandwirth.com/exhibitions/2003/022003Martin/press.html, January 1, 2006.

55. Lynne Cooke, "Agnes Martin," DIA Art Foundation, New York, http://www.diabeacon.org/exhibs_b/martin-going/essay.html, January 1, 2006.

56. Bell, "Agnes Martin."

57. Cooke, "Agnes Martin."

58. Bell, "Agnes Martin."

59. Michael Govan, "Agnes Martin," Dia, http://www.diacenter.org/exhibs_b/martin/essay.html, January 1, 2006.

60. Bell, "Agnes Martin."

61. Hal Foster, Rosalind Krauss, Yve-Alain Bois, and Benjamin Buchloh, *Art Since 1900*, New York: Thames & Hudson, 2004, p. 400.

62. Cooke, "Agnes Martin."

63. Govan, "Agnes Martin."

64. Ibid.

65. Nancy Spector, Guggenheim Museum, http://www.guggenheimcollection.org/site/artist_work_md_103_1.html, January 1, 2006.

66. Ken Johnson, "The Modernist vs. the Mystics," *New York Times*, April 12, 2005, B1 and B7, p. 7.

67. Spector, Guggenheim Museum.

68. Auping, "On Relationships," p. 106.

69. Govan, "Agnes Martin."

70. Agnes Martin, *Writings—Schriften*, Winterthur: Kunstmuseum Winterthur, in association with Cantz, Ostfildern-Ruit, 1991.

71. Art Minimal, http://members.aol.com/mindwebart4/agnes2.htm, January 1, 2006.

72. Cooke, "Agnes Martin."

73. Ibid.

74. Ibid.

75. In Auping, "On Relationships," p. 85.

76. University Art Museum, University at Albany State University of New York, http://www.albany.edu/museum/wwwmuseum/crossing/artist16.htm, January 1, 2006.

77. Cooke, "Agnes Martin," footnote 13.

78. Govan, "Agnes Martin."

79. Agnes Martin, "Beauty Is the Mystery of Life," in Charles Brummer, Iowa State University, http://www.public.iastate.edu/~brummer/culture/art/agnes.htm, January 1, 2006.

80. Richard Polsky, "Art Market Guide 2001," Artnet, http://www.artnet.com/Magazine/features/polsky/polsky5-2-01.asp, January 1, 2006.

81. Lillian Ross, "Taos Postcard: Lunch with Agnes," *The New Yorker*, July 14 and 21, 2003, p. 32.

82. Ibid., p. 33.

83. Robert Taplin, "Joel Shapiro at PaceWildenstein," *Art in America*, May 1999, online version, http://www.findarticles.com/p/articles/mi_m1248/is_5_87/ai_54574763, January 21, 2006.

84. Steven Nash, "Integration, Disintegration," in *Joel Shapiro: Work in Wood, Plaster, and Bronze 2001–2005*, New York: PaceWildenstein, 2005, pp. 5–6.

85. Michael Amy, "Joel Shapiro at PaceWildenstein," *Art in America*, October 2003, p. 124.

86. Donald Kuspit, "Joel Shapiro at Pace," *Art in America*, September 2003, online version, http://www.findarticles.com/p/articles/mi_m0268/is_n3_v32/ai_14875091, January 21, 2006.

87. Nancy Princenthal, "Joel Shapiro at Pace," *Art in America*, September 1993, online version, http://www.findarticles.com/p/articles/mi_m1248/is_n9_v81/ai_14406845, January 21, 2006.

88. Barbara MacAdam, "Joel Shapiro, Pace," *ARTnews*, October 1993, p. 160.

89. Amy, "Joel Shapiro," p. 124.

90. Nash, "Integration," p. 6.

91. Ibid., pp. 7–8.

92. Ibid., p. 9.

93. Barbaralee Diamonstein, *Inside the Art Word: Conversations with Barbaralee Diamonstein*, New York: Rizzoli, 1994, p. 236.

94. Ibid., p. 235.

95. Ibid., p. 236.

96. Ibid., p. 236.

97. Ibid., p. 235.

98. Amy Newman, "Interview with Joel Shapiro," *Joel Shapiro: Recent Sculpture and Drawings*, New York: Pacewildenstein, 2001, p. 9.

99. Chuck Close, *The Portraits Speak: Chuck Close in Conversation with 27 of His Subjects*, New York: Art Press, 1997, p. 572.

100. Joel Shapiro, in Close, p. 577.

101. Newman, "Interview with Joel Shapiro," p. 9.

102. Ibid., p. 7.

103. Diamonstein, *Inside the Art World*, p. 238.

104. Newman, "Interview with Joel Shapiro," p. 8.

105. Diamonstein, *Inside the Art World*, p. 236.

106. Benjamin Genocchio, "Bewitched by Nature and Its Ephemera," *New York Times*, February 23, 2003, online version, http://query.nytimes.com/gst/fullpage.html?res= 9C04E0D8113DF930A15751C0A9659C8B63, January 12, 2006.

107. Simon Schama, "Garden of Stones," first published in *The New Yorker*, September 22, 2003, reprinted in Andy Goldsworthy, *Passage*, New York: Abrams, 2004.

108. Andy Goldsworthy, *Rivers and Tides: Working with Time*, a film by Thomas Riedelsheimer, available on DVD from Documdrama, http://www.docudrama.com.

109. David Bourdon, "Andy Goldsworthy at Lelong—New York, New York—Review of Exhibitions," *Art in America*, November 1933, online version, http://www.findarticles.com/p/ articles/mi_m1248/is_n11_v81/ai_14647058, January 12, 2006.

110. Ibid.

111. Ken Johnson, "Indoor-Outdoor Relations along the Hudson Valley," *New York Times*, July 21, 2000, online version, http://query.nytimes.com/gst/fullpage.html?res=9F03EFD61 F3BF932A15754C0A9669C8B63, January 12, 2006.

112. Anne L. Strauss, "Stone Houses," New York: The Metropolitan Museum of Art, 2004, p. 57.

113. Roberta Smith, "The Met and a Guest Step Off in Opposite Directions," *New York Times*, September 3, 2004, online version, http://www.nytimes.com/2004/09/03/arts/design/ X03SMIT.html?ex=1137214800&en=5231edd7271ee699&ei=5070, January 12, 2006.

114. Ibid.

115. Schama, "Garden of Stones," p. 59.

116. Ibid., p. 59.

117. Ibid., p. 60.

118. Ibid., p. 61.

119. Tim Adams, "The Call of the Wild," *The Observer*, January 26, 2005, online version, http://www.guardian.co.uk/arts/reviews/observer/story/0,14467,1391227,00.html, January 11, 2005.

120. Genocchio, "Bewitched by Nature."

121. Ken Johnson, "Andy Goldsworthy," *New York Times*, June 9, 2000, online version, http://query.nytimes.com/gst/fullpage.html?res=9B02EED9113 FF93AA35755C0A9, January 20, 2006.

122. Museum of Jewish Heritage, "Garden of Stones," http://www.mjhnyc.org/visit_gar denofstones.htm, January 13, 2006.

123. Schama, "Garden of Stones," p. 63.

124. Goldsworthy, *Passage*, p. 7.

125. Museum of Jewish Heritage, "Garden of Stones."

126. Ibid.

127. Schama, "Garden of Stones," p. 69.

128. Ed Halter, "Things Fall Apart," *Village Voice*, January 1–7, 2003, online version, http:// www.villagevoice.com/film/0301,halter2,40899,20.html, January 14, 2006.

129. Ibid.

130. Goldsworthy, *Passage*, pp. 7–8.

131. Ibid., p. 7

132. Ibid., pp. 6–12.

133. Ibid., p. 7.

134. Richard Shusterman, "The End of Aesthetic Experience," *The Journal of Aesthetics and Art Criticism*, Vol. 55, No. 1, Winter, 1997, pp. 29–41.

135. Jill Lloyd, "Berlin Twentieth-Century Modernism," *The Burlington Magazine*, Vol. 139, No. 1133, August 1997, pp. 565–567, http://links.jstor.org/sici?sici=0007-6287%28199708%29139%3A1133%3C565%3ATMB%3E2.0.CO%3B2-8, January 17, 2006.

136. In Ned Rifkin, "Interview with Sean Scully," May 20, 1994, in *Sean Scully: Twenty Years, 1976–1995*, London: Thames & Hudson, 1995, p. 57.

137. Armin Zweite, "To Humanize Abstract Painting: Reflections on Sean Scully's *Stone Light*," tr. by John Ormrod, in *Sean Scully*, pp. 21–22.

5.1 Lorna Simpson | *Guarded Conditions*, 1989.

Eighteen color Polaroid prints, twenty-one plastic plaques, and plastic letters, 91 x 131 inches.
Courtesy of the artist and Sean Kelly Gallery, New York. Used with permission. 2006.

5 | Postmodern Pluralism

ART DESTABILIZES THE GOOD, THE TRUE, THE BEAUTIFUL, AND THE SELF

Introduction

Philosopher Richard Shusterman begins "Aesthetics and Postmodernism" with this sentence: "Perhaps the clearest and most certain thing that can be said about postmodernism is that it is a very unclear and very much contested concept." However, he concludes the chapter by arguing that Postmodernism "insists that art and aesthetics are too powerful and pervasive in our social, ethical, and political world to be considered on their own apart from their non-aesthetic influences. If it diminishes the sublime claims of high art, postmodernism compensates by making aesthetics more central to the mainstream issues of life."[1]

There are some initial points to be made about Shusterman's article. First, it is the second-to-last chapter in a book of forty-eight chapters and is the only chapter to deal exclusively with Postmodernism. Anglo-American philosophers do not generally embrace Postmodernism: Postmodernist writing is primarily a continental endeavor and is predominantly French. Although Anglo-American analytic philosophy prizes clarity of reason, in the Enlightenment tradition, Postmodernist writers are quite content with lack of clarity, delighting in wordplay that often resists analytic explanation.

Shusterman acknowledges Postmodernism's lack of clarity. He calls Postmodernism a "concept" rather than a "theory" or a "philosophy," and others call it a "movement" or a "set of attitudes" or a "condition." Shusterman's second point is that Postmodernism is a contested concept: Postmodernists themselves hold different positions, and philosophers of other traditions are often hostile to Postmodernist claims and conclusions. Nonetheless, Shusterman, an American Pragmatist, values aspects of Postmodernist critiques of Modernist aesthetics and Formalist theory because Postmodernists will not allow art and aesthetics to be considered apart and aloof from the social, ethical, and political world. Postmodernists (and Shusterman) think art and aesthetics are too important to be isolated from life.

American philosopher and critic Arthur Danto also observes that "philosophy has almost been immune to the impact of what has, since the 1970s, been called Theory—a body of largely deconstructionist strategies that has inflected nearly every other branch of the humanities," except philosophical aesthetics. He, along with Shusterman, thinks that Postmodernist theory was not taken seriously by mainline

philosophers because "the language in which [it was] written was perceived as grotesquely at odds with the standards of clarity and consequence to which philosophical writing was expected to perform." It is telling that most university art departments are offering seminars in "theory" rather than in "aesthetics," considered a conservative and remote area irrelevant to contemporary (Postmodern) art practice. Danto also observes that "aestheticians are not interested enough in art to pay for it," referring to a poster he commissioned Saul Steinberg to make for an aesthetics conference, which did not sell.[2]

This chapter accepts the challenge of trying to clarify Postmodernism and its integral relation to Poststructuralism. It also seeks to show its importance to current artmaking and its interpretation and evaluation. Finally, it attempts to make Poststructuralist and Postmodernist thinking and art more attractive to traditional aesthetic philosophy.

Precursors to Poststructuralism and Postmodernism

There are many scholars who profoundly influence Modernism and Postmodernism. Their ideas remain relevant today, although they have been furthered by scholars who have benefited from their pioneering work. The writings of Marx and Freud are very contributory and have already been discussed in Chapter 3. Other contributors follow.

Friedrich Nietzsche

The German philosopher Nietzsche (1844–1900) is as important to Postmodernism and Poststructuralism as Kant is to Modernism and Formalism. He is a precursor to whom many who come after him acknowledge their debts to his thought: Heidegger,[3] Derrida,[4] Foucault,[5] and Danto[6] are some of the many who have written on Nietzsche and his influence through the thirty books the philosopher has authored.

One of the most influential themes relevant to all life and to art provided by Nietzsche is a distinction he arrived at while investigating Greek tragedy: the Apollonian and the Dionysian. The Apollonian represents order, clearly marked borders, and static beauty. The Dionysian represents a collapse of borders, frenzy, and excess. The Apollonian is close to Formalism. The Dionysian embraces ambiguity, content beneath the visible surface, and messy complexity that a "detached" gaze cannot reveal.[7]

Nietzsche rejects the concept of "disinterestedness" while apprehending art proposed by Kant and supported later by the German philosopher Arthur Schopenhauer (1788–1860), with whom Nietzsche takes issue on the topic. Schopenhauer sees disinterestedness and lack of will as essential to the aesthetic state. In ordinary consciousness we look at things practically for their use value, and, according to Schopenhauer, such views give us an object's "relative" rather than "absolute essence." Routines of ordinary viewing rely on clichés that result in viewing the world as boring and oppressive. Artists, however, view the world in its full richness, and objects become open to novel views, sparkling views that can result in beauty available to both artist and viewer. Nietzsche, however, stresses willfulness in all of his philosophy and rejects Schopenhauer's "will-lessness": Nietzsche advocates active seeing and interpreting, he embraces ambiguity, and he engages in hidden depths of works of art. Nietzsche

upholds aesthetics over politics: He doubts that the ills of existence can be solved by politics and instead advocates that an aesthetic appreciation of life can provide meaning and significance. The essence of aesthetic doing and seeing for Nietzsche is willful transfiguration and transformation toward perfection. The aroused and frenzied will is the motivating power of aesthetic perception.[8]

Philosopher Michael Peters succinctly summarizes the importance of Nietzsche's work to Poststructuralist and Postmodernist thinking:

> Nietzsche's critique of truth, his emphasis on interpretation and the differential relations of power and knowledge, and his attention to questions of style in philosophical discourse have become central motifs within the works of the poststructuralists, who have developed these Nietzschean themes in a number of ways: by attending to questions of language, power, and desire in ways that emphasize the content in which meaning is produced while making problematic all universal truth and meaning claims; by challenging the assumptions that give rise to binary, oppositional thinking, often opting to affirm that which occupies a position of subordination within a differential network; by questioning the figure of the humanistic human subject, challenging the assumptions of autonomy and transparent self-consciousness while situating the subject as a complex intersection of discursive, libidinal, and social forces and practices; by resisting the impulse toward claims of universality and unity, preferring instead to acknowledge difference and fragmentation.[9]

Critical Theory, the Frankfurt School, and Neo-Marxism

The three terms *critical theory*, the *Frankfurt School*, and *Neo-Marxism* are often used interchangeably. *Critical theory* designates an approach to the study of society between 1930 and 1970 by members of the *Frankfurt School*, which was first comprised of a group of theorists associating with the Institute for Social Research founded in Frankfurt, Germany, in 1923. They were among Jewish scholars chased from Germany by the rise of the Nazis. The group relocated in New York City as the New School for Social Research. After World War II, some members returned to Germany and others remained in the United States. It is *Neo-Marxist* because it identifies limitations of traditional Marxism and updates it to meet current times. Critical theory is multidisciplinary, drawing from many areas of theoretical investigation, both philosophical and empirical.

Max Horkheimer (1895–1973), Theodor Adorno, and Herbert Marcuse (1898–1979) were very influential thinkers in the group. They saw modern Western society turning into closed totalitarian systems that eliminated individual autonomy. They meant critical theory to resist totalitarianism of any form through internal criticism: Every society ought to be seen to be making an implicit claim to allow its members to live a good life. Through immanent criticism, critical theorists sought to show how different societies fail to live up to their own claims.[10]

Jurgen Habermas (1929–) is a leading member of the school in recent years. Like other members of the school, he insists that the sciences are ideologically dependent rather than neutral and that Enlightenment reason has become oppressive. They point to values embodied in science, such as the desirability of the technological domination

of nature, which *seems* a self-evident good based on disinterested devotion to science, although such a value is questionable. Habermas and others envision communication that involves all rational subjects free of domination and error-inducing vested interests. He promotes psychoanalysis and other non-Marxian liberatory methods.[11]

Theodor Adorno (1903–1969) is a particularly important critical theorist regarding aesthetics and is the author of *Aesthetic Theory*,[12] published posthumously. Walter Benjamin (1892–1940) was a friend, and the two influenced one another's thinking, with Benjamin encouraging Adorno's interest in Karl Marx. Adorno's style of writing predates that of Jacques Derrida, who shared Adorno's assertion that no thought escapes the influence of the marketplace or transcends the discourse it is critiquing.[13]

Adorno critiques "the culture industry" (popular culture, popular media, and culture that produces commodities for mass consumption), which he believes dampens innovation by promoting passive viewers and deadening political awareness. The culture industry objectifies people as politically apathetic, passive consumers; it seeks only profit and exploits the masses (think of globalization and the entertainment industry). "True art" is the antidote. It is autonomous and resists commercialization and preserves subjectivity, protecting it from objectification. Art can provide genuine happiness rather than the fleeting sensations that popular media provides. Art offers true content that can offset popular media and transform society. Art challenges conformity and passivity. Clement Greenberg was influenced by Adorno's thinking that art ought to resist the deadening effects of mass-produced culture, or kitsch.[14]

Poststructuralism

It is difficult to sort out Structuralists from Poststructuralists because many moved from the former group to the latter, and many refused to acknowledge being either. Glen Ward, artist, scholar of visual culture, and author of an introductory overview called *Postmodernism*, provides some helpful generalizations about Poststructuralism. Poststructuralists, like Structuralists, continue to ask questions about meanings and "texts" of all sorts but provide a broader range of answers and resist any single answer. Poststructuralism is neither a single system of thought nor an academic discipline. It is an approach to study that freely mixes many disciplines, including philosophy, political theory, psychoanalytic theory, literary studies, semiotics, structuralism, and feminism.

Glen Ward ascribes to Poststructuralism three broad and overlapping ideas inherited from Structuralism: "language cannot point outside of itself; languages produce (rather than reflect) meaning; language does not express individuality."[15] Poststructuralists, like Structuralists, continue to distance "texts" from "reality" and from individual authors, but unlike Structuralists, Poststructuralists reject any ultimate, foundational grounds beneath meaning. Structuralists believe they can find eternal global truths behind all "texts"; Poststructuralists believe that we are limited by our own area of inquiry and cannot and should not attempt an explanation of everything. Structuralists tend to think of language as relatively stable and even "tyrannical"; Poststructuralists stress "difference" and see any "text" as always in process and never finished, never whole.[16]

The following are summaries of some ideas relevant to aesthetics and current art criticism by Lacan, Foucault, Barthes, Derrida, Deleuze and Guattari, Kristeva, and Rorty. Each of these scholars are major contributors to Poststructuralist and, in turn, Postmodernist thinking.

Jacques Lacan

Lacan (1908–1981) was a French psychoanalytic theorist and clinical psychiatrist who radically reinterpreted the work of Freud by including insights from Saussure, Levi-Strauss, and Structuralist linguistic theorists. He reworked Freudian developmental theory to account for the biological being becoming "human" and the influence of language and ideology on the formation of the biological being's identity. Freud placed emphasis on the biological creature that is born with natural instincts and the conflicts that arise when the psyche is confronted with cultural forces. Whereas Freud believed that many such conflicts can be resolved through psychotherapy, Lacan accepted that discord and fracture constitute the psyche. Lacan is the most famous of "philosophers of desire," who distinguish themselves from rationalist philosophers, especially philosophers of Modernism. Desire, rather than reason, is what drives the world.

Lacan's writing is allusive and punning, not wanting "to inform but to evoke," and is influenced by Surrealism, giving a feel for the way the subconscious operates. In Lacan's view, the subject is without a center and is characterized by "lack." He deflates the commonsense notion of identity by arguing that individual autonomy is an illusion. Lacan distinguishes between need, desire, and demand. The self or subject is structured through recognition of "the other," and through this necessary recognition comes an awareness of one's own lack. Language precedes consciousness, and it directs and mediates one's desires. The child's entry into language marks its transition from merely biological to human.[17]

The subject is dependent on three interdependent and inseparable orders: the Symbolic, the Imaginary, and the Real. The ego or conscious self is not biologically determined, nor is it autonomous. The subject becomes an "I" only when it enters the Symbolic order that is constituted by preexisting language and desire, which is caused by the child's separation from the mother, and also by the father's interference in the relationship of the child and its mother. Language and the father signify prohibition and authority.

The order of the Imaginary is a mix of "self as other" and "self and other." Lacan's famous "mirror stage" is part of the Imaginary. In the Imaginary order, during the mirror stage of development, the child between the age of six and eighteen months becomes aware of itself as an image. It recognizes itself in a mirror and it identifies with its own image as a whole but also experiences its uncoordinated body as fragmented. The mirror stage constitutes a sense of alienation: Lacan writes, "to know oneself through an external image is to be defined through self-alienation."[18] The child sees "self as other." The child also sees "self and other" when it sees the adult holding it in front of the mirror.

Lacanian thinking influences art criticism, notably writing by Hal Foster, whose work on Cindy Sherman and Paul McCarthy is taken up later in this chapter. Lacan's

"mirror stage" of psychic development has been instrumental in furthering theoretical work in film theory, notably Laura Mulvey's,[19] and all lens-based media, including perspectival renderings in drawing and painting. Lacan's theory of "the gaze" is particularly compelling for many artists and critics. The gaze reveals to Lacan a split between eye and sight: Sight examines what one looks at, but the gaze emanates from what one looks at. There is asymmetry in the relation between the sight of the self and the gaze of the thing looking back: As Lacan writes, "You never look at me from the place from which I see you." The gaze reinforces Lacan's notion of the subject within the self.[20]

Lacan looks to art to understand how we represent ourselves in relation to desire. He challenges us to view art with two tasks: (1) Recognize our own desire in looking; and (2) listen, read, and interpret the "text," not the "author." Lacan pleads, "Please give more attention to text rather than to the psychology of the author."[21]

Michel Foucault

Foucault (1926–1984) saw philosophy as a work upon the self through which the individual can resist dominant and controlling institutions by developing individual ethics to form an admirable life. Foucault took up personal issues as starting points of larger investigations: power and knowledge, the constitution of subjects, bio-power and governmentality, and normalization. He contributed two influential approaches to analyzing social phenomena: *archaeology*, by which he describes the historical assumptions underlying any system of thought, and *genealogy*, by which he reveals how any given thought system develops and is transformed.[22] In tracing histories of ideas and institutions, Foucault was influenced by Nietzsche's idea that history is always written from the perspective of the present and fills a need of the present.

Foucault is especially known for linking power, knowledge, and body. He rejects the "totalizing grand narratives" of Marxist and humanist models of power, which hold that power is possessed, that it flows from top to bottom, and that it is primarily repressive. Instead, Foucault shows that power is exercised rather than possessed, that it can be productive as well as repressive, and that it is omnipresent. His explorations of power-knowledge-body are focused on "madness," the rise of the prison, and the history of sexuality. Foucault was trained in both philosophy and psychopathology, worked in a mental institution when he was young, and later formed a group that gave voice to prisoners. Late in his life he wrote three volumes of *The History of Sexuality*, a project that remained unfinished when he died of AIDS-related illness.

Foucault's analysis of prisons can serve as an example of his model of power-knowledge-body. He examines the history of prisons as one of many controlling institutions in the nineteenth century, such as the army, the factory, the school, and the prison. Each of these institutions discipline the bodies of their subjects through real and perceived surveillance. The Panopticon, an architectural design of a prison by Jeremy Bentham, allows the surveillance of a large number of prisoners by a small number of guards, often invisible. Eventually the prisoners are the embodiment of surveillance and the actual guards are almost rendered obsolete. The prison is a social tool of knowledge that forms subjects in an inextricable link of embodied knowledge and power. Social critics of photography such as Susan Sontag and Allan Sekula apply Foucault's analysis of the surveillance of the Panopticon to photography.

Foucault had a long-standing interest in Surrealism and wrote an essay about Rene Magritte's painting *This Is Not a Pipe*, a representational painting of a pipe with the words "this is not a pipe" painted onto the same canvas. The painting is significant for many Postmodernist artists because of its mixing of the codes of painting and language, its denial of the assuredness of representations, and its acknowledgment of the arbitrariness of signifying systems. Foucault uses the painting to put forth differences between "resemblance" and "similitude." Resemblance, in Foucault's explanation, relies on a model, a referent, or an origin in the world. Paintings made between the fifteenth and twentieth centuries are hierarchically ordered according to the fidelity of the copies to the models (that is, "realism"). Similitude, however, obeys no hierarchy but propagates itself from small difference to small difference. Resemblance predicates itself on a model to which it must return, but similitude circulates as infinite relations of the similar to the similar. Magritte breaks the system of representation to the thing represented. Magritte's painting is a relation of "text" to "text" rather than of text to "reality." Both texts and images, for Foucault, circulate around "the ghost of the thing-itself."[23]

Julia Kristeva

Similarly, Julia Kristeva (1941–), a Bulgarian philosopher, psychoanalyst, novelist, and feminist working in France, moved away from fixed Structuralist notions of social phenomena and argues for understanding of such phenomena to be "in process." Kristeva, a student and colleague of Barthes, is especially important for furthering the notion of "intertextuality" by which she, Barthes, and others mean that every text is an intertextual "mosaic of quotations" drawn from other texts (signifying systems). Attribution of meaning is thus shifted from the author to the reader, who puts together a network of relations from other texts. This idea severely challenges Modernist notions of originality and artistic genius.

In his genealogy of Poststructuralism, American philosopher Alan Schrift puts forth Poststructuralism as "a loose association of thinkers" rather than as a theory with a uniform set of shared assumptions.[24] Poststructuralists such as Jean Baudrillard, Jacques Derrida, Michel Foucault, Jean-François Lyotard, Gilles Deleuze, Luce Irigaray, Julia Kristeva, Georges Bataille, and Jacques Lacan draw upon a variety of sources, but especially the German philosopher Friedrich Nietzsche (1844–1900).

Kristeva contributes significantly to the concept of the abject, a predominant theme in Postmodern art. She describes one form of abjection as "loathing an item of food, a piece of filth, waste, or dung. The spasms and vomiting that protect me. The repugnance, the retching that thrusts me to the side and turns me away from defilement, sewage, and muck. The shame of compromise, of being in the middle of treachery. The fascinated start that leads me toward and separates me from them."[25] She examines personal items of disgust, but also places them in social contexts, examining them as taboos. Every culture constructs boundaries about its abject and jettisons as taboos what is too threatening to it. Taboos arise from family and sexuality and affect the status and treatment of men and women across cultures. In Kristeva's psychoanalytic theory, the subject's relation to abjection is ultimately rooted in the fight that every human engages in with his or her mother when one cuts the instinctual bond of the mother and child to become autonomous.[26]

David Hopkins, an art historian of recent art, describes Kristeva's concept: "*abjec-tion* covers both an action, of abjecting, by which primordial experiences of the separation of inside and outside, or self and other, are re-experienced via bodily expulsions, and a wretched condition, that of being abject."[27] Curators for the Tate Modern comment on the relevancy of Kristeva's abject in recent works of art:

> The abject is a complex psychological, philosophical and linguistic concept developed by Julia Kristeva in her 1980 book *Powers of Horror*. She was partly influenced by the earlier ideas of the French writer, thinker and dissident Surrealist Georges Bataille. It can be said very simply that the abject consists of those elements, particularly of the body, that transgress and threaten our sense of cleanliness and propriety. Kristeva herself commented "refuse and corpses show me what I permanently thrust aside in order to live." In practice the abject covers all the bodily functions, or aspects of the body, that are deemed impure or inappropriate for public display or discussion. The abject has a strong feminist context, in that female bodily functions in particular are "abjected" by a patriarchal social order. In the 1980s and 1990s many artists became aware of this theory and reflected it in their work.[28]

Jacques Derrida

The most influential of the Poststructuralists is Jacques Derrida (1930–2004), the prolific French philosopher and literary critic credited with being the founder of Deconstruction. As a student in the 1950s, he worked with Michel Foucault and Louis Althusser. His earliest work was a study of Edmund Husserl (1859–1938), a German philosopher known as the founder of phenomenology who influenced Martin Heidegger, whom Derrida also studied. Nietzsche is another major influence on Derrida's thought.

In 1966 Derrida delivered a paper that was both laudatory and critical of Structuralism at Johns Hopkins University to an American audience becoming familiar with Structuralism. At that conference Derrida met Jacques Lacan and became friends with Paul de Man, who became an influential literary Deconstructionist critic. Derrida introduced Deconstruction at the conference, his most influential and controversial concept. Much of the controversy over Deconstruction is its ambiguity, and part of that ambiguity is Derrida's refusal to allow Deconstruction to be a fixed method or to allow the concept to be immune from its own critique. Nor did he allow himself the comfort of choices between understanding and misunderstanding, holding that each is part of the other.

When one deconstructs a text, one opens it to a range of meanings and interpretations, usually by finding key ideas in the text that usually turn out to be binary, oppositional, and rigidly fixed by definition: for example, good and evil, male and female. The oppositions are often "violent hierarchies," whereby one is given superiority and the other inferiority: West/East, light/dark, heterosexual/homosexual, us/them. A text depends on these oppositions. A Deconstructionist reading, however, shows that the two terms are not as fixed or stable as first thought but are ambiguous and eventually subvert each other in the text's internal logic. Derrida does not do something to a text, he sees what the text does to itself.

A concept interrelated with binary oppositions is what Derrida calls the false notion of "the metaphysics of presence"—the myth that things have meaning before we put language to them. In this Derrida is consistent with Saussure and the Structuralists, who argue that language is a self-referring system that does not get outside of itself. Derrida, however, denies the notion of essentialist "deep structures."

Derrida's use of *différance* marks a break with Saussure's account of meaning. *Différance* is a French term meaning both "to differ" and "to defer." The term has both active and passive senses. When one looks up a word in a dictionary one is faced with other words, some of which one needs to also look up. Meaning is deferred, delayed. A meaning of a word is also dependent on its difference from other words. Derrida's *différance* connotes "the restlessness of language and the slipperiness of meaning." Derrida does not look for stable linguistic patterns, as does Saussure.

A major tenet of both Structuralism and Deconstruction is that writing is never able to be neutral or transparent: We cannot simply see through language to arrive at "the real." Further, writing is highly selective by what it includes and excludes in any given text. Any event or phenomenon could be explained in any number of ways depending on one's position. Written and spoken language is always tied to interpretation, which is influenced by society, history, and politics. Texts are selective in what they reveal and conceal: What is central to a text is made so by what is made marginal in the same text. Thus Derrida looks for "present absences" or "productive silences" that "haunt" a text.

Mary Klages, an American literary scholar, offers a way to deconstruct a text:

Find a binary opposition. Show how each term, rather than being polar opposite of its paired term, is actually part of it. Then the structure or opposition which kept them apart collapses. . . . Ultimately, you can't tell which is which, and the idea of binary opposites loses meaning, or is put into "play." This method is called "Deconstruction" because it is a combination of construction/destruction—the idea is that you don't simply construct a new system of binaries, with the previously subordinated term on top, nor do you destroy the old system—rather, you deconstruct the old system by showing how its basic units of structuration (binary pairs and the rules for their combination) contradict their own logic.[29]

Although Warren Hedges acknowledges Derrida's refusal to reduce Deconstruction to a method, he summarizes recurring foci of Deconstruction in literary studies: Explorations and excavations of tensions and instabilities within a text, highlighting what a text does to itself; questioning hierarchies set up in oppositions; charting how hierarchical key terms, motifs, or characters are defined by oppositions and show how these oppositions are unstable, reversible, and mutually dependent on one another; and attending to how texts subvert, go beyond, or even undermine an author's stated purpose.[30]

Gilles Deleuze and Felix Guattari

Gilles Deleuze (1925–1995), a French philosopher, is more embracing of systematic thinking than other Poststructuralists, is more optimistic than many, is less skeptical of empiricism, and embraces creativity toward social life, politics, education, and art in an

unpredictable world. His writings include a mixture of philosophy, science fiction, and nonsensical writing in the manner of Lewis Carroll. Deleuze accepts aspects of Modernist thinking but rejects rationalism and transcendentalism in all its forms, including Hegel's, in favor of a respect for the particular and the plural and hence for "difference." He is very concerned with ethics and asserts "philosophy must constitute itself as the theory of what we are doing, not as a theory of what there is."[31] Transcendence for Deleuze is violence.

Deleuze subordinates critique and negativity to a positive exploration of existence— "laughter, roars of laughter"—by an insistence on plurality to guard against a tyrannical unity and an insistence on becoming to guard against the tyranny of identity.[32] He was drawn to philosophers (Lucretius, Hume, Spinoza, Nietzsche, and Bergson) of the past who were united by a "secret link which resides in the critique of negativity, the cultivation of joy, the hatred of interiority, the exteriority of forces and relations, the denunciation of power."[33]

Felix Guattari (1930–1992), a French psychoanalyst trained in Lacanian theory, was politically active and participated in the upheavals of 1968. He resists what he sees as cynicism in much Postmodernist thinking and postmodern political inaction, which yields it conservative. He began collaborating with Deleuze in 1969. Guattari and Deleuze advocate radical social change through a liberation of desire by which individuals free themselves from Modernist notions of fixed identity. They share much with Foucault, but unlike him, they are less critical of knowledge and rationality but critique capitalist society and hold onto some positive and liberating aspects of Modernism. However, neither Foucault, Deleuze, nor Guattari embraces Marxism.[34]

Deleuze and Guattari take up and further Nietzsche's critique of Modernist representation and reject Realist theories that claim the world can be represented or reflected without the mediations of language, culture, and the body. Perception of the world is dependent on discourse and subjectivities that are socially constructed. Deleuze deconstructs Plato's binaries between essences and appearances and instead embraces difference, impermanence, contradiction, nonidentity, and simulacra.[35]

Richard Rorty

Rorty (1931–), an American Pragmatist, constructively draws upon aspects of the theories of Darwin, Dewey, Hegel, Nietzsche, Heidegger, Wittgenstein, and Derrida in deconstructing Modernist epistemology and metaphysics. Regarding images and other "texts," Rorty is particularly adamant about rejecting the idea that knowledge is representation or that knowledge is a mental mirroring of a world external of the mind: "My strategy . . . is to move everything over from epistemology and metaphysics into cultural politics, from claims to knowledge and appeals to self-evidence to suggestions about what we should try." He rejects positions that draw lines between what is made and what is found, the subjective and objective, and what is mere appearance and what is real. Such distinctions and applications are always bound by contingent contexts and interests. He adopts a "conversationalist view" of knowledge: "We understand knowledge when we understand the social justification of belief, and thus have no need to view it as accuracy of representation."[36]

Such pragmatic epistemological views bear on making images as well as interpreting them. Rorty is never after the "real meaning" of a "text," not believing there is such a thing. For Rorty interpreting "texts" is a matter of "reading them in light of other texts, people, obsessions, and bits of information, or what have you, and then seeing what happens."[37] Rorty continues, "For us pragmatists, the notion that there is something a given text is *really* about, something which rigorous application of method will reveal, is as bad as the Aristotelian idea that there is something which a substance really, intrinsically, is as opposed to what it only apparently or accidentally or relationally is."

Rorty admits to being a romantic liberal, rejecting political extremes of the right and the left; he believes that we can advance economic justice, increase freedoms of citizens, by deepening and widening solidarity among humans. Regarding social justice, our task is to sensitize ourselves to the suffering of others, depend and expand our ability to identify with others, think of others as being like ourselves in morally relevant ways, and reduce suffering and combat cruelty. He advocates redescriptions of events and new vocabularies for ideas in order to contribute to more just practices.

Rorty advocates democratic exchanges of views to discover what works rather than what is said to be "true." Good science provides one model. Rorty acknowledges different vocabularies for different purposes and problems, and our vocabularies are tools. No single vocabulary is better than another at arriving at what is "true"; to say so would be like claiming a hammer is better than scissors. The usefulness of the tool or the vocabulary depends on the problem one is trying to solve.[38]

Feminism

In an influential article in 1971, art historian Linda Nochlin published "Why Have There Been No Great Women Artists?"[39] Her answer, very briefly, was for the same reasons there are no great Alaskan tennis players. Institutional, educational, and economic factors prevented the development of women artists. Nochlin argues that feminist art historians must ask new kinds of questions and arrive at new formulations of art historical knowledge. Subsequently, feminist art historians are introducing lost or forgotten women's art from the past.

In his influential short book *Ways of Seeing*, published in 1972 and based on a series of television programs on art broadcast by BBC, British Marxist critic John Berger argues persuasively that in art and in advertising, "Men act and women appear. Men look at women. Women watch themselves being looked at."[40] He thus identifies and describes "the male gaze." He argues that many nude paintings of women in Western art are made for the enjoyment of the male. The woman subject is present as passive and available. Man is always assumed to be the ideal spectator, woman the oppressively surveyed, reduced to an object of aesthetic contemplation and sexual desire and thereby dehumanized. The existentialist philosopher Jean-Paul Sartre earlier made a similar point to Berger's. Sartre wrote that the perceived object, aware of herself perceived, finds herself coerced to self-awareness as through the eyes of another, thus ceasing to be herself.[41]

In another influential publication, in 1975 feminist film theorist Laura Mulvey, using psychoanalytic theory, wrote an essay on the male gaze in cinema. In analyses of mainstream films, Mulvey shows how visual presentations and female characters are

constructed to satisfy voyeuristic desires of male viewers, which in turn are based on fear of women and men's subconscious need to exert power over them.[42]

In her book *Postmodernism*,[43] art critic Eleanor Heartney provides an overview of the evolution of feminist artmaking. In the 1970s, some women artists began exploring the idea that there are essential differences in the experiences of men and women that could be discerned in their art. Feminist art critic Lucy Lippard identified motifs suggesting female sensibility. She pointed to the abstracted sexuality inherent in circles, domes, eggs, spheres, boxes, and biomorphic shapes. She noted a preoccupation with the body and bodylike materials. She perceived a fragmentary, nonlinear approach in the work of women that set it off from that of their male counterparts. She believed that such dissimilarities reflected the different way in which women organize their experience of the world.

In "First Wave Feminism," women artists immersed themselves in female experience, reveling in the hitherto forbidden territory represented by vaginal imagery and menstrual blood, posing themselves naked as goddess figures, defiantly recuperating "low" art forms such as embroidery and ceramics, which had traditionally been dismissed as "women's work." They formed women's cooperative galleries, put together exhibitions of women's work, and generally saw their art as a form of feminist consciousness raising. However, feminists informed by Poststructuralist ideas objected to the impossible and undesirable task of "essentializing" a supposed female essence. Poststructuralists also refused to accept as limiting and oppressive designations imposed on women by patriarchal culture—"woman as nature, woman as body, woman as emotion." Rather, poststructuralists exposed how ideas of femininity are socially constructed.

In Heartney's view, some Postmodern feminists assumed a "puritanical tone":

> First Wave Feminists who had celebrated female sexuality and publicly exposed their own, often voluptuous, naked bodies were criticized for playing into patriarchal power structures. Postmodern feminists seeking to destroy the aesthetic pleasure that satisfied men at the expense of women often pursued a form of iconoclasm, choosing to work with media images of women in a way that undercut their seductiveness. Or they opted to avoid representing the female body altogether on the theory that any form of representation perpetuates the objectification of women.[44]

Feminist aesthetician Hilde Hein offers a caution to any summary of feminism: "Feminism is nothing if not complex." In Hein's view, until the end of the 1960s, most women artists sought to "de-gender" their art in order to compete within the male-dominated mainstream. By the 1960s, the counterculture no longer considered the mainstream to be ideologically neutral, and feminists recognized that the art system and art history had institutionalized sexism. Feminist artists exhumed women artists ignored in the past, and feminist historians began writing "revisionist" art histories to include the women artists who had been ignored. Many feminists dismissed the distinction between the crafts and high art as a male distinction, especially since women traditionally made craft items. Feminist artists in the 1970s began including "decoration" in their art. Other feminists produced autobiographical works in many media as well as cathartic, ritualized performances. During the 1980s, some feminist art took a

conceptual bent—for example, Cindy Sherman's photographic investigations of female role-playing in culture and Lorna Simpson's investigation of identity in images and words. Feminist principles have currently become widely known; and, in opposition to the purity and exclusivity of modernism, feminists are calling for an expansive, pluralistic approach to artmaking, including the use of narrative, autobiography, decoration, ritual, and craft-as-art. Hein asserts that feminists' acceptance of popular culture helped to catalyze the development of Postmodernism.[45]

Feminist theorists assert that sex is different from gender. The term sex refers to the physical features that make us female or male or some combination of the two, and *gender* refers to the cultural ideas of what it is to be a man or a woman. Some forty years ago, Simone de Beauvoir observed that "one is not born a woman; one becomes one"—she then went on to show how woman has been constructed as "Man's Other."[46] Genders are the political constructions of what it means to live in a world where we are not merely human, but always man or woman. Genders are several and they are socialized. Gender is how a culture expects and tries to ensure that men act a certain way and women another, or a gay man this way and a lesbian that way. Of course there are many ways one could act, but cultures specify which ways one *should* think, feel, and behave if one is of a certain sex. Genders are usually hierarchically constructed: Power, usually male, would have it be that it is better to be male than female, masculine than feminine, "straight" than "queer." Gender is a meta-level phenomenon; it is something to think about, not just something we do on a nonconscious level. As we become more conscious of behavior, our judgments change, and our conscious acts also change. Gender in a hierarchical society can be very constraining, and in a nonhierarchical society, gender might merely be a matter of choice.

Feminism is instrumental or consequential in that to be a feminist is a political choice, a choice toward action to resist and to change the status quo. One is not born a feminist, but rather, one chooses to become one. All women are not feminists, and all women artists do not make feminist art, nor do all feminists make feminist art, although feminists deny distinctions between art and politics. Hein recalls that in the 1950s and 1960s Helen Frankenthaler, an important United States Abstract Expressionist, and Bridget Riley, important in the Op Art movement in Britain, enjoyed great prominence in the artworld, but their content was not feminist because it neither addressed the historical condition of women nor looked like art made by women.[47]

Abigail Solomon-Godeau, a critic and theorist of photography, asserts that feminist theory is concerned with how women are represented: "Central to feminist theory is the recognition that woman does not speak herself: rather, she is spoken for and all that that implies: looked at, imagined, mystified and objectified."[48] Barbara DeGenevieve, a feminist artist committed to changing oppressive representations of women and other minority groups in society, writes:

Images carry ideological messages, which cumulatively shape the culture's ideas, values, and attitudes. They are the bearers of cultural mythologies. If we see enough pictures of a certain type (women being brutalized by men, minorities as ghetto residents) we can conclude that such imagery is valuable to the culture. Especially, if certain aspects of society are not represented, it is most likely due to

the fact that no importance is given to them or that they have a negative value for the culture (vulnerability in male sexuality, nonstereotypical images of women and people of color).[49]

Griselda Pollock and Deborah Cherry, two feminist art historians, make a related point about how women have been positioned in fine art: "Representing creativity as masculine and circulating Woman as the beautiful image for the desiring male gaze, High Culture systematically denies knowledge of women as producers of culture and meaning."[50]

In Hein's words, "one becomes a feminist by declaration—not by birth or chance or out of habit." Hein goes on to explain, "contrary to a commonly held belief, feminism comes no more naturally to women than to men. Women are normally socialized to experience the world in accordance with male determined categories. Knowing themselves to be female, they nevertheless understand what that means in male terms, unless they explicitly take an oppositional stand and declare their right to self-determination."[51]

Although feminist critics reject the notion that aesthetics and politics can be independent of one another, some critics still maintain that there should be a separation between art and politics. Hilton Kramer proclaims that feminism "tells us nothing about the qualities one should be studying in a work of art." Hein counters the assertion that overtly political representations have no place in art by arguing that such critics "are failing to grasp the charge implicit in the feminist art that 'conventional' art is equally political, the politics being cast in that 'neutral' or masculinist mode that appears invisible."[52]

Feminist and *feminine* are not interchangeable terms. *Feminine* is a term assigned to women, that connotes socially determined qualities of women, such as delicacy and gentleness (these qualities are often assumed to be innate and to transcend historical eras) or inherent qualities such as generally smaller physiques than those of men. *Feminism* should be understood as a political commitment to bring about change in a specific historical moment and to meet special needs that the lives of women dictate.[53]

Rosalind Coward emphatically makes a similar point: "Feminism can never be the product of the identity of women's experiences and interests—there is no such unity. Feminism must always be the alignment of women in a political movement with particular political aims and objectives. It is a grouping unified by its political interests, not its common experiences."[54] Hein also holds that feminists have not found a body of truths or a central dogma, but she credits feminists with reframing the questions. The list of problems feminists have abandoned as misguided are "the characterization of aesthetic 'disinterest,' the distinction between various art forms, as well as differences between craft and art, high and popular art, useful and decorative arts, the sublime and the beautiful, originality, and many puzzles that have to do with the cognitive versus the affective nature of aesthetic experience."[55]

Aesthetician Mary Deveraux refers to feminist aesthetics as the "new" aesthetics to mark it as different from traditional aesthetics, which "adds on" new writings by aestheticians such as Goodman, Danto, or Dickie. In her view, to take feminism seriously is to rethink basic concepts, and that requires more than merely adding women's writings to the canonical list of great philosophy. Moreover, feminist theory does not have its roots in Plato, Aristotle, and Kant but in Foucault and Lacan. Whereas the

Western European tradition promotes a view of art as positive and characterizes its tradition as liberating, enlightening, and uplifting, feminists understand art to be similar to other forms of patriarchal oppression and reject the division of art and politics that is basic to Anglo-American aesthetics.

Deveraux draws five major conclusions from her understanding of feminist aesthetics. First, "feminist theorists ask us to replace the conception of the artwork as an autonomous object—a thing of beauty and a joy forever—with a messier conception of art." The messier conception pulls art from an autonomous realm, "art history," into "history" and the everyday realms of social and political practice. It also pulls aesthetic philosophy from its autonomous realm into the general realm of knowledge, and Devereux wonders, "Is the discipline of aesthetics possible apart from sociology, cultural studies, identity politics?"

Second, feminist theorists question the Aristotelian premise that great art exists in and speaks to a universal human condition. Rather, feminists understand a work of art to be made in a gendered voice that privileges some experiences and some ways of seeing over others. Although feminist theorists question claims of autonomy and universality, they also hold that art can be judged, that artworks have value, but perhaps different values than we thought. In ranking works, feminists ask that we define criteria for "important" and "great" works of art. By explicitly acknowledging our criteria "we create space for competing criteria."

Third, feminists challenge assumptions about the canon of great works of art history, held by some to be the reservoir of "the best of human thinking." Some accuse the canon of excluding and silencing women and other groups. Feminists reject a monolithic "we" and its assumptions that the canon is uniformly enlightening and liberating. Such an assumption ignores those who find the authority of the traditional problematic: "Being willing to ask *who* is doing the reading forces us to question whether the pleasures of art are invariant and impervious to factors such as class, race, and gender."

Fourth, feminist theorists "seek to explain how the social and historical placement of the spectator affects the meaning derived from the text," accepting that meaning is no longer determined exclusively by the text. By careful readings, feminists also contribute by showing how texts assume a particular reader through narrative and style.

Last, like Poststructuralist theorists, feminists "endeavor to make the unnoticed noticed . . . the informed spectator is a more critical spectator, and the critical spectator is one less likely to be victimized by the text." Feminist theorists "replace reverence for art with skepticism. They ask that we be willing to rethink what we value and the reasons we value it." All art may not be good for all of us.[56]

Postmodernism

The term *Postmodernism* implies a chronology that Postmodernism comes after Modernism or replaces it. However, Postmodernism historically lives with, follows after, or replaces Modernism, depending on one's point of view. Postmodernism is probably best understood as "a complex map of late 20th century thought and practice"[57] rather than as a philosophic, political, or aesthetic movement.

Some writers claim we have been living with Postmodernism for many decades, and some symbolically date its birth to the student riots in Paris in May 1968, during which students, with the support of prominent scholars, demanded participation in changing what they saw as a rigid, closed, and elitist European education system. The earliest writings of Derrida and Foucault were contributory to the unrest. Theory took on an activist edge in the United States in the mid-sixties into the early seventies with the civil rights movement, radical feminism, gay liberation, and the anti–Vietnam war movement. Some scholars identify Jean-François Lyotard's publication of *The Postmodern Condition* in 1979 as the beginning of Postmodern thought. Examples of "Postmodernist architecture," however, are cited in the 1950s, and Postmodern buildings are associated with architects' witty ornamental reactions to the austerity of Formalist architecture of the International Style, famous for its minimalist steel and glass skyscrapers and slogan, "Form follows function."

The term *Postmodernism* is probably better understood as anti-Modernism. An introductory key point in understanding Postmodernism is that rather than merely following a historical period of thought called Modernism, Postmodernism is proffered by theorists who are generally critical of Modernism and of the foundational beliefs of the Enlightenment, from which Modernism grew. Modernists uphold Enlightenment beliefs in the power of rationality and science; the ability of language to match the real and uncover objective and universal truths; salutary progress toward social justice and freedom through reason, science, and technology; the individual and distinct nature of different disciplines such as science and philosophy; and an unshakable belief in the uniqueness of individuals.

Postmodernists confront such principles of Modernism, critiquing Modernist concepts of "objectivity," the power of rational thought, a supposed reality apart from the language that is thought to describe it, trust of technology, the uniqueness of the individual, and any "grand narratives" used to explain the world. Indeed, Lyotard defines Postmodernism simply as "incredulity towards metanarratives."[58]

Postmodernists generally reject Modernist aesthetic beliefs in the separation of knowledge into discrete disciplines (such as aesthetics apart from ethics, for example), Modernists' separation and isolation of art and aesthetics from other domains of knowledge and types of experience, the salutary powers of art to liberate humankind from crass consumer culture (and bad taste) made available by the Industrial Revolution, concepts of artistic "originality" and "genius," progress toward a purer art (abstraction), Modernists' hierarchical and disdainful distinction between high art and popular visual culture, and the ideal of "disinterested" engagement with pure visual form.

The title of this chapter, "Postmodern Pluralism," is influenced by Arthur Danto's explanation of "the end of art," by which he refers to the fulfillment of Modernist aesthetics through a series of erasures listed in Chapter 3: Art no longer needs to be beautiful, representational, or realistic; have subject matter; or bear evidence of the artist's touch. Modernist art may have come to an end or a conclusion, but artists continue to make art, only now they are liberated from strict constraints of Formalist theory, and aesthetic pluralism reigns and a multiplicity of styles and art forms proliferate based on sources of thought other than those of the Kantian tradition.

The grand narratives of Modernism as constructed by Danto and others highlight the contributions of thinkers such as Kant, Dewey, and Greenberg and art movements

embracing abstraction such as Russian Constructivism and American Formalism. Postmodernists, however, pay their intellectual debts to Heidegger, Nietzsche, Wittgenstein, Marx, and Freud and to art movements that include the representational, such as Dada, Surrealism, photography, and other lens-based media.

Some critics of Poststructuralism express resentment toward Derrida for the lack of credit he gives to Austrian philosopher Ludwig Wittgenstein's (1889–1951) ideas about language, which are similar to Derrida's later thoughts about language.[59] Wittgenstein stresses the importance of language and takes an "anti-Essentialist" stance toward it. He sees language as an activity grounded in human practice. He builds an analogy between language and games and thinks of the different uses of language as language games. Just as there is no set of features that is common to all games that makes them games, there is no essence of language, no features common to all of the uses of language. Rather than an essence, language games have a "family resemblance" with some shared features and characteristics.[60] Deconstructionist critics gain insights from Wittgenstein's concept of language games supporting the indeterminacy of meaning.

Wittgenstein believes that aesthetics gives reasons as to how a word in a poem or a phrase in a musical composition functions within the poem or musical composition. A work of art is best understood by placing it alongside other works by the artist or works by other artists. Aesthetic attention ought to be directed toward the larger contexts of a work, such as its history, conventions, and practices; without knowledge of these we cannot understand the work. Artworks mean within cultures. One aesthetically investigates works of art in order to come to one's own sense of the value and meaning of the work.[61]

Jean-François Lyotard

Lyotard (1924–1998) was a social activist philosopher who as a teacher in Algiers saw firsthand the repression and brutality of colonialism. Lyotard's *The Postmodern Condition*, published in France in 1979, offers a new non-Marxist interpretation of knowledge, science, and technology in advanced capitalist societies. He identifies a "crisis of narratives" referring to Enlightenment meta-narratives about meaning, truth, and emancipation that have become "transformed" by new, language-related technologies since the 1950s and their miniaturization and commercialization. Lyotard argues that the status of knowledge is permanently altered, having become an international commodity within a global economy and a means of military international monitoring. He sees "grand narratives" (Christianity or Marxism, for example) as "totalizing," authoritative, and repressive, and instead favors "mini-narratives" that are provisional, temporary, relative, and contingent on context. He adds an ethical concern through use of the term *differend* (dispute, difference, otherness) to explain how ideas or voices that do not fit within the totalitarian, ideological system are silenced.[62]

Lyotard breaks with Poststructuralists in that he does not believe language accounts for everything. He posits a gap between language and experience that language cannot cover; thus extralinguistic experience, in the form of the aesthetic, is crucial. An event is a singularity that cannot be completely accounted for by discourse. What discourse cannot account for, works of art can through feeling, sensation, and desire. Works of art reveal the limitations of discourse and grand narratives.[63]

Lyotard brings back "the sublime" from Burke. For Lyotard, the sublime counters established rules and breaks with consensus. The sublime represents what is "other" and what cannot be represented. The purpose of Postmodern art, for Lyotard, is to disorient the viewer, to blur the boundaries of discourse, and to challenge the normative by the singularity of a work of art.[64]

Jean Baudrillard

The media, specifically television, is a site of Postmodern investigation for Baudrillard (1929–), but he looks at a wide range of cultural phenomena and his writings are an interdisciplinary mix of linguistics, philosophy, sociology, political theory, and science fiction. He is best known in Postmodern discourse for his notions of "simulation," the "simulacrum," and "hyperreality."

A simulation is a copy of a copy that is so removed from its relation to the original that it no longer seems to be a copy. The simulacrum stands on its own as a copy without a model. He applies the notion widely: "All of our values are simulated. What is freedom? We have a choice between buying one car or buying another car? It's a simulation of freedom." We observe spectacles rather than have experiences.

Regarding the simulacrum, he asserts that sign systems are detached from reality and that media images have become more real than reality. He identified television in 1988 as a site that "bears no relation to any reality itself: It is its own pure simulacrum." TV is consumed by "frantic self-referentiality" where TV news becomes entertainment and TV entertainment is the subject of news. Events made for television become news on television in a circular relationship.

Whereas Marx and Friedrich Engels (1820–1985) describe the "explosion" of industrial capitalism and its constantly expanding production, transportation, communication, and colonization of the world, Baudrillard talks of Postmodern "implosion" that collapses boundaries between meaning and media messages that "flatten" each other out in a constant stream of information, entertainment, and advertising. Baudrillard argues that the masses become bored and resentful of constant solicitations and become apathetic. Living within a simulated world produces panic. Hyperreality reassures us of reality. Examples of the hyperreal are extreme sports, the revelation of private lives on television talk shows, interactive television, court TV, giant video screens at live events, and virtual reality computer programs.[65]

Author and funeral director Thomas Lynch offers a succinct critique of the Postmodern "memorial event":

> The postmodern memorial event is too often an exercise in absence rather than presence, avoidance rather than confrontation, the "virtual" instead of the "real." Everyone is welcome but the corpse, which has disappeared, replaced by a memorial collage or DVD, consigned to a commemorative Website or turned into a kind of mortuary knickknack. Stuff replaces substance; essentials give way to accessories; the sacred texts and metaphors are replaced by Hallmark sentiments and smarmy marketing. The dead are no longer considered as Methodists or Muslims or secular humanists, but as golfers, gardeners, bowlers and bikers—fellow hobbyists rather than fellow pilgrims.[66]

Baudrillard commented heavily on the first Gulf War of 1991. He first predicted that the war would not occur, and after it had he argued that it had not, in the sense that the reality of the war had been replaced by a copy war delivered to televisions where no fighting was taking place. He claimed that America was engaged in the illusion that it was fighting, like in a video game. Few people experienced the combat directly, and those that did were far away from America, where Americans watched it on TV.[67] Baudrillard's view of the war in Sarajevo and in Iraq and in Postmodernist critiques of reality prompted Susan Sontag to write about people suffering in *Regarding the Pain of Others*.[68]

Baudrillard maintains a sense of lightness about Postmodernism. In an interview in 2005, in response to the claim that humanities study in American universities has been damaged by Deconstruction and other French theories, Baudrillard responded: "That was the gift of the French. They gave Americans a language they did not need. It was like the Statue of Liberty. Nobody needs French theory."[69]

Fredric Jameson

A Marxist critic of Postmodernism, Jameson (1934–) objects to Postmodernists' merging of all discourses into a blurry whole. In his view, new corporate capitalism has colonized the culture industry. Jameson, along with Adorno and other Neo-Marxists, considers traditional Marxist-Leninist theory to be too narrowly focused on historical materialism and economic production. Jameson supplements such traditional Marxist analysis with a critique of culture. He argues that cultural objects must be understood within economic conditions. He is particularly resistant to Modernist Formalism, which separates the art object from its context of production or immediate history and which glorifies the artist while isolating the artist from cultural contexts. His study of Structuralist theory of language and literature evolved in his influential book, *The Prison House of Language: A Critical Account of Structuralism and Russian Formalism*[70] in 1972. Jameson's critical readings put autonomous aesthetic objects back into the unconscious frameworks of artistic traditions and norms that guided their production. Culture constrains the individual creative subject.

Postcolonialism

Postcolonialism influences and is influenced by Poststructuralism and Postmodernism. Elizabeth Cornwall, a literary scholar, sets forth some general parameters of a loosely held set of beliefs and interests. Postcolonialism is a multidisciplinary area that began in the 1980s and achieved prominence in the 1990s. It involves scholars of literary criticism, art history, cultural studies, philosophy, and humanities in general.

Postcolonial scholars investigate the cultural situations of peoples or nations that have been or are under the imperialist territorial control of a colonizing power. Studies include considerations of processes of colonization and decolonization, how these historical events influence cultural products of both the colonized and the colonizer, and the "subject positions" of all involved in these systems.

Colonialism is the social assertion by a dominant power over an indigenous people based on the colonizer's belief in its own unique superiority that gives it the right to dominate indigenous people politically and culturally and to take control of their

raw materials and land. Colonizing mechanisms do not cease to end when territorial control ceases, and scholars seek to understand the continuing influences of domination and subordination. Although the relationship between the colonizer and the colonized is severely asymmetrical, both groups are affected by colonization. The colonizers' ways of domination meet secretly subversive means of resistance in cultural artifacts as well as in behaviors. Such resistance is a topic for Postcolonial analysis. A further topic of study entails notions of "hybridity," or the dialectical relation between two cultures and their receptions and resistances.[71]

Edward Said (1935–2003) was a Palestinian born in Jerusalem. His family fled to Egypt as refugees, and Said lived in Lebanon and Jordon before immigrating to the United States, where he pursued graduate studies. He spent his career as a professor of literature at Columbia University, where he published important work and was a politically engaged activist for Palestinian independence and human rights. His academic and political work focuses on how white European and North Americans fail to understand differences between Western and non-Western cultures.

Emerling credits Said with inaugurating the discourse of Postcolonial theory with his groundbreaking book *Orientalism*, published in 1978. In it, Said addresses questions of colonization by the West: How are colonized cultures represented, what is the power of such representations in controlling cultures, and what is the discourse by which colonizers and the colonized construct their subject positions? In answering these questions, Said was influenced by Foucault's notions of discourse as a form of power-knowledge, that is, a system of language and codes that produces knowledge about a conceptual area and identifies what can be known, said, and not said within that system of knowledge. Such discursive knowledge is power, and Said seeks to explain how such delimited and constructed knowledge gains the status of "reality."[72]

Said defines "Orientalism" as Western discourse about the East that establishes the oppressor-oppressed relationship within colonial discourse. The Orient, for Said, is an "imaginative geography" mapped by discourse, and the mapping occurs through binary racist oppositions between what is said to be "Oriental" and its inferiority to the "Occidental" or the West. European universalism sets up the binary racism by its supposed superiority and the inferiority of the colonized cultures. The West constructs "Orientals" as a homogenous population without individual faces and identifies all members of the group by a few negative stereotypes.[73]

While colonial discourse oppresses the colonized subject it simultaneously affects the colonizer: "European" is constructed in part by how it is not "Oriental." Such debased depictions by imperialists of the colonized are constructed in literature and visual representations. Such negative depictions become alibis for violence against the colonized.

To counteract "Oriental" constructions, Postcolonial theorists seek to resist totalizing identity constructions of colonized individuals, give voice to particular people, and give examples of local practices, values, and ideas. Postcolonial theorists also try to resist Eurocentrism that privileges the West and marginalizes the rest. Reclaiming the cultural past of the colonized and showing its value is an important strategy of resistance. Another strategy that Said proposes is to read the "texts" constructed by the colonizers to "draw out, extend, give emphasis and choice to what is silent or marginally present or ideologically represented."[74]

Emerling points out the merits of Postcolonialism for aesthetics and criticism. It encourages reading for Orientalist bias in representations. Said's work has also challenged museum studies: One should no longer look "disinterestedly" at art within museums that we have previously viewed as innocent institutions. Rather, we should examine objects in museums and their roles in light of social and political discourse. We ought also to police imperial means of obtaining such objects from cultures.[75]

Cindy Sherman: Photographs

British postcolonial cultural critic Anandi Ramamurthy explores colonialism, photography, and power, linking the camera and the gun in the processes of colonization, analyzing the unequal relationship of power of the white photographer over the colonized subject, who was usually of color. The "Other" is seen and photographed as submissive, exotic, and primitive. By means of such photographs, "the European photographer and viewer could perceive their own superiority. Europe was defined as 'the norm' upon which all other cultures should be judged. That which was different was disempowered by its very 'Otherness'."[76]

Eroticized photographic representations of Others were made to serve anthropological, geographical, and economic interests. The Belgian company Kasai, for example, hired photographers to explore the Congo, looking for resources and markets.

The French developed a new genre of photography, exotic and erotic postcards of Algerian women taken by French studio photographers during the colonization of Algeria. Their constructed sexual visions of Algerian women suited European fantasies. Ramamurthy sees such commercial images of women as perversely apt for the colonial times and with continuing influence today:

> Colonial power could be more emphatically represented through gendered relations—the white, wealthy male photographer versus the nonwhite, poor female subject. These images, bought and sold in the thousands, reflect the commodification of women's bodies generally in society. They are also part of the development of postcard culture which enabled the consumption of photographs by millions. The production of exotic postcards also brought photographs of the "Empire" and the non-European world into every European home. It was not only the photographs of non-European women which were sold: landscape photographs, which constructed Europe as developed and the non-European world as underdeveloped, were also popular. These colonial visions continue to pervade contemporary travel photography, not only through postcards, but also in travel brochures and tourist ephemera.[77]

Contemporary art critic and author of *Postmodernism*, Eleanor Heartney considers photography "quintessentially postmodern" for these reasons:

> any number of equally distinct prints can be made from a single photographic negative, [and] there is no "original," a condition that meshes perfectly with the postmodern negation of uniqueness and originality. Because photography, however manipulated, lies at the heart of most advertising and mass media, it provides the

most pervasive conduit for ideology, making it ripe for deconstruction. And because photography is based on visual illusion—even the most abstract photograph is still a photograph of something—it wreaks havoc with Greenberg's efforts to remove all external reference from art. As a result, photography provides postmodernists both with the perfect tool and the perfect target.[78]

Most of Cindy Sherman's works are photographs, although she considers herself more of a performance artist than a photographer trained in traditional photographic studies (5.2). Sherman (1954–) is a mid-career artist of great import in Postmodernist and Poststructuralist discourse. She lives and works in New York City. She made a feature film in 1996, *Office Killer*. In most of her photographs she uses herself as subject matter in various guises; that is, her photographs are self-portraits, in a sense. In another Poststructuralist sense, there is no "self" to be photographed, or a multiplicity of indeterminate selves. She usually makes series of works, including, for example, "Untitled Film Stills," "Fairy Tale Disasters," "History Portraits," "Fashion," "Centerfolds," "The Sex Pictures," and "Clowns."

5.2 Cindy Sherman | *Untitled Film Still*, **1980**.
Black and white photograph, 8 x 10 inches. Courtesy of the artist and Metro Pictures.

Critical Commentary on Sherman's Photographs

Jennifer Eisenhauer, an art educator versed in Postmodernism, wonders in print about Sherman's corpus of photographs (5.3):

> *Black and White* (1975–1980) There she is, wool coat collar gripped in breeze whisked hand, blonde wig, sculptural like Marilyn Monroe's peroxide frozen strands. There she is, with her heavy mascara gaze, scarf wrapped brunette with tightly tied bow. Hepburn. There she is, collared shirt sexy soul on a bed of chocolate satin. Is it her? No, not *real* enough. She does remind me of a movie I once saw though . . . What movie? . . . I can't recall. She just looks so familiar. *Rear Screen Projections* (1980). In color now, she must be real. Gray haired maiden, Cindy are you older now? Brown highlighted strands and blue eye shadow. She's in the 80s . . . but where are you? The screens are so distracting. *Centerfolds* (1981) There she is, men's black evening jacket grasped in frightened pale hands, tear dampened hair. She's crying. Are those tears real? *Pink Robes, Color Tests* (1982), *Fashion, Disasters and Fairy Tales* (1983–1989). There she is, prosthetic breasts, nose job, vomit-laden walkway. There she is, *History Portraits* (1988–1990), *Civil War* (1991); *Sex Pictures* (1992). There she is, waxy red gaping hole and plastic molded nipples wandering the desert of the real.[79]

The authors of *Art Since 1900* credit Sherman for making "extraordinary changes on the idea of self-portraiture as she disappeared behind the guises of the movie stars

5.3 Cindy Sherman | *Untitled (119),* **1983.**

Color photograph (image), 17 1/2 x 38 inches. Courtesy of the artist and Metro Pictures.

5.4 Cindy Sherman | *Untitled Film Still, #3,* **1977.**
Black and white photograph, 8 x 10 inches. Courtesy of the artist and Metro Pictures.

she impersonated (Monica Vitti, Barbara Bel Geddes, Sophia Loren), the characters she implied (gun moll, battered wife, heiress), the directors whose style she pastiched (Douglas Sirk, John Sturges, Alfred Hitchcock), and the film genres she dissimulated (film noir, suspense, melodrama)."[80]

In 1995 the Museum of Modern Art in New York City acquired the only complete set of Sherman's "Untitled Film Stills," (5.4) a series of sixty-nine black and white photographs that she made between 1977 and 1980. Herbert Muschamp in *Artforum* magazine recalled the days and his thoughts of when they were made, and refers to them as a "generation-defining series":

> Here, a single person presents herself in the guise of a cast of dozens, if not thousands—the girl next door recast as social and cinematic stereotype: siren housewife, victim, vixen, hayseed, career girl, spoiled princess, runaway, beatnik, lady of leisure, slut. These pictures are a triumph of self-invention, and also an expression of its discontents: a witty howl of protest against a restrictive quota system that would insist, One self per person, please.[81]

In personal and subjective language, Muschamp writes, "I liked the crudeness of Sherman's photographs. I liked that they were black and white. That they contradicted

the glamour of the Hollywood they evoked. Most of all, I liked their view of the self as a repertoire of roles."[82]

In her reading of Sherman's "Film Stills," Rosalind Krauss, founder of *October*, an influential critical journal, applies Barthes's semiology in his book *S/Z* and his sense of the inner workings of realism in "texts" that produce "mythology." Krauss sees Sherman as a demythologizer. All of Sherman's filmic characters are functions of signifiers; neither the roles she plays nor the actresses she assumes are freestanding. Each filmic character is constructed by means of a separate code signifying difference: male/female, young/old, rich/poor, and other codes operate by reference to general cultural knowledge, and still other codes are driven by narrative (who, what, when, where, why?). According to Krauss, "Barthes makes clear that when a name finally arrives to refer to or denote a character, that name is buoyed up, carried along, by the underlying babble of the codes." The filmic character that appears real "is an effect of the vast already-written, already-heard, already-read of the codes." The viewer of Realist fiction "believes in the 'character', believes in the substance of the person from whom all the rest seems to follow as a set of necessary attributes—believes, that is, in the myth."[83]

Krauss and coauthors Foster, Bois, and Buchloh offer thoughts on the implications of the "Film Stills": Sherman jettisons her selfhood as author and individual and suggests "that the very condition of selfhood is built on representation: on the stories children are told or the books adolescents read; on the pictures the media provide through which social types are generated and internalized; on the resonance between filmic narratives and fantasy projections."[84] More specifically, the photographs make explicit "the traces of a male gaze trained on a waiting and defenseless female; the ways the female reacts to this gaze, entreating it, ignoring it, placating it."[85]

Eleanor Heartney discusses the different receptions of Sherman's "Film Stills": "they were embraced by feminist theorists who saw in it a brilliant exposition of the idea of femininity as masquerade . . . they hailed her work as a critique of the objectifying operations of the male gaze." Heartney writes that Sherman has always resisted interpretations that pose her work as that made by a "feminist ideologue" and eludes "the more puritanical aspects" of feminism. Heartney writes,

> Her films can be read as critiques of the male gaze and the mass media's tendency to objectify woman. But they also are permeated with Sherman's own enjoyment of the time-honored adolescent girl's game of dress up. They are powerful reminders that there is a feminine form of pleasure that cannot be theorized out of existence.[86]

Although many saw the work as feminist, Heartney explains that others saw "Film Stills" as a critique of the media, "noting that her *Film Stills* demonstrate how our contemporary sense of self is a commercial creation subject to the whims of the film industry." Deconstructionists saw "a representation of the postmodern world's decentered self. A fictional creature composed of fictions."[87]

Psychoanalytic critic Hal Foster, in *Return of the Real*, applies Lacan's three cones of representation to Sherman's "Film Stills" and other early works (1975–1982). The first cone is that derived from a Renaissance perspective: From a geometrical point we

see an image of an object. In the second cone, a point of light projects a picture onto a screen. In the third and most sophisticated gaze, the viewer is aware of the image, the screen, and the subject of representation, and conversely, the subject of representation is aware of the image and the screen, as well as the viewer's gaze.

Foster thinks Sherman evokes "the subject under the gaze, the subject-as-picture."

> Her subjects see, of course, but they are much more *seen*, captured by the gaze. Often, in the film stills and the centerfolds, this gaze seems to come from another subject, with whom the viewer may be implicated; sometimes, in the rear projections, it seems to come from the spectacle of the world. Yet often, too, this gaze seems to come from within. Here Sherman shows her female subjects as self surveyed, not in phenomenological immanence *(I see myself seeing myself)* but in psychological estrangement *(I am not what I imagined myself to be)*. . . . Sherman captures the gap between imagined and actual body images that yawns in each of us, the gap of (mis)recognition where fashion and entertainment industries operate every day and night.[88]

Foster sees Sherman, in her fashion photographs, fairy tale illustrations, art history portraits, and disaster pictures, moving more centrally to Lacan's "image-screen" and its repertoire of representations:

> Here Sherman parodies vanguard design with a long runway of fashion victims, and pillories art history with a long gallery of butt-ugly aristocrats (in ersatz Renaissance, baroque, rococo, and neoclassical types, with allusions to Raphael, Caravaggio, Fragonard, and Ingres). The play turns perverse when, in some fashion photographs, the gap between imagined and actual body images becomes psychotic (one or two sitters seem to have no ego awareness at all) and when, in some art-history photographs, deidealization is pushed to the point of desublimation: with scarred sacks for breasts and funky carbuncles for noses, these bodies break down the upright lines of proper representation, indeed of proper subjecthood.[89]

In Foster's Lacanian interpretation, in these pictures and horror movies and bedtime stories, "horror means horror of maternity, of the maternal body made strange, even repulsive, in repression." In Sherman's pictures, the body is also the site of the abject (Color Plate 21).

Foster writes this about Sherman's civil war and sex pictures, which include close-ups of simulated damaged and dead body parts, sexual body parts, as well as excretory body parts: "Sometimes the screen seems so torn that the object-gaze not only invades the subject-as-picture but overwhelms it . . . we sense what it is to behold the pulsatile gaze, even to touch the obscene object, without a screen for protection."[90] Thus in Foster's view via Lacan, Sherman's earliest work erodes the subject and tears at the screen where the subject is caught in the gaze. In Sherman's middle work the subject is invaded by the gaze, and in more recent work the subject is obliterated by the gaze.

Sherman's Thoughts about Her Own Work

Sherman intentionally mixed "high" and "low" in her art. During the late 1970s and early 1980s, those interested in painting and sculpture looked down on photography. Sherman considered her work "art" and did not want to make "high" art: "I wanted to find something that anyone could relate to without knowing about contemporary art." As an artist working with photography, she was not interested in making precious prints: The issue was not "the quality of the print, it was about the idea."[91]

The 1980s produced a great deal of critical theory, and Sherman's work was cause for a good part of that writing. "There were times I would read something and I wouldn't understand what the hell they were talking about or where they got that idea; there were times when I'd say, 'Oh, yeah, that's right, though I wasn't thinking of it when I was doing it. I work without really pondering what I am doing. The only time critical writing really affected my work was when it seemed someone was trying to second-guess where I was going next: I would use that to go somewhere else."[92] Sherman has also said that "Media, the idea of originality, those were issues of the time . . . feminist politics, but also race, AIDS . . . there was more a sense then of art having serious content, as opposed to addressing formal issues or being decorative."[93]

Sherman is consciously aware of her use of the abject in her art: "I like making images that from a distance seem kind of seductive, colorful, luscious and engaging, and then you realize what you're looking at is something totally opposite. It seems boring to me to pursue the typical idea of beauty because that is the easiest and the most obvious way to see the world. It's more challenging to look at the other side."[94]

Artist and writer Betsy Berne, a friend and occasional sparring partner in the boxing ring with Cindy Sherman, interviewed her for *Tate Magazine* in 2006. Berne refers to Sherman as "an eccentric artist in the guise of an ordinary person, who happens to be one of the most successful and influential artists of our time." Berne also describes Sherman's studio space as being "as modest as she is: a large room that takes up roughly half her loft apartment in New York; a small shooting area with backdrops and desks strategically placed. Three months ago, this studio was so pristine you could lick the floor; today it's a disaster area with clown clothing and props everywhere. Cindy's making new work."

In the interview Sherman reveals that when she works on a project, she works intensively: "When I make work, I get so much done in such a concentrated time that once I'm through a series, I'm so drained I don't want to get near the camera." She works to music: "I can't work without it. And it has to be the right kind, because if it's not then I get into a bad mood. I work with a remote so that I can change CDs instantly if I need to. When I'm working I usually buy about 30 new CDs every couple of weeks."

To get started on new work, she first cleans and organizes: "I know that once I'm working I don't want to be distracted by paperwork or emails, letters. So I try to get all those things out of the way too and the house cleaned . . . you know how obsessive I was when I was trying to get started working—I was just cleaning every drawer and every closet in the studio trying to find some kind of inspiration." She says that the inspiration for her clown series was a funky pair of pajamas she found in one of her costume drawers that reminded her of clowns: "So I took out the pajamas and a couple of other eccentric things that I'd been saving, although I didn't have any particular thing I could apply them to. Then, when I started looking up clown pictures on line, I

realized I could almost use anything, any item of clothing, T-shirts, jeans, and it could be a clown. And I had a couple of multicolored wigs that I'd never used for a picture."

The clown series, however serendipitously begun, was prompted by thoughts and feelings about current events, namely the attack on the World Trade Center by hijacked commercial jetliners: "So many things suddenly made sense for the clowns, for the whole idea. I'd been going through a struggle, particularly after 9/11; I couldn't figure out what I wanted to say. I still wanted the work to be the same kind of mixture—intense, with a nasty side or an ugly side, but also with a real pathos about the characters—and clowns have an underlying sense of sadness while they're trying to cheer people up. Clowns are sad, but they're also psychotically, hysterically happy."

Sherman thinks of her audience as she works, as if she were telling a story: "I try to get something going with the characters so that they give more information than what you see in terms of wigs and clothes. I'd like people to fantasize about this person's life or what they're thinking or what's inside their head, so I guess that's like telling a story."

Sherman is well aware of the amount of criticism and theory written about her work, especially in feminist theory, but says, "I don't want to have to explain myself. The work is what it is and hopefully it's seen as feminist work, or feminist-advised work, but I'm not going to go around espousing theoretical bullshit about feminist stuff." She adds, "I don't theorize when I work. I would read theoretical stuff about my work and think, 'What? Where did they get that?' The work was so intuitive for me, I didn't know where it was coming from."

Berne pushes Sherman on the topic of the critical discourse that surrounds her work: "How do you get past all the crap critics often write about you?" Sherman responds, "Sometimes I've read stuff that never occurred to me. Elizabeth Hess once said something about 'deconstruction' (laughs). It was when I used fake body parts in the work instead of myself; maybe I appear in the reflection of some things. Hess said that 'I' was gradually moving out of the work and so she analyzed the 'deconstruction' of it. I'd never thought of that (laughs)! That's the only time a light bulb went off. Because to me I was just trying to see if I could make pictures that I wasn't in."

When Berne asks her if her work has more humor than it gets credit for, Sherman responds, "I think it's more funny than scary." When asked if she resents people reading into her personal life while looking at her work, Sherman says, "I just think it's funny."[95]

Cindy Sherman and Postmodern Pluralism

Sherman is an artist of major import in part because of her visual assertions that "femininity" is a construct rather than something innate or natural, and these pictorial assertions parallel Poststructuralist and Postmodern theories that make similar claims. Perhaps more important is Sherman's implicit assertion in her untitled "Film Stills" that "representation itself is already pre-coded," an assertion in harmony with Jameson's writings about pastiche, surface effects, and disconnected signifiers.[96] They also fit Baudrillard's notions of copies without originals in his discussions of simulacra. Many of Sherman's body landscapes, including human viscera and vomit, contribute to notions of the abject as theorized by Kristeva.

Lorna Simpson: Photographs with Words

Lorna Simpson was born in 1960 in Brooklyn, New York. She was the first African American woman to represent the United States in the Venice Biennale and to have a solo exhibition in the "Projects" series of the Museum of Modern Art in New York City. Her work from the early 1990s consists mostly of large black-and-white photographs that she made accompanied by words that she wrote. The photographs usually depict an African American woman—often wearing a simple white shift, other times dresses and suits—photographed without revealing the face (5.1, 5.5). The artworks usually consist of multiple images, sparsely framed—and hung in grids to be read as single pieces. The words, brief, tersely phrased, and without punctuation, accompany the photographs as part of the work. Simpson has been increasingly making videos and short films for gallery installations since the late 1990s.

SHE SAW HIM DISAPPEAR BY THE RIVER,
THEY ASKED HER TO TELL WHAT HAPPENED,
ONLY TO DISCOUNT HER MEMORY.

5.5 Lorna Simpson | *Waterbearer,* **1986.**

Silver gelatin print with vinyl lettering, 45 x 77 x 1 1/2 inches. Courtesy of the artist and Sean Kelly Gallery, New York. Used with permission. 2006.

Critical Commentary on Simpson's Work

Ellen Rudolph, writing for *Angle* magazine, introduces the artist's work: "Lorna Simpson's approach to exploring race and gender stereotypes is associative, using text and photographic images to suggest narratives and cultural hypocrisies." Rudolph notes that Simpson does not show faces of her subjects: "The artist's practice of limiting access to her subject creates a tension that varies in tone throughout. Consequently, Simpson's work derives strength from the distance she maintains between subject and viewer."[97]

The Irish Museum of Modern Art in Dublin introduced Simpson in 2003 as "the leading African American photographic artist" and a key representative of "African American visual culture." The museum typifies Simpson's work as addressing racial and sexual issues and as "an exploration of the visible and invisible and other ambiguities and contradictions associated with identity." The museum identifies *Waterbearer* as a signature image of the 1980s: "We see the graceful figure of a woman, with her back to the camera, pouring water from two containers. One is silver; the other plastic, seeming to represent opposite ends of the economic spectrum, or women of all classes denied expression and power."[98]

American photography critic Andy Grundberg refers to Simpson as a Postmodernist artist who "adopts the broad strategy of advertising as her modus operandi, using spare, stylized images and ambiguous, intriguing words and phrases." He quickly gets to the intent of the work: "Simpson's concern is not merely the rhetoric of advertising, or its omnipresence in contemporary life, however, but the very language of stereotypes. As a self-aware female African American, she sees clearly and precisely how prevailing cultural stereotypes operate against one's sense of individuality, choice and freedom." Grundberg understands the work to be "fundamentally political, since it forces a reexamination of how our daily lives are structured by words and pictures." Although the work is political, it does not lack "formal beauty or intellectual and emotional grace."[99]

In his brief essay on Simpson, Grundberg does not directly address race, but Deborah Willis does in her essay in the same exhibition catalog, writing, "the Black woman is the dominant focus of Simpson's work, and she scrutinizes her experience with a circle of voices that questions, embraces and complicates the concept of identity." Willis, a photohistorian, curator, and photographer, places Simpson's work in a tradition of African American photographers who record racist, aggressive acts. That tradition consists mostly of documentary photographers. Simpson, however, introduces a methodology that Willis identifies as bordering on metaphor, biography, and portraiture. Willis, like Grundberg, acknowledges the style Simpson employs to be reminiscent of advertising by Gap and Benetton at the time and praises Simpson's use of the format to "synthesize conscious and unconscious acts of aggression, discrimination, and alienation." Willis asserts that Simpson deals specifically with the notion of invisibility and that Simpson, the narrator of the texts, essentially asks, "Who is invisible?"[100]

Art Since 1900 credits Simpson with successfully combining social critique and beauty in her works of art. The authors note that Simpson's use of language defeats the possibility of reading "that is either voyeuristic or sociological or both." They point to her use of two alternating texts, SKIN ATTACKS/SEX ATTACKS, in *Guarded Conditions* (5.1): "With great economy and force, Simpson conveys the conditions of

many black women as double targets of racism and sexism." Simpson's work does not indulge in "victimology: the poses can be read as defensive or defiant or both, and the markings of 'skin' and 'sex' are underscored in a way that seems to strengthen rather than to debilitate the woman picture."[101]

Thelma Golden, curator of the Studio Museum in Harlem, writes that Simpson's work engages both a range of subjects inside artistic dialogue—"about form, the image of the body, the figure, space, objects in space, narrative"—and many other things outside of artist dialogue. Golden differs in her interpretation of Simpson's use of language, not seeing it as based in advertising but in fiction. She thinks of Simpson's texts as a personalized language, with roots in spoken language.[102]

Beryl Wright, the curator of the exhibition "Lorna Simpson: For the Sake of the Viewer," addresses "invisibility" as part of the early and mostly white feminist psychoanalytic discourse of "the gaze," adding a "gaze of obliteration" to address race (5.6). Wright acknowledges Laura Mulvey's early characterization of "the gaze" in 1975 as the erotic, voyeuristic, paternalistic, male representations of gender and sexuality. This classic "gaze of pleasure" is a psychical obsession that structures representations of the female body as an object of desire, but Wright observes that the concept has been used primarily to address "the gaze" upon the white body. Beneath the "erotic gaze" lies "the gaze" of sexual violence and rape. It stems from the dominant cultural construction of "woman as property." Wright calls it "a gaze that insists upon a privileged right of access."[103] Wright argues that neither of these conceptions of "the gaze" adequately addresses the forces that have shaped representations of the black female body. He discloses the "gaze of obliteration that erases physical presence and denies interiority." It is a gaze of public surveillance, a racial variant of the patriarchal gaze that photographically represents racial difference, a data-collecting gaze used for social control. It obliterates individuals by making them statistics subject to social control. Wright interprets

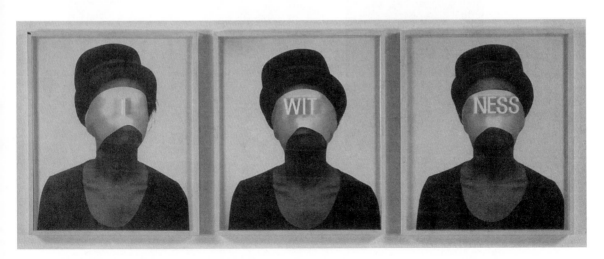

5.6 Lorna Simpson | *Sounds Like*, **1988.**

Three-dye diffusion Polaroid with ceramic letters, 73 1/2 x 25 inches. Courtesy of the artist and Sean Kelly Gallery, New York. Used with permission. 2006.

Simpson's work to resist these three gazes—the classic gaze, its violent variant, and the gaze of obliteration.[104]

Willis interprets Simpson's series of images called "Necklines" to be politically charged references to contemporary and historical conditions, seeming to refer to lynching. Willis interprets the series as Simpson's "attempt to impress on viewers the perpetuality of suffering." In her remarks about *Necklines* (5.7), Kellie Jones, an art historian, asks: "*Neck* and *neck* and *breakneck* are terms that bring to mind speed and racing; might this refer to competition between the figures depicted, or their haste to retreat from an oppressive situation? The sense of velocity also conjures notions of violence in *breakneck*." The historian also reminds us that during conflicts in South Africa over apartheid, "the necklace" referred to the practice of placing a burning tire around the neck of rebellious blacks.[105] The artist confirms Willis's and Jones's insinuations of violence: When working on "Necklines," Simpson says she became aware of "the vulnerability of the neck and started to insinuate potential violence."[106]

Saidiya Hartman discusses Simpson's work by addressing the artist's use of "the body." She writes, "The history of the black body is a chronicle of terror: enslavement,

5.7 Lorna Simpson | *Necklines*, 1989.

Three silver gelatin prints, two engraved plastic plaques, 68 1/2 x 70 inches. Courtesy of the artist and Sean Kelly Gallery, New York. Used with permission. 2006.

domination, subjection, and confinement . . . it has withstood the unimaginable; the body has existed as an object of property, harnessed as a productive and reproductive machine, and acculturated and disciplined through monumental acts of violence."[107] In part, Hartman draws upon the work of Foucault and his assertion that societies impose social control over the body in many different ways, surveillance among them. Hartman furthers this thought about "surveillance" of the body and how Simpson resists representations of black female bodies as debased spectacles.

Hartman observes that Simpson's models are clothed and are not displayed for the viewer's pleasure or mastery. By posing her models to be photographed from behind and by otherwise hiding their faces, Simpson mirrors dominant society's refusal to know black women as individuals. She uses fragments of bodies—the back, a knee, hair—to discuss vulnerability and domination and to indicate the limits of representation of black women's experience. Instead, the identity of subject is a mere leftover of uses of the body. Hartman analyzes *You're Fine* (Color Plate 23) to disclose how Simpson makes apparent observations, judgments, and classifications of the body as a mere means of production:

> In *You're Fine*, the body is dispersed across an array of functions. It is subjected to a series of medical procedures that determine its status ("fine") and use (employment in a "secretarial position"). The list of procedures maps the body's function and arrives at a judgment of its condition. The observance, judgment, and classification of the body is essential in the harnessing of its productive capacities. The powers of observation are instrumental in the construction of gender and sexuality, and in the making of the docile and productive body. The convergence of sexuality and subjection is represented by the female figure in sensual repose. The body made accessible by disciplinary power is subject to a range of uses, which encompass its exploitation as wage laborer and as sexual object. In *You're Fine*, technology governs the body and divides it. The examination procedures map the body into zones and organs essential to its exploitation as worker. Life is collated and categorized in service to the needs and requirements of power.[108]

Simpson first presented *Corridor* (Color Plate 24), a film, in 2004. It shows the daily routines of two women living in two different centuries and two different worlds. Their actions are projected side by side and take place in two historically and architecturally important interiors in New England: the Coffin House in Newbury, Massachusetts, occupied by the Coffin family in 1678, and the single-family residence in Lincoln, Massachusetts, that Walter Gropius built for himself and his family in 1938. The two protagonists are both played by the same actress and are young women, dressed appropriately for their respective situations of doing daily chores. Simpson uses songs that the black pianist "Blind Tom" Wiggins composed in the middle of the eighteenth century in the Coffin House, and she uses twentieth-century jazz in the Gropius House. The actions of the women and their accompanying musical themes serve as the only dialogue between the two women. The film does not lead to a dramatic climax: It simply occurs following a precise, even tempo, suggesting many interpretations without asserting any of them.[109] Grace Glueck of the *New York Times* concludes, "If there's a message, it's well hidden in the cool pantomiming."[110]

Chrissie Iles, an art curator, credits Simpson's films with dismantling three traditional pillars of cinema: (1) Her female protagonists are not passive, domesticated objects of desire; (2) whiteness is no longer the cinematic norm; and (3) her subjects are not unified by a continuous storytelling narrative. Iles writes: "In each piece, black women act out assertive roles, sexualized yet in control, desirous, as well as desired. The woman is the betrayer rather than the betrayed, and when betrayed considers murderous revenge."[111] Simpson behind the lens subverts the conventional assumption of the white male gaze and questions the assumed whiteness of the viewer.

Simpson's Thoughts about Her Own Work

It is unlikely that Simpson would consider Glueck's comment about lack of explicit meanings in the artist's work as a criticism. Simpson says her work "is not answer oriented. It's intentionally left open-ended. There's not a resolution that just solves everything."[112]

When asked how she relates to photography as a Postmodern practice, Simpson responds in a positive tone; as a teacher of photography, she resists Modernist conceptions of photography as a "pure medium" in favor of photography as a more open discipline without rigid categorical divisions. She thinks that universities and museums hold on to divisions, while artists and curators more freely mix media and broaden their conceptions of any one medium such as photography.[113]

Simpson's sources for her work are personal experiences she has had or stories told her by other black women. She says her work is about fifty-fifty autobiography and fictionalized references to media depictions of black women.

When asked about "deconstructing" language in her artworks, Simpson speaks of "the inadequacy of words" and says, "words fall short and really don't describe." She studied black writers such as James Baldwin, Ntozake Shange, Alice Walker, and Zora Neale Hurston, for whom language became "a slippery object. I was really amazed by how much they said in silence. Their work helped me to take a hard look at language—the way that it functions and the way that we use it."[114]

Simpson describes *Twenty Questions*, a work with four circular photographs of equal size of the back of a black woman's head. Five separate phrases beneath the circles state: IS SHE PRETTY AS A PICTURE/OR CLEAR AS CRYSTAL/OR PURE AS A LILY/OR BLACK AS COAL/OR SHARP AS A RAZOR.

> *Twenty Questions* is a piece based on the deduction game of the same name. The subject has a hidden identity: a woman with her back to the camera. The image is repeated four times, and below each one is a clichéd description: *is she pretty as a picture . . . or black as coal . . . or sharp as a razor,* etc. By presenting these clichés about women, I'm dealing with the language of stereotypes. I'm pointing to the fact that the wrong questions are so often asked, and this is why you don't know anything about this person. I intentionally sought to avoid presenting a "them and us" situation, them being a white audience. It is also a self-description, because these stereotypes cross the boundaries of race and gender. It is not necessarily pointing a finger at any individual's ideology, but at the language of stereotypes. Stereotypes don't reveal anything about a woman or an experience anyway. So I am suggesting that clichés and assumptions should be discarded.[115]

Lorna Simpson and Postmodern Pluralism

Simpson's work informs and is informed by poststructuralist thinking on postcolonialism, "identity," "the other," and especially "difference." Curator and author Thelma Golden asserts that what is not white is different. "Whiteness" is a signifier for power, and "the meaning of whiteness actually encompasses very few people, including many who consider themselves white."[116] Golden is in agreement with author and critical theorist Cornel West, who asserts that "difference" involves issues of "exterminism, empire, class, race, gender, sexual orientation, age, nation, nature, religion."[117] Commentators and the artist herself agree that Simpson's work concerns itself with more than race and representation, including issues of power, identity, gender, class, and difference.

Paul McCarthy: Performances, Videos, and Sculptures

Paul McCarthy (1945–) is an American artist based in Los Angeles who has during more than thirty years made drawings, paintings, photographs, sculptures, films, videos, sculptural installations, and performances. Often, his chosen media for his performances are common foods such as mayonnaise, ketchup, and chocolate sauce that stand in for sperm, human blood, and excrement. The starting point for many of McCarthy's performances of chaotic narrative aberrations is a familiar and comfortable TV format such as the cozy family sitcom (*Family Affair*) or a cooking program (*Cooking with Julia Child*). He has also appropriated artificial trees from *Bonanza*, a once popular TV series within the cowboy genre. He was given his first survey exhibition by the New Museum in New York City in 2000, showing pieces from the 1970s to 2000. Lately McCarthy is limiting his work to videos of himself performing within installations he has built and to the construction of sculptures (5.8), usually very large and inflatable.

Critical Commentary on McCarthy's Work

Jerry Saltz is a seasoned art critic, based in New York, who writes criticism for the *Village Voice*. He opens an article on McCarthy's retrospective in 2000 with these thoughts:

> It's rare for those in the art world to be shocked by art. Startled is usually the best we can do. Either we're the most well-adjusted crowd around, or we're out of touch. But as I walked through Paul McCarthy's spotty, bang-up retrospective at the New Museum, I was shocked—not only at how abject and totally sicko his art can be, but at how few people seemed offended by it, and how many appeared mesmerized.

Saltz finds McCarthy's works "excruciatingly nauseating . . . hardcore and hard to take. It's bitter, monotonous, histrionic, and juvenile." The critic admits that he is a "nonfan" and that he does not "like" McCarthy, but after seeing this retrospective, the

5.8 Paul McCarthy | *Pinocchio Pipenose with Donkey's Ears on Toilet,* **1999.**
Pencil on vellum, 8 1/2 x 11 inches. Private collection. Courtesy the artist. Hauser & Wirth Zürich London.

critic says, "I respect him." He is "an amazingly original American voice," "a gargoyle on the cathedral of modernism, a hobgoblin of icky excess."[118]

In her first sentence of the catalog for the same New Museum exhibition, Lisa Phillips, a curator of contemporary art and author, compares the methodology of McCarthy's work to that of Sherman's: "Not unlike Cindy Sherman, McCarthy assumes different guises and roles to explore myths and stereotypes in American popular culture." However, although McCarthy's concerns parallel many of Sherman's, "What interests him in particular are consumer icons from the entertainment industry—Hollywood, television, theme parks—and how these sanitized images intersect with the dark underside of American life where child abuse, insanity, rape, pornography, and violence lurk."[119]

Phillips notes that McCarthy's work relies on actual or implied narratives as "a first level of content," which he uses to explore four central issues that permeate all of his works, early to recent: "(1) plays on perception and illusion, (2) the fusion of body, architecture, and object, (3) violating boundaries and inverting polarities such as

inside/outside, animate/inanimate, male/female, real/virtual, natural/artificial, and (4) the use of repetitive, obsessive, and expressive actions."[120]

David Thorp, a curator and author, characterizes McCarthy's work this way: "From early on McCarthy has plundered scenarios and symbols from the interconnected realms of popular entertainment, Hollywood film, advertising and children's literature to explore and expose, through parody and critique, the stark realities of the American Dream. In performance, video, theatrical tableaux and sculpture McCarthy articulates the gap between the real and the imaginary, between the bland, sanitized worlds of an increasingly commodified popular culture (5.10) and its violent underpinnings."[121]

These general summations of the major concerns of McCarthy's work implicitly accept the work as a valuable contribution to art and to life. Dan Cameron, a curator and author, echoes the themes that these authors iterate, and also explicitly adds high praise for the work: "It is impossible to overstate the achievement of the American artist Paul McCarthy in the past thirty years or to name another artist more persuasive in articulating the brutality and dehumanization that underlie the social equilibrium of this country."[122]

Other critics are less favorably inclined toward McCarthy's work. Peter Plagens, an art critic for *Newsweek* magazine, refers to the artist and his scatological videos as attempts to cling romantically to the appearance of a "scruffy outsider." Plagens points out that McCarthy is a professor of art, "but he plays delinquent in the gallery."[123]

Introducing an article about a group of McCarthy exhibitions in London between 2001 and 2003, Adrian Searle, an art critic for the *Guardian Unlimited* in London, writes: "Paul McCarthy's art is crazed, inventive, obscene and often very funny. It is also stomach-churning, and his video performances are a disturbing gore-fest of chocolate sauce, syrupy drool, exhibitionism, onanism, self-harm and extreme violence, played out in weird costumes and with rumbustious, clownish fervour." She concludes her review by writing, "Excess is everything, and it always slides in the same direction in McCarthy's world, whether he is playing at being Captain Morgan or Santa Claus, Heidi or a mad abstract expressionist. Everything slides into evil, the scatological." She refers to his work as "acting out" and ultimately concludes that it "doesn't work, because he always ends up in the same place, forever re-enacting the same squalid scenes. Call it repetition-compulsion, call it obsession . . . it is, finally, a gleeful wallowing in debasement." She does credit it, however, with having "a great deal to do with America—with the amorality of the movie industry, with consumerism, with hypocrisy, double standards and repression."[124]

In *Art Now,* a book surveying recent art, Nina Montmann aptly summarizes one important theme of McCarthy's work as a presentation of society "as a social body, which finds its concentrated reproduction in each individual human body." Montmann notes McCarthy's "obsessive preoccupation with bodily-orifices and fluids," like we find in movies of gore and in filmic pornography. "He wallows in an orgiastic deployment of such viscous foods as ketchup, mayonnaise, mustard and chocolate sauce, which he substitutes for blood, sperm, sweat, and excrement."[125]

Lisa Phillips concurs that liquids are a "quintessential material in McCarthy's work, serving as metaphors for the primal substances of life—blood, pus, urine, feces, sperm, milk, sweat—these fluids erase the boundary between interior of the body and the exterior world." She notes that McCarthy takes his use of liquids to extremes when

he uses "foodstuffs as emblematic of American family life as hamburgers, hotdogs, mustard, mayonnaise, catsup, and chocolate." These common items of the American diet have become McCarthy's signature palette loaded with associations. In performances he slathers the pliable food substances on bodies, both his and others, "to simulate penetration, childbirth, castration, elimination, and a host of other primal joys and horrors."[126]

Some critics apply psychoanalytic theory to account for McCarthy's work. In live performances, McCarthy relies heavily on ketchup as a medium that he sometimes smears on his bare body. When discussing McCarthy's *Inside Out Olive Oil*, Amelia Jones, an art historian and critic, observes that the ketchup smeared on his body in live performances is both visual and olfactory: "The smell of the ketchup evokes olfactory sensations of longing and disgust, reminding the audience of childhood barbecues but within the inappropriate context of sexual perversion." Jones reads such a use of ketchup-as-blood as a desublimation of the male performer's masculinity "as if symbolically returning the shamed but sublimated/repressed male subject to a shameless, Edenic state of primitive lust," while also identifying the macho male performer with femininity by association with menstrual flow. She notes that Freud claimed women to be unable to sublimate to the extent that men do; thus it is males who raise the level of civilization through successful sublimation. McCarthy, however, by "making himself 'bleed' and smell and exposing his penis frequently to view (denying the shame signaled by sublimation)—assigns such a lack to masculinity."[127]

Jones pursues her thesis about McCarthy reversing Freud's thoughts on the process of sublimation and repression. In Freud's theory, the subject becomes socialized by means of repressing or sublimating instincts deemed inappropriate by patriarchal society. Jones argues that McCarthy's work does not attempt to overthrow patriarchy and its subjects but to show that masculine and feminine, self and other, ego and id, inside and outside are "intimately related as obverse print of one another."[128]

Inside Out Olive Oil takes place in two reciprocal spaces, one conceptual and the other material, one architectural and the other embodied. Thus McCarthy links the personal, specific and private with the social, cultural, and public. According to Jones, "These architectural/embodied enactments activate the psychoanalytic narratives of subject formation *and* the structuring of civilization outlined in the work of Sigmund Freud."[129]

In a related thought about McCarthy's use of architectural space, Canadian art critic Philip Monk makes observations about the architectural sets that the artist builds for his debased take-offs on family television programs. The constructed set "is both a hidden site of discipline and a surveillance device. As the latter, the set and the camera become one—a means through which society peers into the family, most effectively through the apparatus of television which instructs individuals as to society's dominant values."[130]

Dan Cameron applies Lacanian influences in his essay on McCarthy, "The Mirror Stage."[131] Cameron's reading is that McCarthy "is deeply committed to exploring the effects of media and consumerism on the subconscious." McCarthy "holds up a mirror to a range of taboos that American popular culture coyly circumscribes and never takes seriously." According to the critic, McCarthy has made clear the irony "that we have reached a point where people can be instantly in touch with the furthest reaches of the

planet, yet we are beset by increasing sectarian violence, prejudice, intolerance, and mutually assured ignorance of what makes us different from one another and from other species." Cameron continues:

> Rather than offer yet another vision of liberation through attainment, he reveals the horror that lies on the other side of the mirror of American strength and prosperity. One of the key implications of his work is that this entire facade of well being and harmony must be shattered before we can ever articulate a credible vision of who we really are. It is a far from impossible task, but it requires coming face to face with a reality that is as terrifying as its opposite is seductive.[132]

Donald Kuspit, a philosopher, art historian, and critic versed in psychoanalytic theory, however, asserts that McCarthy confuses the unconscious and the spectacle, "Blurring—indeed collapsing—the difference between manifest and latent content, [normalizing] the unconscious into entertaining event."[133] Kuspit is negatively critical of McCarthy's Freudian attempts to spill out his unconscious.

McCarthy's performances, environments, films, installations, and sculptures take American myths as their subjects and undermine them. He stages apocalypses of American visual culture "in which icons of the entertainment industry's illusory world are blended with images from pornography and the hidden horrors of societal ills like violence, rape and pedophilia."[134] Using mannequins and masks and toys, children's fictional heroes like Heidi, Pinocchio, Popeye and Olive Oyl, and Santa Claus, often used as McCarthy's alter ego, become "psychopathic players in his nursery of horrors."[135]

Coauthors Frances Morris and Sarah Glennie consider McCarthy's work dependent on a "strategy of contagion": The concept denotes, in part, the artist's use of props such as dolls, masks, and mannequins as surrogates, and foodstuffs as metaphors for bodily fluids and excretions. By his use of these motifs he constrains his horrors so that we can read them as metaphors, and not as actual brutal reality.[136]

Pinocchio is one of McCarthy's enduring archetypal characters in the artist's bizarre variations of conventional narratives in which he blends violence and farce. In a performance video made in 1994 called *Pinocchio Pipenose Householddilemma* (Color Plate 25) he replaced Pinocchio's most symbolic feature, his ever-changing nose, with an unmistakable phallic device. In the video piece, Pinocchio's nose becomes an erect penis, a weapon, and a feeding tube.

McCarthy used Pinocchio and variations of him in an important installation of outdoor sculptures commissioned by the Tate Modern in London that resulted in two large, freestanding, outdoor sculptures: *Blockhead* and *Daddies Bighead* (5.9), erected in 2003. Both figures are derivative of Pinocchio, most clearly *Blockhead*, which is the more structurally ambitious of the two sculptures. The two huge figures stand on the bank of the River Thames, each with its own long nose. *Daddies Bighead* takes the form of a ketchup bottle, a familiar motif for McCarthy, and is the father of the boy Blockhead. These sculptures are colossal and mark a shift in scale to the monumental by McCarthy, and also new experimentation with inflatable technology. Nevertheless, according to critics Morris and Glennie, "these strange hybrid figures are still firmly rooted in McCarthy's ongoing fascination with body as architecture, theme-park spectacle and a searing critique of the American Dream."[137]

5.9 Paul McCarthy | *Blockhead (Black) and Daddies Bighead*, **2003.**
Installation view across Thames River of Tate Modern, London. Courtesy the artist, Hauser & Wirth Zürich London.

Blockhead was first incarnated as *Chocolate Blockhead,* a commissioned project for Expo 2000 in Hanover, where it was displayed amidst national displays of commerce and spectacle. *Chocolate Blockhead* is an eighty-foot-high inflatable structure of an alteration of Pinocchio, who is sitting on a pile of books and has a box for a head and a long pipe for a nose. Visitors could walk between Blockhead's giant legs through a doorway into an interior hall. Inside the hall the visitor could buy from a vending machine miniature edible "chocolate nose bars" of *Blockhead's* pipenose. In the view of Morris and Glennie, "Expo was a funfair and *Blockhead* with its distorted Disney theme-park roots was a disturbing antidote to the carnival."[138]

Morris and Glennie comment on the cube of a head of *Blockhead,* which also serves as a mask: "It is a hollow space to which we are denied entry. All the visitor can do is enter the body at the base and gaze, upwards into a void." In their view, McCarthy keeps these connotations of the cube from his older *Daddies Bighead,* combining "these architectural concerns with an awareness of the more common commercial use of the inflatable as a tool for advertising and promotion, for gimmicky oversized beer bottles and giant cartoon characters."[139]

In 2010, the city of Milan, Italy, hosted an exhibition of McCarthy's "Pig Island." The press release for the exhibition commented:

> The installation "Pig Island" is a carnivalesque amusement park in which human beings behave like pigs. A treasure island in reverse, "Pig Island" is a sculptural shipwreck in which pirates and their heroines throw themselves with abandon into wild revels. The installation is a contemporary Raft of the Medusa: Its characters can finally cast off their inhibitions and reveal their all-too-human nature. "Pig Island" is a work-in-progress that Paul McCarthy has been developing for over seven years, and which will make its world debut at Palazzo Citterio.[140]

Writing in *Frieze Magazine*, Diana Marrone offered this description and interpretation:

> A never-ending creational podium in which visitors can access the artist's world, "Pig Island" is also a satirical portrait of the U.S. An oversized cowboy hat, spilled cups of paint, buckets, dusty musical instruments, cat cages and athletic trophies mingle with exaggerated masks of former president George W. Bush, including a sculpture of him copulating with a pig. Our democracies, McCarthy seems to say, are places where the only real men are pigs and men dig in the trash like animals. Lies are symbolized by a phalanstery of materials, from foam to wood to plastic to half-built props in which, as treasure hunters, we can find perfectly erected and concluded scenes.[141]

Aoife Rosenmeyer wrote about a contemporaneous exhibition of McCarthy's work showing in a private gallery. Rosenmeyer writes that the work is "chockablock with sculptures heaped on trestles, each an orgy of dripping fiberglass and foam. George W. Bush figures fornicate with pigs swilling in troughs of art publications and symbols of decadence; bald Paula Joneses, pirates, and mawkish Hummel ornaments merrily play along." The critic comments: "McCarthy's pirates are easily read as a metaphor for Bush's military colonization of the world, and McCarthy has had time to repeat the motif." He draws a parallel interpretation that relates the work to the art market as a "greedy encroachment and consumption mark the works here, which also relate to the art market" and sees McCarthy's work as holding "a mirror to the age of inflation, exaggerated prices, and art as accessory." He concludes, however, with a dreary tone, writing that the work "surveys a period coming to a close. But as such, it stagnates, despite the industrious mess. Let's hope these petrified figures are now relegated to bit parts in an invigorated McCarthy narrative."[142]

McCarthy's Thoughts about His Own Work

McCarthy is in agreement with critics who see psychological concerns in his concerns for space in his work. Amelia Jones thinks McCarthy's use of architectural spaces "represent[s] the civilizing influence—the weight of the law and the structuring force of institutions (versus the chaos of open space outside the walls of buildings and rooms), that which, like the mask/hole of the camera, contains—then bodies, too, can be seen—like the ego itself—as containers for the chaos of subjective interiority (associated with

femininity or some other dimension of otherness)." McCarthy is interested in collapsing borders between inside and out through his use of foodstuff, which he calls "the flux." He ruptures the flesh of the building or the body and the insides gush out, and repression and sublimation is denied. Says McCarthy, "I've always had an interest in repression, guilt, sex, and shit."[143]

McCarthy views the mask as an architecture for the head that functions as a window with a view out two holes: "When my head is inside the mask, I'm peering out of these holes which are an inch or so away from my face. My voice changes inside the mask; it's hard to breathe. I also make this connection of the mask to a camera. The eye hole of the mask is similar to the lens hole of the camera or the frame of the picture. You can't see beyond the frame of the hole. I've made this hole metaphor as a metaphor of cultural control, what you can see and what you can't see."[144]

McCarthy is forthcoming about his long-lasting fascination with Pinocchio and all the variations McCarthy has made of the character since the early 1980s. He sees Pinocchio as an icon, a European model for "purity and honesty." He understands Pinocchio the character and the story as "a morality story for children, a story for the cultural conditioning of children."[145]

The artist is articulate about his use of materials. Referring to his use of ketchup from early on and into the present: "I was interested in the bottle as a phallic with an orifice. The smell. Ketchup as food as blood and as paint. Ketchup as an American family icon, processed consumption. I grew up using ketchup on everything; it is an American ritual passed on from father to son."[146]

He explains his attraction to inflatables for his latest projects:

Macy's balloons are actually helium filled balloons that are intended to float in the air. I'm making inflatable pieces with constant airflow from fans. They are made with heavier material and made to sit on the ground. This type of inflatable is tied more to advertising. They're used by big companies like McDonald's, Budweiser and Coors—for promotional events. They are used for film promotions, Spiderman, Godzilla, whatever. I'm trying to subvert inflatables—subvert them away from commercial spectacle. They can be about another dialogue-other issues, sculpture.[147]

McCarthy's choice of color for inflatable *Blockhead* (5.10) is also deliberate:

I was interested in black because it subverted the commercial use of inflatables. The commercial spectacle. Black flattens the form. It suggests a hole in the background, a black form in front of a wall, becomes an illusion of a hole in the wall, a hole in the architecture. We think of black as a non-color, like gray and white. But unlike gray, white and black are culturally loaded. They come with some baggage. The black monotone inflatable is a contradiction to the festive notion of inflatables. In front of the Tate, the black inflatable will tend to disappear.[148]

5.10 Paul McCarthy | *Blockhead (Black),* **2003.**

Steel, vinyl coated nylon, fans, rigging, wood, vending machines, hard candy bars, paint, glass, and rope, 2591 x 1128 x 1707 centimeters. Installation at Tate Modern, London. Courtesy the artist, Hauser & Wirth Zürich London.

In interviews, McCarthy is not always forthcoming about his own work. Often the questions posed by interviewers are more revealing than McCarthy's responses are. A pair of artist-interviewers asked: "How do you feel about the way your work is written about, specifically in terms of Julia Kristeva, 'the abject' and that whole psychoanalytical take on it?" McCarthy responded, "there are people who just dismiss the work and just talk about it as being abject and not trying to analyze it, but just being dismissive. Then there are writers who are more analytical about it. I'm into it both ways because that's kind of how it's made."[149]

Bomb art magazine interviewed McCarthy in 2003. The interviewer observes, "You get a lot of mileage out of words via a spare, fragmented mumblelogue that's more like chanting than dialogue, drilling words into the ground rather than at other characters, and there is something repetitious about this method, within a single work, than from piece to piece, year to year." McCarthy responds that he has talked in his performances since the 1960s and that his "audio babble" got louder in the 1970s. He often uses scripts but abandons them in favor of improvisation. Asked about his strong case of dyslexia and if it is a reason for the repetitious speech of the characters in the videos, McCarthy responds, "I have no interest in conventional language, only when it is an appropriation to illustrate something else. Language is architecture as an institution for repression. I/we can't talk seriously. It's a grid of snakes. A tic-tac-toe grid. Verbal tic-tac-toe."[150]

When asked about the emphasis on his penis in his works, McCarthy relates it to sexual traumas in grade school: "I remember it as sexual theater, theater and architecture: the shower room, the locker room and the gym. The lighting. How it was played out with the other boys in the room and the architectural space, a labyrinth of hallways and doors, moving into a large open space—institutional separation based on gender and function."[151]

On a related topic, the interviewer says, "Talk about holes. They've appeared in your work consistently for 30 years. Holes drilled or dug up, holes to peer through, gawk at and poke, holes like empty eye sockets, portraits to consciousness, the edge of a frame, a camera's lens. You made this metaphor about cultural control, what you can see and what you can't. Please explain further." McCarthy responds,

> Holes are access from one space to another—outside to inside-inside to outside-inside to inside. Round and square holes, body holes and architecture holes, mouth, ears, eye sockets, rectum, vagina, penis hole, front door, back door, windows. Holes are also openings to sleeves, deposit chambers and pockets. Donuts and rods, as sexual mechanisms, rub devices. Drilling holes, making a hole with a drill bit. It's about sex and confusion.[152]

The interviewer asks: "Do you find it strange that people have such strong reactions to fecal matter, blood and mucus? The slightest thing that pops out of us is a total horror. Aren't these standard human materials? Why the shock of what's inside us?" McCarthy responds,

> Maybe it is a conditioned response: we're taught to be disgusted by our fluids. Maybe it's related to a fear of death. Body fluids are base material. Disneyland is

so clean; hygiene is the religion of fascism. The body sack, the sack you don't enter, it's taboo to enter the sack. Fear of sex and the loss of control. . . . The Disney characters, the environment, the aesthetic are so refined, the relationships so perfect. It's the invention of a world [that is] directly connected to a political agenda, a type of prison that you are seduced into visiting.[153]

McCarthy and Postmodern Pluralism

Philosopher and art critic Arthur Danto sees McCarthy's work as "systematically disgusting," but he does not use the term disparagingly. He sees McCarthy's work as a serious challenge to traditional aesthetics and thinks that Kant does not have "a single illuminating thing to say" about McCarthy's work or the work of others, such as Sherman's abject pieces, where such words as "ugly," "revolting," and "disgusting" are normally applied in a descriptive sense. Danto asserts that we know what the word "disgusting" means, but want aestheticians to answer the question of "Why? What does that contribute to what he is doing?"[154] The best answers are likely to come not from the Kantian tradition of aesthetics but from psychoanalytic art theory and such authors as Kristeva and her exposition on "the abject."

Strengths and Weaknesses of Postmodern Pluralism

The difficulty of Postmodernist writing remains a major objection to accepting it. American philosopher John Searle in the *New York Review of Books* discusses the air of difficulty in French Postmodernists' writings and thus the further complication of their translation. Searle says that Michel Foucault "once characterized Derrida's prose style to me as *'obscurantisme terroriste'*. The text is written so obscurely that you can't figure out exactly what the thesis is (hence *'obscurantisme'*) and then when one criticizes this, the author says, *'Vous m'avez mal compris; vous etes idiot'* (hence *'terroriste'*)."[155]

Christopher Butler, a British literary scholar and critic of Postmodernism, writes about Postmodernist theorists' troublesome ways of theorizing:

> A suggestive punning word-play was preferred to a plodding and politically suspect logic, and the result was a theory which was more literary than philosophical, and which rarely if ever came to clear or empirically testable conclusions, simply because it was so difficult to be sure about what it meant. . . . It is the thousands of echoes and adaptations, and unsurprising misunderstandings, of their obscure writings that have made up the often confused and pretentious collective psyche of the postmodernist constituency.[156]

Shusterman says Postmodernism's "very meaning, scope, and character are so vague, ambiguous, and deeply contested that it has been challenged as a pernicious, illegitimate nonconcept." He also acknowledges, however, that "advocates reply that the concept's very vagueness usefully challenges the view that concepts must be clear to be meaningful, fruitful, and important."[157]

Patti Lather, a feminist theorist of libratory education influenced by Poststructuralism, identifies demerits of Postmodernism, arguing that: It prioritizes aesthetics over ethics; it emphasizes language to such an extent that it forgets concerns about the maldistribution of global resources and power; it tends to allow Third World multicultural differences to be packaged into First World appropriations; it lacks an effective theory of social change that tends to deny the possibility of collective action; and its discourse is too often inaccessible, intended for small specialized academic audiences.[158]

Approaches to Postmodern Artmaking

What follows is a straightforward and accessible introduction to major ideas, attitudes, and approaches that influence postmodernists in their artmaking.[159] The concepts are overlapping, and many of them are active in single works of art and artifacts of visual culture produced both by individuals and by groups. In this section, postmodernism is sometimes explained by contrasting it to modernism, but these two predominant ways of thinking about art coexist today and influence one another, and the following is not an attempt to reduce complex ideas of each to oversimplified either/or understandings.

Escaping the Confines of Museums

An integral part of the artworld is the art museum. In 1961, Claes Oldenburg, best known of the Pop Artists and for his public sculptures featuring very large replicas of everyday objects, declared: "I am for an art that is political–erotical–mystical, that does something other than sit on its ass in a museum." Robert Smithson (1938–1973) made *Spiral Jetty* (1970) and other earthworks in part to circumvent museums and galleries. He wrote this skeptical view of museums:

> Museums, like asylums and jails, have wards and cells—in other words, neutral rooms called *galleries*. A work of art when placed in a gallery loses its charge and becomes a portable object or surface disengaged from the outside world. A vacant white room with lights is still a submission to the neutral. Works of art seen in such spaces seem to be going through a kind of aesthetic convalescence. They are looked upon as so many inanimate invalids, waiting for critics to pronounce them curable or incurable. The function of the warden-curator is to separate art from the rest of society.[160]

Other artists, such as Barbara Kruger and Jenny Holzer, show works within art museums but also attempt to reach audiences beyond those that visit museums by placing their works in public venues. Kruger has placed her image-and-word pieces internationally in different languages, on billboards, on the outsides of buses, and on T-shirts, matchbooks, and handbags. Jenny Holzer first displayed her now famous *Truisms* on photocopied sheets of copy paper that she pasted to walls in the SoHo district of New York City (1977–), and she continues to display work in public spaces.

Christo (1935–) and Jeanne-Claude (1935–2009) created *The Gates* in Central Park, New York City, in 2005, a project they began in 1979. Nine hundred financially

compensated workers participated in the preparation, display, and removal of the project. As Christo and Jeanne-Claude have done for their previous projects, they maintained their creative independence from museums and galleries by financing the $21 million project themselves by selling preparatory studies, drawings, collages, and scale models. They donated merchandising rights for *The Gates* to a charitable foundation for the park. They accepted no sponsorship or money from the city. Jeff Koons is another example of an artist placing works in public venues for many to see. Artists with more of a modernist sensibility, such as Joan Mitchell and Joel Shapiro, however, depend on galleries and museums to make their work known. Spaces large enough to comfortably hold a Mitchell painting (Color Plates 8 and 9) tend to be museums.

Collapsing Boundaries Between "High" and "Low"

Postmodern artists seek to collapse boundaries that are important to modernists. Modernist artists generally elevate art to a special, independent, and autonomous sphere of its own, asserting that true art transcends ordinary life. They believe art is "high art" and above the things experienced in "low culture." As we have seen, modernist theorists such as Clement Greenberg disdain "kitsch," and those of a Modernist sensibility use "kitsch" to label what they consider cheap, tasteless, and tacky things often associated with middle- and lower-class visual preferences: Elvis paintings on velvet, lava lamps, and knickknacks of all kinds. Beginning with Pop Art in the late 1950s, some artists began to erase the boundary between high and low art by using popular images in their work—comic book images, Campbell's soup cans, Spam, hamburgers and French fries, gas stations, and celebrities.

Currently, artists are drawing on popular culture as a source for their imagery and artistic ideas. Jeff Koons is especially known for making "kitschy art," a contradiction in terms for modernists. Koons is often associated with his monumental sculpture *Puppy* (Color Plate 1) and his "Banality" series (cover) consisting of enlarged reproductions of small popular objects such as statues of saints, cartoon animals, Hummel figurines, busty women, naked children, and a souvenir doll of pop singer Michael Jackson. Paul McCarthy's art (Color Plate 25) is dependent in its effect on people's awareness of what the artist considers Disney-like culture. Cindy Sherman's source of imagery is popular culture (Color Plate 22).

Rejecting "Originality"

Modernists value and promote the notion of the artist as "genius," which is reflected in the artist's "originality" of thought and expression. In premodern times, artists were anonymous contributors to their communities. In modern times values shifted and the individual artist became honored as a champion of authentic and free personal expression. Postmodernists question the concept of originality in art, and they are suspect of the possibility of being original. They claim not to hold originality as an aesthetic value.

As artist Joyce Kozloff observes, "All artists lift from everything that interests them and always have—from earlier art, other work that's around, or sources outside art."[161] Such a realization liberates artists from the demand to be original and unique,

and in their newfound freedom they are able to quote and borrow from other sources while adding their own imprints and insights.

Cindy Sherman's photographs and Paul McCarthy's performances, videos, sculptures, and installations all unabashedly derive from popular culture. Understandings of their works are dependent on realizations of the works' resistance to popular culture.

Jouissance

As discussed in Chapter 4, *jouissance*, the French word meaning pleasure and enjoyment with sexual overtones, can be considered a postmodernist equivalent to the modernist concept of aesthetic experience. *Jouissance* is dependent on a viewer being so lost in a work of art through intense pleasurable involvement that self-awareness and objective distance are lost. In stark contrast to *jouissance*, the modernist conception of "aesthetic experience" requires a *distanced* and *disinterested* view of an artwork. For Immanuel Kant, it is not even caring whether the object exists. The two approaches to artworks are different, and the differences hinge on postmodernists' close personal engagement and modernists' distanced and disinterested aesthetic appreciation. Postmodernists question the possibility and desirability of disinterested engagement with art and life.

Working Collaboratively

In premodern times, artists often worked collectively and anonymously in lending their skills and crafts to building cathedrals, for example. In modern times, individual contributors were named and honored. In postmodern times, some artists are returning to collaborative working methods. For example, six young contemporary Pakistani artists, trained in traditional miniature techniques, are creating small works based on exquisite sixteenth-century Indian books originally made for the emperor in an imperial studio. The miniature paintings are made with hand-ground pigments on handmade paper and illustrate age-old tales of love, war, religion, and political power. The young artists also work in miniature with handmade paints and papers, but they add collaged photographic images, stencils, and rubber stamps. Rather than working in one collective studio, they work individually across the globe and send their jointly made paintings back and forth to each other between Melbourne, Chicago, Lahore, and New York City. One artist begins an image on a sheet of paper and mails it to someone else, who continues working on it before sending it to the next artist. The contemporary group of artists has a spiritual purpose in their collective artmaking: They are responding peacefully and creatively in contrast to the worldwide rise of political and religious aggressive violence following September 11, 2001.[162]

Appropriating

Appropriation is a direct and clear challenge to modernist notions of originality. To "appropriate" is to possess, borrow, steal, copy, quote, or excerpt images that already exist, made by other artists or available in the public domain and general culture. Precursors to appropriation art of the 1980s and after are informed by Marcel

Duchamp's "readymades," most famously, *Fountain* (1.1), a conceptual rather than an aesthetic gesture with a urinal that challenged the prevailing modernist definition of art.

Art critic Hal Foster writes that appropriation art reveals that "underneath each picture there is always another picture." Foster argues that the importance of appropriation is that it entails a shift in position: "the artist becomes a manipulator of signs more than a producer of art objects, and the viewer an active reader of messages rather than a passive contemplator of the aesthetic or consumer of the spectacle."[163]

The Metropolitan Museum of Art owns a work of appropriation made by artist Richard Prince of a cowboy on horseback that the artist took from an image of a successful advertising campaign for Marlboro cigarettes. Prince selected a portion of the image and enlarged it so that its Ben-Day dots were apparent, thus deteriorating its original sleekness and exaggerating its mechanical means of production. The Metropolitan refers to Prince's piece as "a copy (the photograph) of a copy (the advertisement) of a myth (the cowboy)."

Simulating

To "simulate" is to imitate or copy. "Simulacra" are copies of things that no longer have an original or never had one to begin with. The concept of simulacra, developed especially by Jean Baudrillard, a French theorist of postmodernism, is a prominent theme explored by postmodernists. The 1990 movie *The Matrix* explores people and their simulacra. Neo, one of the film's main characters, has a hollowed-out copy of Baudrillard's book *Simulacra and Simulation* that Neo uses as a secret hiding place. The idea of the simulacrum asserts that we no longer are able to distinguish between the real and the simulated "hyperreal" of television, advertising, video games, role-playing games, and all kinds of spectacles in contemporary society. The distinction between the real and the representation collapses and dissolves away. What are left are the simulacra themselves.

Betty Boop, a popular icon, serves as a clear example of a simulacrum. The cartoon figure is based on an amalgamation of two female jazz singers of the 1920s, Annette Hanshaw and Helen Kane. Under various pseudonyms, Hanshaw performed vocal simulations of Kane. Betty Boop, a copy, survives both Kane and Hanshaw, actual people—she is a copy without an original.[164]

Photography, a medium based on copying with the property of realistic-looking duplication, especially lends itself to play with simulacra by contemporary artists. Cindy Sherman's early "Film Stills" (5.3, 5.4) look very much like photographs of scenes from 1950s Hollywood movies, but they are not. They are photographs of Sherman herself as if she were in a movie.

Hybridizing

Hybridity is mixing diverse cultural influences in a single artwork. In postmodern terminology "hybridity" refers to "the processes and products of cultural mixing which articulates two or more disparate elements to engender a new and distinct entity."[165] This meaning was shared by artists and theorists during the 1980s who

wanted to disrupt and make more complex inadequately simplistic binary divisions of complex cultural generalities, such as Western–non-Western, African–European, black–white, masculine–feminine, gay–straight, and so forth.

Jean-Michel Basquiat's paintings are hybrid. They are not hybrid because of his Haitian-Puerto Rican ethnicity but because they include the consciously primitive styles of artists such as Cy Twombly and Jean Dubuffet, graffiti, and 1980s punk and funk musical influences. To say that an artist's work is hybrid because of the artist's mixed ethnicity implies the false notion that "mixed-ethnic artists" automatically produce "mixed-ethnic art." Basquiat *chose* to construct hybrid works of art based on many different cultural influences.

Mixing Media

Many modernists uphold the ideal that any specific art medium should be used purely; that is, artists ought to discover and exploit the unique nature of any given material. An artwork made of wood should look like wood; plaster and concrete need not be disguised as something else because they are beautiful media in themselves. Joel Shapiro's works in wood look like wood (Color Plate 17), and when they are painted he even allows drips of paint to reinforce the fact that the piece is painted wood, drips and all. His pieces cast in metal (Color Plate 16) look very much like they are made of metal. For modernists, some materials are not the stuff of "art," such as glitter, DayGlo paint, or synthetic fur.

Robert Rauschenberg (1925–2008) began defying such principles and attitudes in the 1950s and '60s with his "combines" that intentionally mix painting and sculpture. Jeff Koons hires highly skilled Hummel craftsmen to construct figures in wood that they then cover with paint, glass eyes, and gold. Chris Ofili utilizes oil and acrylic with beads, glitter, map pins, collaged bits of magazines, and his signature dried elephant dung. In her installations (and photographs of them), artist Sandy Skoglund has used strawberry jam, Cheez Doodles, stuffed artificial birds, raw meats, orange marmalade, bits of mirrors, eggshells, raisins, mannequins, live models, chewed chewing gum, plastic ferns, hand-cast paper, and clay.

Layering

Because of photomechanical reproduction, images are inexpensive, plentiful, and readily available. Some artists pile images on top of each other, changing the meanings of the images in their original uses. Barbara Kruger presents clear examples of the layering of images, texts, and sounds in her installations: the images and words she layers complicate each other through wrenching visual, verbal, audio, and conceptual contradictions.

Ah Xian, a Chinese artist who fled to Sydney, Australia, for political reasons, aptly employs layering in a series of porcelain busts. The glazed white porcelain busts he makes are of anonymous men and women, young and old, heavy and slight. The busts are life-size, molded directly from the models. On the eyes of one of his female figures, the artist layered a glazed photographic image of a bright orange butterfly. He covered

her lips with an image of flowers. He layered similar photographic images on her head and shoulders. The sources of the layered images are traditional Chinese patterns found on plates, bowls, and vases in the Ming (1364–1643) and Qing (1644–1911) dynasties. Through these busts and the images he layers onto them, Xian visually expresses the thought that Chinese culture is part of a Chinese person, no matter where he or she dwells.[166]

Mixing Codes

A "code," in postmodern discourse, is a system of signs and a set of conventions as to how the signs are to be used. Signs within a culture are arbitrary, not natural. We communally agree, for example, that at a traffic intersection, green shall mean "go" and red shall mean "stop." We use codes so effortlessly that they seem natural rather than constructed. Some postmodern artists make us consciously aware of codes in everyday life and how they shape our perceptions.

Michael Ray Charles, an African American artist, effectively mixes codes to unmask racist biases we as viewers may hold. In *Cut and Paste* (1994), for example, he appropriates a coded system from paper doll kits but uses a racist image of a black male as the doll and provides various stereotypical props to be cut out and pasted onto the black male. The props use signifiers that are commonly used to denigrate African Americans: a football, a hair pick, a gun, a banana, a tie, a handbag, a chicken, and a knife. The football can be associated with racist notions of blacks' supposed superior athleticism and inferior mental capability; the gun with the imagined threat of violence posed by black males; the handbag with purse snatching, and so forth. The male figure itself is coded with oversized lips, braided hair, white minstrel gloves, and shorts like Mickey Mouse wears; Mickey Mouse himself is a coded racist reference to a minstrel figure. By employing the conventions of children's paper doll books, Charles emphasizes that at an early age and often in the home children learn to paste racist views on others.

Paul McCarthy uses coded figures or images, such as a rotund man with white hair and beard wearing a red suit to indicate Santa Claus, a positively coded figure with associations of good cheer. McCarthy then mixes the positively coded figure with a similarly coded figure but with negative connotations: an ugly masked face, awkward gestures, making guttural sounds, with sullied hands, face, and suit. The clash of the two coded images is stark.

Lorna Simpson, in a five-part photographic work, *Easy for Who to Say* (1989), mixes codes. She shows five framed duplicate head-and-shoulder photographs of a person with face covered by a white oval. Although the figure's face is not seen, it is coded as a black woman by dreadlocks, a sleeveless and simple white shift that reveals dark skin, and a hint of cleavage. On each of the white ovals covering the faces, she has a letter of the alphabet: A-E-I-O-U, signifying the vowels of the English language, and coded as requisite letters for any word in English. Under each corresponding vowel she has placed these words: Amnesia, Error, Indifference, Omission, and Uncivil. The words can be easily if vaguely associated with African American females and how they have been treated historically in America. As her title indicates, the vowels are easy for anyone to say, but the words are not easy to say for an African American woman.

Recontextualizing

Recontextualization is a means of constructing meaning by positioning a familiar image in a new and unexpected relationship to words, pictures, objects, sounds, and symbols. Fred Wilson is a contemporary master of recontextualization. Wilson forages through museum collections and rearranges objects to give them new significance through unusual juxtapositions. In his renowned exhibition "Mining the Museum" at the Maryland Historical Society (1992–1993) he placed a wooden post used for whipping slaves along with fine furniture of the period. Similarly, Wilson's juxtaposition of steel shackles and silver tea sets displayed the brutality that coexisted with the gentility in slave owners' lives.

Yolanda Lopez appropriates the common and sacred image of Our Lady of Guadalupe and recontextualizes it into political self-portraits such as *The Portrait of the Artist as the Virgin of Guadalupe*, in which she is the virgin, in a short dress and running shoes. She says that her series is her

> way of questioning a very common and potent icon of the ideal woman in Chicano culture. At a time in our history when we were looking to our past historically and culturally I wanted the Guadalupes to prompt a reconsideration of what kinds of new role models Chicanas need, and also to caution against adopting carte blanche anything simply because it is Mexican. By doing portraits of ordinary women— my mother, grandmother, and myself—I wanted to draw attention and pay homage to working-class women, old women, middle-aged overweight women, young, exuberant, self-assertive women.[167]

By placing an old image in a new context, she radically alters the image's originally intended meanings.

Confronting the Gaze

As discussed earlier in this chapter, the concept of the "gaze" originated in film theory in the 1970s and was first identified as the "male gaze," that is, the tendency of Hollywood films to represent women in ways that heightened the sexual or erotic aspects of women's bodies for a presumed male viewer. Further, such cinematic telling and showing usually entails the maker and viewer as the active subject and the woman as the passive object. Film theorist Laura Mulvey argues that the female body is often shown to connote a "to-be-looked-at-ness." The male gaze is readily apparent in many mass media productions.

Art critic John Berger asserts that many Western oil paintings of women in famous historical works of art are the result of male desire to legitimately eroticize and then stare at women. Worse yet, male painters and patrons sometimes cast the blame for male pleasure at the woman. Berger writes, "You painted a naked woman because you enjoyed looking at her, you put a mirror in her hand and you called the painting *Vanity*, thus morally condemning the woman whose nakedness you had depicted for your own pleasure."[168]

As quoted earlier in this chapter, Cindy Sherman has been credited with making explicit "the traces of a male gaze trained on an awaiting and defenseless female; the

ways the female reacts to this gaze, entreating it, ignoring it, placating it."[169] Mara Witzling, quoted in Chapter 3, credits Kiki Smith with "the revision of an art historical tradition that has positioned women as the object of a dominant gaze."[170]

Facing the Abject

"The abject" refers to supposed unsavory aspects of life, especially concerning functions of the body. French theorist Julia Kristeva refers to the abject as "loathing an item of food, a piece of filth, waste, or dung."[171] The concept of the abject accounts for many "ugly" representations in recent art, such as Andres Serrano's "Shit" photographs made in 2008 and Cindy Sherman's vomit-strewn images and intentionally nasty and repulsive sexual images made in the late 1980s and early 1990s. These particular works of Sherman's challenge the male gaze with abject images of the female body and feminine sexuality. In recorded and live performances and in large sculptural installations, Paul McCarthy creates scatological abject images of characters including Pinocchio (Color Plate 25) for ironic effect.

Kiki Smith, however, uses the abject in positive and empowering ways in prints, sculptures, and installations. She finds grace in what many consider the less pleasant aspects of our bodies. For *Pee Body*, she sculpted a naked woman squatting to relieve herself, passing an elegant string of beads rather than urine. Smith says: "My work accepts the reality of those bodily functions. They define our being here on this planet."[172]

Constructing Identities

"Identity politics" refers to the idea that people tend to form their opinions of others based on ideas and attitudes about race, gender, ethnicity, and sexual orientation. Artists working with identity politics make art based on these issues rather than art that strives only for aesthetic appeal.

ACT UP and Gran Fury (1988–1994), two activist collectives, visually assert their identities as gay, lesbian, and bisexual men and women in confrontational graphic images and slogans such as "We're here, we're queer, get used to it." They organized and mobilized government support of research and policies to end the AIDS epidemic. They also launched a graphic campaign with a bus poster showing three couples kissing one another: a man and a woman, two men, and two women, with the slogan "Kissing doesn't kill: Greed and indifference do." The posters refer to the greed and indifference of government and corporate agencies that are doing less than they could be doing to end homophobia and the health crisis.

Melissa Shiff is a contemporary artist working with important social issues in the context of her Jewish heritage. She constructed *Elijah's Chair* out of an antique rocking chair into the back of which she embedded a video monitor showing a continuously playing video that shows doors that open into various homes, rich and poor and in between. She intends the chair to serve as "a meditation on unconditional hospitality and the unequal distribution of wealth in urban America." Shiff's sculpture draws upon Jewish customs related to the prophet Elijah: the opening of the door for Elijah and the setting aside of a chair for him. The artist created the chair to employ the prophet in

the service of social action. For Shiff, the piece "documents the staggering divide of wealth in a city of extremes in an effort to show that Elijah signifies the hospitality and openness to the Other that must occur."[173]

Using Narratives

The telling of narratives, or stories, is an old practice in the history of art, dating to the ancient Egyptians or earlier. "History painting," the depiction of an event from biblical or classical history, achieved a high status during the Renaissance. Nineteenth-century painters and sculptors reveled in making dramatic history stories and sometimes in sentimental family dramas. However, modernist painters turned away from storytelling in painting and sculpture, believing narratives were better suited for writers than visual artists. By the 1960s, self-referential abstract art predominated in the mainstream artworld, and narrative artmaking became taboo. Postmodern artists rebel against such strictures on their creative practices and are reintroducing narratives into their artworks.

Some artforms, such as film and video, can narrate whole stories, and others, such as painting and sculpture, can tell parts of stories or show a key moment and allow the viewer to fill in the before and after of the moment.

Cindy Sherman's still images imply longer narratives. Kiki Smith constructs new narratives in sculpture and prints based on her versions of mythical characters such as Red Riding Hood. Paul McCarthy's videos and live performances use the narrative structure of beginning, middle, and end.

Creating Metaphors

To create a metaphor is to attribute the qualities of one thing to another: "All the world's a stage." In Nelson Goodman's thinking, every depiction is a metaphor in that it shows something *as* something. In a general sense, all images are metaphors because the qualities of the image are attributed to the thing being depicted. A Frida Kahlo self-portrait, for example, is a metaphor for an aspect of Kahlo's persona, a selection of details that shapes our interpretation of her self-image. Many modernist artworks minimize metaphoric meaning in favor of aesthetic form that tends to be self-referential or to refer to other works of art. Postmodernists, however, often refer directly to events outside of art itself and explicitly use metaphors to do so.

Do-Ho Suh's sculpture *Public Figures* is also overtly metaphoric. It depicts hundreds of tiny human figures holding up a relatively huge pedestal of a monumental sculpture that is typically displayed in a public setting, such as a park. Importantly, Suh placed no figure atop the pedestal; the figures supporting the pedestal are the only figures in the sculpture. Suh's sculpture is a metaphor for many unrecognized individuals who support societies' heroes. He explains:

> I just want to recognize them. Let's say if there's one statue at the plaza of a hero who helped or protected our country, there are hundreds of thousands of individuals who helped him and worked with him, and there's no recognition for them. So in my sculpture, *Public Figures*, I had around six hundred small figures, twelve inches high, six different shapes, both male and female, of different ethnicities.[174]

Using Irony, Parody, and Dissonance

Irony, parody, and dissonance are interrelated concepts. Irony is the use of words and images to convey the opposite of what they say and show. Parody is a form of satire that imitates another artifact in order to ridicule or poke fun at either the work itself or the subject of the work. Dissonance refers to lack of harmony or agreement between elements in a work.

Although these strategies are not new, contemporary artists are reemploying them to engage viewers in questioning what they have received as knowledge. Many viewers see much of the work of Jeff Koons as parody, although he insists there is no irony in his work. Some images by Andres Serrano are parodies, and many would take the photographs of feces to be ironic. All of Paul McCarthy's art relies on irony, parody, and dissonance. Knowing whether something is ironic or not is essential to understanding works of art. Artists who use irony have the challenge of letting the viewer know what their artwork is for and against without being didactic and preachy. Sometimes parodies are affectionate: For example, some of Cindy Sherman's photographs of herself imply the joy of the childhood activity of dress-up.

Performance artist James Luna attempts to communicate his political views by performing parodies. In *Take a Picture with a Real Indian*, Luna, a Luiseno Indian, invites passersby on the street to have their pictures taken with a life-size image of Luna wearing one of three native costumes: contemporary, basic breech cloth, or a fictitious "war dance" outfit. The work explores the fascination that the public has for "their" Indians, a fascination that often ignores the reality of the Indian in America today. Luna explains the motivation behind the irony of his work:

> One of the primary reasons I make art is to inform others about Native peoples from our point of view—a view which because of history is rich in native cultural tradition, and both influenced by and influential in contemporary American society. I truly believe that Native Tribal peoples are the least known and most incorrectly portrayed people in history, media, and the arts. I want to change those perceptions.[175]

To realize the meanings and impact of an ironic work of art, it is important to know what it is quoting or referring to. To know what the artwork refers to and how it challenges it enriches our understanding of both.

Conclusion

Postmodern Pluralism and Artists

The artistic pluralism that accompanies the decline of orthodox Modernist Formalism offers artists tremendous freedom of what subjects and styles they would like to pursue without fear of retribution from a narrowly focused critical community of caretakers of the artworld. Currently, many different kinds of art forms exist in neighboring galleries of the artworld: Figurative painting has returned, narratives have a newfound legitimacy after being disparaged for many decades, and overtly politically based art is rampant, for example. None of these were readily accepted during high Modernism—artists might have been making them, but they were not being widely shown, sold, or collected.

Postmodern Pluralism and Artworks

Many Postmodernist works of art are intentionally made to trouble any received notions of beauty, the single most important criterion for many works of art designated as "great" in the history of art. Postmodern artworks and theories trouble and threaten once very stable and intuitively accepted Western notions of an authentic, individual, free, creative "self." In Postmodern works of theory and artworks, "the self" becomes willingly or unwillingly aware of "the other," of "difference," and of what counts as "good." Any former "must" in "the truth" of statements has been rattled for those aware of and open to Postmodern ideas and ideals. Postmodern ideas can be very destabilizing to long-held ways of viewing the self, the other, the world, and what is true. Postmodern times are unsettling.

Postmodern Pluralism and Audiences

There is more variety of kinds of artworks available to viewers and collectors perhaps than ever before. A viewer generally interested in recent art is bound to find something in museums and respected galleries that she or he can readily appreciate. Viewers will also find many objects and events that will likely seem strange, odd, disgusting, or not what they previously thought of as "art" or even "modern art." Many of Cindy Sherman's abject photographs are unsettling to see, and much of the work of Paul McCarthy is repulsive in a stomach-turning way; yet the work of both of these artists is taken seriously and is generally thought to be "good art" by historians, critics, curators, and collectors, even though it is anything but attractive.

Many viewers are still just beginning to learn or to accept that all art is more or less theory dependent and that when they approach Modern art, theory is more important to understanding it than it is to understanding art made by pre-Modernists. Most in the West can readily enjoy the art of the Renaissance or that of the Impressionists. Problems of acceptance begin with many with post-Impressionism, abstraction, "messy" and seemingly childish abstract Expressionism, and extreme Abstraction in Minimalism. The variety of Postmodern art and all the French-based and European theories that support and contribute to it, and it to them, offers further trouble, especially when the language and concepts applied are new, cumbersome, and complex.

Questions for Further Reflection

What are the personal consequences of accepting any single Postmodern belief? The general social consequences?

Of what can I be sure?

What criteria for works of art will I use if I abandon traditional Kantian notions of good art?

Do I still believe that art can be or should be apart from politics and ethics?

Ought Modernist "elements of art" and "principles of design" be eliminated from today's art education? If so, should they be replaced or renewed? With what might they be replaced? How might they be renewed?

Are there artists in this book that would fit better in this chapter than where they currently are placed? Are there artists placed in this chapter that could easily be placed in other chapters? Explain.

Notes

1. Richard Shusterman, "Aesthetics and Postmodernism," in *The Oxford Handbook of Aesthetics*, ed. Jerrold Levinson, New York: Oxford, 2003, pp. 771, 781.

2. Arthur Danto, "The Future of Aesthetics," University of Oslo, October 27, 2005.

3. Martin Heidegger, *Nietzsche*, 2 volumes. New York: Harper Collins, 1991.

4. Jacques Derrida, *Spurs: Nietzsche's Styles*, Chicago: University of Chicago Press, 1979.

5. Michel Foucault, "Nietzsche, Genealogy, History," in *Language, Counter-Memory, Practice: Selected Essays and Interviews*, Ithaca, NY: Cornell University Press, 1977, pp. 139–164; and "Ecce Homo, or the Written Body," *Oxford Literary Review*, Vol. 7, Nos. 1–2, 1985, pp. 3–24.

6. Arthur Danto, *Nietzsche as Philosopher*, New York: Columbia University Press, 1965.

7. Bernd Magnus, "Nietzsche, Friedrich Wilhelm: Survey of Thought," *Encyclopedia of Aesthetics*, New York: Oxford, 1998, pp. 353–359.

8. Gary Shapiro, "Nietzsche, Friedrich Wilhelm: Nietzsche, Schopenhauer, and Disinterestedness," *Encyclopedia of Aesthetics*, New York: Oxford University Press, 1998, pp. 359–360.

9. Michael Peters, "Lyotard, Marxism and Education: The Problem of Knowledge Capitalism," in *Poststructuralism, Philosophy, Pedagogy*, ed. James Marshall, Dordrecht, The Netherlands: Kluwer, 2004, p. 45.

10. Raymond Geuss, "Critical Theory," *The Shorter Routledge Encyclopedia of Philosophy*, ed. Edward Craig, New York: Routledge, p. 157.

11. M. Ingwood, "Frankfurt School," *The Oxford Companion to Philosophy*, ed. Ted Honderich, New York: Oxford University Press, p. 290.

12. Theodor Adorno, *Aesthetic Theory*, tr. Robert Hullot-Kentor, Minneapolis: University of Minnesota Press, 1997.

13. Jae Emerling, *Theory for Art History*, New York: Routledge, 2005, pp. 42–43.

14. Ibid., pp. 43–46.

15. Glen Ward, *Postmodernism*, Chicago: Contemporary Books, 1997.

16. Ibid., p. 96.

17. Ibid., pp. 96–97.

18. Ibid., pp. 147–148.

19. Laura Mulvey, "Visual Pleasure and Narrative Cinema," in *Visual and Other Pleasures*, Bloomington: Indiana University Press, 1989.

20. Emerling, *Theory for Art History*, p. 190.

21. Ibid., p. 192.

22. Ibid., pp. 147–148.

23. Ibid., p. 154.

24. Alan Schrift, *Nietzsche's French Legacy: A Genealogy of Poststructuralism*, New York: Routledge, 1995.

25. Julia Kristeva, *Powers of Horror: An Essay on Abjection*, tr. Leon S. Roudiez, New York: Columbia University Press, 1982, p. 2.

26. Lynda Stone, "Julia Kristeva's 'Mystery' of the Subject in Process," in *Poststructuralism, Philosophy, Pedagogy*, p. 128.

27. David Hopkins, *After Modern Art: 1945–2000*, Oxford, England: Oxford University Press, 2000, p. 225.

28. "Abject Art," Tate Online, retrieved February 27, 2006, from http://www.tate.org .uk/collections/glossary/definition .jsp?entryId=7.

29. Mary Klages, *Structuralism/Poststructuralism, 2006*, retrieved January 25, 2006, from http://www.colorado.edu/English/ ENGL2012Klages/lderrida.html.

30. Warren Hedges, "Derrida & Deconstruction: Key Points," 1998, retrieved June 19, 2006, from http://www.sou.edu/english/hedges/Sodashop/RCenter/Theory/People/pdfs/ derrida%20key.

31. John R. Morss, "Giles Deleuze and the Space of Education: Poststructuralism, Critical Psychology, and Schooled Bodies," in *Poststructuralism, Philosophy, Pedagogy*, p. 87.

32. Ibid., p. 88.

33. In Stephen Best and Douglas Kellner, *Postmodern Theory: Critical Interrogations*, New York: Guilford Press, 1991, p. 80.

34. Ibid., 83.

35. Ibid., 83.

36. Bjorn Ramberg, "Richard Rorty," *Stanford Encyclopedia of Philosophy*, 2001, retrieved February 21, 2001, from http://plato.stanford.edu/archives/win2001/entries/rorty.

37. Ibid.

38. Terry Barrett, *Interpreting Art: Reflecting, Wondering, Responding*, New York: McGraw-Hill, 2002, p. 202.

39. Linda Nochlin, "Why Have There Been No Great Women Artists?," in *Women, Art, and Power and Other Essays*, New York: 1988, pp. 145–178.

40. John Berger, *Ways of Seeing*, London, Penguin, 1972.

41. Sartre, quoted in Hilde, "The Role of Feminist Aesthetics in Feminist Theory," *The Journal of Aesthetics and Art Criticism*, Vol. 48, No. 4, 1990, p. 290.

42. Laura Mulvey, "Visual Pleasure and Narrative Cinema," *Screen*, 1975, reprinted in *Feminism and Film Theory*, ed. C. Penley, New York: Routledge, 1988.

43. Eleanor Heartney, *Postmodernism*, Cambridge, England: Cambridge University Press, 2001.

44. Ibid., pp. 52–53.

45. Hein, "The Role of Feminist Aesthetics in Feminist Theory," *The Journal of Aesthetics and Art Criticism*, Vol. 48, No. 4, 1990, pp. 281–291.

46. Simone de Beauvoir, quoted in Hein, "The Role of Feminist Aesthetics in Feminist Theory," p. 282.

47. Hein, ibid.

48. Abigail Solomon-Godeau, "Winning the Game When the Rules Have Been Changed: Art Photography and Postmodernism," *Exposure*, Vol. 23, No. 1, 1985, p. 13.

49. Barbara DeGenevieve, "Guest Editorial: On Teaching Theory," *Exposure*, Vol. 26, No. 3, 1988, p. 10.

50. Griselda Pollock and Deborah Cherry, quoted by Pollock, "Art, Art School, Culture: Individualism After the Death of the Artist," *Exposure*, Vol. 24, No. 3, 1986, p. 22.

51. Hein, "The Role of Feminist Aesthetics in Feminist Theory," p. 289, n. 2.

52. Ibid., p. xx.

53. Elizabeth Garber, "Feminism, Aesthetics, and Art Education," *Studies in Art Education*, Vol. 33, No. 4, 1992, pp. 210–225.

54. Rosalind Coward, quoted by Jan Zita Grover, "Dykes in Context: Some Problems in Minority Representation," in *The Context of Meaning*, ed. Richard Bolton, Cambridge, MA: MIT Press, 1989, p. 169.

55. Hein, "The Role of Feminist Aesthetics in Feminist Theory," p. 284.

56. Mary Devereaux, "Oppressive Texts, Resisting Readers and the Gendered Spectator: The 'New' Aesthetics," in *Arguing about Art: Contemporary Philosophical Debates*, 2nd ed., ed. Alex Neil and Aaron Ridley, New York: Routledge, 2002, p. 384.

57. Marshall, *Poststructuralism, Philosophy, Pedagogy*, p. xiv.

58. Lyotard, in Shusterman, "Aesthetics and Postmodernism," p. 776.

59. Christopher Butler, *Postmodernism: A Very Short Introduction*, New York: Oxford University Press, 2002, p. 9.

60. Benjamin Tilghman, "Wittgenstein, Ludwig Josef Johann: Survey of Thought," *Encyclopedia of Aesthetics*, p. 60

61. Ibid., p. 60.

62. Emerling, *Theory for Art History*, pp. 203–205.

63. Ibid., p. 206.

64. Ibid., p. 209–210.

65. Best and Kellner, *Postmodern Theory*, p. 121.

66. Thomas Lynch, "Mourning in America," book review of *Death's Door: Modern Dying and the Ways We Grieve* by Sandra Gilbert, *The New York Times Book Review*, Sunday, February 26, 2006, p. 16.

67. "Jean Baudrillard," Wikipedia, retrieved February 15, 2006, from http://en .wikipedia.org/wiki/Baudrillard.

68. Susan Sontag, *Regarding the Pain of Others*, New York: Picador, 2004.

69. Deborah Solomon, "Continental Drift: Questions for Jean Baudrillard," *The New York Times Magazine*, November 11, 2005, p. 22.

70. Frederick Jameson, *The Prison House of Language: A Critical Account of Structuralism and Russian Formalism*, Princeton, NJ: University of Princeton Press.

71. Elizabeth Cornwall, "Postcolonialism," *Encyclopedia of Aesthetics*, pp. 50–57.

72. Ibid., pp. 51–52,

73. Emerling, *Theory for Art History*, p. 220.

74. Ibid., pp. 221–223.

75. Ibid., p. 224.

76. Anandi Ramamurthy, "Constructions of Illusion: Photography and Commodity Culture," in *Photography: A Critical Introduction*, 2nd ed., ed. Liz Wells, New York: Routledge, 2000, pp. 188–189.

77. Ibid., pp. 202–203.

78. Heartney, *Postmodernism*, p. 57.

79. Jennifer Eisenhauer, "Beyond Bombardment: Subjectivity, Visual Culture, and Art Education," *Studies in Art Education*, Vol. 47, No. 2, 2006, pp. 160–161.

80. Foster et al., *Art Since 1900*, p. 583.

81. Herbert Muschamp, "Knowing Looks—Cindy Sherman, Museum of Modern Art, New York, NY," *Artforum*, 1996, http://www.findarticles.com/p/articles/mi_m0268/is_nlO_v35/ai _19677874/print, April 24, 2006.

82. Muschamp, "Knowing Looks."

83. Rosalind Krauss, *Cindy Sherman 1975–1993*, New York: Rizzoli, p. 32.

84. Foster et al., *Art Since 1900*, p. 582.

85. Ibid., p. 582.

86. Heartney, *Postmodernism*, p. 59.

87. Ibid., p. 57.

88. Hal Foster, *The Return of the Real: The Avant-Garde at the End of the Century*, Cambridge, Mass.: MIT Press, 1996, p. 148.

89. Ibid., p. 148.

90. Ibid., p. 149.

91. David Frankel, "Cindy Sherman Talks to David Frankel—80s Then—Interview," *Artforum*, March 2003, retrieved April 23, 2006, from http://www.findarticles.com/p/articles/mi_m0268/is_7_41/ai/ 98918643/print.

92. Ibid.

93. Frankel, "Cindy Sherman Talks to David Frankel."

94. Ibid.

95. Betsy Berne, "Studio: Cindy Sherman," *Tate Magazine*, Issue 5, retrieved April 18, 2006, from http://www.tate.org .uk/magazine/issue5/sherman/htm.

96. Ellen Rudolph, "Obscurely Focused: The Photographs of Lorna Simpson," *Angle*, #17, 2004, retrieved April 17, 2006, from http://www.anglemagazine.org/articles/Obscurely_Focused_The_Photogr_2219.asp; Cindy Sherman, Museum of Contemporary Photography, retrieved January 27, 2006, from http://www.mopc.org/collections/permanent/uploads/sherman2001_33.jpg.

97. Rudolph, "Obscurely Focused."

98. Irish Museum of Modern Art, "Lorna Simpson at the Irish Museum of Modern Art," retrieved April 17, 2006, from http://www.modernart.ie/en/page_19303.htm.

99. Andy Grundberg, "Afterword," in Deborah Willis, *Lorna Simpson*, San Francisco: The Friends of Photography, 1992, p. 61.

100. Deborah Willis, "Eyes in the Back of Your Head: The Work of Lorna Simpson," in Willis, *Lorna Simpson*, 1992, p. 10.

101. Foster et al., *Art Since 1900*, p. 641.

102. Thelma Golden, "In Conversation with Lorna Simpson," in Kellie Jones, Thelma Golden, and Chrissie Iles, *Lorna Simpson*, New York: Phaidon, 2002, p. 107.

103. Beryl Wright, "Back Talk: Recording the Body," in *Lorna Simpson: For the Sake of the Viewer*, Chicago: The Museum of Contemporary Art, 1992, pp. 12–14.

104. Ibid., p. 13.

105. Kellie Jones, "(un)seen & Overheard: Pictures by Lorna Simpson," in Jones et al., *Lorna Simpson*, p. 40.

106. Willis, "Eyes in the Back of your Head," p. 59.

107. Saidiya Hartman, "Excisions of the Flesh," in *Lorna Simpson: For the Sake of the Viewer*, p. 55.

108. Ibid., pp. 61–62.

109. Artnews.info, "Lorna Simpson," retrieved April 17, 2006, from http://www.artnews.info/artist.php?i=149.

110. Grace Glueck, "Art Review; Making History a Part of Today with Some Artifacts and Whimsy," *New York Times*, August 15, 2003, retrieved April 17, 2006, from http://query.nytimes.com/gst/fullpage.html?res=980DE4DF1730F936A2575BC0A9659C 8B63.

111. Chrissie Iles, "Images Between Images: Lorna Simpson's Post-Narrative Cinema," in Jones et al., *Lorna Simpson*, p. 107.

112. Deborah Willis, "A Conversation: Lorna Simpson and Deborah Willis," in Willis, *Lorna Simpson*, p. 60.

113. Ibid., p. 55.

114. Ibid., p. 56.

115. Ibid., pp. 56–57.

116. Thelma Golden, "What's White . . . ?" in *Postmodern Perspectives: Issues in Contemporary Art*, 2nd ed., ed. Howard Risatti, Upper Saddle River, NJ: Prentice-Hall, 1998, p. 277.

117. Cornel West, in Thelma Golden, "What's White . . . ?" in *Postmodern Perspectives: Issues in Contemporary Art*, 2nd ed., ed. Howard Risatti, Upper Saddle River, NJ: Prentice-Hall, 1998.

118. Jerry Saltz, "Backdoor Man," *The Village Voice*, 2002, retrieved April 14, 2006, from http://www.kunstwissen.de/ fachlf-kuns/o_pm/carthy05.htm.

119. Lisa Phillips, "Paul McCarthy's Theater of the Body," in *Paul McCarthy*, New York: New Museum, 2000, pp. 2–3.

120. Ibid., p. 4.

121. David Thorp, "Large Scale Substitutes," in *Paul McCarthy at the Tate Modern*, London: Tate Publishing, 2003, p. 176.

122. Dan Cameron, "The Mirror Stage," in *Paul McCarthy*, p. 57.

123. Peter Plagens, "Of Pigments and Pixels," *Newsweek*, special edition, December 1999–February 2000, retrieved April 14, 2006, from http://www.michaklein.com/news/newsweek .html.

124. Adrian Searle, "Shiver Me Timbers," *Guardian Unlimited*, October 25, 2005, retrieved April 14, 2006, from http://arts.guardian.co.uk/features/story/0,11710,1599800.html.

125. Uta Grosenick and Burkhard Riemschneider (eds.), *Art Now: 137 Artists at the Rise of the New Millennium*, New York: Taschen, 2002, p. 288.

126. Phillips, "Paul McCarthy's Theater," p. 5.

127. Jones, "(un)seen & Overheard," p. 128.

128. Ibid., p. 125.

129. Ibid., p. 125.

130. Philip Monk, "Mike Kelley and Paul McCarthy: Collaborative Works," retrieved April 14, 2006, from http://www .absolutearts.com/artsnews/2000/03/28/26760.html.

131. Cameron, "The Mirror Stage," pp. 57–63.

132. Ibid., p. 63.

133. Kuspit, in Michele Cone, "The End of Pleasure," Artnet, 2004, retrieved April 14, 2006, from http://www.artnet.com/Magazine/index/cone/cone2-17-04.asp.

134. Grosenick and Riemschneider, *Art Now*.

135. Ibid.

136. Frances Morris and Sarah Glennie, "Hollow Dreams," in *Paul McCarthy at the Tate Modern*, p. 179.

137. Ibid., p. 176.

138. Ibid., p. 176.

139. Ibid., p. 178.

140. "Paul McCarthy: Pig Island," press release, *This Is Tomorrow: Contemporary Art Magazine*, retrieved July 23, 2010, from http://www.thisistomorrow.info/viewArticle.aspx?artId =406

141. Diana Marrone, "Paul McCarthy," *Frieze Magazine*, retrieved July 23, 2010, from http://www.frieze.com/shows/review/paul_mccarthy/.

142. Artinfo, retrieved July 23, 2010, from http://www.artinfo.com/news/story/32418/ paul-mccarthy/.

143. Jones, "(un)seen & Overheard," p. 126.

144. Ibid., p. 126.

145. James Rondeau, "Paul McCarthy in Conversation with James Rondeau," in *Paul McCarthy at the Tate Modern*, p. 183.

146. Ibid., p. 183.

147. Ibid., p. 183.

148. Ibid., p. 183.

149. "Paul McCarthy," interviewed by Graham Ramsay and John Beagles, The Saatchi Gallery, retrieved March 2, 2006, from http://www.saatchi-gallery.co.uk/artists/paul_mccarthy_articles.htm.

150. "Paul McCarthy Interview," *Bomb*, Summer 2003, retrieved April 14, 2006, from http://www.ralphmag.org/DT/mccarthy.html.

151. Ibid.

152. Ibid.

153. Ibid.

154. Danto, in James Elkins (ed.), *Art History Versus Aesthetics*, New York: Routledge, 2006, p. 67.

155. Searle, in Butler, *Postmodernism*, p. 9.

156. Butler, *Postmodernism*, p. 9.

157. Shusterman, "Aesthetics and Postmodernism," p. 776.

158. Patti Lather, *Getting Smart: Feminist Research and Pedagogy with/in the Postmodern*, New York: Routledge, 1991.

159. These approaches are inspired by a treatment of similar ideas for younger learners by Olivia Gude, "Postmodern Principles: In Search of a 21st Century Art Education," *Art Education*, Vol. 57, No. 1, 2004, pp. 6–14, in which she explores layering, juxtaposition, recontextualization, reinterpretation, metaphor, low/high blur, space, installation, found objects, authentic located voices, reality and representation, (mixed messages) text/image hybridity, advertising strategies, appropriation, and mixing codes of styles.

The approaches given here are also treated in similar fashion elsewhere: Terry Barrett, "Approaches to Postmodern Art-making," *FATE in Review*, Vol. 28, 2006–2007, pp. 2–15, and with relevant reproductions in Terry Barrett, *Making Art: Form and Meaning*, New York: McGraw-Hill, 2010, pp. 202–228.

160. Paul Fabozzi, ed., *Artists, Critics, Context: Readings in and Around American Art Since 1945*, Upper Saddle River, NJ: 2002, pp. 248–249.

161. Judy Seigel, ed., *Mutiny and the Mainstream: Talk That Changed Art, 1975–1990*, New York: Midmarch Arts Press, 1992, p. 7.

162. Holland Cotter, "Great Meaning in Asian Small Works," *New York Times*, December 2, 2005, online, retrieved December 9, 2005, from http://www.nytimes.com/2005/12/02/arts/design/02mini.html.

163. Hal Foster, *Recordings: Art, Spectacle, Cultural Politics*, Seattle, Wash.: Bay Press, 1985.

164. "Simulacrum," *Wikipedia*, retrieved July 12, 2007, from http://en.wikipedia.org/wiki/Simulacra.

165. Kobena Mercer, "What Did Hybridity Do?," *Handwerker Gallery Newsletter*, Vol. 1, No. 4, Winter 1999, retrieved December 4, 2005, from http://www.ithaca.edu/hs/handwerker/g/publications/news/200001/hybridy1.htm.

166. Roni Feinstein, "A Journey to China," *Art in America*, February 2002, 108–113.

167. Susan Cahan and Zoya Kocur, eds, *Contemporary Art and Multicultural Education*, New York: Routledge, 1996, p. 80.

168. John Berger, *Ways of Seeing*, London: Penguin Books, 1972, p. 51.

169. Foster et al., *Art Since 1900*, ibid.

170. Mara Witzling, "Kiki Smith", in *Contemporary Women Artists*, ibid.

171. Julia Kristeva, *Powers of Horror: An Essay on Abjection*, trans. Leon S. Roudiez, New York: Columbia University Press, 1982, p. 2.

172. Howard Halle, "Body Language," *Oprah* Magazine, July 2006, p. 40.

173. "Art, Culture and Information," The Jewish Museum, January 8, 2004.

174. *Art: 21, 2*, New York: Abrams, 2003, p. 49.

175. Cahan and Kocur, *Contemporary Art*, p. 138.

6.1 Jeff Koons │ *Stacked*, **1988.**

Polychromed wood, 61 x 53 x 31 inches, from an edition of three plus one artist's proof.

Auctioned by Sotheby's in 2009 for $4,136,939. © Jeff Koons.

6 | Conclusion

Introduction

What conclusions can we draw from the preceding chapters? Amidst the disagreements, ambiguities, and unresolved problems in the preceding chapters, are there any generalities that hold true? This chapter, with some brief reviews of material and the addition of new thoughts, attempts to bring some comforting closure to an open and ongoing discussion that is beneficial to continue.

Why Is *Stacked* Art?

Jeff Koons, whose work is discussed in Chapter 2, made *Stacked* (6.1) in 1988. *Stacked* and many of his other pieces may lead to the question: "Why is that art?" *Stacked* is "cute" and doesn't look like objects we are used to calling "art"; the work is not unique (there are four of them); and Koons had the objects made for him by workers. However, we now can review and apply some answers as to why *Stacked* is art, the question asked by many about much recent art that does not meet their expectations of what art should be.

Art by Definitions

Stacked is art by definition. Recall George Dickie's classificatory "institutional definition" from Chapter 1:

1. An artist is a person who participates with understanding in making a work of art.
2. A work of art is an artifact of a kind created to be presented to an artworld public.
3. A public is a set of persons whose members are prepared in some degree to understand an object that is presented to them.
4. The artworld is the totality of all artworld systems.
5. An artworld system is a framework for the presentation of a work of art by an artist to an artworld public.[1]

(1) Koons has advanced degrees in artmaking, intends to make works of art, and is aware of what making a work of art traditionally entails. (2) Koons made *Stacked* for an artworld public, as well as the public that includes "any viewer." We know that he addresses artworld audiences by showing his work in art galleries and museums as well as in public sites such as the Rockefeller Plaza in New York City. (3) People who regularly go to galleries and museums that show contemporary art are prepared to greater and lesser extents to understand *Stacked* in some sense that does not leave them totally baffled. Critics and curators, for example, have defensible understandings of the object. By these criteria set forth by Dickie, a respected aesthetician, *Stacked* is a work of art.

Where does this institutional account get us? It tells us in general, almost sociological, terms how *Stacked* became a work of art. The explanation does not tell us if and why it deserves the honor or attention works of art generally receive. On the other hand, by this definition, there is no denying that *Stacked* already has the status of an artwork, and it leaves it to us, or someone, to determine its meanings and values.

Dickie's criteria are useful when responding to typical questions that arise when people are introduced to the institutional theory—for example, "I declare this yellow pencil I am holding to be a work of art! So is it a work of art?" It is not art because of conditions 2 and 5: The classroom is not an artworld public; the student is not an artist within the artworld. Basically, no one in the artworld cares about the student's pencil or the declaration that it is art. Answers become less clear if the student is a college art student and presents the pencil in a college art gallery that is run by a curator, a juror, or a member of an art faculty. If the pencil in the gallery has the status of a work of art, it probably is not a very important work of art within art institutions.

Stacked is also a work of art by Arthur Danto's classificatory definitional criteria:

X is a work of art if and only if
1. X has a subject
2. about which X projects an attitude or point of view
3. by means of rhetorical (usually metaphorical) ellipsis
4. which ellipsis requires audience participation to fill in what is missing (interpretation)
5. where both the work and the interpretation require an art-historical context.[2]

Stacked has the subject matter of carved, wooden, polychromed animals: A bird sits on the back of a dog that stands over a smaller dog that is lying on the back of a goat that is lying on a large pig's back that is lying on a simple white sculptural pedestal one would find in a contemporary art gallery. *Stacked* presents an attitude by its figuration: The animals are cute and cartoonish and like Hummel figurines; they look happy; they are very clean; and they are larger than what we would expect in such souvenirlike or Hummel-like figurines. *Stacked* is metaphorical in the sense that it is a consciously stylized *representation of* its subject matter, not the subjects themselves. Possible interpretations are many, and they do include art-historical contextual information.

Koons writes this about his intent and hope for *Stacked*:

I've tried to make work that any viewer, no matter where they came from, would have to respond to, would have to say that on some level "Yes, I like it." If they

couldn't do that, it would only be because they had been told they were not supposed to like it. Eventually they will be able to strip all that down and say "You know, it's silly, but I like that piece. It's great."[3]

In his remark, he means to appeal to a mass audience—"any viewer"—and he is implicitly aware of the artworld, especially art critics, who may have told people "they were not supposed to like it." Koons's use of the word "like" here is not particularly helpful. Certainly one might like *Stacked* but think that it is not art or that it is bad art. Probably all of us like some bad things. Critics may dislike Koons's works and still value them as works of art; recall, for example, in Chapter 5, art critic Jerry Saltz saying that he disliked Paul McCarthy's "sicko" work but believed it to be important art and respected it. Presumably, Koons the artist wants his art to be valued (not just liked) by the artworld where he typically shows it.

Stacked has many historical references that enlighten viewers about the work if they know the references. *Stacked* is possible because of Duchamp's *Fountain* in 1917: Both show an irreverent, challenging attitude toward what art is and could be. *Stacked* also challenges high Modernists' disdain for kitsch and intentionally blurs boundaries between art and kitsch; the concept of "kitsch" dates back to art discourse in Germany in the 1860s. *Stacked* and Koons's works have precedents in the work of Andy Warhol and in the Pop Art of the late 1950s. Koons and most in the artworld are aware of such references, although the "man on the street" may not be.

To the extent that one is aware of these references, interest in and respect for *Stacked* may increase. For those not versed in aesthetics, recent art theory, and newer art, Danto's classificatory criteria are not of much help, except, again, to assert that *Stacked* is a work of art with the backing of an artworld, that we should deal with it as an artwork, and, further, that we ought to or need to know art history if we are going to engage intelligently with *Stacked* as a work of art.

Is *Stacked* a Good Work of Art?

Realist Considerations

Neither Plato, Aristotle, nor those holding Realist criteria today would likely argue that *Stacked* is a good work of art by Realist criteria. The animals depicted in *Stacked* are very far removed from real birds, dogs, goats, and pigs. The bird, in particular, does not accurately resemble a living bird. The animals do not add to our knowledge of animals or the world, and indeed, they misinform us about animals by humanizing them, making them pretty by cartoonish conventions, and removing any signs of life in a pigsty, barnyard, or backyard.

Expressionist Considerations

Stacked might fare better by Expressionist criteria. The animals express friendliness in their facial expressions, relaxed postures, and playful positioning atop one another. *Stacked* is likely to put some viewers at ease and cause them to smile.

Stacked could be judged aesthetically dull, childishly simplistic, cloying, grating, melodramatic, derivative, overly commercial, garish, or insipid, lacking any interesting uses of form and medium, and devoid of content worth thinking about. An Expressionist might judged *Stacked* negatively because it could easily be argued that it expresses sentimentality rather than emotion. Aesthetician Alan Goldman explains that

> melodramatic and sentimental art engages us on an emotional level too easily, while the garish, merely skillful, and pretentious engage us perceptually or cognitively that way. What is meant by "too easily" is not simply that such art does not sufficiently challenge us, but that our absorption by it is one-dimensional, blocking attention to other features of the works by other faculties. Melodramatic and garish works are often trivial in their cognitive content, while persons who react positively to sentimental art often remain focused more on their own responses and responsiveness than on various features of the works. A work that causes us to respond inappropriately causes our evaluative faculties to come apart rather than uniting them in the appreciation of the work, if it does not simply switch them off. Because it is one-dimensional, such art typically fades quickly in attraction and hence does not attract knowledgeable and properly sensitive critics.[4]

Formalist Considerations

It would be difficult to find a Formalist who appreciates *Stacked* as a good work of Formalist art. *Stacked* confronts Formalism. It does not rely on "significant form" for its value. It is part of Koons's "Banality" series, and Formalism seeks to rise above the banal into the spiritual, especially through nonobjective abstraction. Formalist viewers ignore subject matter, except in terms of its form. Formalist artists tend not to use subject matter in their works. Formalists delight in honesty of material: wood, for example, ought to look like wood when it is used in art. Formalists are opposed to kitsch or mass-produced items made in "bad taste."

The form of *Stacked* is simplistic and pragmatic, and not what one would call elegant. The sculpture is very dependent on the subject matter. The wood of the sculpture does not look like wood, does not honor the simple integrity of wood, but disguises the material as something else. *Stacked* is based in the culture and commercial enterprise of knickknack objects of decoration.

By Formalist criteria, *Stacked* is a bad work of art. Even if a Formalist viewer wanted to be very generous about *Stacked*, he would be hard pressed to find anything about it to appreciate. As art critic Hilton Kramer remarks, "The problem with contemporary art today is a profound lack of belief in what we used to, without embarrassment, call 'the higher values of life,' whether they are religiously defined or socially defined, morally defined."[5]

Postmodernist Considerations

Stacked will probably be judged most favorably by Postmodern Pluralists who will tend to engage the issues it raises about kitsch, high art and low art distinctions, merging popular art with fine art, art as commodity, and the artist as self-promoting celebrity rather than judging its worth as an "aesthetic object."

Aesthetician Joseph Margolis provides a succinct summary of the themes of Postmodernist aesthetics that is useful here as a summary and for application to *Stacked*. Postmodern and Poststructuralist theorists generally believe

> (1) that cultural "entities"—artworks and persons preeminently—lack determinate natures, have or are only histories, cannot be determinately bounded though they can be individuated and reidentified primarily because of their distinctly intentional properties; (2) that the properties they are interpretatively assigned are themselves affected by the very process of interpretation, and they themselves affect and alter the "nature" of their interpreters and other interpretable things ("texts"); (3) that the capacity for interpretation is preformed, prejudiced, interested, partial, horizontal, incapable of including all possible interpretative perspectives or of reaching any straightforwardly neutral or objective account of what is interpreted; and (4) that the whole of human inquiry, including the physical sciences, is in some measure infected by the same constraints.[6]

When we apply Margolis's observations to *Stacked*, we can understand the piece to be questioning any determinate and fixed notions of what shall count as art, and we ought to note that Koons is asserting his particular view of art in *Stacked*. When we interpret *Stacked*, we affect both ourselves and the art object, and our interpretations will be very much influenced by who we are and what we believe, which is limited. It is these kinds of considerations that *Stacked* evokes in Postmodernist viewers rather than whether and how it is a good work of art. Rather than "good" (or not), it is "interesting" (or not).

Purposes of Art

There are many ways to divide art theory. This book uses divisions of Realism, Expressionism, Formalism, and Postmodern Pluralism. Other divisions are by the purposes of art and often include Instrumentalism as a major division. Instrumentalism is a theory of art that asserts that the purpose of art is to cause positive social change. Art that produces undesirable behavioral consequences must be avoided, and art that yields good behavioral consequences should be produced for the benefit of society. For instrumentalists, ethical values supersede aesthetic values. However, contradictory values are upheld by instrumentalists of different ethical or political persuasions: For example, both atheistic Marxists and devout theists may hold instrumental values regarding art.

If this book were to include such a category, then artworks that clearly, explicitly, and forcefully attempt to persuade one to change beliefs and behaviors would be placed under the heading of Instrumentalism. The most likely candidates in this book for reassignment to an Instrumental category are works by Alexis Rockman, Kiki Smith, Lorna Simpson, and Paul McCarthy.

However, each of the four general theories used in this book includes artists, aestheticians, and artworks with Instrumentalist motivations. With Plato's Realism, for example, art is suspect of having negative consequences for the populace; Aristotle, however, sees a purpose of art to advance knowledge. Alexis Rockman (Color Plate 4) painted *Manifest Destiny* to change societal values that degrade the natural environment.

Within Expressionism and Cognitivism, Nelson Goodman, for example, sees art to be a way of "worldmaking," contributing knowledge that would not be possible in language systems other than the visual. Kiki Smith (Color Plates 12 and 13) makes prints and sculptures, according to critic Helaine Posner, as "an engagement and reshaping of the religious, literary, and art-historical narratives that have defined the way we understand our origins and being, with the body as her focus."[7] Smith forcefully states, "To me the most essential thing is your spiritual life."[8]

Formalism has origins in early Abstractionists' beliefs in "spirituality." Wassily Kandinsky, Piet Mondrian, and Kazimir Malevich think of art as a means to raise consciousness to a level higher than the material. Kandinsky is author of *Concerning the Spiritual in Art*.[9] Mondrian also sees art as a means of confronting a higher reality. For Malevich, the purpose of abstract artworks is to reveal reality and to transform viewers. Malevich's "Suprematism, as implied by its name, was to be a new and prophetic kind of painting, representing a world to be, rather than one that is."[10] In England, Clive Bell asserts that the importance of "significant form" is that it provides unique "aesthetic" experiences and through these experiences "we become aware of its essential reality, of the God in everything."[11] Agnes Martin (Color Plates 14 and 15) asserts, "Painting is not about ideas or personal emotion . . . paintings are about freedom from the care of this world—from worldliness."[12]

Postmodern Pluralists face many choices, particularly regarding methodologies with which they may think about art and its making: feminism, psychoanalytic theory, postcolonial theory, and so forth. In general, their stances tend to be Instrumental, toward making a more just society (Lorna Simpson, Color Plates 23 and 24), sometimes by questioning the myths we live by (Paul McCarthy, Color Plates 25 and 26), and generally destabilizing our comfort with accepted versions of "truth" and "reality."

Selecting Criteria

When faced with judging a work of art, we are faced with decisions about criteria: Shall I use one criterion for all works of art? Which one and why? Shall I use many criteria and apply them to the same work of art? If so, will I be self-contradictory? Shall I use different criteria for different kinds of art? These can be difficult choices. Some considerations follow.

A Single Criterion or Multiple Criteria for All Works of Art

This book accepts and implicitly promotes the value of multiple sets of criteria. It lets the artwork decide by which criterion it is most advantageously seen, interpreted, and judged. The multiple criteria examined in this book can also be applied to a single work of art, as we briefly attempted earlier in this chapter with an analysis of Koons's *Stacked*. The presupposition is that different criteria, and theories of art, may beneficially broaden our view of art and the world. By understanding different criteria and how people apply them, we might also come to a more sympathetic understanding of aesthetic and social differences. We might see that what we abhor others like for certain reasons, that works that we might honor are abominable to other viewers, and,

very importantly, why people hold their views. If we simply count how many are "for" and "against" a particular work of art, we have some information but not an understanding of difference.

Many people who are not informed about art bring a single criterion or a narrow set of criteria to works of art without having carefully considered their criteria. People carry embedded assumptions about art that they apply rather unconsciously and reveal in casually stated but firmly declared comments, such as: "If I can't understand the work, it is not good art. Art means only what the artist meant it to mean; when in doubt, ask the artist. Art ought not require prior knowledge for me to appreciate it. Art ought to be beautiful in traditional senses. Art should make me feel good. Ugly art should not count as art at all. Art ought to be representationally realistic, no further removed from appearance than what the Impressionists gave us. Art should show a great degree of manual dexterity, and art that is childlike in the way it is made is not good art. Skill is admirable. Degree of difficulty in skill level is more admirable. Art should stay away from politics. Viewing art should be an uplifting experience."

Some professional critics also hold to single criteria and apply that criterion to all works of art. In the nineteenth century, Leo Tolstoy held firmly to the criterion that art should improve moral behavior and build communal closeness in sound moral values. In the twentieth century, Clement Greenberg was the outstanding example of one who held to a single criterion, namely, Formalism, which insists upon elegance of the purely visual aspects of art, ignoring its historical context and intended content. In the twenty-first century, critic Roger Kimball vehemently opposes any discussion of a work of art if that discussion is influenced by feminism, cultural studies, postcolonial studies, and any other inflections that are based on "politics" rather than "art."[13]

Questions for Further Reflection

Currently, what is your philosophy of art? Have you adjusted it at all because of what you have read? How? Why?

Which art examples reproduced in the book are your most and least favorite? Why? Can you articulate the criteria by which you favor some over others?

Regarding works of art in general, of what are you most certain?

Where in discussions of art and aesthetics do you feel more uncomfortable now than before? How did you come to a new comfort level?

What would you like to know that would disarm any remaining discomfort regarding current art and aesthetics?

Notes

1. George Dickie, in Robert Stecker, "Definition of Art," in *The Oxford Handbook of Aesthetics*, ed. Jerrold Levinson, New York: Oxford University Press, 2003, p. 147.

2. Noel Carroll, ibid., p. 146.

3. Jeff Koons, *The Jeff Koons Handbook*, New York: Rizzoli, 1992, p. 112.

4. Alan Goldman, "Evaluating Art," in Peter Kivy, ed., *The Blackwell Guide to Aesthetics*, Malden, Mass.: Blackwell, 2004, p. 106.

5. Hilton Kramer, in PBS's *Art Under the Radar*, http://www.pbs.org/thinktank/arts_transcript.html, June 9, 2006.

6. Joseph Margolis, "History of Aesthetics," in *The Oxford Companion to Philosophy*, ed. Ted Honderich, New York: Oxford University Press, 1995, p. 13.

7. Helaine Posner, "Once Upon a Time . . . ," in Kiki Smith, *Telling Tales*, New York: International Center of Photography, 2001, p. 5.

8. Ibid., p. 5.

9. Wassily Kandinsky, *Concerning the Spiritual in Art*, New York: George Wittenborn, Inc., 1947.

10. Myroslava Mudrak, "Suprematism," *Encyclopedia of Aesthetics*, New York: Oxford University Press, 1998, p. 336.

11. Clive Bell, in N. Wolterstorff, "Art and the Aesthetic: The Religious Dimension," in Kivy, ed., *The Blackwell Guide to Aesthetics*, p. 327.

12. Agnes Martin, in Jill Johnson, "Agnes Martin, 1912–2004," *Art in America*, March 2005, http://www.findarticles.com/p/articles/mi_m1248/is_3_93/ai_n13470723, June 21, 2006.

13. Roger Kimball, *The Rape of the Masters: How Political Correctness Sabotages Art*, San Francisco: Encounter Books, 2004.

Glossary

abject, the In Julia Kristeva's (1941–) usage, "the repugnance, the retching that thrusts me to the side and turns me away from defilement, sewage, and muck."

Abstract Expressionism An American art movement begun after World War II that shifted the center of the Western world of art from Paris to New York City. Abstract Expressionist paintings generally have the characteristics of a lack of realistic subject matter, intense introspection, and mural-size canvases.

aesthetic attitude Being open to the sensual qualities of art whereby one views an art-work with distance, not wanting to possess it or what it pictures.

aesthetic cognitivism A theory of art that proposes that art provides us with knowl-edge not obtainable by other means.

aesthetic experience A unique, heightened kind of human experience whereby one de-lights in something for its own sensual sake and not for any other reason, such as its utilitarian, moral, or economic value.

aesthetician One who philosophizes about art and related topics.

aestheticization The practice of seeing something ugly as beautiful, such as "aestheti-cizing" poor people or polluted landscapes; constructing images of people or events in a way that beautifies them, masking the undesirable.

aesthetics A branch of philosophy concerned with art and related topics such as beauty, aesthetic experience, ethics and aesthetics, interpretation, judgment, and so forth.

anti-essentialism The view that people and things do not have a fixed nature or that there is the really real of anything. A denial of essences or some fundamental charac-teristic that distinguishes one thing from another.

art criticism Discourse about art, usually published, to increase understanding, appre-ciation, and conversation.

artistic intent What an artist meant to accomplish or express with a work of art.

art theory A more commonly used term than "aesthetics" by the contemporary art press, artists, and art schools for philosophizing about art; heavily influenced by French theory and Postmodernism.

artworld An informal network of people and institutions involved in the production, display, distribution, sale, preservation, commission, and promotion of, as well as dis-course about, art. Its major centers include New York, London, and Berlin, but art-worlds are multiple, globally scattered, and constantly in flux.

camera lucida An optical device to aid artists while drawing, patented in 1807. It allows artists to see a subject projected onto a drawing surface. It is also the name of an influential book of photography theory by Roland Barthes, 1980.

classificatory definitions of art Identifications of what is art and what is not art by appeal to the institutions that do or do not exhibit such objects; based on institutional definitions of art. Such definitions tell us what is considered art by an artworld but not what qualities artworks should have.

colonialism Studies of the social assertion by a dominant cultural group over an indigenous people. The belief of the colonizer that it is superior to the colonized, giving the colonizer the justification for cultural and political domination, including the seizure of land and raw materials.

connotations The suggested or implied meanings of words or images, as opposed to their primary or literal denotational meanings.

conventionalism In photography theory, the belief that photographs are no more "real" than other images: We take them to be realistic because we are so accustomed to the conventions of photography that photographs seem to be natural rather than constructed.

conversationalist view of knowledge Richard Rorty's (1931–2007) rejection of the view of knowledge as representation or as a mental mirroring of an external world by the mind (a representationalist view of knowledge) and his belief in "knowledge as a matter of conversation and of social practice, rather than as an attempt to mirror nature."

critical theory A wide range of theories of culture and society such as cultural studies, semiotics, feminist theory, and Poststructuralist theory.

culture industry Theodor Adorno (1903–1969) critiques "the culture industry" (popular culture, popular media, and commodities for mass consumption), which he believes dampens innovations by promoting passive viewers and deadening political awareness.

Dadaism An "anti-art" movement regarding the arts begun in Europe and the United States immediately after World War I. Because of the devastating results of the war, Dadaists rejected the Enlightenment notion that reason and technology were positive forces. They reacted by making confrontational, nonsensical, absurd, playful, nihilistic, intuitive, and emotive works of art.

Daguerreotype A kind of early fixed photographic image invented by Louis-Jacques-Mandé Daguerre around 1839 in France.

deconstruction From Jacques Derrida, an examination of texts looking for their blind spots and contradictions; a questioning of dogmatic and complacent habits of belief through close readings of texts.

decontextualization In Formalist theories of art, the tendency to encourage the perception of art apart from its origins and purposes, seeing it only as form. For example, the display of African tribal masks with no contextual information about their origins and uses in favor of seeing them as a kind of abstract sculpture.

denotation The primary or literal meaning of a word or image, as opposed to its connotations, or its secondary implied, suggested, or inferred meanings.

dialectical materialism In Marxist theories, the assertion that empirical science reveals knowledge of the world and a simultaneous disbelief in nonmaterial and supernatural entities.

différance Jacques Derrida's term that means to defer the meaning of any word or sign, because words and signs are dependent on an endless play with other words and signs. Meaning should forever be "deferred" or postponed rather than being fixed, definite, or conclusive.

difference In semiotics and linguistics, the idea that words and signs only can have meaning by their difference from other words and signs: For example, "pawn" means nothing without "chess" and "knight." In Poststructuralism, difference also asserts a belief that we cannot separate "reality" from the ways we represent it.

differend Jean-François Lyotard (1924–1998) uses the term "*differend*" (dispute, difference) in examining how ideas or voices that do not fit within a dominant ideology are silenced.

Dionysianism In Friedrich Nietzsche's (1844–1900) usage, derived from the Greek gods Dionysus and Apollo, Dionysianism represents a collapse of borders, frenzy and excess, and an embracing of ambiguity, content beneath the visible surface, and messy complexity.

disinterestedness The belief that to properly view art, that is, to view it aesthetically, one ought to be free from any desires to possess the art or what it shows. Disinterestedness is a necessary condition for having an aesthetic experience. *Jouissance* can be understood as a reaction against disinterestedness.

earthworks Sculptures, usually of very large size, built into or from the natural environment. They purposively resist installation in an art museum or gallery.

Emotivism Another term for Expressionism.

Enlightenment, the A cultural movement in Europe and America, also known as the Age of Reason, begun in the eighteenth century. A core belief of the Enlightenment is a strong and optimistic view of reasoning and science as a way to understand the world and solve problems.

epistemology A core area of philosophy concerned with the nature, sources, and limits of knowledge.

essentialism In feminist theory, the view that because women are biologically different from men they are necessarily fundamentally different and thus produce art different in kind than men. The belief that all women share natural and unique characteristics and the celebration of such characteristics.

ethics A philosophic investigation of morality, rightness and wrongness, and human values. One's value system in matters of human acts.

Expressionism A cultural movement originating in Germany at the beginning of the twentieth century that celebrates subjective perspectives and distortion for emotional effect and the transmission of personal responses rather than accurate depictions of the world. A view of art as communication of emotion.

Expressivism Another term for Expressionism.

Fauvism A brief early-twentieth-century art movement by a group of artists derogatorily referred to as *fauves* (wild beasts) who used strong, clashing colors, flat patterns, and antinaturalism in depictions of figures and landscapes.

feminism A core belief that women are illegitimately disadvantaged or oppressed in comparison to men and considerations of how to rectify the situation. There are many feminisms and no one single comprehensive theory.

feminist aesthetics Multifarious and diverse conceptions about how feminist theories affect art, its production, distribution, and acceptance. Variously informed by psychoanalytic theory, Poststructuralism, semiotics, and Marxism.

fine art "Fine" is sometimes distinguished from "applied" and considered by some to be superior to other forms of art, such as decorative art or functional crafts. Generally, painting and sculpture preserved in art museums.

Formalism A twentieth-century theory of art that privileges considerations of compositional elements and principles above all else: Subject matter, narrative, symbolism, cultural, political, and religious references are deemed distracting, irrelevant, and to be ignored.

gaze Can be male or female. See "male gaze." Some feminists posit a female gaze that places the female in a subject position as one who actively desires.

genealogy Michel Foucault's (1926–1984) concern with power relationships by which persons are made into subjects. His genealogy is concerned with how subjects come to be both controlled and productive within institutional fields of power.

German Expressionism An avant-garde cultural movement in Germany begun before World War I and peaking in Berlin in the 1920s. It is the beginning of the larger cultural movement of Expressionism in Europe and eventually in the United States.

grand narrative For Jean-François Lyotard, all-encompassing accounts, such as Christianity or Marxism, for example, are totalizing, authoritative, and repressive in contrast to "mininarratives" that are provisional, temporary, relative, and dependent on contexts.

honorific definitions of art Articulations of what a "good" work of art should have and do in order to achieve the status of "art." For example, the human effort to imitate, supplement, alter, or counteract the work of nature.

hybridity In Postcolonial studies, the mixing of cultures and peoples resulting from colonization; the transactions between cultures and what they assimilate and what they resist.

hyperreality Jean Baudrillard (1929–2007) asserts that the world we live in has been replaced by a copy world of simulated stimuli. The inability to distinguish fantasy from reality, especially in technologically saturated cultures. The belief that a multitude of media radically shape an original event or experience.

icon In Charles Sanders Peirce's (1839–1914) semiotics, a sign that looks like what it signifies: for example, an icon of a cat as a realistic drawing of a cat.

illusionism The belief that realistic representations in art are provided by renderings of subject matter that deceive the eye into believing they are real.

imitation theory Synonymous with Realism.

Impressionism An art movement, primarily in France, 1870–1890. Paintings character-ized by bright colors applied in disconnected strokes intended to be unified by a viewer's eyes. Popular subject matters include sun-dappled landscapes, cityscapes, still lifes, portraits, and entertainment centers such as dance halls.

indexical quality In Charles Sanders Peirce's semiotics and subsequently in photogra-phy theory, an index is a sign that is caused by what it signifies: for example, an index of a cat would be a cat's paw print in the mud. In photography theory, the belief that photographs are indexical and iconic: They look like what they show and are caused by what they show.

institutional definitions of art The artworld empirically defines what is art by what it exhibits in art museums and other venues it sanctions.

instrumentalism A theory of art that requires art to have social value and conse-quences, not just aesthetic value.

intentionalist fallacy The (false) belief that an artwork is limited to what the artist wanted it to mean.

International Style In architecture, the avant-garde style of buildings that appeared in Europe between 1920 and 1930, that emigrated from Germany to America with the Bauhaus. Exemplified in minimalist steel and glass skyscrapers and the slogan "form follows function."

interpretation A critical activity that seeks to provide meanings about a work of art.

intertextuality In Postmodernism, the shaping of a text's meaning by other texts; the inevitability of influence; the inevitable influence among texts in which one is echoed in another.

jouissance A French term signifying intense pleasure and enjoyment with sexual over-tones in response to "texts." Viewers' involvements in works of arts are so intense they lose self-awareness and objective distance. In contradiction to "aesthetic experience."

kitsch Objects of decoration, fashion, and entertainment, usually mass produced, con-sidered to be not in good taste. Sometimes accepted with a sense of irony, and some-times made into subject matter for art. See the work of Jeff Koons, for example.

language games Ludwig Wittgenstein's notion about the flexibility, indeterminacy, and mutability of language. Any single word has differing meanings depending on how it is used in a context. Meanings blend into one another by "family resemblance." Works of art can be best understood in relation to family resemblances to other works already established as works of art.

langue Linguist Ferdinand de Saussure distinguishes between *langue* and *parole*. *Langue* can be translated from French to English as "language," which Saussure iden-tified as the total system and shared rules of a language. *Langue* is a bond by conven-tion among the brains of individuals and the language group to which they belong.

male gaze The idea that depictions of women are constructed to heighten erotic or sex-ual aspects of women's bodies. Narratives and spectacles build an imbalance between the active male subject and the passive female object.

Marxism Philosophical and social theories that examine the struggle for control of the materials on which people depend. Exposés of the ideologies that hide the nature of such

struggles. Marxists seek to understand the formative power of the material conditions of existence. The arts reflect or mask the economic and industrial power of a society.

Marxist aesthetics A concern about the relationships of the arts and social class, and whether the arts merely mirror or affect social structures.

metanarratives Ideas about other ideas; stories about stories, similar to metacriticism as an analysis of criticism.

metaphor In rhetoric, a figure of speech in which one class of things is referred to as if it belonged to another class: for example, Shakespeare's line, "All the world's a stage." Postmodernists claim that all language and other sign systems are metaphoric and that we know and explain our experiences only through metaphors. Nelson Goodman believes all art is metaphoric; it shows us something *as* something.

metaphysics A broad area of philosophy concerned with the nature of reality. Closely associated with ontology.

mimetic theory of art Synonymous with Realism and Copy Theory, stressing that a work of art ought to accurately depict reality in a realistically representational manner.

Modernism Cultural tendencies and movements arising from changes in Western society in the late nineteenth and early twentieth centuries. The view that traditional forms of culture are outdated. An assessment of the past as different from the modern age; a recognition of a more complex world; a challenging of traditional authorities, such as reason, science, government, and God.

narratives Stories or reasoned accounts of events occurring in time, often with a cause-and-effect relationship.

Neo-Marxism A loosely applied term referring to twentieth-century social theory that extends the application of Marxism from an emphasis on materialism especially by applications from psychoanalytic theory and feminism.

New Critics Literary critics who influenced art criticism in England and America, especially from the 1920s to the 1960s. They treated a work of literature as if it were self-contained and knowable through close reading of the relationship between structure and meaning. They ignored the authors' intents, readers' responses, and historical or cultural contexts so as to be objective.

Objectivity In philosophy, the belief that phenomena can be known apart from biases, prejudice, interests, and human desires. In aesthetics, the belief that judgments of art can be more than subjective preferences.

ontology The philosophic investigation of existence or being.

Other, the One who is colonized or one whom a dominant culture sees as less than civilized based on differences of social customs, cultural values, language, and race.

panopticism Michel Foucault's notion of the disciplinary function of architecture, specifically a prison designed as a ring-like structure with a vantage point in the center by which prisoners could be under constant surveillance without being able to see who was watching them.

parole Linguist Ferdinand de Saussure distinguishes between *langue* and *parole*. *Parole*, or "speech," denotes the use of the rules of a language in particular utterances. Such utterances are allowed and confined by *langue* and the limits it establishes.

Platonic ideals, Forms Plato's belief that the perfect fundamental reality is based on ideal, nonmaterial abstract ideas. Aspects of the material world that we know through our senses are distortions, copies, or mimics of the Forms.

Postcolonialism Studies of the effects of colonization on both the colonized and the colonizer.

Postmodernism In art theory, a condition or loosely connected ideas that assert that art and aesthetics cannot be separated from social, ethical, and political worlds. Postmodernism critiques Modernism and all its tenets, such as the possibility of originality, the uniqueness of the artist, and distinctions between "high art" and "low art" and rejects Formalism as a theory of art.

Poststructuralism A philosophical reaction to the Structuralism of the 1960s in linguistics, psychology, and the social sciences; a critique of the Structuralist position that a system can be autonomous and self-sufficient; a denial of an internal coherence of systems.

psychoanalytic theories A complex domain of knowledge that generally asserts that artists express what is buried in their subconscious minds. Viewers' experiences of art are also influenced by their subconscious minds.

Realism A theory of art that holds that a good work of art allows the viewer to quickly and easily recognize what is pictured.

repleteness Nelson Goodman's notion that works of art are plentifully abundant: Everything in a work of art carries significance and contributes to meanings.

Representationalism Another term for Realism. The aesthetic belief that art should look like what it is meant to show.

Representation theory Another term for Realism.

resemblance theory An aspect of Realism: the belief that a representation is realistic to the extent that it resembles or looks like what it is meant to show.

semiology A discipline devoted to the study of signs and symbols and processes of articulating and conveying meanings.

semiotics Synonymous with "semiology."

sexism The belief or attitude that one sex or gender is inferior, less valuable, or less competent than the other sex or gender. Sexism results in stereotypes of masculinity and femininity.

significant form The Formalist belief that abstract elements of art and their combinations result in an aesthetic experience. The idea makes form in art essential and subject and social content secondary, insignificant, and irrelevant.

sign In semiotics, something that stands for something to someone in some context.

signifier In semiotics, the part of a sign that denotes or connotes that to which it refers.

simulacrum Jean Baudrillard's term for the condition of a world in which the representations of things through mass media, and not the things themselves, are taken to be real.

simulation In Jean Baudrillard's usage, a simulation is a copy of a copy that is so removed from the original that it no longer seems to be a copy.

Socialist Realism A style of realistic art that developed in the Soviet Union and other communist countries to further the goals of socialism and communism. Not to be confused with Social Realism, an art movement that depicts subject matter that is meant to promote democratic values.

Structuralism A recent movement that conceives of all cultural phenomena, including artworks, as signs that operate on the basis of a deep and hidden structure; a representation of social, linguistic, cultural, and cognitive realities as patterns.

subconscious From psychoanalytic theories, the aspect of the mind that gives rise to mental phenomena in a person's mind that the person is unaware of at the time, such as dreams, unconscious thoughts, repressed or hidden desires, hidden phobias, automatic and unnoticed perceptions, and feelings that one is unaware of having.

subjectivity In aesthetics, whether judgments of artistic value are merely personal or can be objective. In psychology, an individual's sense of self. In Postmodernism, Michel Foucault conceives of the individual as subject of and subject to regimes of power. In feminism, how subjects are produced through conceptions of gender.

sublime, the A concept dating to the early Greeks (the vast and indefinite, the unpredictable and terrible) that took on renewed significance in the Romantic tradition (confrontation, the surprising, the unfamiliar, and experiences beyond an individual's reach). Awesome landscapes and terrifying nature are contrasted with safe, quiet beauty. The feeling of the insignificance of the human in the face of dramatic nature.

superego In Sigmund Freud's (1856–1939) model of the psyche, the superego plays critical and moralizing roles over the id's instinctual trends and over the ego's functioning between desires and repressions.

Suprematism An art movement begun in Russia in 1915–1916 based on fundamental geometric forms. Founded by Kasimir Malevich (1879–1935).

Surrealism A revolutionary cultural movement begun in the early 1920s known by artworks and writings that feature elements of surprise, unexpected juxtapositions, and contradictions.

texts In the semiotic tradition, all types of cultural products. An artwork is not to be considered a "work" in the sense of being the product of an individual artist but rather as a "text" or an organization of many signifying materials and sources.

unconscious In psychoanalytic theories, synonymous with "subconscious."

Venice Biennale A major and prestigious art exhibition that features selected contemporary art from around the world, held every two years in Venice, Italy.

visual culture A field of study that explores aspects of culture, especially those which are heavily visual. As an academic study it draws from many disciplines, including cultural studies, art history, critical theory, and psychoanalytic theory.

voyeurism The pleasure derived from looking; often the sexual pleasure of looking obtained by the objectification of the one who is being watched. It is often understood to be a masculine form of pleasure, providing a sense of power over women.

Bibliography

"Abject Art." Tate Online. n.d. http://www.tate.org.uk/collections/glossary/definition.jsp?entryId=7 (27 February 2006).

Adams, Tim. "The Call of the Wild." *The Observer*, January 26, 2005. http://www.guardian.co.uk/arts/reviews/observer/story/0,14467,1391227,00.html (11 January 2005).

Adorno, Theodor. *Aesthetic Theory*. Translated by Robert Hullot-Kentor. Minneapolis: University of Minnesota Press, 1997.

Alexander, Thomas. "Suzanne Langer." In *A Companion to Aesthetics*, ed. David Cooper. Malden, Mass.: Blackwell, 1992.

———. "John Dewey." In *A Companion to Aesthetics*, ed. David Cooper. Malden, Mass.: Blackwell, 1995.

Amy, Michael. "Joel Shapiro at PaceWildenstein." *Art in America*, October 2003, p. 124.

Anderson, Richard. *Calliope's Sisters: A Comparative Study of Philosophies of Art*. 2nd ed. Upper Saddle River, NJ: Pearson Prentice Hall, 2004.

Appel, Stephen. "Lacan, Representation, and Subjectivity: Some Implications of Education." In *Post-structuralism, Philosophy, Pedagogy*, ed. James Marshall. Dordrecht, The Netherlands: Kluwer, 2004.

Arasse, Daniel. "Les Transis." In Andres Serrano, *The Morgue*. Paris: Galerie Yvon Lambert, 1992.

Art: 21, 2, New York: Abrams, 2003, p. 49.

Art at the Millennium. London: Taschen, 1999.

Artinfo, http://www.artinfo.com/news/story/32418/paul-mccarthy/ (23 July 2010).

"Art, Culture and Information," The Jewish Museum, January 8, 2004.

"Art Minimal." http://members.aol.com/mindwebart4/agnes2.htm (1 January 2006).

Auping, Michael. "On Relationships." In *Agnes Martin/Richard Tuttle*. Fort Worth, TX: Modern Art Museum of Forth Worth, 1998.

Avgikos, Jan. "Jeff Koons, Sonnabend Gallery." *Artforum*, February 2003.

Bal, Mieke. "Autotopography: Louise Bourgeois as Builder." *Biography: An Interdisciplinary Quarterly*, Winter 2000, Vol. 25, Issue 1.

Barrett, Terry. *Criticizing Art: Understanding the Contemporary*. 3rd ed. New York: McGraw-Hill, 2012.

———. *Interpreting Art: Reflecting, Wondering, Responding*. New York: McGraw-Hill, 2003.

———. *Criticizing Photographs: An Introduction to Understanding Images*. 5th ed. New York: McGraw-Hill, 2012.

Barthes, Roland. "The Death of the Author." In Roland Barthes, *Image-Music-Text*. New York: Hill & Wang, 1968.

———. "Rhetoric of the Image." In Roland Barthes, *Image-Music-Text*. New York: Hill & Wang, 1971.

———. *Camera Lucida: Reflections on Photography*. New York: Hill & Wang, 1981.

Batchen, Geoffrey. *Burning with Desire: The Conception of Photography*. Cambridge, Mass.: MIT Press, 1997.

Baumgarten, Alexander. *Aesthetica 1750*. In Richard Eldridge, *An Introduction to the Philosophy of Art*. Cambridge, England: Cambridge University Press, 2003.

Beardsley, Monroe, and William Wimsatt. "The Intentionalist Fallacy." In *On Literary Intention*, ed. D. Newton de Molina. Edinburgh: Edinburgh University Press, 1967.

Bearn, Gordon. "Kitsch." *Encyclopedia of Aesthetics*. New York: Oxford University Press, 1998.

Bell, Clive. *Art*. London: Chatto and Windus, 1914; reprinted, New York: G. P. Putnam's Sons, 1958.

Bell, Kristine. "Agnes Martin: Five Decades, February 20–April 26, 2003, Zwirner & Wirth Gallery." http://www.zwirnerandwirth.com/exhibitions/2003/022003Martin/press.html (1 January 2006).

Berger, John. *Ways of Seeing*, London: Penguin Books, 1972, p. 51.

Berger, Maurice. "Last Exit to Brooklyn." In Alexis Rockman, *Manifest Destiny*. New York: Brooklyn Museum, 2004.

Bergstrom-Katz, Sasha. "In Focus: The Destruction of the Father 1974," *Artslant*. http://www.art-slant.com/la/articles/show/2711 (27 August 2010).

Berne, Betsy. "Studio: Cindy Sherman." *Tate Magazine*, Issue 5. http://www.tate.org.uk/magazine/issue5/sherman/htm (18 April 2006).

Best, Stephen, and Douglas Kellner. *Postmodern Theory: Critical Interrogations*. New York: Guilford Press, 1991.

Bettelheim, Bruno. *The Uses of Enchantment: The Meaning and Importance of Fairy Tales*. New York: Vintage Books, 1989.

Bourdon, David. "Andy Goldsworthy at Lelong—New York, New York—Review of Exhibitions." *Art in America*, November 1993. http://www.findarticles.com/p/articles/mi_m1248/is_n11_v81/ai_14647058 (12 January 2006).

Bourgeois, Louise. *Louise Bourgeois*. New York: Phaidon, 2003.

Broudy, Harry. *Enlightened Cherishing*. Champaign-Urbana: University of Illinois Press, 1972.

Butler, Christopher. *Postmodernism: A Very Short Introduction*. New York: Oxford, 2002.

Cahan, Susan, and Zoya Kocur, eds, *Contemporary Art and Multicultural Education*, New York: Routledge, 1996, p. 80.

Cameron, Dan. "The Mirror Stage." In *Paul McCarthy*. New York: New Museum, 2000.

Carroll, Noel. "Definition of Art." In *The Oxford Handbook of Aesthetics*, ed. Jerrold Levinson. New York: Oxford University Press, 2003.

Champa, Kermit. "Piet Mondrian." *Encyclopedia of Aesthetics*. New York: Oxford University Press, 1998.

"Cindy Sherman, Museum of Contemporary Photography." http://www.mopc.org/collections/permanent/uploads/sherman2001_33.jpg (27 January 2006).

Close, Chuck. *The Portraits Speak: Chuck Close in Conversation with 27 of His Subjects*. New York: Art Press, 1997.

Collingwood, R. G. *Principles of Art*. Oxford, England: Clarendon Press, 1938.

Cone, Michele. "The End of Pleasure." Artnet, 2004. http://www.artnet.com/Magazine/index/cone/cone2-17-04.asp (14 April 2006).

Cooke, Lynne. "Agnes Martin," DIA Art Foundation, New York. http://www.diabeacon.org/exhibs_b/martin-going/essay.html (1 January 2006).

Cooper, David, ed. *A Companion to Aesthetics*. Malden, Mass.: Blackwell, 1992.

Cotter, Holland. "Great Meaning in Asian Small Works," *New York Times*, December 2, 2005. http://www.nytimes.com/2005/12/02/arts/design/02mini.html (9 December 2005).

Coward, Rosalind, quoted by Jan Ziat Grover. "Dykes in Context, Some Problems in Minority Representation." In *The Context of Meaning*, ed. Richard Bolton. Cambridge, Mass.: MIT Press, 1989.

Crawford, Donald. "Kant." *The Routledge Companion to Aesthetics*. New York: Routledge, 2001.

Danto, Arthur. "The Future of Aesthetics." University of Oslo, October 27, 2005.

———. "Abstraction." In Arthur Danto, *The Madonna of the Future: Essays in a Pluralistic Art World*. New York: Farrar, Straus and Giroux, 2000.

———. "Clement Greenberg," May 30, 1994. In Arthur Danto, *The Madonna of the Future: Essays in a Pluralistic Art World*. New York: Farrar, Straus and Giroux, 2000.

———. *Beyond the Brillo Box: The Visual Arts in Post-Historical Perspective*. New York: Farrar, Strauss, and Giroux, 1992.

———. *Nietzsche as Philosopher*, New York: Macmillan, 1965.

Davies, Stephen. *The Philosophy of Art*. Malden, Mass.: Blackwell, 2006.

DeGenevieve, Barbara. "Guest Editorial: On Teaching Theory." *Exposure*, Vol. 26, No. 3, 1988, p. 10.

Derrida, Jacques. *Spurs: Nietzsche's Styles*. Chicago: University of Chicago Press, 1979.

Devereaux, Mary. "Oppressive Texts, Resisting Readers and the Gendered Spectator: The 'New' Aesthetics." In *Arguing about Art: Contemporary Philosophical Debates*, ed. Alex Neil and Aaron Ridley. 2nd ed. New York: Routledge, 2002.

Diamonstein, Barbaralee. *Inside the Art World.* New York: Rizzoli, 1994.

Dickie, George. *Art and the Aesthetic: An Institutional Analysis*. Ithaca, NY: Cornell University Press, 1974.

———. *Introduction to Aesthetics: An Analytic Approach*, New York: Oxford University Press, 1997.

———. "Definition of Art." In *The Oxford Handbook of Aesthetics*, ed. Jerrold Levinson. New York: Oxford University Press, 2003.

Doss, Erika. *Twentieth-Century American Art*. New York: Oxford University Press, 2002.

Dubin, Steven. "How *Sensation* Became a Scandal." *Art in America*, January 2000.

Eaton, Marcia. *Basic Issues in Aesthetics*. Belmont, Calif.: Wadsworth, 1988.

Eco, Umberto, ed. *Interpretation and Overinterpretation*. New York: Cambridge University Press, 1992.

Eisenhauer, Jennifer. "Beyond Bombardment: Subjectivity, Visual Culture, and Art Education." *Studies in Art Education*, Vol. 47, No. 2, 2006, pp. 155–169.

Eldridge, Richard. *An Introduction to the Philosophy of Art*. New York: Cambridge University Press, 2003.

Elkins, James. *What Happened to Art Criticism?* Chicago: Prickly Paradigm Press, 2003.

Emerling, Jae. *Theory for Art History*. New York: Routledge, 2005.

Fabozzi, Paul, ed. *Artists, Critics, Context: Readings in and Around American Art Since 1945*, Upper Saddle River, NJ: 2002, pp. 248–249.

Feinstein, Roni. "A Journey to China," *Art in America*, February 2002, 108–113.

Fenner, David. "Attitude: Aesthetic Attitude." *Encyclopedia of Aesthetics*. New York: Oxford University Press, 1998.

———. *Introducing Aesthetics*. Westport, Conn.: Praeger, 2003.

Ferguson, Frances. "The Sublime from Burke to the Present." *Encyclopedia of Aesthetics*. New York: Oxford University Press, 1998.

Fisher, John Andrew. *Reflecting on Art*. Mountain View, Calif.: Mayfield, 1993.

———. "Environmental Aesthetics." In *The Oxford Handbook of Aesthetics*, ed. Jerrold Levinson. New York: Oxford University Press, 2003.

Foster, Hal. *Recordings: Art, Spectacle, Cultural Politics*, Seattle, Wash.: Bay Press, 1985.

———. *The Return of the Real: The Avant-Garde at the End of the Century*. Cambridge, Mass.: MIT Press, 1996.

Foster, Hal, Rosalind Krauss, Yve-Alain Bois, and Benjamin Buchloh. *Art Since 1900*. New York: Thames and Hudson, 2004.

Foucault, Michel. "Nietzsche, Genealogy, History." In *Language, Counter-Memory, Practice: Selected Essays and Interviews*. Ithaca, NY: Cornell University Press 1977.

———. "Ecce Homo, or the Written Body." *Oxford Literary Review*, Vol. 7, Nos. 1–2, 1985, pp. 3–24.

Frankel, David. "Cindy Sherman Talks to David Frankel—80s Then—Interview." *Artforum*, March 2003. http://www.findarticles.com/p/articles/mi_m0268/is_7_41/ai/98918643/print (23 April 2006).

Frueh, Joanna. "Toward a Feminist Theory of Art Criticism." In *Feminist Art Criticism*, ed. Arlene Raven, Cassandra Langer, and Johanna Frueh. Ann Arbor, MI: UMI Press, 1988.

Garber, Elizabeth. "Feminism, Aesthetics, and Art Education." *Studies in Art Education*, Vol. 33, No. 4, 1992.

Geuss, Raymond. "Critical Theory." In *The Shorter Routledge Encyclopedia of Philosophy*, ed. Edward Craig. New York: Routledge, 2005.

Gilmore, Jonathan. "Pictorial Realism." *Encyclopedia of Aesthetics*. New York: Oxford University Press, 1998.

Glueck, Grace. "Art Review; Making History a Part of Today with Some Artifacts and Whimsy." *New York Times*, August 15, 2003. http://query.nytimes.com/gst/fullpage.html?res= 980DE4DF1730F936A2575BC0A9659C8B63 (17 April 2006).

Golden, Thelma. "What's White . . . ?" In *Postmodern Perspectives: Issues in Contemporary Art*, ed. Howard Risatti. 2nd ed. Upper Saddle River, NJ: Prentice-Hall, 1998.

———. "In Conversation with Lorna Simpson." In Kellie Jones, Thelma Golden, and Chrissie Iles, *Lorna Simpson*. New York: Phaidon, 2002, p. 107.

Goldman, Alan. "Evaluating Art." In *The Blackwell Guide to Aesthetics*, ed. Peter Kivy. Malden, Mass.: Blackwell, 2004.

Goldsworthy, Andy. *Passage*. New York: Abrams, 2004.

———. *Rivers and Tides: Working with Time*, a film by Thomas Riedelsheimer, Docudrama.

Goodman, Nelson. *Languages of Art*. Indianapolis: Hackett, 1968.

———. *Ways of Worldmaking*. Indianapolis: Hackett, 1978.

Govan, Michael. "Agnes Martin, Dia." http://www.diacenter.org/exhibs_b/martin/essay.html (1 January 2006).

Graham, Gordon. "Expressivism: Croce and Collingwood." In *The Routledge Companion to Aesthetics*, ed. Berys Gaut and Dominic McIver Lopes. New York: Routledge, 2001.

Grosenick, Uta, and Burkhard Riemschneider, eds. *Art Now: 137 Artists at the Rise of the New Millennium*. New York: Taschen, 2002.

Grundberg, Andy. "A Medium No More or Less: Photography and the Transformation of Contemporary Art." In *Visions from AmeriCalif.: Photographs from the Whitney Museum of American Art, 1940–2001*, ed. Sylvia Wolf. New York: Prestel, 2002.

———. "Afterword." In Deborah Willis, *Lorna Simpson*. San Francisco: The Friends of Photography, 1992.

Guyer, Paul. "Immanuel Kant: Survey of Thought." *Encyclopedia of Aesthetics*. New York: Oxford University Press, 1998.

Hagen, Charles. "Andres Serrano, After the Storm." *ARTnews*, September 1991.

Halle, Howard. "Body Language," *Oprah* Magazine, July 2006, p. 40.

Halliwell, Stephen. "Aristotle." In *A Companion to Aesthetics*, ed. David Cooper. Malden, Mass.: Blackwell, 1995.

———. "Aristotle on Form and Unity." In *Encyclopedia of Aesthetics*. New York: Oxford University Press, 1998.

Halter, Ed. "Things Fall Apart." *Village Voice*, January 1–7, 2003. http://www.villagevoice.com/film/ 0301,halter2,40899,20.html (14 January 2006).

Hammond, Anna. "Alexis Rockman at Gorney Bravin + Lee." *Art in America*, April 2001.

Hartman, Saidiya. "Excisions of the Flesh." In *Lorna Simpson: For the Sake of the Viewer*, ed. Beryl J. Wright and Saidiya Hartman, Chicago: Museum of Contemporary Art, 1992.

Hayward, Susan. *Cinema Studies: The Key Concepts*. London: Routledge, 2000.

Heartney, Eleanor. "Louise Bourgeois at Peter Blum." *Art in America*, January 1995.

———. "Jeff Koons at Sonnabend." *Art in America*, May 2004.

———. "Looking for America." In Andres Serrano, *America and Other Work*. London: Taschen, 2004.

————. *Postmodernism*. Cambridge, England: Cambridge University Press, 2001.

Hedges, Warren. *Derrida & Deconstruction: Key Points*. 2006. http://www.sou.edu/english/Hedges/Sodashop/RCenter/Theory/People/derdakey.htm (25 January 2006).

Heidegger, Martin. *Nietzsche*. 2 volumes. New York: Harper Collins, 1965.

Heiferman, Marvin. "Andres Serrano—Paula Cooper Gallery, Chelsea, England." *Artforum*, Summer 1997. http://www.findarticles.com (2 April 2005).

Hein, Hilde. "The Role of Feminist Aesthetics in Feminist Theory." *The Journal of Aesthetics and Art Criticism*, Vol. 48, No. 4, 1990.

Hepburn, Ronald. "Theories of Art." In *A Companion to Aesthetics*, ed. David Cooper. Malden, Mass.: Blackwell, 1995.

Herkenhoff, Paulo. "In Conversation with Louise Bourgeois." In *Louise Bourgeois*, ed. Robert Storr and Paulo Herkenhoff, London: Phaidon Press, 2003.

Hickey, Dave. "States of Art Criticism: A Symposium." The School of the Art Institute of Chicago, October 11, 2005.

Hirsch, E. D. *The Validity of Interpretation*. New Haven, Conn.: Yale University Press, 1967.

Hobbs, Robert. "Andres Serrano: The Body Politic." In *Andres Serrano: Works 1983–1993*. Philadelphia: University of Pennsylvania, 1994.

Honderich, Ted, ed. *The Oxford Companion to Philosophy*, New York: Oxford University Press, 1995.

Hopkins, David. *After Modern Art: 1945–2000*. Oxford, England: Oxford University Press, 2000.

Houlgate, Stephen. "Hegel, Survey of Thought." *Encyclopedia of Aesthetics*. New York: Oxford, 1998.

Hughes, Robert. *The Shock of the New*. New York: Alfred A. Knopf, 1996.

Iles, Chrissie. "Images Between Images: Lorna Simpson's Post-Narrative Cinema." In Kellie Jones, Thelma Golden, and Chrissie Iles, *Lorna Simpson*. New York: Phaidon, 2002.

Ingwood, M. "Frankfurt School." In *The Oxford Companion to Philosophy*, ed. Ted Honderich. New York: Oxford University Press.

Irish Museum of Modern Art. "Lorna Simpson at the Irish Museum of Modern Art." http://www.modernart.ie/en/page_19303.htm (17 April 2006).

Jameson, Frederick. *The Prison House of Language: A Critical Account of Structuralism and Russian Formalism*. Princeton, NJ: Princeton University Press.

Janaway, Christopher. "Plato." In *The Routledge Companion to Aesthetics*, ed. Berys Gaut and Dominic McIver Lopes. New York: Routledge, 2001.

————. "Plato." *Encyclopedia of Aesthetics*. New York: Oxford University Press, 1998.

"Jean Baudrillard." Wikipedia. http://en.wikipedia.org/wiki/Baudrillard (15 February 2006).

Johnson, Jill. "Agnes Martin, 1912–2004." *Art in America*, March 2005. http://www.findarticles.com/p/articles/mi_m1248/is_3_93/ai_n13470723 (21 June 2006).

Johnson, Ken. "Andy Goldsworthy." *New York Times*, June 9, 2000. http://query.nytimes.com/gst/fullpage.html?res=9B02EED9113FF93AA35755C0A9 (20 January 2006).

————. "Indoor-Outdoor Relations along the Hudson Valley." *New York Times*, July 21, 2000. http://query.nytimes.com/gst/fullpage.html?res=9F03EFD61F3BF932A15754C0A9669C8B63 (12 January 2006).

————. "The Modernist vs. the Mystics." *New York Times*, April 12, 2005, B1 and B7, p. 7.

Jones, Kellie. "(un)seen & Overheard: Pictures by Lorna Simpson." In Kellie Jones, Thelma Golden, and Chrissie Iles, *Lorna Simpson*. New York: Phaidon, 2002.

Kalina, Richard. "Expressing the Abstract." *Art in America*, December 2002.

Kandinsky, Wassily. *Concerning the Spiritual in Art*. New York: George Wittenborn, Inc., 1947.

Kessler, Serra. "Andres Serrano Interview in Whitehall," July 29, 2001, http://sarahkessler.wordpress.com/2008/12/28/andres-serrano-interview-in-whitewall/.

Kimball, Roger. *The Rape of the Masters*. San Francisco: Encounters, 2004.

Kimmelman, Michael. "Art View; A Few Artless Minutes on '60 Minutes,'" *New York Times*, October 17, 1993. http://query.nytimes.com/gst/fullpage.html?res=9F0CE0DA1530F934 A25753C1A965958260 (1 June 2006).

Kivy, Peter, ed. *The Blackwell Guide to Aesthetics*. Malden, Mass.: Blackwell, 2004.

Klages, Mary. "Structuralism/Poststructuralism." 2006. http://www.colorado.edu/English/ENGL 2012Klages/1derrida.html (25 January 2006).

Kleiner, Fred, and Christin Mamiya. *Gardner's Art Through the Ages*. 12th ed. New York: Wadsworth, 2005.

Koons, Jeff. *Jeff Koons: Pictures 1980–2002*. New York: D.A.P., 2003.

———. *The Jeff Koons Handbook*. New York: Rizzoli, 1992.

Kramer, Hilton. PBS. *Art Under the Radar*. http://www.pbs.org/thinktank/arts_transcript.html (9 June 2006).

Krauss, Rosalind. *Cindy Sherman 1975–1993*. New York: Rizzoli, 1993.

Kristeva, Julia. *Powers of Horror: An Essay on Abjection*. Translated by Leon S. Roudiez. New York: Columbia University Press, 1982.

Krukowski, Lucian. "Formalism: Conceptual and Historical Overview." *Encyclopedia of Aesthetics*. New York: Oxford University Press, 1998.

Kundera, Milan. *The Unbearable Lightness of Being*. 1984. Translated by Michael Henry Heim. New York: Perennial Classics, 1999.

Kuspit, Donald. In Arlene Raven, *Crossing Over: Feminism and the Art of Social Concern*. Ann Arbor: UMI Press, 1988.

———. "Joel Shapiro at Pace." *Art in America*, September 2003. http://www.findarticles.com/p/ articles/mi_m0268/is_n3_v32/ai_14875091 (21 January 2006).

———. "The Triumph of Shit," *Artnet Magazine*. http://www.artnet.com/magazineus/features/ kuspit/kuspit9-11-08.asp (22 July 2006).

Lambert, Yvon. "Paris: Andres Serrano—Shit, September 2008–16 October 2009." http://www.re-ti- tle.com/exhibitions/archive_YVONLAMBERTPARIS3166.asp (18 September 2010).

Landi, Ann. "Jeff Koons, Sonnabend." *ARTnews*, February 2004.

Langer, Suzanne. *Problems of Art*. New York: Scribner's, 1957.

———. *Feeling and Form*. New York: Scribner's, 1953.

———. *Mind: An Essay on Human Feeling*. 3 vols. Baltimore, Md.: Johns Hopkins University Press, 1967, 1972, 1982.

Lather, Patti. *Getting Smart: Feminist Research and Pedagogy with/in the Postmodern*. New York: Routledge, 1991.

Lee, Yvette. "'Beyond Life and Death': Joan Mitchell's Grande Vallée Suite." In Jane Livingston, *The Paintings of Joan Mitchell*. New York: Whitney Museum of American Art, 2002.

Levinson, Jerrold. "Philosophical Aesthetics: An Overview." In *The Oxford Handbook of Aesthetics*, ed. Jerrold Levinson. New York: Oxford University Press, 2003.

Littlejohn, David. "Who Is Jeff Koons and Why Are People Saying Such Terrible Things about Him?" *ARTnews*, April 1993.

Livingston, Jane. *The Paintings of Joan Mitchell*. New York: Whitney Museum of American Art, 2002.

Lloyd, Jill. "Berlin Twentieth-Century Modernism." *The Burlington Magazine*, Vol. 139, No. 1133. August 1997. http://links.jstor.org/sici?sici=0007-6287%28199708%29139%3A1133%3C565 %3ATMB%3E2.0.CO%3B2-8 (17 January 2006).

Lyas, Colin. "Intentional Fallacy." In *A Companion to Aesthetics*, ed. David Cooper. Malden, Mass.: Blackwell, 1992.

———. "Intention." In *A Companion to Aesthetics*, ed. David Cooper. Malden, Mass.: Blackwell, 1992.

———. "Art Criticism." In *The Shorter Routledge Encyclopedia of Philosophy*, ed. Edward Craig. New York: Routledge, 2005.

Lynch, Thomas. "Mourning in America." Book review of *Death's Door; Modern Dying and the Ways We Grieve* by Sandra Gilbert. *The New York Times Book Review*, Sunday, February 26, 2006.

MacAdam, Barbara. "Joel Shapiro, Pace." *ARTnews*, October 1993, p. 160.

MacKinnon, Catharine. *Women's Lives, Men's Laws*. Cambridge, Mass.: Harvard University Press, 2005.

Magnus, Bernd. "Nietzsche, Friedrich Wilhelm: Survey of Thought." In *Encyclopedia of Aesthetics*. New York: Oxford University Press, 1998.

Makkreel, Rudolf. "Immanuel Kant: Kant and Art History." *Encyclopedia of Aesthetics*. New York: Oxford University Press, 1998.

Margolis, Joseph. "History of Aesthetics." In *The Oxford Companion to Philosophy*, ed. Ted Honderich, New York: Oxford University Press, 1995.

Marrone, Diana. "Paul McCarthy," *Frieze Magazine*, June 1, 2010. http://www.frieze.com/shows/review/paul_mccarthy/, (23 July 2010).

Marshall, James, ed. *Poststructuralism, Philosophy, Pedagogy*. Dordrecht, The Netherlands: Kluwer, 2004.

Martin, Agnes. *Writings—Schriften*. Winterthur: Kunstmuseum Winterthur, in association with Cantz, Ostfildern-Ruit, 1991.

———. "Beauty Is the Mystery of Life." In "Charles Brummer, Iowa State University." http://www.public.iastate.edu/~brummer/culture/art/agnes.htm (1 January 2006).

McEvilley, Thomas. "Doctor Lawyer Indian Chief: 'Primitivism' in Twentieth-Century Art at the Museum of Modern Art in 1984." *Artforum*, November 1984. In *Uncontrollable Beauty: Toward a New Aesthetic*, ed. Bill Beckley. New York: Allworth Press, 1998.

McGee, Celia. "A Personal Vision of the Sacred and Profane." *New York Times*, Sunday, January 22, 1995.

McGuigan, Cathleen. "Painter Alexis Rockman Pictures Tomorrow," *Smithsonian*, December 2010. Smithsonian.com. http://www.smithsonianmag.com/arts-culture/Painter-Alexis-Rockman-Pictures-Tomorrow.html (22 November 2010).

Mercer, Kobena. "What Did Hybridity Do?," *Handwerker Gallery Newsletter*, Vol. 1, No. 4, Winter 1999. http://www.ithaca.edu/hs/handwerker/g/publications/ news/200001/hybridy1.htm (4 December 2005).

Monk, Philip. "Mike Kelley and Paul McCarthy: Collaborative Works." http://www.absolutearts.com/artsnews/2000/03/28/26760.html (14 April 2006).

Möntmann, Nina. *Art Now: 137 Artists at the Rise of the New Millennium*. New York: Taschen, 2002.

Morris, Frances, and Sarah Glennie. "Hollow Dreams." In *Paul McCarthy at the Tate Modern*. London: Tate Publishing, 2003.

Morss, John R. "Giles Deleuze and the Space of Education: Poststructuralism, Critical Psychology, and Schooled Bodies." In *Poststructuralism, Philosophy, Pedagogy*, ed. James Marshall. Dordrecht, The Netherlands: Kluwer, 2004.

Mothersill, Mary. "Beauty." In *A Companion to Aesthetics*, ed. David Cooper. Malden, Mass.: Blackwell, 1992.

———. "David Hume: 'Of the Standard of Taste.'" *Encyclopedia of Aesthetics*. New York: Oxford University Press, 1998.

Mudrak, Myroslava. "Suprematism." *Encyclopedia of Aesthetics*. New York: Oxford University Press, 1998.

Mulvey, Laura. "Visual Pleasure and Narrative Cinema." In *Visual and Other Pleasures*. Bloomington: Indiana University Press, 1989.

Muschamp, Herbert. "Knowing Looks—Cindy Sherman, Museum of Modern Art, New York, NY." *Artforum*, 1996. http://www.findarticles.com/p/articles/mi_m0268/is_n10_v35/ai_19677874/print (24 April 2006).

Museum of Jewish Heritage. "Garden of Stones." http://www.mjhnyc.org/visit_gardenofstones.htm (13 January 2006).

Nash, Steven. "Integration, Disintegration." In *Joel Shapiro: Work in Wood, Plaster, and Bronze 2001–2005*. New York: PaceWildenstein, 2005.

Newman, Amy. "Interview with Joel Shapiro." In *Joel Shapiro: Recent Sculpture and Drawings*. New York: PaceWildenstein, 2001.

Nochlin, Linda. "Why Have There Been No Great Women Artists?" First published in *Art News*, Vol. 69, No. 9, January 1971. Reprinted in Linda Nochlin. *Women, Art and Power and Other Essays*. New York: Harper & Row, Publishers, 1988.

———. "Joan Mitchell, A Rage to Paint." In Jane Livingston, *The Paintings of Joan Mitchell*. New York: Whitney Museum of American Art, 2002.

Olssen, Mark. "The School as the Microscope of Conduction: Doing Foucauldian Research in Education." In *Poststructuralism, Philosophy, Pedagogy*, ed. James Marshall. Dordrecht, The Netherlands: Kluwer, 2004.

Pappas, Nickolas. "Beauty: Classical Concepts." In *Encyclopedia of Aesthetics*. New York: Oxford University Press, 1998.

"Paul McCarthy Interview." *Bomb*. Summer 2003. http://www.ralphmag.org/DT/mccarthy.html (14 April 2006).

"Paul McCarthy: Pig Island," press release, *This Is Tomorrow: Contemporary Art Magazine*. http://www.thisistomorrow.info/viewArticle.aspx?artId=406 (23 July 2010).

Peters, Michael. "Lyotard, Marxism and Education: The Problem of Knowledge Capitalism." In *Poststructuralism, Philosophy, Pedagogy*, ed. James Marshall. Dordrecht, The Netherlands: Kluwer, 2004.

Peters, Michael, and Nicholas Burbules. *Poststructuralism and Educational Research*. New York: Rowman & Littlefield, 2004.

Phillips, Lisa. "Paul McCarthy's Theater of the Body." In *Paul McCarthy*. New York: New Museum, 2000.

Plagens, Peter. "Of Pigments and Pixels." *Newsweek*, special edition, December 1999–February 2000. http://www.michaklein.com/news/newsweek.html (14 April 2006).

Pollock, Griselda, and Deborah Cherry, quoted by Pollock. "Art, Art School, Culture: Individualism After the Death of the Artist." *Exposure*, Vol. 24, No. 3, 1986.

Polsky, Richard. "Art Market Guide 2001, Artnet." http://www.artnet.com/Magazine/features/polsky/polsky5-2-01.asp (1 January 2006).

Posner, Helen. "Once Upon a Time . . ." In Kiki Smith, *Telling Tales*. New York: International Center of Photography, 2001.

Princenthal, Nancy. "Joel Shapiro at Pace." *Art in America*, September 1993. http://www.findarticles.com/p/articles/mi_m1248/is_n9_v81/ai_14406845 (21 January 2006).

Ramamurthy, Anandi. "Constructions of Illusion: Photography and Commodity Culture." In *Photography: A Critical Introduction*, 2nd ed., ed. Liz Wells. New York, Routledge, 2000.

Ramberg, Bjorn. "Richard Rorty." *Stanford Encyclopedia of Philosophy*. 2001. http://plato.stanford.edu/archives/win2001/entries/rorty/ (21 February 2001).

Ramsay, Graham, and John Beagles. "Paul McCarthy." Interview. The Saatchi Gallery. http://www.saatchi-gallery.co.uk/artists/paul_mccarthy_articles.htm (2 March 2006).

Reed, Christopher. "Bloomsbury Group." *Encyclopedia of Aesthetics*. New York: Oxford University Press, 1998.

Ricard, Rene. "Not about Julian Schnabel." *Artforum*, 1981.

Rifkin, Ned. "Interview with Sean Scully," May 20, 1994. In *Sean Scully: Twenty Years, 1976–1995*. London: Thames and Hudson, 1995.

Rimanelli, David. "Alexis Rockman, Jay Gorney Modern Art." *Artforum*, December 1993.

Rockman, Alexis. *Manifest Destiny*. New York: Brooklyn Museum, 2004.

Rondeau, James. "Paul McCarthy in Conversation with James Rondeau." In *Paul McCarthy at the Tate Modern*. London: Tate Publishing, 2003.

Rosenberg, Karen. "On Being a Woman, From Cradle to Grave," *New York Times*, February 13, 2010. http://www.nytimes.com/2010/02/13/arts/design/13sojourn.html (1 September 2010).

Rosenblum, Robert. "Notes on Jeff Koons." In Jeff Koons, *The Jeff Koons Handbook*. New York: Rizzoli, 1992.

———. "Dream Machine." In Jeff Koons, *Easy Fun-Ethereal*. Berlin: Deutsche Guggenheim, 2000.

———. "Jeff Koons, *Christ and the Lamb*." *Artforum*, September 1993.

Ross, Lillian. "Taos Postcard: Lunch with Agnes." *The New Yorker*, July 14 and 21, 2003, p. 32.

Ross, Stephen David. "Beauty." *Encyclopedia of Aesthetics*. New York: Oxford University Press, 1998.

Rothkopf, Scott. "Screen Test: Jeff Koons's *Olive Oyl*." *Artforum*, October 2004.

Rudolph, Ellen. "Obscurely Focused: The Photographs of Lorna Simpson." *Angle*, No. 17, 2004. http://www.anglemagazine.org/articles/Obscurely_Focused_The_Photogr_2219.asp (17 April 2006).

Sakamoto, Gabriela. "Resemblance." *Encyclopedia of Aesthetics*. New York: Oxford University Press, 1998.

Saint Girons, Baldine. "The Sublime from Longinus to Montesquieu." *Encyclopedia of Aesthetics*. New York: Oxford University Press, 1998.

Saltz, Jerry. "Alexis Rockman at Sperone Westwater." *Art in America*, December 1992.

———. In *M/E/A/N/I/N/G: An Anthology of Artist's Writings, Theory and Criticism*, ed. Susan Bee and Mira Schor. Durham, NC: Duke University Press, 2000.

———. "Backdoor Man." *The Village Voice*, 2002. http://www.kunstwissen.de/fach/f-kuns/o_pm/carthy05.htm (14 April 2006).

———. "Looking Out for No. 2," *New York Magazine*, September 21, 2008. http://www.artnet.com/magazineus/features/saltz/saltz9-29-08.asp (22 July 2010).

Sandler, Irving. "Mitchell Paints a Picture." *Art News*, October 1957, pp. 44–47.

Sartwell, Crispin. "Realism." In *A Companion to Aesthetics*, ed. David Cooper. Malden, Mass.: Blackwell, 1992.

Schama, Simon. "Garden of Stones." First published in *The New Yorker*, September 22, 2003. In Andy Goldsworthy, *Passage*. New York: Abrams, 2004.

Schjeldahl, Peter. "Critical Reflections." *Artforum*, November 1994.

———. "A Jeff Koons Retrospective," *The New Yorker*, June 9, 2008. http://www.newyorker.com/arts/critics/artworld/2008/06/09/080609craw_artworld_schjeldahl?currentPage=1 (1 August 2010).

———. "The Junkman's Son." *The New Yorker*, November 3, 2003, pp. 102–103.

Schrift, Alan. *Nietzsche's French Legacy: A Genealogy of Poststructuralism*. New York: Routledge, 1995.

Schwabsky, Barry. "Octoberfest." *The Nation*, December 26, 2005. http://www.thenation.com/doc/20051226/schwabsky (6 June 2006).

Schwartzman, Allan. "Untitled." In *Louise Bourgeois*, ed. Robert Storr and Paulo Herkenhoff. London: Phaidon Press, 2003.

Searle, Adrian. "Louise Bourgeois Dies in New York, Aged 98," Guardian.co.uk. http://www.guardian.co.uk/artanddesign/2010/jun/01/louise-bourgeois-dies-new-york-98 (27 August 2010).

———. "Shiver Me Timbers." *Guardian Unlimited*. October 25, 2005. http://arts.guardian.co.uk/features/story/0,11710,1599800.html (14 April 2006).

Seigel, Judy, ed. *Mutiny and the Mainstream: Talk That Changed Art, 1975–1990,* New York: Midmarch Arts Press, 1992, p. 7.

Serrano, Andres. *Andres Serrano: Works 1983–1993*. Philadelphia: University of Pennsylvania, 1994.

———. *The Morgue*. Paris: Galerie Yvon Lambert, 1992.

———. *America and Other Work* London: Taschen, 2004.

Shapiro, Gary. "Nietzsche, Friedrich Wilhelm: Nietzsche, Schopenhauer, and Disinterestedness." *Encyclopedia of Aesthetics*. New York: Oxford University Press, 1998.

Shusterman, Richard. "The End of Aesthetic Experience." *The Journal of Aesthetics and Art Criticism*, Vol. 55, No. 1, Winter 1997, pp. 29–41.

———. *Pragmatist Aesthetics: Living Beauty, Rethinking Art.* 2nd ed. New York: Rowman & Littlefield, 2000.

———. "Aesthetics and Postmodernism." In *The Oxford Handbook of Aesthetics,* ed. Jerrold Levinson. New York: Oxford University Press, 2003.

Sim, Stuart. "Structuralism." *Encyclopedia of Aesthetics.* New York: Oxford University Press, 1998.

"Simulacrum," *Wikipedia.* http://en.wikipedia.org/wiki/Simulacra (12 July 2007).

Smith, Edward-Lucie. *Artoday.* London: Phaidon, 1996.

Smith, Kiki. *Telling Tales.* New York: International Center of Photography, 2001.

———. *Books, Prints & Things.* New York: Museum of Modern Art, 2003.

Smith, Roberta, quoted by Deborah Drier. "Critics and the Marketplace." *Art & Auction,* March 1990.

———. "The Met and a Guest Step Off in Opposite Directions." *New York Times,* September 3, 2004. http://www.nytimes.com/2004/09/03/arts/design/X03SMIT.html?ex=1137214800&en=5231edd7271ee699&ei=5070 (12 January 2006).

Snyder, Joel. "Picturing Vision." In *The Language of Pictures,* ed. W. J. T. Mitchell. Chicago: University of Chicago Press, 1980.

Solomon, Deborah. "Continental Drift: Questions for Jean Baudrillard." *New York Times Magazine,* November 11, 2005, p. 22.

Solomon-Godeau, Abigail. "Winning the Game when the Rules Have Been Changed: Art Photography and Postmodernism." *Exposure,* Vol. 23, No.1, 1985.

Sontag, Susan. *On Photography.* New York: Farrar, Straus and Giroux, 1973.

———. *Regarding the Pain of Others.* New York: Picador, 2004.

Spector, Nancy. "Guggenheim Museum." http://www.guggenheimcollection.org/site/artist_work_md_103_1.html (1 January 2006).

Sprinkle, Annie. "Hard-Core Heaven." *Arts Magazine,* March 1992, p. 46.

Steiner, Wendy. "Introduction: Below Skin Deep." In *Andres Serrano: Works 1983–1993.* Philadelphia: University of Pennsylvania, 1994.

Stone, Lynda. "Julia Kristeva's 'Mystery' of the Subject in Process." In *Poststructuralism, Philosophy, Pedagogy,* ed. James Marshall. Dordrecht, The Netherlands: Kluwer, 2004.

Storr, Robert. "A Sketch for a Portrait: Louise Bourgeois." In *Louise Bourgeois,* ed. Robert Storr and Paulo Herkenhoff, London: Phaidon Press, 2003.

Strauss, Anne L. "Stone Houses." New York: The Metropolitan Museum of Art, 2004.

Stroll, Diana. "Interview with Adrian Piper." *Afterimage,* No. 166, Spring 2002.

Talbot, William Henry Fox. *The Pencil of Nature.* London: Longman, Brown, Green, & Longmans, 1844.

Taplin, Robert. "Joel Shapiro at PaceWildenstein." *Art in America,* May 1999. http://www.findarticles.com/p/articles/mi_m1248/is_5_87/ai_54574763 (21 January 2006).

Tavin, Kevin. "Wrestling with Angels, Searching for Ghosts: Toward a Critical Pedagogy of Visual Culture." *Studies in Art Education,* Vol. 44, No. 3, Spring 2003.

Thom, Paul. *Making Sense: A Theory of Interpretation.* New York: Rowman & Littlefield, 2000.

Thorp, David. "Large Scale Substitutes." In *Paul McCarthy at the Tate Modern.* London: Tate Publishing, 2003.

Tilghman, David. "Wittgenstein, Ludwig Josef Johann: Survey of Thought." *Encyclopedia of Aesthetics.* New York: Oxford University Press, 1998.

Tucker, Marsha. *Joan Mitchell.* New York: Whitney Museum of American Art, 1974.

"University Art Museum, University at Albany State University of New York." http://www.albany.edu/museum/wwwmuseum/crossing/artist16.htm (1 January 2006).

Vaizey, Marina. "Art Is More Than Just Art," *New York Times Book Review,* August 5, 1999.

Van Camp, Julie. "Freedom of Expression at the National Endowment for the Arts: An Opportunity for Interdisciplinary Education," *Journal of Aesthetic Education,* Vol. 30, Fall 1996, pp. 43–65.

Walton, Kendall. "Transparent Pictures: On the Nature of Photographic Realism." *Critical Inquiry*, December 11, 1984.

Ward, Glen. *Postmodernism*. Chicago: Contemporary Books, 1997.

Weitman, Wendy. "Experiences with Printmaking: Kiki Smith Expands the Tradition." In Kiki Smith, *Books, Prints & Things*. New York: Museum of Modern Art, 2003.

———. "Kiki Smith, Prints, Books & Things." Exhibition brochure. The Museum of Modem Art, December 5, 2003–March 8, 2004.

Weitz, Morris. *Hamlet and the Philosophy of Literary Criticism*. New York: Dutton, 1964.

———. "The Role of Theory in Aesthetics." In *Aesthetics: A Reader in Philosophy of the Arts*, ed. David Goldblatt and Lee Brown. Upper Saddle River, NJ: Prentice Hall, 1997.

Westphall, Kenneth. "Kant on the Sublime." *Encyclopedia of Aesthetics*. New York: Oxford University Press, 1998.

Willis, Deborah. "Eyes in the Back of Your Head: The Work of Lorna Simpson." In Deborah Willis, *Lorna Simpson*. San Francisco: The Friends of Photography, 1992.

———. "A Conversation: Lorna Simpson and Deborah Willis." In Deborah Willis, *Lorna Simpson*. San Francisco: The Friends of Photography, 1992.

Witzling, Mara. "Kiki Smith." In *Contemporary Women Artists*, ed. Laurie Hillstrom and Kevin Hillstrom. Detroit: St. James Press, 1999.

Wolfe, Tom. *The Painted Word*. San Francisco: Farrar, Straus and Giroux, 1975.

Wright, Beryl. "Back Talk: Recording the Body." In *Lorna Simpson: For the Sake of the Viewer*, ed. Beryl J. Wright and Saidiya Hartman. Chicago: The Museum of Contemporary Art, 1992.

Zöller, Günter. "Immanuel Kant: History of Kantian Aesthetics." *Encyclopedia of Aesthetics*. New York: Oxford University Press, 1998.

Zweite, Armin. "To Humanize Abstract Painting: Reflections on Sean Scully's *Stone Light*." Translated by John Ormrod. In *Sean Scully: Twenty Years, 1976–1995*. London: Thames & Hudson, 1995.

Index